But is it *Art*?

The Spirit of Art as Activism

Edited by
Nina Felshin

Bay Press
Seattle

Printed in the United States of America.

First Printing 1995

Second Printing 1996

Bay Press

115 West Denny Way

Seattle, Washington 98119-4205

Project editor: Patricia Draher

Manuscript editors: Helen Abbott, Sigrid Asmus, and Victoria Ellison

Designer: Philip Kovacevich

Text set in Adobe Garamond, display type set in Franklin Gothic and Regency Script

Cover design: Philip Kovacevich

Cover photos: (top) Gran Fury, *The Government Has Blood on Its Hands* (detail), photo by Gran Fury; (center) David Avalos, Louis Hock, and Elizabeth Sisco, *Welcome to America's Finest Tourist Plantation*, courtesy of the San Diego Union Tribune; (bottom) WAC, *Pink Slips for Quayle and Bush*, photo by Teri Slotkin

Frontispiece: WAC, *Pink Slips for Quayle and Bush*, photo by Teri Slotkin

Page 8: Gran Fury, *The Government Has Blood on Its Hands,* photo by Gran Fury

Library of Congress Cataloging-in-Publication Data

But is it art?: the spirit of art as activism / edited by Nina Felshin.

 p. cm.

 Includes bibliographical references.

 ISBN 0-941920-29-1 : $18.95

 1. Arts—Political aspects. 2. Politics in art. 3. Social problems in art. 4. Mass media and the arts. 5. Performance art. 6. Artists and community. 7. Arts, Modern—20th century. I. Felshin, Nina.

NX650.P6B88 1995 94-36846

700' .1'03—dc20 CIP

For my parents, Seon and Dorothy Felshin

Contents

THE GOVERNMENT HAS BLOOD ON ITS HANDS

ONE AIDS DEATH EVERY HALF HOUR

Nina Felshin

Introduction |

The Process of Change

With one foot in the art world and the other in the world of political activism and community organizing, a remarkable hybrid emerged in the mid-1970s, expanded in the 1980s, and is reaching critical mass and becoming institutionalized in the 1990s. This new activist cultural practice is the subject of conferences and articles, museum exhibitions and museum-sponsored community-based projects. It provides the impetus and program for several magazines and organizations, and it has also led to much critical and theoretical speculation, raising many unanswered questions. Now, through careful scrutiny and critical analysis of twelve exemplary individual and group practices originating from the mid-1970s to the present, the essays in _But Is It Art?_ define the essential parameters of this hybrid cultural form and reveal its richly various character. Written specifically for this book, the essays offer an in-depth examination of activist art and of the artists engaged in it. This introduction is not intended as an exhaustive history of activist art, but rather is meant to provide a particular context in which to approach the artists in this book.[1]

The twelve practices examined here are all characterized by the innovative use of public space to address issues of sociopolitical and cultural significance, and to encourage community or public participation as a means of effecting social change. While the specific issues vary—homelessness, the AIDS crisis, violence against women, the environment, sexism, ageism, illegal immigration, racism, and trade unionism, among others—the artists share similar methodologies, formal strategies, and intentions, so that what most sets this kind of work apart from other political art is not its content, but its methodologies, formal strategies, and activist goals.

Most of the art of this century has been produced, distributed, and consumed within the context of the art world. Personal expression has guided its makers, and discrete objects have more often than not been the product of this expression. Until the late 1960s, formalism—one of the last gasps of modernism—was critically ascendant. Formalism sought to define each art in terms of its self-defining characteristics, emphasizing not only the purity of each relative to other disciplines, but also the separateness of culture from other areas of life. Beginning in the late 1960s, however, changes began to occur in the art world that reflected changes in the "real world."

The hybrid cultural practice examined in this book has evolved from these changes. Shaped as much by the "real world" as by the art world, activist art represents a confluence of the aesthetic, sociopolitical, and technological impulses of the past twenty-five years or more that have attempted to challenge, explore, or blur the boundaries and hierarchies traditionally defining the culture as represented by those in power. This cultural form is the culmination of a democratic urge to give voice and visibility to the disenfranchised, and to connect art to a wider audience. It springs from a union of political activism with the democratizing aesthetic tendencies originating in Conceptual art of the late 1960s and early 1970s.

Before going on to the individual essays that discuss in depth how these formal strategies operate in specific projects and how they serve the philosophical underpinnings of the work, a few general observations may be helpful. Activist art, in both its forms and methods, is process- rather than object- or product-oriented, and it usually takes place in public sites rather than within the context of art-world venues. As a practice, it often takes the form of temporal interventions, such as performance or performance-based activities, media events, exhibitions, and installations. Much of it employs such mainstream media techniques as the use of billboards, wheat-pasted posters, subway and bus advertising, and newspaper inserts to deliver messages that subvert the usual intentions of these commercial forms. The various uses of media, a key strategy of much activist art, will be discussed in greater detail below. A high degree of preliminary research, organizational activity, and orientation of participants is often

at the heart of its collaborative methods of execution, methods that frequently draw on expertise from outside the art world as a means of engaging the participation of the audience or community and distributing a message to the public. The degree to which these formal strategies—collaboration among artists, public participation, and the employment of media technology in information delivery—successfully embody and serve the work's activist goals is an important factor in the work's impact. Whether the form these activities take is permanent or impermanent, the process of their creation is as important as its visual or physical manifestation.

Activist cultural practices are typically collaborative. All but three of the practices examined in this book—those by Suzanne Lacy, Mierle Laderman Ukeles, and Peggy Diggs—involve the collaborative efforts of two or more artists. And although only the Guerrilla Girls, and at one time, Gran Fury, prefer to remain anonymous, four others—Group Material, the American Festival Project, WAC, and the the Artist and Homeless Collaborative—have opted for group names, thus challenging art-world notions of individual authorship, private expression, and the cult of the artist. As many artists who work collaboratively have noted, attention on personalities diminishes the impact of their work. The fact that the composition of many of these groups shifts over time—members come and go, ranks swell and shrink—further underscores the activist deemphasis of notions of independent expression and authorship. (It should be noted, however, as several essays suggest, that group practices are not immune to conflict: internal politics and the desire of some members to pursue individual careers, for example, can be factors in a group's shifting composition.) In another step beyond individual authorship, five of the collaboratives (Avalos, Hock, Sisco, and their cohorts in San Diego; the Guerrilla Girls; Gran Fury; Group Material; and WAC) also employ or make use of such relatively impersonal technological means as reproducible forms, media techniques, and mass communication. Marshall McLuhan couldn't have been more correct when, more than twenty-five years ago, he observed that "as new technologies come into play, people are less and less convinced of the importance of self-expression. Teamwork succeeds private effort."[2]

Finally, when activist artists extend their collaborative way of working to an audience or community, the process takes the form of a similarly inclusive activity—public participation. Such participation is a critical catalyst for change, a strategy with the potential to activate both individuals and communities, and takes many forms. The projects of activist artists are often closely tied to individuals and organizations in the community that have a personal stake in the issues addressed. When artists choose to involve local government agencies, community organizations, other activist groups, labor unions, organizations on university campuses, environmental specialists, churches, artists, art professionals, and even other activist artists in their projects, it broadens both the audience and the base of support and, ideally, contributes to the project's long-term impact on the targeted community. In works that address specific constituencies—such as homeless women, high school students, older women, union members, sanitation workers, victims of sexual violence—it is that particular community that takes part in various activities with the artists, through such means as dialogue, oral history, performance or performative events, and the collaborative design of posters, billboards, and related forms. Participants may even make relatively traditional works of art, as in the case of the Artist and Homeless Collaborative projects.

Participation is thus often an act of self-expression or self-representation by the entire community. Individuals are empowered through such creative expression, as they acquire a voice, visibility, and an awareness that they are part of a greater whole. The personal thus becomes political, and change, even if initially only of community or public consciousness, becomes possible. With activist art, participation, as Jeff Kelley puts it, can also be "a dialogical process that changes both the participant and the artist."[3]

I selected the artists in this book on the basis of the consistency, integrity, and inventiveness with which they employ their formal strategies, as well as for their interesting, complex, and at times unresolved relationships to the art world. If economy did not dictate a limited number of chapters, other artists could certainly have joined the present company. Nevertheless, the artists discussed here are

exemplary of a viable cultural practice that draws on elements of popular and political culture, technology and mass communication, and, in the arts, Conceptualism and postmodernism, from the 1960s to the present. Together, they are creatively expanding art's boundaries and audience and redefining the role of the artist. In the process, they seem to suggest that the proper answer to the question posed by the ironic title *But Is It Art?* is: "But does it matter?"

Activist Roots in the 1960s

A new form of "politics" is emerging, and in ways we haven't yet noticed. The living room has become a voting booth. Participation via television in Freedom Marches, in war, revolution, pollution, and other events is changing *everything*.[4]

A generation that grew up in a decade of social conformity and a Cold War–derived fear of "the Other" came of age in the 1960s. Out of the civil-rights movement, the Vietnam War, the growing student movement, and an emerging counterculture came a questioning of the authority, values, and institutions of the "establishment." McLuhan's prediction that the proliferation of electronic technologies would increase cultural participation was about to be tested. The antiwar, free speech, and environmental movements were born, as were movements for sexual, racial, and ethnic liberation. When the voiceless demanded to be heard, much of this resistance and dissent took the form of activism. Behind-the-scenes organizing was augmented by public expression in the form of protests, demonstrations, and more creative means, such as guerrilla theater and media events created specifically to take place in that public domain that the late activist Abbie Hoffman described as "the street":

In 1976, two San Diego artists undertook one of their first cross-disciplinary projects aimed at critiquing and deconstructing public policy on issues concerning watersheds and other environmental systems in the United States and abroad. The piece included a mural, billboards, radio and television performances, posters, and graffiti that questioned the irrigation policies of a Northern California watershed.

For middle class Americans the street is an extremely important symbol because your whole enculturation experience is geared around keeping you out of the street. . . . The idea is to keep everyone indoors. So, when you come to challenge the powers that be, inevitably you find yourself on the curbstone of indifference, wondering: "Should I play it safe and stay on the sidewalks, or should I go into the street?" And it's the ones that hit the street first that are the leaders. It's the ones that are taking the most risk that will ultimately effect the change in society. I'm not just speaking of the street as a physical, actual street . . . it's also the street of what we used to call "Prime Time" because of the impact of TV.[5]

Activists in the late 1960s had learned from the experience of the civil-rights movement earlier that decade that the news media could be used to their advantage. It became clear that newspapers, and especially television, could not only transmit news and images, but also initiate public debate and ultimately influence public opinion. It is not surprising, therefore, that civil-rights leaders learned to stage demonstrations and confrontations for the media. As photography critic Vicki Goldberg puts it, "Civil rights proved that media coverage was a lever with which to move the world."[6]

In the 1960s and early 1970s, a number of political and countercultural groups were engaged in a form of highly creative, media-savvy performative activism that anticipated and reflected some of the practices in this book, among them the environmental organization Greenpeace and the Yippies (Youth International Party) led by Abbie Hoffman.[7] Although these groups had no connection to the art world and did not necessarily self-identify as artists, their creative use of publicly sited images and performative events designed to seize the attention of the media foreshadowed the employment

During a three-week period in May 1977, a Los Angeles artist collaborated with numerous organizations and individuals to orchestrate a series of widely divergent art and nonart events. A press conference, performances, discussions, self-defense demonstrations, luncheons, and a moment of silence brought to public attention the then generally hidden subject of rape.

of similar methods by activist artists. In "usin' the tools of Madison Avenue . . . because Madison Avenue is effective in what it does," Hoffman pioneered an activist media strategy that was informed by McLuhan's vision of the power of mass communication.[8] By the 1980s, media manipulation would become a central feature of activism on both the left and the right.

Experiencing the Media

Media manipulation—the exploitation of media communication and the use of visual imagery designed specifically for media consumption—became pervasive in the 1980s and continues to be explored in the 1990s as activists learn from the sophisticated packaging methods of Madison Avenue, corporate America, and the White House. "To the extent that such activism has, of necessity, become bound up with the creation of legible and effective images," writes Brian Wallis, "this new style of politics might be called 'cultural activism,'" which he defines as "the use of cultural means to try to effect social change."[9]

Although most of the artists described in this book, including the American Festival Project, Diggs, Ukeles, Lacy, Carole Condé and Karl Beveridge, and the Artist and Homeless Collaborative, endow their work with its activist potential through grassroots participation, others make use of the media as a vehicle to involve the public. These artists intersect with, challenge, and use the education and information delivery techniques of the mass media in essentially two ways, although sometimes the methods are combined.

First, as mentioned earlier, many activist artists mimic the forms and conventions of commercial advertising and news media to deliver information and activist messages one does not expect to encounter in commercial space. Their use of

In 1978, the newly appointed, unsalaried artist-in-residence of New York City's Department of Sanitation began a carefully choreographed, yearlong performance in which she shook the hands of each of the city's 8,500 sanitation workers. Designed to empower the workers and bring public attention to the importance of maintenance work, the handshake ritual was part of a larger project that spanned six years.

publicly sited commercial space guarantees their work a broad, multi-faceted audience. Then, by employing images and text that are direct and powerful, often nuanced with irony, humor, understatement, or questions, and rarely exclusively didactic or confrontational, the artists encourage public "participation through interpretation." Some artists, including Diggs, Group Material, the Artist and Homeless Collaborative, and Condé and Beveridge, have combined elements of grassroots activity with media techniques. In such cases, the form and content of the poster, billboard, or photo-narrative may be shaped by the participating constituency at the same time that it is targeted for a much broader audience.

Second, outside media coverage itself is an important strategy in activist art. Groups including Gran Fury, WAC, and the San Diego–based collective that includes David Avalos, Louis Hock, and Elizabeth Sisco, recognized that television and the news media are powerful resources that can be provoked and manipulated to communicate a message to a greatly expanded—sometimes national—audience, exploit controversy, and spark public debate. For them, as well as for the Guerrilla Girls, Lacy, and Ukeles, media coverage is an integral part of their work.

With only one exception (the American Festival Project), all the artists discussed in this book have employed vehicles of mass media. Activist media strategies have indeed been influential, but it should be noted—and will be discussed later—that in their use of the media and its accompanying language, activist artists are perhaps equally indebted to that critical postmodernist art that addressed the media's role in shaping dominant cultural representations. In short, media became a national cultural obsession in the 1980s, and virtually no one since then has escaped its power and influence.

In 1981, in the first of many collaborations with trade unions, two Canadian artists produced a photo-narrative work that documented the struggle of a group of women workers to unionize. The work incorporated statements by the women reflecting their political and personal problems in fighting for their first contract.

The Legacy of Conceptual Art

Like the social activists, artists in the late 1960s were questioning the authority and exclusionary practices in their own world, in terms of both its institutions and its aesthetic strategies. In 1969, for example, the Art Workers' Coalition was established. Initially an artists' rights organization (although it also functioned as a group opposing the Vietnam War), it demanded, among other things, greater representation and participation of artists within the museum structure, greater representation of women and minorities in exhibitions and permanent collections, and greater political accountability from institutions.[10]

The Art Workers' Coalition, which disbanded by the end of 1971, is probably the best-known artists' organization, but it was not the only one; other artist groups focused their activities on the war and on feminist issues within the art world. What is significant about the AWC is that many of its members were Conceptual artists. And like the AWC's critique of the art establishment, Conceptualism's critique of the art object and formalist aesthetic strategies, and its desire to narrow the distance between art and audience and art and life, can be seen as the art-world equivalent of the "real world" urge toward greater participation, inclusivity, and democratization of existing institutions.

Two other art movements that emerged in the democratic, creative climate of the late 1960s and early 1970s are performance art and feminist art. Like Conceptual art, they have also had a significant influence on many of the artists in this book. Performance art is an ephemeral, cross-disciplinary, hybrid form with great potential for engaging an audience.[11] As such, it not only opens aesthetic boundaries within the visual arts, but also challenges those of traditional theater. Although performance art exploded in the 1970s, an earlier model is also relevant here. In the late 1950s, as Jeff Kelley points out in his essay, Allan Kaprow introduced

Spurred by the feminist backlash, an anonymous group of women artists launched a poster campaign in New York's SoHo in the mid-1980s that pointed directly at institutionalized art-world sexism with sarcasm and irony, backed up by incriminating statistics and facts. Their ubiquitous black-and-white posters targeted museums, galleries, collectors, critics, art magazines, corporations, and foundations.

the idea of "Happenings" as a form of "participation performance" in which both the audience and the stuff of everyday life—objects, activities, tasks, experience—were embraced as viable materials for art. Of the artists examined here, Suzanne Lacy and, it would seem, Mierle Laderman Ukeles (in her early "maintenance art"), were directly influenced by Kaprow's ideas. Later in the 1960s and in the early 1970s, performance art was adopted by many artists. Activist artists employ performative activities for many reasons, but often because their openness and immediacy invites public participation and can act as a magnet for the media. Performance or performance-based activities are either central to or figure significantly in nearly half of the practices described in this book.[12]

Feminist art, in a variety of media, reverberated with the issues and concerns of the newly emergent feminism and brought aesthetic form to the credo "the personal is political," an idea guiding much activist art in its examination of the public dimension of private experience. Many feminist artists who adopted performance art in the 1970s shaped it according to feminist art strategies. Interestingly, these strategies, which, according to Lucy Lippard, include "collaboration, dialogue, a constant questioning of aesthetic and social assumptions, and a new respect for audience," parallel those employed by the artists examined in the essays gathered here.[13] Also worth noting is the fact that whether the artists emerged in the 1970s, 1980s, or 1990s, feminist and gender issues figure significantly in much of their work as either its exclusive or primary focus. At one time or another, nearly all the artists presented here (the only exception being the Harrisons) have addressed issues that concern women, including sexism, reproductive rights,

In 1987, a New York City artist collective examined the AIDS crisis in a project that juxtaposed culturally and politically significant objects, texts, government documents, and art works in a chronological timeline, to emphasize the federal government's neglect of the epidemic. While the timeline was exhibited in art museums in the United States and Berlin, the artists simultaneously exhibited related work in non-art-oriented public sites.

lesbophobia, sexual and domestic violence, AIDS, homelessness, and ageism—a fact that became apparent to me only long after the book was underway. Clearly, the art practices of the 1970s that made creative use of feminist methodologies to grapple with issues of self-representation, empowerment, and community identity have provided important precedents for activist artists.

Conceptual art's contempt for the art object and its commodity-driven delivery system, its desire to expand aesthetic boundaries, and its emphasis on ideas over physical form or visual definition, led Conceptual artists to experiment with all manner of impermanent, cheap, and reproducible materials and forms. Many of Conceptual art's strategies, including photocopies and other nonart communication systems, instructions (to be executed by others), video, installation, and performance work, as well as deliberately ephemeral projects, were rooted in the "real world." The projects often demanded a degree of viewer participation and frequently occurred outside of traditional art venues. Robert Barry's *Telepathic Piece* of 1969, for example, was accompanied by a catalog statement that read: "During the exhibition, I will try to communicate telepathically a work of art, the nature of which is a series of thoughts that are not applicable to language or image."[14] In another example from the late 1960s, Joseph Kosuth purchased space in newspapers and periodicals for a series of work that "consists of categories from the Thesaurus" and "deals with the multiple aspects of an idea of something." "This way," continued Kosuth in a catalog statement, "the immateriality of the work is stressed and any possible connections to painting are severed. The new work is not connected to a precious object—it's accessible to as many people as are interested; it's nondecorative—having nothing to do with architecture;

In the first of seven public projects addressing local issues, an informal collective of San Diego artists placed a bus poster that underscored the exploitation of undocumented workers by the city's tourist industry on one hundred buses. Its presence during the 1988 Super Bowl virtually guaranteed that local and national media would quickly respond and become the artists' unwitting, though not unintended, collaborators.

it can be brought into the home or museum but wasn't made with either in mind."[15]

In these and other reactions to the exclusionary aesthetics of formalism, Conceptual art posited the view that the meaning of an art work resides not in the autonomous object, but in its contextual framework. This idea that the physical, institutional, social, or conceptual *context* of a work is integral to its meaning influenced many subsequent developments in the 1970s, including expanded notions of sculpture and public art.

The relevance of contextualization comes into play for this book with respect to the argument put forth by a number of critics and artists that activist art is "the new public art," and that consideration of context represents a refinement of the notion of "site specificity" as it has evolved in relation to sculpture and public art. Initially, "site specific" referred to an integral formal relationship between sculpture and site, one in which the work could not be separated from its setting. In the late 1960s and 1970s, such works were created in remote western landscapes (often at the mercy of environmental conditions), as well as in domesticated and urban landscapes, and in galleries and museums. In contrast to the notorious "turd in the plaza," a variety of public art often consisting of little more than a scaled-up version of a studio work, site-specific public art had a real relationship to its context, as well as to the people who encountered it.[16] The General Services Administration, the federal government's landlord, which was also in the business of commissioning art work for its new federal buildings, acknowledged the new thinking about public art when it changed the name of its art program in the mid-1970s from Fine Arts in New Federal Buildings to Art-in-Architecture.

For a group of AIDS activists, participation in the internationally prestigious Venice Biennale in 1990 provided an ideal context for a work that addressed the Catholic Church's position on AIDS. It came as no surprise to them when the resulting controversy attracted wide media coverage and exposure for their message.

Works that incorporated the historical or some other nonphysical significance of a site represented a more evolved notion of site specificity. Robert Smithson and George Trakas

are among the artists who responded to the nonformal aspects of a site. Smithson, in a number of outdoor environmental sculptural works, reclaimed industrial-waste sites to underscore the need for constructive solutions to environmental devastation, while Trakas produced indoor and outdoor site-related sculptures that sometimes incorporated references to local history. Like others who were influenced by Conceptualist thinking and, in his case, hybrid forms of various performing arts, Trakas conceived his work with the viewer in mind. Many of his sculptures, for instance, incorporated accessible bridges and walkways. The viewer, no longer a passive spectator, became an active participant whose spatial perceptions could be altered by his or her interaction with the work.

Discussions about the "new public art" have centered around a notion of the community or the public as the "site," and the public artist as one whose work is responsive to the issues, needs, and concerns that define that elusive, hard-to-define entity. According to this definition, both the work examined in this book, as well as a wide range of politically engaged art that is publicly sited and therefore assumed to be participatory, are viewed as the "new public art." The problem with this broadly inclusive view is that in its effort to articulate a viable new model of public art, it often fails to acknowledge major strategic and methodological differences among the artists it embraces. Proponents of the "new public art" tend to lump together artists who effectively employ process-oriented activist strategies with those who employ only its trappings. The fact that a political work is publicly sited, in exclusively physical terms, does not guarantee comprehension or public participation. Political art, in short, is not synonymous with activist art.

While discussions about the "new public art" do not necessarily ignore other influences,

After extensive research and consultation with victims of domestic violence, an artist from western Massachusetts orchestrated a project in 1992 in the New York and New Jersey metropolitan area in which 1.5 million milk cartons, printed with a strong graphic image and text on the subject, were distributed to local grocery stores and found their way into private residences.

the "new public art" label places a confusing emphasis on a public art lineage at the expense of other defining characteristics, particularly those process-oriented methodologies whose origins are to be found elsewhere. It is also important to point out that the so-called "new public art" does not replace or even challenge the work from which its theorists claim it has evolved. I would suggest that the expanded or inclusive notion of site, as delineated by theorists of the "new public art," is instead part of a broader, contextualizing urge that has influenced many sectors of the art world, as well as the culture at large, since the late 1960s. I also feel that within the art world, the origins of this shift toward a more inclusive aesthetic are primarily to be found in Conceptual art, and later in interdisciplinary postmodernist approaches. The practices examined in this book (and others like them) do not, in my opinion, represent an evolution in public art, but rather an exciting and unique synthesis of democratizing impulses linking the art world and the world of political activism.

Regrettably, Conceptualism's capitalist critique never really succeeded in abolishing the art object or undermining the commodity system. The content of Conceptual art, as demonstrated by the Barry and Kosuth examples above, was never commensurate with its democratic philosophy, methodologies, and forms; social and political issues were never really embraced as viable subject matter. So, although Conceptual art's ambitions and strategies were democratic, it remained an exclusive art form, one essentially off-limits to anyone outside the art world. Nevertheless, Conceptualism had far-reaching aesthetic implications that have been enormously influential; it created a climate in the art world in which subsequent artists could complete the revolution it set in motion. Conceptual art helped pave the way to postmodernism and provided a firm structural framework for the activist art practices examined in this book.

During the 1992 Republican National Convention in Houston, a recently formed, New York City–based coalition of women activists in the arts engaged in a series of public events, including an outdoor audiovisual presentation and performances by a chanting drum corps, that condemned national policy on issues affecting women.

Synthesis in Practice

For the most part, the practices discussed in this book initially formed in response to conditions prevailing at a given time in both the art world and the culture at large. Four chapters in this book are devoted to practices that emerged in the mid-1970s, directly out of late 1960s and early 1970s activism and the newly emergent, expansive aesthetic tendencies. Helen and Newton Harrison's ecological art was born out of a meeting between Conceptualism and the environmental movement; Suzanne Lacy's performative practice derived from 1970s feminism, both inside and outside the art world; Mierle Laderman Ukeles's maintenance art was also shaped by feminism, as well as environmentalism and Conceptual art; and the seeds of Canadian artists Carole Condé and Karl Beveridge's labor union–based art practice can be traced to their stay in New York City from 1969 to 1976, where they were deeply involved with Conceptual art and internal and external activist politics. Although the American Festival Project was not established until 1983, one of its founders, John O'Neal, had been artistic director of a philosophically and methodologically related theater company, the Free Southern Theater (active from 1963 to 1980), that had close ties to the civil-rights movement. However, despite its appearance in the mid-1970s, it was not until the 1980s that activist art truly came into its own, in response to the conservative forces that dominated both the political world and the art world, the increased incidence of activism on both the left and the right, and the pervasive influence of media and public-relations packaging.[17]

The erosion of democracy, in both the dismantling of social programs and the promotion of initiatives favoring the wealthy during the Reagan-Bush years, led to increased polarization of the rich and the poor, the powerful and the powerless, and the left and the right. Activists on the left were mobilized by such

In 1993, a southern university experiencing gender- and race-related violence was the site of a series of participatory events, dialogues, and performances that dealt with these issues. The events took place over many months and were coordinated by an African American writer/actor member of a national network of multicultural, community-based performing artists' groups.

issues as the nuclear crisis, U.S. intervention in Central America, the defeat of the Equal Rights Amendment and the threat to abortion rights, homelessness, the federal government's resounding silence in response to the AIDS crisis, censorship, and the further disenfranchisement of already marginalized sectors of society. Activists on the right protested abortion and lobbied for public policy in support of their views on private and public morality. The world of high art was ground zero for many of their attacks on culture.

In many respects, the art world of the 1980s mirrored the "real world." The tentative steps taken in the 1970s toward a more democratic climate were completely reversed by a renewed emphasis on market-driven concerns as the commodity status of the art object, the cult of the individual artist, the prestige of collecting, public-relations packaging, and media manipulation were elevated to new heights. Male painters dominated the scene until the late 1980s (some acquired stardom and enormous wealth virtually overnight), and the backlash against feminism was echoed in the art world, where the gains of the 1970s seemed suddenly to vanish. The Guerrilla Girls formed in 1985 in direct response to the backlash, and Group Material came together to address the art world's cultural elitism and to question "the entire culture we have taken for granted," inviting others to do likewise. Group Material's formation in 1979 is significant, suggesting that while Conceptual art (in which the collective's philosophy is rooted) may have changed the art-world climate in the 1970s, exclusionary practices still prevailed. From our perspective now, the fact that these practices would become even more entrenched in the 1980s made Group Material's timing impeccable.

In reaction to these conservative trends in the art world and beyond, an increasing number of artists embraced political subject matter during the course of the 1980s and 1990s. They addressed many of

In 1994, residents of a homeless shelter for women in New York City collaborated with each other and volunteers of an artist-run collaborative in the making of a "Polaroid quilt." Each participant contributed a series of images and handwritten text on themes that encouraged self-expression and self-representation.

the same issues as political activists and advocacy groups on the left, including the nuclear crisis; imperialism; intervention in Central America; the environment; homelessness and gentrification; racial, ethnic, and sexual politics, as the liberation movements of the 1960s evolved into identity politics in the 1980s and multiculturalism in the 1990s; and the AIDS crisis. Interestingly, the AIDS crisis in the 1980s politicized the art world in much the same way feminism did in the 1970s, although far more pervasively.[18] Institutional acceptance of political art reached its pinnacle in 1993, when the Whitney Museum of American Art devoted virtually its entire prestigious Biennial Exhibition to all manner of politically and socially engaged art.

Throughout the 1980s, postmodernist artists employed the feminist critique of representation and expanded it into a more general critique of prevailing cultural representations. Many of these artists used diverse mainstream media techniques, primarily photography, to reevaluate the implicit codes of representation. The language developed by some of them, especially Jenny Holzer and Barbara Kruger, has no doubt been influential for many activist artists. But whether postmodernist politically engaged art was presented within traditional art-world settings, as most of it was, or situated in more public venues, it was for the most part both literally and figuratively inaccessible to a general audience. Participation through interpretation—a key strategy of activist art—is impossible if ambiguity and obscurity, however provocative aesthetically and intellectually, bar comprehension. Moreover, politically engaged postmodernist art was acquired by affluent collectors and museums at inflated prices, and some of its makers were represented by the hottest commercial galleries in SoHo. Ironically, most of it participated fully in the dominant culture it sought to challenge, and in so doing met the same fate as Conceptual art.

While the methodologies and intentions of Conceptual art, politically engaged postmodernist art, and activist art differ, and although they should not be regarded as successive movements, a common thread runs through them. Conceptualism's critique of art institutions and formalist aesthetic strategies, postmodernist art's critique of representation, and activist art practices are similarly political, in that they question dominant cultural representations, and are concerned with

the configurations of power. And implicit in all three is some version of the questions posed by Group Material, whose own practice serves to link the Conceptualism of the 1970s with the postmodernism of the 1980s: "What politics inform accepted understandings of art and culture? Whose interests are served by such cultural conventions? How is culture made, and for whom is it made?"[19]

For activist artists, it's no longer simply a matter of adopting a set of more inclusive or democratic aesthetic strategies, or embracing social and political subject matter in a critique of representation within the confines of the art world. Instead, activist artists have created a cultural form that adapts and activates elements of each of these critical aesthetic practices, uniting them organically with elements of activism and community organizing. Not content to simply ask the questions, these artists engage in an active *process* of representation, attempting at the very least to "change the conversation," to empower individuals and communities, and ultimately to stimulate social change.

But do they succeed? And how does one assess the impact of projects that often strive for difficult-to-measure results like stimulating dialogue, raising consciousness, or empowering a community? If these goals are increments in the process of social change, it is critical for activist artists to establish relationships and mechanisms within the community of their projects to help ensure the long-term impact of their work. This is particularly important for activist artists who undertake work in other cities or abroad, as many in this book have. "Figuring out where the juice is," as an American Festival Project choreographer puts it—in other words, identifying people in the local community who will sustain the impact of their efforts—is one way to do it.[20] Regardless of the method, activist artists will be most effective if they take an active role in sustaining the public participation process their work has set in motion.

Regarding the Future

And what is the future of activist art? One can only speculate that it will be linked to cycles of activism in the political arena. Both political activism and activist art seem to flourish, as they did during the conservative backlash of the 1980s, when public participation in the

democratic process is strikingly curtailed and when society is blatantly polarized between the powerful and the powerless, those who are heard and those who are silenced. Although the political climate changed with Clinton's election in 1992, to date, his campaign promises remain largely unfulfilled, at least in terms of concrete change. It would thus be easy to speculate that political activism and activist art will continue to flourish in the 1990s. Nevertheless, it is interesting to observe that, of the twelve practices examined in this book, two (Gran Fury, WAC) have more or less disbanded, a third (Guerrilla Girls) is facing an identity crisis, and a fourth (Group Material) is rethinking its future. These changes certainly do not signal the demise of activist art. They merely suggest that some activist art, like political activism, is contextual. Times change, external politics change, internal politics wreak havoc, anger cools, frustration or despair sets in, goals need to be reevaluated and practices need to be reshaped, and, not surprisingly perhaps, some activist artists decide to return to their own art. Interestingly, and probably not coincidentally, the four groups mentioned above are collectives whose members' individual artistic identities have been subordinated for periods of up to fifteen years. Interestingly too, of the other practices included in the book, those with the greatest longevity are conducted by individuals (Suzanne Lacy, Mierle Laderman Ukeles), or husband-and-wife teams (Carole Condé and Karl Beveridge, Helen and Newton Harrison), whose work, despite its participatory nature, is distinctly marked with their aesthetic signatures. Along with Peggy Diggs, the Artist and Homeless Collaborative, and the American Festival Project, these artists are more directly involved than at least three of the collectives mentioned above in grassroots community organizing and in directly empowering constituents, rather than in actions aimed at exposing issues to public view as a means of sparking public debate. Yet both methodologies are effective and are certain to be a part of the activist art practice in its efforts to effect social change.

Given that the artists in this book align themselves with "real-world" issues, it is perhaps ironic that most have ongoing relationships with the art world. Each relationship is unique, with some more complex or problematic than others. Museums and alternative spaces sponsor their projects, arts agencies and foundations fund them, art

schools hire them, and art critics write about them. Impermanent though much of their work is intended to be, some of it has been presented in, or in a few cases even collected by, major American, European, and Canadian museums, and several artists are represented by commercial galleries. One collective has participated in the Whitney Biennial, as well as in Documenta in Kassel and the Venice Biennale, two of the most prestigious international art events.

But just as political activism in the 1990s is being reshaped by the political conditions of this decade, activist art is also being shaped by the art world of the 1990s, which is a radically different entity than it was in the 1980s. By the end of the 1980s, the art world was in a shambles. The market had crashed and Senator Jesse Helms and others on the right had declared war on culture and the National Endowment for the Arts. Private and public funding all but dried up as a result of the economic downturn, censorship controversies, and shifting funding patterns. Following the closing or downsizing of many commercial galleries and in response to correspondingly limited institutional opportunities, artists in the 1990s have demonstrated a renewed interest in uncommodifiable forms, such as installations, and performance-based, activist, and related practices.

Along with the explosion of activist art in the 1990s, we are also beginning to see cultural and arts funding diverted to social programs. "In L.A., Political Activism Beats Out Political Art," reads the headline of an article that appeared in the *New York Times* in March 1994.[21] The article reports a major change in funding priorities of the Lannan Foundation, formerly a generous supporter of contemporary art exhibitions and acquisitions, including some of a political nature.[22] The article also comments on the general trend among foundations and corporations in recent years of shifting their contributions from the arts to social programs. Earlier in 1994, the *Village Voice* reported a shift in NEA and state arts funding away from individual artists to community-based projects that are essentially educational (and apolitical) in nature.[23] This trend was viewed both as a means of avoiding controversy and as part of a general change in public funding patterns. It parallels a growing tendency among museums in the 1990s to invite artists to engage in community-based projects that can be broadly characterized as empowering.

In a related phenomenon, the Lila Wallace–Reader's Digest Fund in 1992 launched its International Artists Program. This program, in which both Lacy and Diggs have recently participated, supports international residencies in which American artists are offered support to undertake community-based projects abroad and then share their insights in related projects back home. "One of the unique qualities of this program," states a press release defining the program's goals, "is the potential to encourage discussion in U.S. communities about the pressing social, artistic and environmental issues of our time." These events, along with the broadly inclusive exhibition *Public Interventions,* presented at Boston's Institute of Contemporary Art in spring 1994,[24] appear to be a sure sign of institutional support in the 1990s for the kind of work addressed in this book. In fact, this book itself signals an additional level of recognition.

In their 1990 book on AIDS activist art, Douglas Crimp and Adam Rolston lament the fact that postmodernist critical art rarely delivered on its "implicit promise of breaking out of the museum and marketplace to take on new issues and find new audiences."[25] They cite ACT-UP's activist art as the rare exception to the exclusivity of most politically engaged postmodernist art. Now, a number of years later, it is clear that AIDS activist art, which includes the work of Gran Fury, was not alone in its success. Activist art is thriving, as its current proliferation indicates. But with the increasing acceptance of activist art by institutions in the 1990s, activist artists must pay close attention to avoiding what Crimp and Rolston observe is "the fate of most critical art practices . . . the art world's capacity to co-opt and neutralize them."[26] If they can keep a critical eye sharply and uncompromisingly on themselves and the intentions of their work—not always an easy task, as some of the following essays suggest—activist artists may yet prove that art-world acceptance and support is not the kiss of death for critical art practices. If keeping one foot in the art world is regarded by activist artists as a means of keeping the other foot more firmly planted in the world of political activism, then activist art will remain on solid ground, thus ensuring the continued viability of this lively cultural phenomenon.

what was the nature of the
relationship between audience
& art work?

How are we to judge the success
or failure of the works?

Robert L. Pincus

The Invisible Town Square:

Artists' Collaborations and Media Dramas in America's Biggest Border Town

Public art was once a village green with a statue on it. But the whole concept of community has changed radically. Politics has become something that happens in newspapers and through television ads. The community ground now is the media, telephones, computer bulletin boards, and such things. And our work is placed like a statue in it.

—Louis Hock

During the past six years, a small and shifting number of San Diego artists and community activists have garnered a great deal of attention for their work—a series of projects concerning the lack of recognition and rights for illegal immigrants, questionable police killings, and the brutalization of women. If they had conveyed the same concerns in art designed for galleries and museums, we can be virtually certain their efforts wouldn't have gained the prominence that has been granted them. Even if they had designed socially critical objects for public spaces, it's likely they would have been quickly forgotten. Such is the relationship between art and society—and they know, as well as any artists at work today, that this is the case.

David Avalos, Louis Hock, and Elizabeth Sisco knew it back in 1988, when they designed a poster declaring "Welcome to America's Finest Tourist Plantation" and purchased advertising space for it on one hundred local buses for one month. It was the first of seven collaborative projects to dramatize issues central to the civic life of San

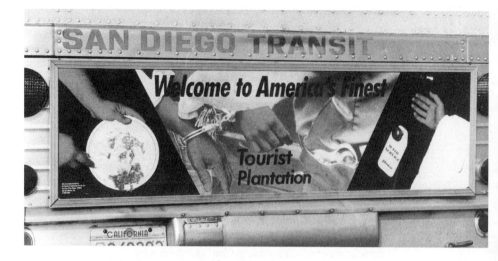

David Avalos, Louis Hock, and Elizabeth Sisco, *Welcome to America's Finest Tourist Plantation*, 1988. Silkscreen on paper, 50" x 20". The image was displayed on one hundred buses during January 1988, to coincide with Super Bowl XXII.

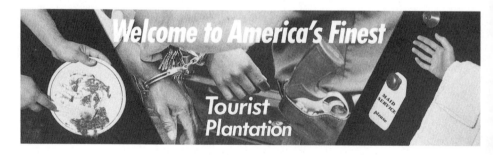

The image from the poster *Welcome to America's Finest Tourist Plantation*.

Diego and the region surrounding it, bordering on Mexico. The words of the poster were superimposed on three images that comprised the photographic mural. The central and largest one was of a border-patrol agent handcuffing two people, a picture taken by Sisco on a San Diego Transit bus in the affluent seaside community of La Jolla. Flanking this photograph were images of a dishwasher and a chambermaid representing, in the artists' words, "the restaurant and hotel/motel industries."

"We wanted to reinterpret commercial space, which reaches a broad, popular audience," Hock observed in my 1988 interview with the artists, conducted during the week the posters first surfaced on the buses.[1] At that point, they couldn't have been sure it would spark news coverage and thereby generate discussion of the issue they were addressing: the pervasive but largely unacknowledged presence of illegal immigrants in the economy of San Diego, a city that had long billed itself as a mecca for tourists. Nonetheless, the artists had a hunch the event would act as a magnet for the mass media and local officials, whose attention was to prove crucial to the fulfillment of their ambitions for the poster.

The work was to be, in Avalos's phrase, an "advertisement for itself."[2] By employing public advertising space, the trio of artists chose to raise a thorny issue about the reality of civic life just at a moment when city officials didn't want it raised: in the full glare of the national media, gathered in San Diego for the Super Bowl. One hundred posters became thousands of reproductions when front-page stories accompanied by photographs were published in the morning (the *San Diego Union*) and evening (the *San Diego Tribune*) newspapers, as well as in the local edition of the *Los Angeles Times* on January 7, 1988. Commentaries followed (including mine); certain city officials let it be known to the press that they were trying to have the poster removed, and national coverage ensued. (In *USA Today*, a story about the poster and the image itself appeared alongside separate items about the participating teams: the Denver Broncos and the Washington Redskins.) Most important, the role of the illegal immigrant in the local economy and the validity of the poster were debated through editorials, guest editorials, and letters to the editors of the local papers.

Throughout January 1988, the poster was the catalyst for a civic debate regarding the intersection of a pressing social issue with a complex aesthetic one—the shape of art for public spaces. Referring to San Diego's boosterish slogan, "America's Finest City," one letter writer to the *San Diego Union* argued, "I think it's time we stop fooling ourselves with Madison Avenue slogans," while a letter from the opposite end of the spectrum declared, "It is hoped that John Q. Public will see these 'signs' are pulled off and put where they belong—in the trash dumpster."[3] Michael Tuck, then a local television news commentator, didn't like the bus poster much, but he pinpointed factors in the relationship between the work and civic officials that had catapulted the image to prominence:

> The artists must have known tourist officials would overreact. And, as usual those officials were so afraid somebody from Duluth would be offended and not come here again to clog our freeways. They did. They screamed bloody murder, which only meant the artists and their message would be plastered all over the news.[4]

It was, too. No other group of activist artists in the United States has succeeded so consistently with its projects in sparking public debate about social issues, both within the media arena and outside it, even when the works themselves have had a few flaws. Yet these artists had no manifesto, no overarching plan for a series of projects, not even a set group with a name. Louis Hock and Elizabeth Sisco have been involved in all the events; David Avalos in most; Deborah Small, Scott Kessler, Carla Kirkwood, and Bart Scher in two. But, as Hock recently explained, "We saw it [the bus poster] as singular. We always saw each of the projects as a singular event."[5]

Nevertheless, the "events" cohere as an ad hoc body of work worthy of scrutiny in any discussion of socially engaged art and artists. In formal terms, the group's projects have varied considerably—from billboards, bus-bench images, and an exhibition of photographs to street theater and performance art. But in conceptual terms, they are quite coherent, sharing three essential qualities: innovative use of public space, the ability to generate controversy, and the artist's willingness to articulate responses in the resulting debate about a substantive issue as well as the art. A coherent pattern also emerged, nearly

ritualistic in nature, during the course of each project's duration. The work itself would be unveiled and the artists would then deliver press releases to the news media. Reporters would rush to cover the story, fearing that other news organizations would beat them to it. Politicians and other officials who were a target of the piece would move just as fast to deride it, thereby creating the very controversy that triggered subsequent stories. Wire stories then followed, making the local story national (and, in one instance, international). And with controversy came the need for commentary. Editors would turn to art critics for "think pieces"; unsigned editorials also appeared in newspapers, since each of these projects became a social issue as much as an arts issue. The most recent project, *Art Rebate/Arte Reembolso* (1993), became so notorious that syndicated columnists like George Will and Mike Royko joined the fray—the first, in an ill-informed way; the second, in an amusingly sardonic fashion. Will used the occasion to attack all Conceptual art as a hoax and defenders of the National Endowment for the Arts (NEA) as "philistines passing as anti-philistines." Royko, equally skeptical, slyly celebrated his own tendency to give money to panhandlers, from "liberal guilt," as an aesthetic act.[6]

One additional dimension of the ritual was the consistent objection voiced by detractors concerning the funding sources for particular projects. To create their works, the artists needed grant money—and much of that money was from public sources. Why, the argument went, should critics of the system get money from the system itself? This issue came into sharpest focus with *Art Rebate/Arte Reembolso,* for which the artists gave ten-dollar bills to illegal workers in San Diego to bring to light their unacknowledged role as taxpayers. Although only $1,250 of the $4,500 they handed out during July and August of 1993 came from the National Endowment for the Arts (as part of a large grant awarded to the Museum of Contemporary Art, San Diego for a series of shows and events concerning border issues), that was enough to provoke misguided editorials from even such "liberal" newspapers as the *Los Angeles Times* and the *New York Times.* Simply because the performance might have "negative repercussions" on the National Endowment for the Arts and the institutions that commissioned the piece (the Museum of Contemporary Art, San Diego, and the Centro Cultural de la Raza), the *Los Angeles Times*

editorial writer argued, the artists shouldn't have done it. This variety of attack consistently appears to be an obtuse form of objection to the kind of activist art that these artists create. Yet if activist work is a valid genre, funding agencies should award money to its practitioners on their merits, just as with every other genre. So far, however, the NEA apparently views the matter differently, having informed the museum that the $1,250 it spent on the 1993 project was an "unallowable expense."[7]

Back in 1988, the artists couldn't have predicted the amount of debate and controversy their bus poster would generate, but they clearly built the potential for it into the design of *Welcome to America's Finest Tourist Plantation* and subsequent projects. David Avalos said as much later that same year, when we talked on the occasion of his departure as artist-in-residence from the Centro Cultural de la Raza, the Chicano showcase in San Diego. "My interest is in looking at systems when, metaphorically, they're dogs that bite their own tails, when they're forced to confront themselves. My work looks at the blind spots systems create when they have to look at themselves."[8] For Avalos, one of the works that he employed as an example, *The San Diego Donkey Cart,* had pointed the way toward other public art. In January 1986, he had installed his life-size parody of a Tijuana tourist photo backdrop in the plaza fronting a downtown San Diego federal building. It was one of several works placed in and around the city as part of *Streetsites,* an annual exhibition of temporary public art organized by Sushi, a non-profit gallery best known for its performance art programming. The construction itself was not incendiary; however, in place of conventional folk iconography, Avalos presented a man being detained and frisked by a member of the border patrol on the portion of the cart that would ordinarily have served as the backdrop for a photograph.

The artists couldn't have predicted the controversy.

The artist believed his contribution to *Streetsites* might provide debate, but it gained notoriety for a different, unexpected reason: U.S. District Court Judge Gordon Thompson, Jr., had it removed, labeling it a security risk. One story quoted Thompson to this effect: "We didn't know if some kook would get into this chicken-wire-and-box arrangement in the middle of the night and plant some bomb."

The American Civil Liberties Union joined forces with Avalos and Sushi to seek damages, though the process ended unsuccessfully when the Supreme Court denied an appeal of a Circuit Court of Appeals ruling. This defeat, however, was only a marginal setback when compared with the insights Avalos gleaned from the experience, which he would then apply to his collaborative work. "The lesson learned is that it [*The San Diego Donkey Cart*] had more of a presence because of its absence. We intended to get a response this time [with the bus poster], create a provocation. And so the poster couldn't be removed, we moved it into informational space."[9]

By 1987, Sisco, a photographer and part-time instructor at the University of California, San Diego (UCSD), had become dissatisfied with showing her photographs of illegal immigrants (one of which appeared on the 1988 bus poster) in gallery settings. Meanwhile, Hock, a visual arts professor at UCSD, was looking for a more effective way to reach a broader audience with his installations, projection pieces, and videotapes such as *The Mexican Tapes* (1986), which chronicled the lives of Mexican immigrants in Solana Beach and aired on PBS stations nationwide. Informing the collaboration was the influence of another group: the Border Art Workshop/Taller de Arte Fronterizo (BAW/TAF), established in 1984 under the sponsorship of the Centro Cultural de la Raza. Avalos had been one of its founding members, but had grown impatient with its emphasis on raising issues about the border through traditional art channels, such as annual exhibitions at the Centro and other shows. Indeed, he, like Hock and Sisco, wanted his collaboration to be provisional in nature and focus on the public arena. Like BAW/TAF, the composition of the group was multiethnic; yet unlike that collaborative, with its focus on border issues, the group was interested in a range of issues affecting the city and the region. "Our intention was to challenge the status quo," said Sisco. "We simply wanted to speak obvious truths, unacknowledged truths, out loud."[10]

The forms their statements took owed something to then-recent manifestations of the Conceptualist aesthetic, particularly the street posters of the Guerrilla Girls, Jenny Holzer, and Group Material. Yet their work was just as firmly linked to the activist art tradition of San Diego itself, whose most prominent and eloquent manifestation can

be seen in the group of murals in Chicano Park. Both the art and the park grew out of the occupation of a plot of land below the Coronado Bay Bridge in 1969, situated in the city's Barrio Logan. Through the political pressure created by that event, activists and supporters (including a young David Avalos) prevented the site from becoming a California Highway Patrol station. In 1970, some of the same group occupied a water storage tank in the city's largest park, Balboa Park, and that same year the round structure became the Centro Cultural de la Raza, where the Border Art Workshop/Taller de Arte Fronterizo was established and where Avalos came of age as an artist. Thus, through the bus poster and with the projects to follow, Conceptual activism met Chicano activism.

The group's next target, attacked in a billboard that went up in late April 1989 and stayed up for a month, was an ugly strain of racism that had manifested itself in San Diego as homages to Martin Luther King, Jr., were being proposed. The artists' project was commissioned by Installation, one of two nonprofit showcases in San Diego. For it, Avalos, Hock, and Sisco were joined by Small, a graduate of UCSD's visual arts program who had exhibited trenchant, socially critical works of her own and had collaborated with Avalos, as well as historian William Weeks and artist James Luna, on an absorbing installation, *California Mission Daze*. Exhibited at Installation in late 1988, this multimedia work, incorporating electronically transmitted text, an alcove devoted to Mission-motif trinkets, and a mock classroom with a companion book by the artists, took a skeptical view of the treatment of Indians by eighteenth-century missionaries.

In 1986, the city had changed the name of a major downtown thoroughfare, Market Street, to Martin Luther King Jr. Way, only to have a voter initiative overturn the decision in 1987. Then, two years later, although the city council voted to name a new convention center for King, the overseer of the property on which it stands, the San Diego Port Commission, balked at the idea. The billboard made its debut precisely at a time when the council would have to reconsider the issue. Along with a painted portrait of King, the work included text that parodied the form answers might take in a multiple-choice test; it read: "Welcome to America's Finest a) city b) tourist

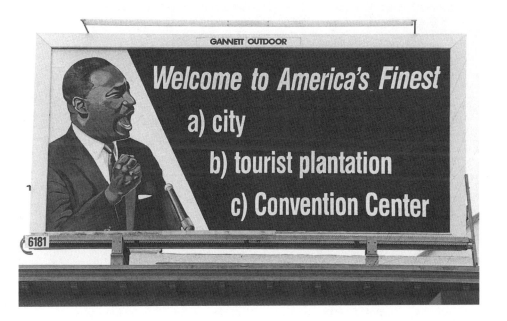

David Avalos, Louis Hock, Elizabeth Sisco, and Deborah Small, Martin Luther King, Jr., billboard, April 1989. Acrylic on paper, 272" x 125". The billboard was easily visible from sidewalk or street in downtown San Diego.

plantation c) Convention Center." Bumper stickers with similar wording were made available, too.

By carrying forward this reference to the bus poster and taking on the similarly public forms of billboard and bumper sticker, the King project underscored the continuity of the artists' vision of activist art. At the same time, by raising a different sort of civic issue, it also declared the broadening of their ambitions. No longer content to focus on a single nexus of issues, that is, border problems, they wished to involve themselves with—indeed, generate discussion about—the full range of issues central to the life of the city. Along with its long-standing reputation for political conservatism, the city's resistance to change and reform has links to its historical (if now diminishing) economic reliance on military bases and the defense industry. In San Diego, as in various other cities throughout the United States, a dependency on military industries and a right-wing mindset have gone hand in hand. These artists, in their King billboard, sought, by contrast, to connect with a segment of San Diego's populace largely ignored in local political discourse: its African American community and others sympathetic to King's role in recent American history.

"We wanted to hook up with the community in a concrete way."

"We wanted to hook up with the community in a concrete way," said Sisco at the time the billboard went up. "We are artists of course, but we see ourselves as part of a larger community."[11] In this instance, one concrete way to achieve this aim was to enlist African American community leaders as an advisory board during the time the piece was being designed. The three people who assisted the artists represented varied disciplines and interests: Cleo Malone was director of Palavra Tree, a drug rehabilitation center serving central San Diego; Robert Tambuzi was then president of the African American Artists and Writers Association; and Theodore Jones practiced as a licensed family, child, and marriage counselor. When they also became spokespeople on equal standing with the artists as the press focused on the billboard, the underlying message was clear: the artists felt it was presumptuous to speak for the African American community. They wanted their image, hovering above the street and displayed on cars, simply to be the catalyst for an open debate, and their advisors

agreed. Malone, in my contemporaneous story on the piece, said, "We simply wanted to get the dialogue going on this issue. It's an art statement. It doesn't advocate a point of view, but says 'Hey folks, are you going to hide behind your racism or are we interested in doing something for King?'"[12] Unfortunately, the outcome was not the desired one; the convention center was never named for King. A nearby promenade was given that honor, and contains King's words, but they are chiseled in ground-level granite blocks along its path and are hardly noticeable. Nevertheless, the artists' billboard and bumper sticker foreshadowed their willingness to engage San Diegans on a diversity of issues.

For example, during a well-heeled Soviet Arts Festival spearheaded by Maureen O'Connor, then mayor of San Diego, these same artists, with the assistance of playwright and actress Carla Kirkwood, director Bart Scher, and his theater troupe Plus Fire Performance Group, produced a theatrical event for the street in November 1989. It lampooned the festival, the mayor, and the Union–Tribune Publishing Co., publisher of both local newspapers and itself involved in tense labor negotiations at the time. The performance brought attention to—and welcomed the participation of—the homeless in downtown San Diego. Titled *Welcome Back, Emma,* the piece drew inspiration from an incident of 1912, when labor organizer Emma Goldman made a stop in San Diego and was prevented from speaking by a group of vigilantes. Seventy-seven years later, Kirkwood, as Emma Goldman, along with an ensemble of some one hundred people, including the news media, paraded from the same Santa Fe (Amtrak) station where the real Goldman had arrived, to Horton Park, centrally located and in front of a downtown shopping center. The homeless joined the procession and offered spontaneous commentary on the words of speakers at an outdoor podium.

The next work for the streets of San Diego, twenty-five bus benches, followed in 1990, a year after *Welcome Back, Emma.* Their subject was the police killing of citizens (an issue that later segued into the more elaborate *"NHI"* project of 1992, focusing on a series of murders of prostitutes and the inadequate police department investigation of their deaths). In 1990, there had been a disturbing spate of such killings; nine since January 1, with fourteen other persons

wounded. The victims were alleged to have been carrying such "weapons" as a garden stake, a baseball bat, a trowel—but some had no weapon at all. One of those victims, Tony Tumminia, had been a friend of Scott Kessler, a community activist in Ocean Beach; after his death, Kessler approached Avalos, Hock, Sisco, and Small about creating a piece addressing the situation. Avalos, who was a graduate student in UCSD's visual arts program at the time, declined, but the other three collaborated with Kessler to design a bench containing seven pictographic figures resembling the human silhouettes familiar from target-practice ranges. Within each figure was a smaller image that alluded to the item the victim carried or wielded at the time of his death: the trowel, the garden stake, and so forth. The chest of the last figure was punctuated by a question mark, forcefully suggesting "who's next?" Above the figures hovered the text: "America's Finest?"

The artists called a press conference on October 30, at a bench installed directly across the street from the downtown police headquarters. The bench became an instant news story like the bus poster and billboard before it. But it then remained a news story during the month in which the image appeared on benches, thanks to the efforts of a local public official and the police. Bill Lowry, a Republican congressman from San Diego running for reelection, clearly thought he had discovered a great campaign issue, protesting the use of $3,600 in federal funds for the benches. (The amount was a portion of a $12,500 grant the artists had received from the NEA to do a series of works, with money funding the King billboard and *Welcome Back, Emma* as well as the bus benches.) Meanwhile, the Police Officers' Association transformed the project into a forum for a debate on free speech when the group lobbied for the removal of the images with the advertising company that had leased space to the artists. The image itself, like that of the bus poster, appeared to be too cryptic for its own good: in this instance, because the viewer would have had to follow a series of events to understand its pictographic allusions. But no matter—the media as well as the project's detractors provided all the explanation it needed. Lowry got the press he wanted by assuming the role of aesthetician. He told reporter Uri Berliner of the *San Diego Union*: "It sure looks like political advertising to me, not art."[13] One newspaper story reported the display of a photograph of one of

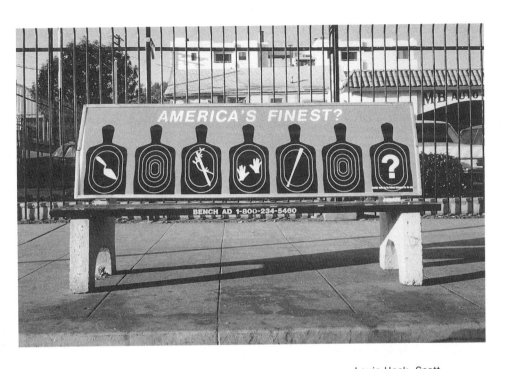

Louis Hock, Scott Kessler, Elizabeth Sisco, and Deborah Small, *America's Finest?*, 1990. Silkscreen on vinyl, 84" x 24". This was one of twenty-five bus benches for the project. Their presence, and the resulting press coverage during late October and November, was a catalyst for the police department to review its policy on use of deadly force.

the benches, with an artist's palette drawn on one of the human contours. Other stories reported the defacement of benches with the loosely painted slogan "Kops Are OK" and the names of two slain officers. Then there were commentaries by art critics (again, including mine) and television newscasters, as well as local citizens writing for the op-ed pages of newspapers.

In its entirety, the history of the bench, as played out in the mass media, revealed just how powerful a catalyst art can be in public debate. Though the police department had held community forums about the shootings, the benches brought broader public attention to the crimes. Another group of benches even went up in December as a retort to the artists' benches, reading, "Happy Holidays to America's Finest Police S.D.P. D." (These were reportedly sponsored by an ad hoc group of police supporters.) And two local residents issued T-shirts imprinted with the words, "America's Finest the REAL Targets." In a sense, then, Hock, Sisco, Small, and Kessler had set the civic agenda for November and December 1990, even though their benches weren't the actual locales for the confrontation, and the debate instead took place largely in that non-place called the mass media. But there was no more impressive evidence of the effect of their project than the decision by Police Chief Bob Burgreen in late December that same year to alter police procedures regarding the use of deadly force. Although the art alone didn't trigger his decision, no one could doubt that its presence had been an instrumental factor in it.

While doing research for the bus benches, the project's creators became well acquainted with information on an epidemic of deeply disturbing murders that had taken place in San Diego County since 1985. The victims, all women and numbering at least forty-five, had been classified as prostitutes, drug addicts, and transients, even though such labels were suspect in several instances. Police officers had been personally involved with some of these women, a fact that appeared to hinder the investigation of a task force set up in 1988 to solve the crimes. It was also reported that the acronym "NHI"—standing literally for "No Humans Involved," but implying a cruel devaluation of the lives of the victims—had been used to describe these women, an assertion that police officials denied.

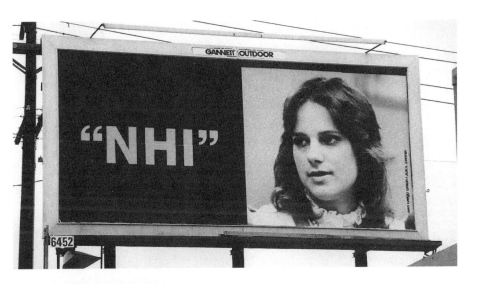

Louis Hock, Carla Kirkwood, Scott Kessler, Elizabeth Sisco, and Deborah Small, *"NHI,"* 1992. Silkscreen on vinyl, 240" x 120". This billboard, in downtown San Diego, was the first component of the *"NHI"* project, dramatizing the murders of forty-five women, the subject of a controversial police investigation.

Portraits of Diana Gail Moffit (top left) and Michelle Riccio (bottom) were among those in the exhibition that was part of *"NHI."* In several other instances, when a photograph of one of the murdered women was not available, a woman from the community volunteered to have her face appear above a deceased woman's name.

Whether true or not, *"NHI"* became the name of the 1992 project by Hock, Kessler, Kirkwood, Sisco, and Small. Because it had several components, *"NHI"* differed from the group's other projects. A pair of billboards, each containing an already familiar picture by photo-journalist Joel Zwink of Donna Gentile, one of the murder victims, went up on February 19. An exhibition of photographs opened three days later in downtown San Diego, in a temporarily leased space, and an accompanying book was first made available on that date as well. Kirkwood's related play, *MWI—Many Women Involved,* was performed in the gallery space on March 7 and 14, while on March 8 a panel including experts and the mother of one of the victims was held in the gallery as well. The ongoing program of events triggered a steady stream of media coverage and created many opportunities for a dialogue between the artists, family members of the victims, and the community.

The billboards themselves told the person on the street little. Both had the same stark design: a picture of a sweet-looking Donna Gentile accompanied by the text *"NHI"* in white against a black background. Without an immediate response from the print and electronic media, they would have remained obscure. But four years after the bus poster, the artists could calculate, quite accurately, how the media would react. And react they did, spreading the word about the exhibition, the performances, and the panel. The show employed a conceptually simple but brilliant conceit. It consisted of forty-five photographs, one per victim, each named below the picture. But when images weren't available for some of the dead, the coordinators of the project asked women from the community to lend their faces. By having other women act as stand-ins for those murdered, *"NHI"* made the point, quite concretely, that the marginalizing and dehumanizing of the victims was clearly about all women.

Although Police Chief Burgreen condemned it, this project wasn't nearly as controversial in the media, though its sheer poignancy did yield moving commentary in the gallery notebook. "What a wonderful voice you've given these women, whose cries cannot be heard," wrote someone with the initials C. S., and "My heart weeps," observed

David Avalos, Louis Hock, and Elizabeth Sisco, distributing envelopes with a statement and ten-dollar bill for *Art Rebate/Arte Reembolso,* in the Pacific Beach area of San Diego, 1993. The project was commissioned by the Centro Cultural de la Raza and the San Diego Museum of Contemporary Art as part of its *La Frontera/ The Border* exhibition.

J. S. The San Diego Press Club selected the artists for its Headliner of the Year award in the arts for "local residents/organizations that were prominent in the news in a positive way." But the NEA felt differently. After having awarded the group $12,000 for their work, on March 9, acting NEA chair Anne-Imelda Radice sent a letter asking that the NEA's imprimatur be removed from the project, even if the money could not be returned. The artists published their retort in the *La Jolla Light,* a local weekly newspaper, declaring, "Withdrawing support from the *'NHI'* project demonstrates the NEA's ethical and moral cowardice and its inability to provide leadership in the arts any longer. . . . The NEA is dead."[14]

Their point about the agency's cowardice was well taken, but it was perhaps premature to think *"NHI"* marked the end of their involvement with the NEA, since, in the summer of 1993, Hock, Sisco, and Avalos irritated the NEA once again with *Art Rebate/Arte Reembolso.* Even the initial story on this piece in the *San Diego Union–Tribune* made the use of taxpayer funds the leading issue, ignoring the artists' central concern with the role of illegal immigrants in the U.S. economy. The artists had made money their means for dramatizing this role—more specifically, ten-dollar bills. Beginning in July and continuing through August, they distributed $4,500 of a $5,000 commission from the San Diego Museum of Contemporary Art, and the Centro Cultural de la Raza, at locales where undocumented workers congregate. Each willing participant would sign a sheet and receive an

envelope containing ten dollars and a statement outlining the intention and themes of *Art Rebate/Arte Reembolso.* In bold letters, the sheet declared, "This ten dollar bill is part of an art project that intends to return tax dollars to taxpayers, particularly 'undocumented taxpayers.' The art rebate acknowledges your role as a vital player in an economic community indifferent to national borders."

The project's detractors multiplied swiftly, with criticism coming from predictable quarters, such as the far-right congressman from North San Diego County, Randy "Duke" Cunningham. He quickly drafted a letter to the NEA, exclaiming, "I can scarcely imagine a more contemptuous use of taxpayers' hard-earned dollars. If 'artists' want to hand out cash to illegal aliens, let it be their own." Bowing to Cunningham's demand for an audit of the grant that funded *Art Rebate/Arte Reembolso,* the NEA would soon disallow the $1,250 of its money that went into the project.

It is not the job of artists, however, to refrain from creative expression for the good of a public agency—to censor themselves, in other words. People who were invisible had in fact become visible because of this project. As in the past, the artists were bringing marginalized people into the media's high-tech town square, implicitly arguing that undocumented workers, by virtue of their very presence, were entitled to rights the rest of us possess. This was old-fashioned populist thinking in the American tradition, which happened to take the form of Conceptual art with wry and extravagant means; but it was a brilliant provocation in the Duchampian and Surrealist traditions as well.

> **It is not the job of artists to refrain from creative expression for the good of a public agency.**

The artists couldn't have taken the side of these workers at a more auspicious moment. During August of that year, Governor Pete Wilson launched a "get tough on Mexican immigrants" policy that continues to this day. "The piece itself is not that exotic or radical," rightly observed Hock when *Art Rebate/Arte Reembolso* had just begun. "What makes it stand out is the calcification of viewpoints about undocumented workers."[15] When California politicians such as Wilson and Senator Dianne Feinstein staged press conferences at the border to advocate tighter border control, Avalos was prompted to

observe, "The politicians are acting like performance artists, while we're trying to be political."[16] In its subject and inventive design, this project took the trio of artists full circle back to the 1988 bus poster, although the distribution of money, however small the amount by federal standards, proved more attention-getting than dubbing San Diego a tourist plantation.

The flaw of *Art Rebate/Arte Reembolso* was in its inadvertent symbolism—with the rebate being perceived as a handout. In this sense, the project played into the hands of those who argue that undocumented workers are leeching off the U.S. economy. However, since the project argued for the continuation of the very tradition of acceptance that has made American culture dynamic, its embracing spirit was far more genuinely American than any nativist hostility to immigrants. History bears witness that each wave of immigration has enriched this society.

As a zone of transition and societal tensions, San Diego has been ripe for activist art in the 1980s and 1990s. But that doesn't mean the appearance of these challenging projects was inevitable—only that with enough vision, humor, and media savvy, artists could seize the moment. The loose coalition of artists and others who created the bus poster, the King billboard, *Welcome Back, Emma,* the bus bench, *"NHI,"* and *Art Rebate/Arte Reembolso* fit the bill. The "statues" placed in the high-tech town square provoked criticism, praise, and debate. By stimulating vigorous discussion of troublesome issues, these projects really have made a measurable impact on the life of San Diego, and nothing could be more central to their purposes.

A few months after the furious debate over *Art Rebate/Arte Reembolso* had subsided, Avalos observed, "The collaborations have a conceptual bent. But viewers shouldn't assume they are theoretically motivated. They're communitarian in spirit. It's no coincidence that all of us lived here a long time, if not all our lives."[17] Just by commenting on concerns in their own backyard, these artists have garnered attention across the United States and beyond. They have given new meaning to philosopher John Dewey's famous line, "The local is the only universal, upon that all art builds."[18]

questions of
sexuality/the
body in public
spaces

This Is to Enrage You:

Gran Fury and the Graphics of AIDS Activism

We don't need a cultural renaissance; we need cultural practices actively participating in the struggle against AIDS. We don't need to transcend the epidemic; we need to end it.

—Douglas Crimp

Kissing Doesn't Kill

A large advertisement affixed to the side of a city bus offers three inter-racial couples dressed in high-contrast colors and posed against an expanse of white monochrome. Each of the couples is kissing. Both the brightly patterned clothing worn by the figures and the overall visual style of the image simulate the well-known "United Colors of Benetton" ad campaign. Indeed, at first glance, we may think we have encountered yet another in that would-be provocative, if ultimately vacant, series of advertisements. It only takes another moment, how-ever, to notice the differences this image has propelled into the space of advertising and to recognize that its agenda has nothing to do with boosting retail sales of Italian sportswear: two of the three couples are of the same sex, and a banner caption extending above the entire image declares, "Kissing Doesn't Kill: Greed and Indifference Do." In smaller type, a box of text to the right reads, "Corporate Greed, Government Inaction, and Public Indifference Make AIDS a Political Crisis."

Kissing Doesn't Kill was produced by Gran Fury, a self-described "band of individuals united in anger and dedicated to exploiting the power of art to end the AIDS crisis."[1] During the course of a relatively brief career—the group was founded in 1988 and (unofficially) dis-banded in 1992—Gran Fury created some of the most arresting AIDS

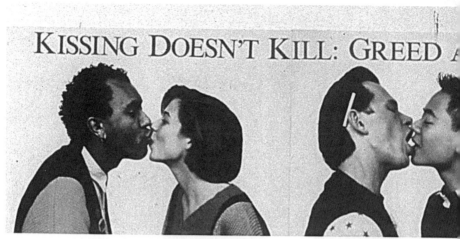

KISSING DOESN'T KILL: GREED

Gran Fury, *Kissing
Doesn't Kill*, bus panel,
1989–90. 136" x 28".
Courtesy of Creative Time

*United Colors of
Benetton* advertisement,
1987, fall/winter
campaign.
Photo by Oliviero Toscano

activist graphics of its day. *Kissing Doesn't Kill* exemplifies the spectacular strategies often exploited by the collective: it mimics the codes of capitalist pleasure and visual seduction to capture the viewer's attention and direct it to the AIDS crisis. Equally as important, it affirms the power of queer desire in the face of an ongoing epidemic, insisting that lesbians and gay men fight the efforts of the larger culture to render their sexuality—their desiring bodies—invisible.[2] *Kissing Doesn't Kill* also challenges misinformation about AIDS, rejecting early accounts (and rumors) that erroneously included kissing as a risk behavior and saliva as a likely fluid of transmission.[3] As in all its work, Gran Fury locates the root cause of the AIDS crisis

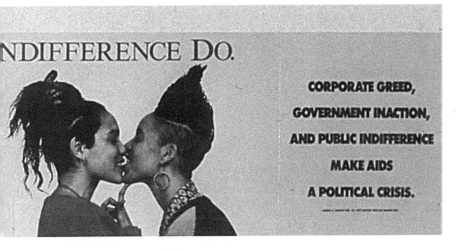

NDIFFERENCE DO.

CORPORATE GREED, GOVERNMENT INACTION, AND PUBLIC INDIFFERENCE MAKE AIDS A POLITICAL CRISIS.

not in HIV infection but in larger social forces and constituencies— the government, the corporate culture, the mainstream public—that ignore, remain silent about, or profit from the pandemic. Finally, *Kissing Doesn't Kill* functions as a mobile advertisement, traveling through various neighborhoods of the city rather than remaining within the bounds of any one community or subculture. It courts as wide a consumer audience as possible, jockeying alongside other advertisements and mass-produced images within the public spaces of urban culture. "We are trying to fight for attention as hard as Coca-Cola fights for attention,"[4] observes Gran Fury member Loring McAlpin of the group's mass-market ambitions.

Since its initial appearance in 1989, *Kissing Doesn't Kill* has become something of an activist classic, widely reproduced in both the mainstream and alternative presses, reprinted several thousand times as a poster, even restaged as a music video and broadcast on European MTV and American public television.[5] Gran Fury member Avram Finkelstein describes the success of *Kissing Doesn't Kill* as deriving from the fact that it puts "political information into environments where people are unaccustomed to finding it. . . . It's very different from being handed a leaflet where you automatically know someone's trying to tell you something and you may not be receptive to hearing it. But when you're walking down the street and you're gazing at advertising . . . who knows what goes through [your] mind?"[6]

Gran Fury frequently displayed its work at or on sites such as urban billboards, bus shelters, subway trains, newspaper vending machines, and television screens—sites where the work might be mistaken, if temporarily, for a familiar form of mainstream media. The collective simulated the glossy look and pithy language of advertising to seduce its audience into dealing with the difficult issues of AIDS transmission, research, funding, and government (non)response, issues that might otherwise be avoided or rejected out of hand. In catching viewers off-guard, Gran Fury sought to shock them into a new awareness of—and new activity about—the AIDS crisis.

In contrast to *Kissing Doesn't Kill*, activist graphics of the 1970s and early 1980s often employed self-consciously "craftsy" modes of fabrication, including freehand drawing, silkscreens, rough-hewn stencils, and woodcut printing. Through these handmade means, such posters sought a visual style appropriate to their grassroots context and counter-capitalist politics. The graphic look of Leslie Bender's *Stop Gentrification*, for example, measures an unmistakable distance from the dominant imagery of consumerism, a distance that constitutes part of its critique of real-estate development on the Lower East Side of New York City.

When market advertising was mimicked by protest posters of the 1970s and early 1980s, it was simultaneously upended, as in Esther Hernandez's *Sun Mad Raisins* of 1981. Hernandez replaces the wholesome face and healthy body of the familiar "raisin girl" with the skull and bones of a corpse, thereby indicting Sun Maid's use of environmental contaminants through a monstrous revision of its corporate logo.

Against such work, Gran Fury relied on visual pleasure, rather than terror, in creating its AIDS activist imagery. In part, this was because the collective was challenging the mainstream representation of the AIDS crisis—and of people living with AIDS—as alien, pathetic, monstrous, and/or murderous. As Jan Zita Grover has documented, early advertisements for AIDS prevention frequently presented the crisis "via fright—dead bodies on gurneys, PWA's [People with AIDS] close to death, dead IV drug users with needles stuck in their arms."[7] Since Gran Fury's aim was not to frighten its audience about infection but to provoke them to anger and political action, it avoided such imagery

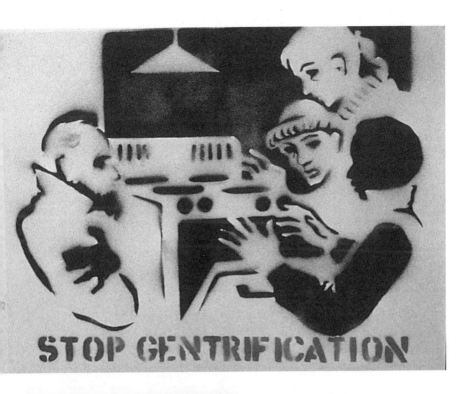

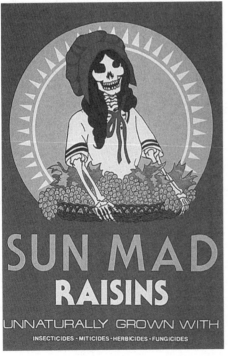

Leslie Bender, *Stop Gentrification*, poster, 1981. Also appeared as printed stencil on city walls and sidewalks, New York.

Esther Hernandez, *Sun Mad Raisins*, poster, 1981.

outright. As collective member Marlene McCarty puts it, "There was no way we were going to make victim photography" or extend "the dominant representation of AIDS as pathetic images of people dying in hospital beds."[8] Rather than portraying AIDS as a matter of individual abjection or personal pathos, Gran Fury addressed the larger social and political context of the epidemic.

In producing affirmative images of gay and lesbian desire, Gran Fury also insisted on the centrality of sexual liberation to its practice of AIDS activism and on the ideal of (safe) sexual freedom in the midst of the crisis. As early as 1985, queer theorists such as Cindy Patton were arguing that "AIDS must not be viewed as proof that sexual exploration and the elaboration of sexual community were mistakes . . . lesbians and gay men . . . must maintain that vision of sexual liberation that defines the last fifteen years of [our] activism."[9] In its defiantly joyous homoeroticism, *Kissing Doesn't Kill* offers just such a liberationist vision, now resituated within the context of the crisis.[10]

Kissing Doesn't Kill was initially created for *Art Against AIDS On the Road*, a 1989 public art project organized in conjunction with several auctions of contemporary art to benefit the American Foundation for AIDS Research (AMFAR).[11] The invitation for Gran Fury to participate in the project, alongside such high-profile artists as Barbara Kruger, Cindy Sherman, and Robert Mapplethorpe, was itself indicative of the art-world attention the collective was receiving at the time. Invitations to exhibit at the Whitney Museum of American Art and the Venice Biennale, among other prestigious venues, would soon follow. By exploiting such attention and the financing and public access that accompanied it, Gran Fury could stage its graphics in ever more ambitious formats. Its output—initially, photocopied posters wheat-pasted on city streets—soon evolved into state-of-the-art billboards, bus panels, subway placards, street signs, and music videos.

Even as Gran Fury became celebrated within the contemporary art world, the collective insisted on its connection to the larger AIDS activist movement and on the necessity of situating its work within the public sphere. "It would have been easy to be confined and co-opted by the art world," recalled McAlpin. The struggle not to be so compromised while "using the art world and its money to achieve our activist ends"[12] remained a continuing challenge for the group.

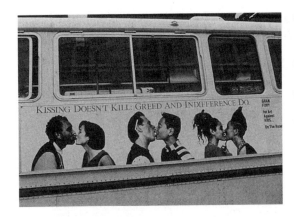

Gran Fury, *Kissing Doesn't Kill*, 1989, 136" x 28". Bus panel installed on San Francisco MUNI as part of *Art Against AIDS On the Road.*
Photo by Gran Fury

Even within the terms of a campaign as progressive as AMFAR's, Gran Fury ran into problems with project organizers over questions of content. AMFAR, an organization largely devoted to fundraising and reliant on corporate donations, refused to run the rejoinder text of the bus panel: "Corporate Greed, Government Inaction, and Public Indifference Make AIDS a Political Crisis." Gran Fury was thus faced with the decision of eliminating the rejoinder text or dropping the entire project. The group decided in favor of the former, believing that the visual power of the kissing couples, alongside the force of the primary slogan, was strong enough to stand on its own. In San Francisco, Washington, D.C., and Chicago, *Kissing Doesn't Kill* was thus displayed in an incomplete fashion, though viewers in those cities had no sense of what they were missing.

Stripped of its rejoinder text, *Kissing Doesn't Kill* now addressed the AIDS crisis rather loosely.[13] Some viewers concluded that the ad was chiefly about the right of lesbians and gay men to kiss in public. In Chicago, this "misreading" abetted the efforts of conservative politicians to prohibit the poster's exhibition on mass transit. City alderman Robert Shaw, for example, argued that *Kissing Doesn't Kill* "has nothing do with the cure for AIDS. It has something to do with a particular lifestyle, and I don't think that is what the CTA [Chicago Transit Authority] should be [in] the business of promoting."[14] Shaw further claimed that the graphic was "directed at children for the purposes of recruitment."[15] Shortly before *Kissing Doesn't Kill* was to arrive in Chicago in June 1990, the Illinois State Senate passed a bill

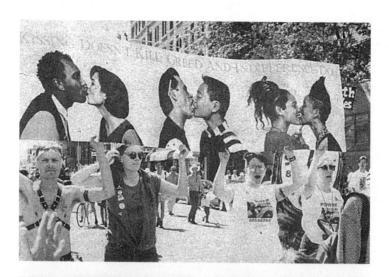

ACT-UP Chicago members
carrying *Kissing Doesn't
Kill* in Gay Pride Parade,
June 1990.
Photo by Lisa Ebright, originally
published in *Windy City Times*,
June 28, 1990

The defacement of
Kissing Doesn't Kill,
1990, Chicago.
Photo by Bill Stamets/Impact
Visuals

outlawing the public display of "any poster showing or simulating physical contact or embrace within a homosexual or lesbian context where persons under 21 can view it."[16]

Marchers in that summer's Chicago Gay Pride Parade carried *Kissing Doesn't Kill* as a symbol of their struggle against public intolerance and legislative censorship.[17] The American Civil Liberties Union soon joined forces with the local lesbian and gay community to protest the bill as unconstitutional. After weeks of lobbying and often vitriolic debate, the bill was defeated in the State House of Representatives. In August 1990, several dozen *Kissing Doesn't Kill* graphics were displayed on Chicago buses and subway platforms. Within twenty-four hours of their installation, however, nearly all were defaced by vandals, a defacement widely reported in both the local and national press.

The controversy surrounding *Kissing Doesn't Kill* in Chicago, as well as the press coverage that controversy provoked, opened up a significant dialogue about homosexuality, homophobia, AIDS, and visual representation. Such controversy formed a strategic part of Gran Fury's activism, extending the political reach of its graphic production by tapping into the power of the mass media to spark and sustain public debate. The "work" of Gran Fury's art thus occurred as much in its reception as in its initial production, as much in its coverage by the press as in its original display by the collective.

Kissing Doesn't Kill became Gran Fury's most widely seen—and in that sense its most successful—contribution to AIDS activism. Yet the bus panel marks but one project in a far more ambitious production, a production whose history extends back to the earliest days of ACT-UP. Before discussing Gran Fury's work in further detail, we should return to the larger AIDS activist movement from which it sprang.

SILENCE = DEATH

Ronald Reagan delivered his first public speech on the AIDS epidemic on May 31, 1987. By this time, 36,058 American citizens had been diagnosed with the syndrome and 20,849 had died as a result of its complications. Nearly six years had elapsed since the first AIDS-related deaths in the United States.[18]

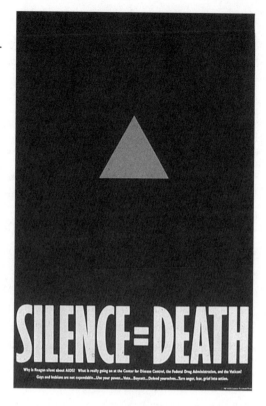

Gran Fury, *SILENCE =
DEATH*, poster, 1986, for
SILENCE = DEATH project.
Offset lithography, 24" x
29". Subsequently used
as placard, T-shirt,
button, and sticker.
Photo by Gran Fury

In late 1986, posters featuring pink triangles floating above block typeface reading "SILENCE = DEATH" seemed to saturate the streets and storefronts of lower Manhattan. This saturation occurred not only through the quantity of the posters reproduced (there were approximately 2,000) but also through the visual power and mystique of their design. The ironic appropriation of the pink triangle, the Nazi marker of homosexual men imprisoned in the death camps, combined with the blunt admonishment of the text, signified gay outrage while refusing to give away too much, refusing to speak explicitly or at length. It was only when one moved in fairly close to the poster that the specific accusations were lodged. Along the bottom edge of the image, the fine print read: "Why is Reagan silent about AIDS? What is really going on at the Center for Disease Control, the Federal Drug Administration, and the Vatican? Gays and Lesbians are not expendable . . . Use your power . . . Vote . . . Boycott . . . Defend yourselves . . . Turn anger, fear, grief into action."[19]

SILENCE = DEATH was revived the following year by the newly formed AIDS Coalition to Unleash Power (ACT-UP), a group that vowed to answer the poster's call by turning its anger into direct political action to end the AIDS crisis.[20] Shortly after its incorporation in March 1987, ACT-UP began reproducing the graphic on stickers, buttons, T-shirts, and protest placards. SILENCE = DEATH effectively announced ACT-UP's "image" and political agenda to New York City and soon became synonymous with the group's radical forms of civil disobedience: provoking arrest, stopping traffic, mounting guerrilla street theater, and otherwise interrupting "business as usual" at such venues as the New York Stock Exchange, Grand Central Station, and St. Patrick's Cathedral. Like the public zaps and demonstrations that ACT-UP staged, the SILENCE = DEATH logo insisted on the voice and visibility of those battling the AIDS crisis. Equally as important, it represented ACT-UP to ACT-UP, solidifying the group's self-image by serving as both rallying cry and symbol of collective identification.

The signifying power of SILENCE = DEATH persisted long after individual ACT-UP demonstrations had concluded. Wherever the logo surfaced in public space, so too did its potential for focusing awareness on the pandemic. As ACT-UP members Douglas Crimp and Adam Rolston argue:

> It is not merely what SILENCE = DEATH says, but how it looks, that give it its particular force. The power of this equation under a triangle is the compression of its connotations into a logo, a logo so striking that you ultimately have to ask, if you

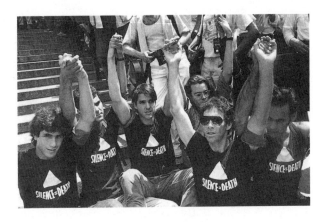

ACT-UP demonstration, June 30, 1987 at Federal Plaza, New York City.
Photo by Donna Binder/ Impact Visuals

don't already know, "What does that mean?" And it is the answers we are constantly called upon to give to others—small, everyday direct actions—that make SILENCE = DEATH signify beyond a community of lesbian and gay cognoscenti."[21]

The slick visual style of *SILENCE = DEATH* imbued it with a particular kind of cultural power, a power usually reserved for mass-market advertising. As Rolston put it, "It looked like a corporate logo, like some institution was speaking to me. It's the appropriation of the voice of authority. Like a trick."[22]

SILENCE = DEATH would prove but the first in a remarkable series of graphic designs that ACT-UP has used to mobilize its forces and signify its anger in spectacular formats. Having witnessed, during the early years of the epidemic, an absence of mainstream press reporting on AIDS or, worse, the scapegoating of gay men and IV drug users as the threat and "deviant" cause of the crisis, ACT-UP understood the importance of taking representation into its own hands, of creating imagery and agitprop that would force AIDS onto the public agenda.[23]

One of the earliest examples of such imagery was an ambitious reworking of the *SILENCE = DEATH* logo that appeared in November 1987. At that time, Bill Olander, a curator at the New Museum of Contemporary Art in New York City and himself an ACT-UP member, invited the collective to create an installation in the museum's window on lower Broadway. An ad hoc committee of approximately thirty ACT-UP members, some (but by no means all) of them artists and graphic designers, collaborated on a project they entitled *Let the Record Show*.

Crowned by the *SILENCE = DEATH* symbol, now illuminated in hot-pink neon, the window offered a "rogues' gallery" of six public figures (among them Jesse Helms, William F. Buckley, and Ronald Reagan) who had aggravated the AIDS crisis. The figures were represented by cardboard silhouettes and set against the backdrop of a mural-size photograph of the Nuremberg trials. As with the pink triangle, the Nuremberg photo summoned the purposefully "risky" analogy of the Holocaust to the AIDS crisis. Lest anyone think the comparison overblown, a concrete slab stationed directly beneath each silhouette bore an AIDS-related quote from that figure. Jerry Falwell's slab proclaimed that "AIDS is God's judgment of a society that does not live by his

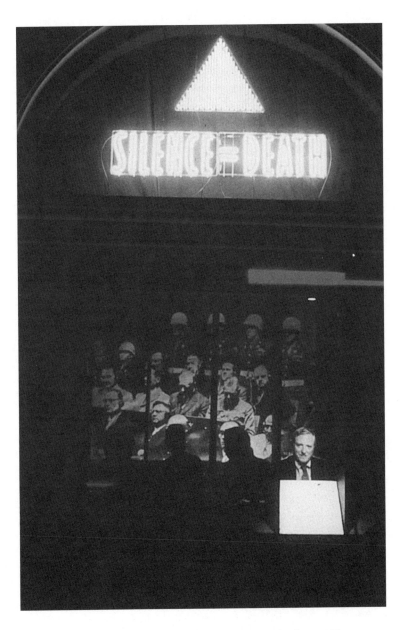

Let the Record Show,
1988, mixed media.
Created by an ad hoc
committee of ACT-UP
New York for the New
Museum of Contemporary
Art, New York.

rule," while Jesse Helms's declared that "the logical outcome of testing is a quarantine of those infected." Ronald Reagan's concrete slab stood empty, reflecting his years of (deadly) silence on the crisis. The final element in the installation was an LED sign that flashed statistical information about the epidemic as well as activist rallying cries ("ACT-UP, fight AIDS, fight back!") in response to that information.

Although *Let the Record Show* was sponsored by the New Museum, it became, by dint of its placement in an exterior window on lower Broadway, part of the sidewalk culture of a heavily commercial block in downtown Manhattan. This liminal location—at once inside an art space and extending into the public sphere of the city street—became an influential model for later AIDS activist art work.

Also exemplary was the collective process through which *Let the Record Show* was created. Tom Kalin, a filmmaker who worked on the window project and later became a member of Gran Fury, recalls:

> There were big workshop sessions, like the one where the slabs of concrete were made by cutting rubber stencils. All the labor-intensive work was being done in someone's studio with fifteen to twenty people there at a time. Various people came in for specific tasks. I came in myself because I knew how to do mural photography. Other people came with their own abilities—the person who made the neon and so on.[24]

Kalin underscores the (amiable) division of labor among a large group of activists with different kinds of technical expertise and training. The shared creative effort behind *Let the Record Show* resonates with its complex layering of representations (the LED sign, the neon logo, the cardboard silhouettes, the concrete slabs, the photo mural), representations that respond to the AIDS crisis in a complex and collective fashion rather than in an individual, authorial voice.

Spinning Off from ACT-UP

Following the success of *Let the Record Show*, a group of approximately fifteen ACT-UP members decided to form a collective devoted to the ongoing production of AIDS activist imagery. They took the name Gran Fury, a reference both to their own rage in the midst of the epidemic and, somewhat campily, to the specific model of Ply-

mouth sedan that the New York City Police use as squad cars. Although several commercial and fine artists were part of the collective, so too were a hairdresser, a costume designer, an architect, a filmmaker, and a nurse. The heterogeneity of the group's constitution underscored its activist—rather than expressly artistic—commitments. The group's activist ethos was also reflected in its early insistence on anonymity. During the initial years of their collaboration, Gran Fury members refused to be photographed by the press or individually credited for their work. As one participant put it: "Our activism was the important thing, not our appearance. If there was going to be a photograph in a story on Gran Fury, we wanted it to be a photograph of the work."[25]

Though organized as an autonomous collective, Gran Fury worked in close alliance with ACT-UP New York, producing agitprop to accompany the larger group's demonstrations and serving, in the words of Crimp and Rolston, as ACT-UP's "unofficial propaganda ministry and guerrilla graphic designers."[26] For an ACT-UP demonstration on Wall Street in March 1988, for example, Gran Fury printed up small handbills that simulated the appearance of currency on one side and lodged aggressive accusations on the other. The slogan on the flip-side of the ten-dollar bill read: "White Heterosexual Men Can't Get AIDS . . . DON'T BANK ON IT," a response to the presumption of AIDS as a gay or minority disease. The verso of the fifty-dollar bill proclaimed: "WHY ARE WE HERE? Because Your Malignant Neglect KILLS," an indictment of public indifference to the crisis. The most expensive currency, the hundred-dollar bill,

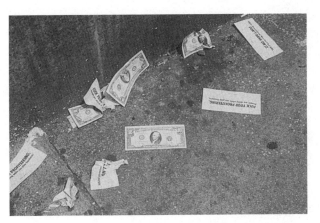

Gran Fury, *Wall Street Money* (on streets of financial district, New York), flyer, photocopy, recto-verso (three versions), 8 $^1/_2$" x 3 $^1/_2$". Created to accompany ACT-UP's *Wall Street II* demonstration, March 24, 1988.
Photo by Gran Fury

carried the most direct confrontation: "FUCK YOUR PROFITEERING. People are dying while you play business."

Gran Fury's money functioned successfully as an attention-getting device, not only for the Wall Street workers passing by on their lunch hour but also for the mass media. The image of fake currency showering the streets of the financial district—and of well-dressed passersby momentarily duped into thinking the money genuine—made for a telegenic image on the nightly news and helped secure increased press coverage for the Wall Street demonstration. When collaborating with ACT-UP, Gran Fury considered not only how its graphics would function within the demonstration but also how they would "read" in coverage by the mainstream press. The impact of Gran Fury's work thus extended into its subsequent reproduction on the nightly news and in the local papers.[27]

Read My Lips

In the spring of 1988, the "nine days of protest" were held in various cities throughout the United States. The first coordinated action of a now national coalition of ACT-UP chapters, these protest days were devoted to demonstrations around nine different AIDS issues, among them AIDS in prison, women and AIDS, homophobia, HIV testing and treatment, and health care. Gran Fury, working in subsets of two,

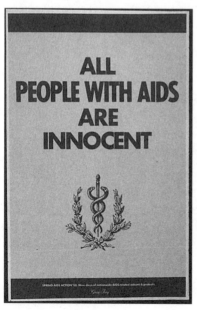

Gran Fury, *All People with AIDS Are Innocent*, poster, 1988. Offset lithography, 10 $^1/_2$" x 16 $^1/_4$". Created for *Nine Days of Protest*, April 29–May 7, 1988.

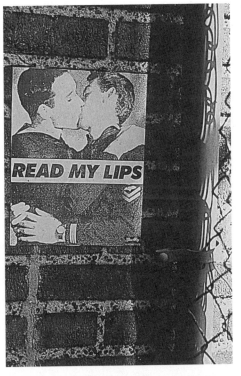

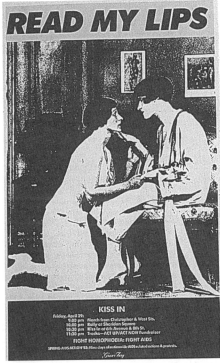

Gran Fury, *Read My Lips* (boys), poster, 1988. Offset lithography, 10 $^3/_4$" x 16 $^3/_4$". Also used as a T-shirt. Created for *Nine Days of Protest*, April 29–May 7, 1988.
Photo by Gran Fury

Gran Fury, *Read My Lips* (girls), poster, 1988. Offset lithography, 10 $^1/_8$" x 16 $^1/_2$". Created for *Nine Days of Protest*, April 29–May 7, 1988.

Gran Fury, *Read My Lips* (girls), poster, 1988. Offset lithography, 10" x 16 $^1/_2$". Also used as T-shirt.

produced a separate graphic project for each day of protest. The group's health care poster, *All People with AIDS Are Innocent,* stood as an eloquent rebuttal to the media's categorization of gay men and IV drug users as the "guilty" carriers of AIDS and infected children, hemophiliacs, and heterosexuals as "innocent" victims.[28] The poster employed the single graphic element of a caduceus, the winged staff with interlocking serpents that symbolizes the medical profession. Taken together, symbol and slogan "demand[ed] of health care professionals that they live up to their purported ethical standard of equal and compassionate treatment for all, including all people with AIDS."[29]

For the day of protest against homophobia, Gran Fury combined the phrase "Read My Lips" with historical images of same-sex couples: a World War II shot of smooching sailors and a 1920s photograph of two women gazing, with longing intensity, into each other's eyes. *Read My Lips* would acquire an extra layer of significance (and irony) a few months later when George Bush made his notorious vow "Read my lips: no new taxes," during his acceptance speech at the Republican National Convention.

In *Read My Lips,* as in *Kissing Doesn't Kill,* the representation of same-sex desire becomes an act of defiance because it is projected, with style and activist bravado, into the public sphere. *Read My Lips* was initially created in conjunction with a massive "kiss-in" (in which hundreds of same-sex couples made out at the same moment) organized by ACT-UP New York as the central action of its anti-homophobia day of protest. While public displays of affection between heterosexual couples are routine, even banal, those between same-sex couples remain relatively rare because of the threat of bias-related violence (or "queer-bashing") to which gay men and lesbians are routinely subject. According to ACT-UP, its kiss-in was held as "an aggressive demonstration of affection" that would "challenge repressive conventions that prohibit displays of love between persons of the same sex" while protesting "the cruel and painful bigotry that affects the lives of lesbians and gay men."[30] As a graphic, *Read My Lips* might be said to perform the same functions, though with an added historical resonance: the recovery of homoerotic imagery from the first half of the twentieth century ties the contemporary act of same-sex kissing to a larger legacy of queer culture and self-representation.

As several lesbians in ACT-UP were quick to point out, however, the women's graphic for *Read My Lips* was troubling insofar as it reduced lesbian eroticism to a gaze, a fixed distance, a refined delicateness: while the sailors smooched, the flappers just looked. When Gran Fury subsequently revived *Read My Lips* as a T-shirt, the 1920s image was replaced with a Victorian one of two women in the midst of a passionate embrace. Such revision was characteristic of Gran Fury's working method: the group's graphics, placed in dialogue with the larger AIDS activist movement, were open to the criticism and creative input of that movement.

The representation of women's issues by Gran Fury, a predominately gay male collective, would surface as a problem in another of the graphics produced for the nine days of protest. The poster for the "women's" day of demonstration featured a close-up image of a monumentally erect penis surrounded by three slogans: "Sexism Rears Its Unprotected Head" in largest type at the top, "Men Use Condoms or Beat It" to the left of the shaft, and "AIDS Kills

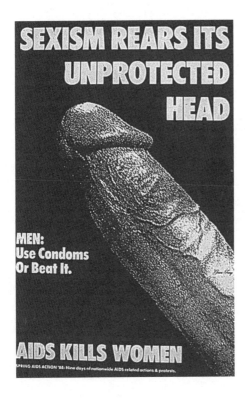

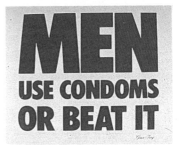

Gran Fury, *Sexism Rears Its Unprotected Head*, poster, 1988. Offset lithography, 10 $^3/_8$" x 16 $^3/_8$". Created for *Nine Days of Protest*, April 29–May 7, 1988.

Gran Fury, *Men Use Condoms or Beat It*, crack-and-peel sticker, 1988. 8 $^1/_2$"x 7 $^1/_4$". Also used as T-shirt and button.

Women" along the bottom margin. Though unanimously approved by Gran Fury, the poster was received with marked ambivalence by some members of ACT-UP, especially by several women who felt the graphic glorified phallic power more forcefully than it encouraged safer sex.[31]

In a fine piece of reediting, Gran Fury isolated the best part of its poster, the central slogan, "Men Use Condoms or Beat It," and reproduced it on a series of crack-and-peel stickers, T-shirts, and buttons. With its block type and bold black-on-yellow color scheme, the graphic now recalled a "MEN AT WORK" construction sign, an association that enhanced its subtly confrontational humor. On its own, *Men Use Condoms or Beat It* performed well and wittily, challenging both straight and gay men to practice safer sex without presuming to speak for women.

The Government Has Blood on Its Hands

Gran Fury never hesitated to appropriate graphic designs when such borrowings suited its activist aims. Consider, for example, the group's 1988 poster of a bloody, outstretched handprint sandwiched between two slogans: "The Government Has Blood on Its Hands" and "One AIDS Death Every Half Hour." The poster, which indicted the government's inaction on AIDS while grabbing the viewer's attention with the graphic appeal of that bloody, open handprint, directly recalled John Heartfield's: *A Hand Has 5 Fingers. With 5 You Can Repel the Enemy! Vote List 5.* Heartfield's graphic was created for the German elections of 1928, a year in which the number five carried a double significance, marking both the date of the election and the row on the ballot where Communist party candidates were listed.[32]

Rather than merely simulating Heartfield's design, Gran Fury revised and updated it. Where Heartfield's image featured the sullied hand of a worker, reaching up and out as if to stop us in our tracks, Gran Fury's graphic depicted a hand*print,* a trace of a body that is no longer present, presumably because it has died from government neglect. To extend the graphic impact of *The Government Has Blood on Its Hands*, members of Gran Fury would dip their own hands in red paint and then register their handprints on street signs, mailboxes, and kiosks near where the poster had been displayed. This strategy set

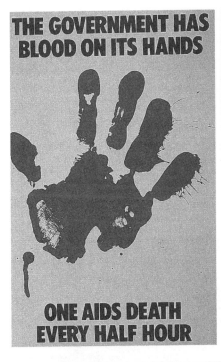

THE GOVERNMENT HAS
BLOOD ON ITS HANDS

ONE AIDS DEATH
EVERY HALF HOUR

5 Finger hat die Hand
Mit 5 packſt Du den Feind!
Wählt Liſte
Kommuniſtiſche Partei!

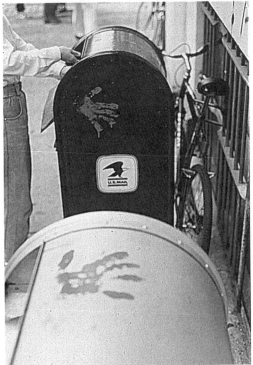

Gran Fury, *The Government Has Blood on Its Hands*, poster, 1988. Offset lithography, 21 ³/₈" x 31 ³/₄". Also used as placard, T-shirt, and sticker.

John Heartfield, *A Hand Has 5 Fingers. With 5 You Can Repel the Enemy! Vote List 5*, 1928. Communist party campaign poster.

Gran Fury, *Untitled* (bloody handprints), 1988. Red paint on mailboxes and city streets, downtown New York City.
Photo by Gran Fury

Gran Fury, *New York Crimes,* four-page newspaper, 1989. Web offset, each page 15" x 22 ¹/₄". Created to accompany ACT-UP's *Target City Hall* demonstration, March 28, 1989.

up a call-and-response between the painted handprints and the printed poster: the poster's message clarified the meaning of the red handprints even as the handprints dramatized the anger and immediacy of the poster. The dripping handprints also announced that Gran Fury would not confine itself to the expected forms of street art and political agitprop: wheat-pasted posters would never mark the limits of the group's activist outrage.

New York Crimes

Throughout its history, Gran Fury sought out new textual and graphic devices to communicate its political message. To accompany an ACT-UP demonstration at New York City Hall in 1989, for example, Gran Fury created the *New York Crimes,* a four-page simulation of the *New York Times* that cannily captured the graphic and typographical look

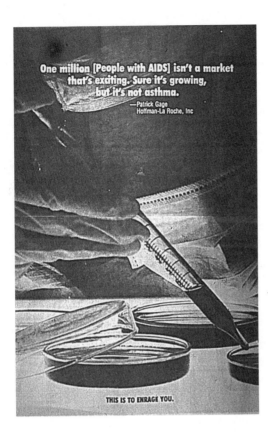

One million [People with AIDS] isn't a market that's exciting. Sure it's growing, but it's not asthma.
—Patrick Gage
Hoffman-La Roche, Inc

THIS IS TO ENRAGE YOU.

Gran Fury, *New York Crimes*, back cover of four-page newspaper, 1989. Web offset, each page 15" x 22 ¼". Created to accompany ACT-UP's *Target City Hall* demonstration, March 28, 1989.

of its predecessor. The articles, at once informational in content and outraged in tone, were written by members of ACT-UP. They assailed the city's handling of the AIDS crisis with such headlines as "N.Y. Hospitals in Ruins, City Hall to Blame, Koch Fucks Up Again." The *Crimes* also carried Gran Fury graphics such as the microscopic image of a virus superimposed with an arrow pointing to a map of city hall. The graphic's caption: "Scientists discover real reason behind the high incidence of HIV infection in New York." Once again, Gran Fury located the root cause of the worsening crisis not in HIV infection or unsafe sex but in government neglect and inaction.

The back cover of the *New York Crimes* featured a full-page graphic of a lab technician, in surgical mask and gloves, drawing a specimen sample from a petri dish. The image was punctuated by a quote from an executive at the drug company Hoffman–La Roche: "One million

[People with AIDS] isn't a market that's exciting. Sure it's growing, but it's not asthma." In response to such blithe profiteering, a caption beneath the photograph declared: "This Is to Enrage You."

Gran Fury came up with a novel strategy for circulating the *New York Crimes*. At 4:00 a.m. on the morning of ACT-UP's demonstration at city hall, Gran Fury members wrapped copies of the *Crimes* around issues of the *New York Times* for sale in newspaper vending machines. This intervention was possible because newspaper machines provide access to an entire stack of issues for the price of a single paper. Later that day, purchasers of the *Times* were unwittingly confronted with the urgent appeal and informational articles of the *Crimes*. Like other Gran Fury projects, the *New York Crimes* effected a "shock of misrecognition" as an ostensibly familiar form of mass culture gave way to its activist simulation.

The Pope and the Penis

The Venice Biennale, a survey of contemporary art held every other summer, is perhaps the single most prestigious exhibition on the international art circuit. The invitation to display work at the 1990 Biennale marked Gran Fury's ultimate validation by the art world, a validation met with some ambivalence by the collective. On one hand, the group had always committed itself to producing work for the public sphere rather than for interior art spaces. On the other, the Biennale, as an international spectacle and major media event, could provide a significant forum for Gran Fury's message and extend the public reach of its activism.

The collective decided both to accept the Biennale's invitation and to use the Venetian venue as an opportunity to address the Catholic Church's position on AIDS. Gran Fury thus created a site-specific work entitled *The Pope and the Penis,* which juxtaposed two multicolor billboards, the first a reworked version of *Sexism Rears Its Unprotected Head,* with the text magnified and the erect penis diminished in scale. The second billboard, organized as a triptych (a traditional format for Roman Catholic altarpieces), presented an image of the Pope with a quotation reflecting the Church's position on the AIDS crisis: "The truth is not in condoms or clean needles, these are lies . . .

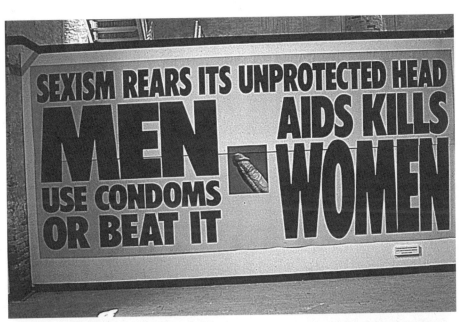

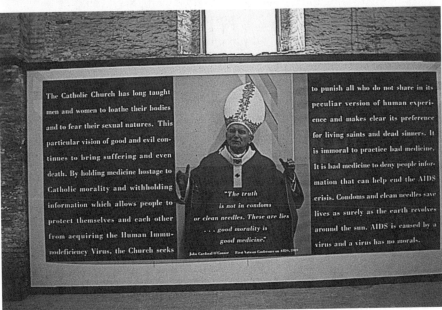

Gran Fury, *The Pope and the Penis* (details), 1990. Billboards, 224" x 96" each. At Venice Biennale.

Photo by Gran Fury

good morality is good medicine."[33] Gran Fury's response to this position, printed against a monochrome of (ecumenical) purple, stood on either side of the papal image:

> The Catholic Church has long taught men and women to loathe their bodies and to fear their sexual natures. This particular vision of good and evil continues to bring suffering and even death. By holding medicine hostage to Catholic morality and withholding information which allows people to protect themselves and each other from acquiring the Human Immunodeficiency Virus, the Church seeks to punish all who do not share in its peculiar version of human experience and makes clear its preference for living saints and dead sinners. It is immoral to practice bad medicine. It is bad medicine to deny people information that can help end the AIDS crisis. Condoms and clean needles save lives as surely as the earth revolves around the sun. AIDS is caused by a virus and a virus has no morals.[34]

Upon discovering the content of Gran Fury's work, the director of the Biennale, Giovanni Carandente, declared that the group's contribution was not considered art and vowed to resign if it were exhibited. Simultaneously, Italian officials at the Venice airport were refusing to release Gran Fury's billboards from customs. The collective, furious over the suppression of its work, held a press conference in its assigned (though still empty) exhibition stall. When the press arrived, it found the following text painted on the walls where *The Pope and the Penis* should have hung:

> Two billboards by Gran Fury are being held in Italian Customs. One billboard, with a picture of the Pope, criticizes the Catholic Church's position on condoms and AIDS education. The other billboard, with a picture of an erect penis, mandates that men use condoms to prevent the spread of the AIDS virus. The director of the Biennale, Giovanni Carandente, has threatened to resign if the billboards are exhibited. The Biennale officials refuse to intervene to secure the work.

Accounts of the *"Scandalo alla Biennale"* immediately appeared in Italian newspapers alongside reproductions of the *Pope* (though, predictably, not the *Penis*) billboard. Within forty-eight hours, Gran Fury's work was released from customs and installed in the American exhibition space. The director of the Biennale did not resign.

Italian press coverage of Gran Fury at Venice Biennale, 1990. Left to right: "Scandalo alla Biennale," *Il Gazzettino*, May 25, 1990: 6; "Papa e Aids è scandalo alla Biennale," *La Nuova*, May 25, 1990: 1; "Biennale, l'arte dello scandalo," *La Repubblica*, May 26, 1990: 23.

Photo by Richard Meyer

Once again, Gran Fury used the very threat of censorship as a strategic part of its activism, manipulating controversy to increase the impact and political resonance of its graphic work. As one collective member put it, "In the end, the director's posturing backfired. There was lots of negative publicity for him, and it just escalated the attention the piece got, something we hadn't counted on. He became, in effect, our partner."[35]

By producing work that transgressed the boundaries of "acceptable" art and by willfully courting the category of the blasphemous, Gran Fury catapulted the issue of AIDS to the front pages of the Italian press. Several articles on the Biennale *scandalo* included sidebar stories on the increasing problem of HIV infection in Italy and the government's (non)response to that problem. Gran Fury member Donald Moffett notes that "the strongest thing was not the object [the billboard] itself, but the discussion the object generated . . . it allowed us to break outside the cloistered territory of the Biennale."[36] Such strategic breakouts were, of course, one of the primary ambitions of Gran Fury's activism.

Never Forget

In 1992, Gran Fury was invited by the Montreal Museum of Contemporary Art to participate in an exhibition entitled *Pour la suite du*

monde ("So That the World May Continue"). With the financial backing of the museum, Gran Fury produced posters for the streets and subways of Montreal as well as a closely related work for the central atrium of the museum. The posters presented a hybrid of the Quebec and American flags: the *fleur de lys* and blue-and-white color scheme of the former were combined with the alternating stripes and upper-left rectangle of the latter. For the graphic's primary slogan, Gran Fury appropriated a phrase loaded with political meaning for the local audience: *"Je Me Souviens"* ("I remember," or, idiomatically, "never forget"). This phrase, which appears on every Quebec license plate, implores French Canadians to remember their autonomous identity and resist attempts by outside forces, specifically English-speaking Canada, to colonize their culture.

In borrowing *Je Me Souviens* for its graphic, Gran Fury sought to redirect the slogan's meaning to the AIDS epidemic. Within the terms of the street poster, the phrase now implored viewers "to remember" the practice of safer sex, information about which was printed on the bottom of the poster: *"Pour fourrer, mets un condom"* ("When fucking, use a condom") and *"Viens pas dans la bouche de personne"* ("Don't come in anyone's mouth"). *Je Me Souviens* also directed the Montreal public "to remember" the mistakes of the American government so as not to repeat them, a directive made explicit on the upper-right corner of the graphic: *"Le Gouvernement américain a laissé mourir du SIDA 140,000 de ses citoyens. Dites NON au désastre que prescrivent les États-Unis"* ("The American government has let 140,000 of its citizens die from AIDS. DON'T import the American prescription for disaster").[37] Gran Fury grounded *Je Me Souviens* in the specifics of the U.S. epidemic because that was the situation with which the collective was directly familiar.

As with *The Pope and the Penis* in Venice, Gran Fury here designed a graphic it knew would be arresting, even incendiary, for the local audience. Some Montreal viewers, however, professed as much confusion as outrage over the appropriation of their cultural symbols and slogans.[38] The connections between French Canadian patriotism and the AIDS crisis in the United States were not, it would seem, immediately apparent. Local critics and press commentators wondered why Gran Fury was instructing a Montreal audience *not* to follow the

Gran Fury, *Je Me Souviens*, poster, 1992. Offset lithography. Displayed on streets of Montreal.
Photo by Gran Fury

American example on AIDS by combining the nationalist symbols of both cultures.[39]

Je Me Souviens also proved controversial within the Montreal chapter of ACT-UP, some of whose members felt that their activist voices had been silenced by the more celebrated ones of the New York collective. Douglas Buckley, a spokesperson for Montreal ACT-UP, declared that Gran Fury's poster "reflects an imperialistic, American context and has nothing to do with the AIDS crisis in Quebec. These are American statistics, an American point of view, an American reality all superimposed on some of the most potent of Quebec symbols."[40]

The problems surrounding the reception of *Je Me Souviens* in Montreal reflected a larger dilemma for Gran Fury: How could the collective continue to produce work for foreign venues when its knowledge of the AIDS epidemic was rooted in an American—and specifically, a New York—context? As one member points out, Gran Fury was, by the early 1990s, "becoming a kind of institution in the art world for AIDS activist work, getting offers from all around the world to come and do projects . . . while we could speak to the community in New York, it was extremely difficult to go to another place and address their situation."[41] Gran Fury's attempt to "globalize" its activism by producing work for such far-flung venues as Venice, Berlin, and Montreal became an increasingly vexing issue for the collective.

Issues of private despair and denial do not lend themselves to the seductive imagery and sloganeering perfected by Gran Fury.

Although Gran Fury was not aware of it at the time, the Montreal project would mark the last effort of the group as it had been constituted since 1988. While modest projects bearing the Gran Fury logo have appeared in the two years since Montreal, these have been the work of a much smaller subset (typically three to four members) of the original collective. It is likely that the members of this subset will soon retire the name Gran Fury and reorganize as a new collective.[42]

A number of factors contributed to the disbanding of the original collective, including Gran Fury's own progress in raising public awareness about the AIDS crisis. By 1992, numerous informational projects on AIDS (created not only by activist groups but by main-

stream ad agencies and AIDS service organizations) had appeared throughout the United States, on public transportation, billboards, television, and in mass mailings. Within this expanded field of AIDS representation, Gran Fury's work no longer seemed such a necessary (or radical) intervention. The year 1992 also marked the moment of Bill Clinton's election, a moment which appeared (at the time) to signal a major breakthrough in terms of the federal government's responsiveness to the epidemic.[43] After five years of graphic production, Gran Fury had reason to believe that its activist message had, to some extent, been heard.

Alongside this guarded optimism, however, many Gran Fury members were experiencing a mounting sense of exhaustion about the AIDS crisis, a fatigue resulting from years of fighting the epidemic while losing ever more friends and colleagues to it. Such collective fatigue had also affected the larger AIDS activist community. ACT-UP New York, like other chapters throughout the country, suffered a steady decline in both activity and membership during the early 1990s. According to a 1993 article in *New York Newsday*:

> Where ACT-UP once attracted 800 people to its Monday-night meetings, now the organization is happy to get a sweaty crowd of 150–200. ACT-UP's budget, a million dollars in 1991, is now half that amount. Multiple, well-organized, well-publicized demonstrations—once the hallmark of ACT-UP—have dwindled to a dozen a year, and those that do happen . . . get no coverage in the Washington or New York papers. . . . Even Larry Kramer [the founder of the organization] was quoted as saying, "ACT-UP is dead."[44]

Of course, ACT-UP was (and is) not dead, and, as one of the group's own slogans puts it, "The AIDS Crisis Is Not Over." Yet, as we all move further into the second decade of the epidemic, there is, as Douglas Crimp has written, "a new kind of indifference, an indifference that has been called the 'normalization of AIDS'. . . . How often do we hear the list recited?—poverty, crime, drugs, homelessness, and AIDS. AIDS is no longer an emergency. It's merely a permanent disaster."[45] It may well be this sense of "normalization"—this resignation and numbness—that AIDS activism must now address. Unlike corporate greed or government inaction, issues of private despair and denial

do not lend themselves to the seductive imagery and sloganeering perfected by Gran Fury in the late 1980s and early 1990s. What strategies of address, then, are appropriate to this moment of the crisis? And what of the future of AIDS activist imagery?

As mentioned above, a small offshoot of Gran Fury has produced occasional public art projects since 1992. The most significant of these to date has been a black-and-white poster, wheat-pasted on the streets of downtown Manhattan, whose modest format and neglible cost recall the earliest graphics of ACT-UP. The rhetorical tone of the poster, however, marks a departure from everything that has come before. Rather than grabbing the viewer's attention in a spectacular fashion, it speaks modestly, even softly. Devoid of graphic imagery, the poster is entirely textual. In small, typewritten print it poses a series of questions to the viewer: "Do you resent people with AIDS?" "Do you trust HIV-negatives?" "Have you given up hope for a cure?" and "When was the last time you cried?"

Rather than making a demand (e.g., *Read My Lips, Use Condoms or Beat It*), the poster asks us to reflect on the psychic stakes of the AIDS crisis and our own ambivalence about those stakes. Rather than direct action, it calls for introspection and individual analysis. In doing so, it marks a turning point, not only for the members of Gran Fury who created it but for AIDS activists more generally. Underlying the four questions printed on the poster is a larger question that each of us must now ask:

How can we continue to fight an epidemic that, after all these years of anger and activism, still shows no signs of going away?

Gran Fury, untitled
poster, 1993. Offset
lithography, 20" x 24".
Photo by Gran Fury

What were the strengths &
limitations of Group
Materials 1st yr. in its
Lower East Side Gallery? (98-99)

Problems of
creating art
for "the working class"

working within vs outside
of system

Group Material Timeline:

Activism as a Work of Art

Our project is clear. We invite everyone to question the entire culture we have taken for granted.

— **Group Material**

Terms of Agreement

What does it mean "to question the entire culture we have taken for granted"? Let's accept that there are cultures within cultures within cultures. Let's start, in the most literal sense, with one immediately at hand. Imagine the following scenario. You pick up a book entitled *But Is It Art? The Spirit of Art as Activism.* You happen to flip to a chapter on Group Material and start to read an essay that begins, quite self-consciously, by drawing attention to the context in which it appears and by calling into question the premises set forth by the book's title. The author suggests that the question of when something is and is not art is a threadbare polemic that has been tossed around for most of the century, and that it reflects not only deeply rooted ideological biases whereby "art" and "activism" are set in hegemonic opposition but a fundamental crisis concerning art's identity and function within the social order.

If art is in question and if art transforms into activism, it follows deductively that art ceases to exist. (Notice how the inflection shifts if we reverse the order of the subject and predicate of the syllogism to read, "But is it activism? The spirit of activism as art." In this construction it is the existence of activism that is called into question, not that of art.) The end of art was *the* black hole of the historical avant-garde: those who argued to protect art's autonomy from the social order saw its demise in debased forms of representation; those who

turned against the "institution of art" protested against its lack of social relevance. Hardly abated, the dispute surfaced with a vengeance in the 1980s when art's viability was considered, by many, to be in doubt and its ability to achieve renewed function within social praxis was put to the test, as is evinced by the groundswell of "alternative" discourses and practices and spaces that arose in opposition to the art world's status quo. In the spirit of "questioning the entire culture we have taken for granted," the author suggests that the narrative models upon which 1980s-style activism was based and continues to be promoted might not be that "alternative" after all.

Challenging the underlying logic of the question ("But is it art?"), the response ("The spirit of art as activism"), and the conclusion it begs ("the end") as implicitly Modernist—which leads us to formulate the wrong questions and answers about art in relation to a world that is decidedly no longer compatible with Modernist ethics or values—the author directs the reader's attention to the systematic impact of a progressive, hierarchically structured model that dictates the polarization of autonomous art and socially engaged, or political, art; that, in turn, frames the production and interpretation of art history; that, in turn, frames artistic theory and practice in the twentieth century; that, in turn, frames a highly debated and, as yet, unresolved dilemma within contemporary art; that, in turn, frames the context of this essay and the history it puts forth as a chronicle of Group Material's formation and activities; that, in turn, frames the relative success or failure of political and conceptual dimensions within its work; that, in turn, frames our perspective on late twentieth-century art; that, in turn, frames the question of the frame itself as the principal regulatory mechanism of art. The author, resorting to rhetorical overkill, proposes that frameworks, in and of themselves and configured in overlapping networks, constitute primary sites of meaning. She also infers that the frame can neither be ignored nor regarded as ideologically neutral—particularly if we posit art as the means to question the entire culture we have taken for granted.

But what about the imperative the author issued to the reader at the outset of this text? To imagine an event identical to one that actually transpires, and to do so at the same time that the reader is engaged in that event, requires a complex mode of perception analogous

to the experience of being at once inside and outside the frame. The author exhorts the reader to consider the self-conscious or reflexive quality of this perceptual maneuver—one in which the subject is indistinguishable from its direct object—as a potential model for criticality. (I, the author, deploy this model semantically by referencing myself in the first, second, and third person, inflections that draw attention to my voice as the speaking subject, the subject addressed, and the subject spoken of.) I suggest, furthermore, that only from a position of reflexive criticality can we evaluate possible alternatives to the Modernist conundrum we have yet to resolve: When an activity is designated as "art" and its function is described as political, in the final analysis what efficacy does it possess to do more than rail against the limitations of its self-imposed status?

Point of Departure: The Storefront Project

In 1979, fifteen young artists, writers, and activists, all of whom held "day jobs," began to meet in each other's homes every Monday night to discuss the possibility of creating an alternative means of producing and exhibiting art that would be responsive to their own needs and cultural dialogues in New York City. They questioned the exclusionary policies of the institution and the dominance of a market economy, and they were dedicated to exploring "those assumptions that dictate what art is, who art is for, and what an art exhibition can be," as they would state in one of their first official press releases, dated October 2, 1980. This group—a loose association of old friends from art school and assorted companions, composed of five graphic designers, two teachers, a waitress, a cartographer, two textile designers, a telephone operator, a dancer, a computer analyst, and an electrician—shared the conviction that art should be a force for social communication and political change. Their common interest was to provide a context for art and ideas that, in the broadest sense, dealt with the politics of representation and identified a range of themes related to gender, sexuality, ethnicity, class struggle, education, cultural imperialism, and otherwise "unmarketable" contents. Committed to activism at the most grassroots level, the group sought to address the needs of an expanded audience of working people and nonart professionals from all walks of life; to make art that wasn't

compromised by the interests of a narrow few but that spoke the language of the people; to show how the complexity of social problems can be investigated through artistic means; and, most important, to respond constructively to the effects of discrimination and alienation upon the individual and society as a whole. The group envisioned forms of communication as savvy as those produced by Madison Avenue and as accessible as popular entertainment but highly informed by cultural theory and methodologies of institutional critique. The self-appointed challenge, in effect, was to throw out the rule book, rethink art from the ground up, and imbue it with new substance and meaning.

During the initial meetings, the members formulated a course of study and action. They also began, strategically or not, to write their own history—a history that focuses more on ideology than "facticity" and that preserves, almost exclusively, a singular voice: the voice of the group. Consequently, it is that entity that speaks, from the perspective of its own historical development, in various printed documents that the members would later distribute to their audiences and that read as a "how-to" manifesto on cultural activism. In *Caution! Alternative Space!*, dated September 1981, the group gives one such account of its start-up process and gradual progress from "home" to "home away from home":

> Starting two years ago, we met and planned in living rooms after work. We saved money collectively. After a year of this, we were theoretically and financially ready to look for a gallery space. This was our dream—to find a place that we could rent, control, and operate in any manner we saw fit. This pressing desire for a room of our own was strategic on both the political and psychological fronts. We knew that in order for our project to be taken seriously by a large public, we had to resemble a "real" gallery. Without these four walls of justification, our work would probably not be considered as art.

On September 20, 1980, the collective issued a press release announcing the opening of one of the first storefront art spaces on Manhattan's Lower East Side. Located at 244 East 13th Street, the gallery was named Group Material.

Like their predecessors in the historical avant-garde—the first in the twentieth century to define their practice in opposition to the institution of art and the idea of art as autonomous from society—the artists who came together under the moniker of Group Material were motivated out of individual frustration with the traditions of Modernist formal aesthetics whereby art had become increasingly divorced from the social realities of everyday life. Distributed as "information" in the form of press releases, posters, calendars of events, exhibition announcements, and related handouts, their early manifestos attacked the elitism of the art world, its market-based power structure, its bankrupt values, its patterns of consumption, and its demand for a nonconfrontational, aesthetically pleasing product. Rather than accommodate the prevailing system, Group Material envisioned a new social art order, which it described with all the youthful enthusiasm and utopian optimism that characterizes the early manifestos of Italian Futurism, Dada, and Russian Constructivism. Its mission was to lead art back into life, thus bringing new life to art. Art would become relevant not only to the lives of the Group's members, but to those disenfranchised audiences with whom they identified. Sponsoring cultural diversity, emphasizing community, promoting democratic ideals, righting injustice, art itself would become an instrument of social change. Art would represent not the privilege of the upper class, but the prerogative of the masses to speak for themselves and be heard. Art would make a difference at a time when "difference" had become a political cause célèbre. The kernel of the Group's thinking is expressed in the *Group Material Calendar of Events, 1980–81:*

The challenge was to rethink art from the ground up.

> We are desperately tired and critical of the drawn out traditions of formalism, conservatism, and pseudo avant-gardism that dominate the official art world. As artists and writers we want to maintain control over our work, directing our energies to the demands of social conditions as opposed to the demands of the art market. While most art institutions separate art from the world, neutralizing any abrasive forms and contents, Group Material accentuates the cutting edge of art. We want our work and the work of others to take a broader cultural activism.

By "real gallery" business standards, Group Material was unorthodox. Group Material, in fact, was not a "business" at all. Its hours—5:00 p.m. to 10:00 p.m. weekdays, noon to 10:00 p.m. weekends and some holidays—were oriented toward people who, like the Group's members, had "day jobs." Fiscal responsibility for the gallery was shared by the members, who continued to pool their resources to cover operating expenses. They did not "represent" artists, nor were they obliged to broker politics or package their ideas in the form of salable commodities. They were not dependent upon private collectors, institutional patronage, or corporate sponsorship, nor did they solicit government grants for support. They positioned themselves in opposition to the market economy and upon occasion referred to themselves as an alternative-alternative space, but in the same breath they disdained the associations that adhere to prominent "alternative spaces," which they perceived in appearance, policy, and social function to be tantamount to farms situated at the low end of the food chain that feeds dominant commercial galleries and institutions of high rank. Group Material was determined to be something else.

By "real gallery" exhibition standards, the Group's curatorial policy was unorthodox. It refused to show artists as singular entities, yet its exhibitions were much more than group shows: Group Material elevated the concept of exhibition to the status of art work. The entire spectrum of activity directed toward the production of art—the conceptual processes, the physical labor, the collaborative efforts—in the most literal sense, is the *work* of art. Emphasizing the substantive value of work as equal rather than subordinate to art, and refusing to define the existence or function of art as independent from the work required to produce it, Group Material exhibitions were freighted in support of an ideology that values process *as* product, subject *as* object—and work *as* art. In its scheme of the aesthetic situation, the Group occupies the role of individual producer; artists invited to participate in exhibitions do so as coproducers, and their product, or work of art, is signified by the exhibition itself and the collaboration it represents. Such parities unite to perform a radical critique of an economy predicated upon the superior exchange value of marketable commodities hallmarked by the "hand" of the creator.

From the outset, the emphasis of the Group Material exhibition was multiplicity and diversity. Each installation consisted of art produced by individual Group Material members as well as dozens of others whose numbers included "famous" artists (read: marquee status, major gallery representation), "community" artists (read: no gallery affiliation), and "nonprofessional" artists (read: no art-school training, no art practice per se). Over the course of its first year, and into its second year, the Group's signature exhibition style gradually began to develop largely through discovery rather than purposefully. When it was fully established, "made-to-be-art" objects were integrated with a variety of other types of artifacts and consumer products, thus creating a discursive field in which no single piece was elevated over another as a cultural signifier. Installation design was characterized by montage, bringing into narrative fusion sequences of objects and wall texts that related to different aspects of a single theme. The effect of overall compositional unity was amplified by the use of blocks of wall color and graphic design components that established a series of horizontal or vertical vectors as the structural coordinates of the installation layout. These, in turn, were closely linked to the interior architectural features of the gallery, thus generating an environmental dimension that synthesizes "art space" with the actual space of the viewer.

Relative to the scheme wherein the exhibition signifies the work of art and the Group occupies the role of producer, the "viewer" is represented by an equally expanded signifier indexed to a large and demographically varied public audience. Unlike the typical artists' collective that provides its immediate membership and affiliates with exhibition opportunities and exposure to a select audience, Group Material discerned the need to broaden its audience and affiliate base beyond the exclusive constituency of the art world to the rank-and-file members of the general public. This was axiomatic to the objective that art take a "broad cultural activism." Denoting local residents as a symbolic formation of "the public," the Group grounded its grassroots practice and programming in relation to the neighborhood community.

Efforts to mobilize a "dialectical approach to reality through the means of art" were predicated on the synthesis of two separate and distinct models of social space: the gallery and the neighborhood. Whereas the gallery connotes a highly specialized, elite, and closed society, the neighborhood symbolizes a diverse, heterogeneous, and open society—particularly if the neighborhood is signified by Manhattan's Lower East Side, a melting pot of ethnic groups and subcultures that live side by side, each with a different language, belief system, and political persuasion. In theory, synthesis of the two social orders would serve the best of both worlds: cultural theory and institutional critique meet grassroots realities and fund a forum for the advancement of social welfare, and all benefit from the exchange.

The storefront gallery opened its doors on October 4, 1980, with *The Inaugural Exhibition*—a survey of "new cultural militancy emergent in the work of artists, collectives, and non-artists in the U.S. and abroad"—and a dance party. The *Calendar of Events,* sent out as a press release and available at the gallery as a handout, served as a manifesto and statement of intent:

> We will show art that tends to be under-represented or excluded from the official art world due to the art's sexual, political, ethnic, colloquial, or unmarketable nature. Our exhibitions will not feature artists as individual personalities. Instead, every show has a distinct social theme, a context that militates art works in order to explore and illuminate a variety of controversial cultural problems and issues. Some of our first shows concern: gender, the "aesthetics" of consumption and advertising, alienation, political art by children, the relation between the imagery of high fashion and class authority, cooking as a working class art, and many more.
>
> Group Material investigates problematic social issues through artistic means. The multiplicity of meanings surrounding a subject are presented so that a broad audience can be introduced to the theme, engaging in evaluations and further examinations on their own. Our work is accessible and informal without sacrificing complexity and rigor. . . . We invite everyone to question the entire culture we take for granted.

During the storefront gallery's first year of operation, 1980–81, programming followed projections outlined in the *Calendar of Events*

and was shaped to create an interface between art and neighborhood communities. Exhibitions were characterized by managed eclecticism, the salon-style assemblage of persons, politics, texts, themes, varied media, and visual displays implementing an atmosphere of "complexity and contradiction," considered by Group Material as analogous to the social issues it addressed. Performances, films, videos, lectures and discussions, and music often complemented the welcoming, festive environments, fostering the "something for everyone" approach.

The challenge to the historian who composes an account of individual Group Material exhibitions is considerable. Visual documentation is often incomplete or altogether lacking; written records and personal recollections more often than not reflect discrepancies from one source to the next; the sheer number of participants, objects, and contents included in each exhibition tends to defy descriptive listing; citation of only the most famous participants, the most familiar paintings and sculptures, violates the egalitarian spirit of Group Material's social experiment. What is most significant is that artists of multiple stylistic and conceptual orientations were invited to contribute art works (either preexisting or made for the occasion) for side by side display with mass-produced objects within a context guaranteed to "multiply their meanings," or distort their function, in contrast to the austere "white cube" setting that normatively serves as the frame for art.

Following *The Inaugural Exhibition,* (October 4–27, 1980), Group Material issued an open call to artists to participate in *The Salon of Election '80* (November 1–16, 1980), which officially opened on November 4, 1980, the night of the presidential election. The evening featured live television coverage of Jimmy Carter's defeat and Ronald Reagan's landslide victory—a victory that ushered into power a coalition of the Moral Majority and right-wing conservatives and that launched the repressive regime that was to govern the country for the next decade. On the heels of that event, Group Material's December exhibition, *Alienation* (November 21–December 21, 1980), examined "the modern breakup of reality, the causes and effects of the separations dividing us from each other, our work, our production, our nature, our selves." The announcement for *Alienation* analyzed the condition of social malaise as determined by the

forces of dominant culture and encouraged viewers and readers to interrogate the relation between labor, capital, and class structure within their own lives:

> [We get up in the morning][But the morning isn't ours][We get ready for work][But the work isn't ours][We go to the workplace][But the workplace isn't ours][We work all day][But the day isn't ours][We produce a lot of wealth][But the wealth isn't ours][We get paid some money][But the money isn't ours][We go back home][But the home isn't ours][We would like to be social][But society isn't ours]

In addition to a salon-style installation of art works and visual materials, programming for *Alienation* consisted of a film festival, showcasing premier works by local independent filmmakers and a screening of James Whale's 1931 classic, *Frankenstein*; a lecture by Bertell Olman, a Marxist and political-science professor at New York University and author on the subject of alienation, class struggle, and late capitalism; and a one-night musical extravaganza and "wild dance party." *Revolting Music,* the music and dance component of *Alienation,* featured revolutionary hits of the past three decades, with lyrics demonstrating class, sexual, and racial consciousness—and a "light show" of slides and film clips picturing "western insurrections."

Group Material's message was clear: We have the power to unite and militate against the forces of oppression. Community is our strength. Art is our weapon. Activism is our common cause. The Group's challenge, however, was to integrate and involve the neighborhood residents in the process of social communication and political change. How is culture made, and who is it for? Group Material members had the answer readily at hand when they went door-to-door with a letter addressed to the "friends and neighbors of 13th Street," dated December 22, 1980, introducing themselves and inviting residents on the block to contribute personal possessions (for one month only) for the January exhibition, *The People's Choice* (January 9–February 2, 1981), later renamed *Arroz con Mango.*

"We are a group of young people who have been organizing different kinds of events in our storefront. We've had parties, art shows, movies, and art classes for kids," the letter stated. Neighbors were

Group Material, *The People's Choice (Arroz con Mango),* January 1981. East 13th Street, New York City.

invited to donate "things that might not usually find their way into an art gallery: the things that you personally find beautiful, the objects that you keep for your own pleasure, the objects that have meaning for you, your family, and your friends. . . . Choose something you feel will communicate to others. . . . If there's a story about your object, write it down and we will display it along with your thing." The neighbors responded generously, and *The People's Choice (Arroz con Mango)* was enormously successful with its profusion of family photographs and cherished mementos, folk art and handicrafts, religious imagery and reproductions of art masterpieces, china dolls and tchotchkes. Even a collection of Pez candy dispensers was displayed in the storefront gallery where "kids were always rushing in and out" and where, from

Group Material, *Facere/Fascis,* April 1981. East 13th Street, New York City.

time to time, their parents came as well. The cultural aesthetics of the neighborhood also provided the substance of *Food and Culture (Eat This Show),* June 27–July 11, 1981, which opened the following summer. Organized as a "cook-in and eat-in," it brought together "the common cooks and cooking of the Lower East Side," as the press release read, "presenting edible information about ourselves, our histories, our backgrounds."

Consumption: Metaphor, Pastime, Necessity, March 21–April 20, 1981 (also referred to in documentation of the period as *The Aesthetics of Consumption*), putting a sharper spin on populism, focused on critique rather than celebration. It surveyed "the imagery of our endless urge to buy" and included a "TV commercial festival" and an exhibition of "useless products." Critical appraisal of patterns of consumption and the relation between high-fashion imagery and class authority was the subject of *Facere/Fascis* (April 25–May 18, 1981), which consisted of a montage of wall texts, mass-produced clothing and fashion accessories, advertising imagery, and other "visual aids," demonstrating, in the words of the press release, "the gesture, the gaze, the stance, the class, high fashion as a dimension of the new fascist discourse." An earlier exhibition, *It's a Gender Show* (also appearing in documentation of the period as *It's a Boy! It's a Girl! It's a Gender Show!*), February 7–March 9, 1981, explored aspects of identity formation and the social institutions that endorse, if not enforce, sexual conformity to stereotypical conventions of masculine and feminine behavior.

The intended irony of the Group Material exhibition was the promotion of a "single issue" within an atmosphere verging on controlled chaos. *It's a Gender Show* proved to be no exception to the rule. Works by approximately fifty-five artists were brought together and displayed with gender-specific consumer products, all of which were presented on equal terms and installed in the characteristic high-low intermix. The exhibition investigated sexual freedom as a condition of social change and provided a forum for debate on the politics of gender. The timing of *It's a Gender Show* was critical, for it coincided with interest in cultural forms of representation, or "picture theory," and the assimilation of the languages of feminism, psychoanalysis, sociology, and Marxism into the discourses of postmodernism and contemporary art. With participants that included Adrian Piper, Barbara Kruger, Jenny Holzer, Laurie Simmons, Louise Lawler, Sherrie Levine, and Sylvia Kolbowski, *Facere/Fascis* and *It's a Gender Show* set a precedent for elaborations on the politics of gender, sexuality, and representation that would develop as one of the most acute issues of late twentieth-century art.

Point of Definition: From Home to Headquarters

Group Material's first press release had proclaimed the opening of the storefront gallery and its "permanent" location at 244 East 13th Street. Within a year, almost to the month, the 13th Street gallery was closed and new "headquarters" were established at 132 East 26th Street near Lexington Avenue. A press release and handout entitled *Caution! Alternative Space!*, dated September 1981, explained the move:

> The maintenance and operation of the storefront had become a ball-and-chain on the collective. More and more our energies were swallowed by the space, the space, the space. Repairs, new installations, gallery sitting, hysterically paced curating, fundraising and personal disputes cut into our very limited time as a bunch of individuals who had to work full-time jobs during the day or night or both. People got broke, people got tired, people quit. As Group Material closed its first season, we knew we could not continue this course without self-destructing. Everything had to change. The mistake was obvious. Just like the alternative spaces we had set out to criticize, here we were

sitting on 13th Street, waiting for everyone to rush down and see our shows instead of taking the initiative ourselves for mobilizing into more public areas. We had to cease being a space and become a working group once again.

The storefront gallery on 13th Street was home to some exceptional exhibitions that defined a cutting edge of contemporary art; but as the social experiment envisioned in Group Material manifestos, it had failed. The primary stumbling block in the path to political change through art was the problem of community participation. Group Material's ambition for art to take a broader cultural activism was predicated upon the involvement of a large audience that would supersede the confines of the "art world." If art's use-value was to address issues that impact the lives of working people rather than the elite ruling class—if it was to function as a tool for political change rather than as a sign of privilege and wealth—the means of its production, distribution, and display had to reflect social relations that differ ideologically from those inscribed by dominant culture. Art cannot be about the people; it cannot be for the people; it must be by the people.

Having found "the people" in the residents of 13th Street and the Lower East Side, Group Material used every means at its disposal to create an environment to precipitate the vital exchange between the gallery and the neighborhood. The boundaries of art were expanded to address issues that shaped the special character of the neighborhood and the lives of its inhabitants. Programming had been designed, in part, to reflect and "re-present" the concerns of the residents: their opinions, their aesthetics, their culture. Art had been made accessible, elitist barriers broken, educational opportunities provided, and a community environment fostered by nonart activities—the potlucks, the art classes for kids, the dances, the film series, all open invitations to participate—and yet collaboration between the collective and the residents stalled at the most basic level. Members of the neighborhood were not assimilated within Group Material's ranks, nor did 13th Streeters initiate an independent action group; the gallery did not become a community hotbed of political protest nor did it spawn locally organized campaigns for improved

How is culture made, and who is it for?

neighborhood safety, housing, sanitation, education, and political representation. The "ball-and-chain" problem suggests that the Group Material gallery never developed much beyond being a space operated and curated by a collective of young artists, writers, and activists, who set up shop on the Lower East Side, eager to organize "the people," to enlist them as cultural activists, and, additionally, to give them art.

Was there increased empathy for art by those who typically are excluded from its privileged enclaves? Did politically conscious art galvanize a new order of social relations? Were neighborhood conditions actually improved? Did "art into activism" produce substantive change? Many of the results of the storefront experiment are intangible and can never be calculated. To question Group Material's missionary zeal from another perspective, however, the Group's appropriation of an economically depressed, predominantly Hispanic neighborhood can be interpreted as an act of colonization. While members of the collective may have shared common political goals and the belief that art could function dialectically to unite the intelligentsia and the working class, the same cannot be assumed in regard to "the people" of 13th Street. Dance parties and potlucks and movie nights and art classes for children may have resonated with ideological correctness for the activists, but who can say that such events were perceived by locals as anything more than free entertainment provided by congenial "outsiders"? While Group Material's embrace of neighborhood concerns can be legitimately criticized as "getting down" with the community it had moved in on, it can also be said that the Group learned the hard way that, ironically, oppositional stances often correspond to the systems they are designed to combat. In *Caution! Alternative Space!,* Group Material acknowledges difficulties and contradictions that surfaced in the initial formation of their practice:

> We've learned that the notion of alternative space isn't only politically phony and aesthetically naive—it can also be diabolical. It is impossible to create a radical and innovative art if this work is anchored in one special gallery location. Art can have the most political content and right-on form, but the stuff just hangs there silent unless its means of distribution make political sense as well.

The collective's founding formula for cultural activism was predicated on the union of social orders synonymous with the gallery and the neighborhood. As representations of "alternative art" and "the public," respectively, neither prototype had proven sufficiently flexible to function beyond conventions incumbent to each model or to offset the degree to which they are typically regarded as mutually exclusive. The gallery, unlike the church, the school, the sports arena, etc., did not correspond to traditional community space; rather, it replicated a system of display and distribution analogous to commerce and high culture. The neighborhood, on the other hand, was too narrow a sample to stand as a cogent synecdoche of the urban population as a whole. (It should be noted as well that in 1979–80, the Lower East Side had yet to absorb the great influx of artists' communities, galleries, clubs, and, subsequently, real-estate speculators and investors that would significantly alter the predominantly Hispanic cultural environment of the neighborhood and define the bohemian climate of the "East Village" and later gentrification.)

The anticipated dynamic alliance between the gallery and the neighborhood necessary to facilitate social change through art had not occurred. In addition, the "ball-and-chain" problem aggravated internal disputes within the collective, which had begun to splinter under the weight of maintaining a space originated to operate as a "home away from home." In contrast to the "security blanket" of the 600-square-foot storefront situated in the friendly, protective environment of the 13th Street neighborhood, the 26th Street location was not intended to function as a gallery, or a quasi-alternative space, or a neighborhood social center. The headquarters would occasionally host an exhibition or two, but its primary purpose was to be a base of operations from which to produce a variety of site-specific projects, many of which were conceived for installation in nonart places (transit systems, city streets and squares, urban walls, etc.), designed to appear in nonart spaces (usually those occupied by commercial advertising), and targeted to address random nonart audiences (commuters, passersby). Armed with the lessons of the storefront experience, Group Material began to take art to the people rather than wait for the people to come to art. In contrast to its initial manifestos, the press release announcing

the opening of the headquarters describes a "leaner and meaner" sub-versive strategy for cultural activism:

> If a more inclusive and democratic vision for art is our project, then we cannot possibly rely on winning validation from bright, white rooms and full-color repros in the art world gloss-ies. To tap and promote the lived aesthetic of a largely "non-art" public—this is our goal, our contradiction, our energy. GROUP MATERIAL WANTS TO OCCUPY THAT MOST VITAL OF ALTERNATIVE SPACES—THAT WALL-LESS EXPANSE THAT BARS ARTISTS AND THEIR WORK FROM THE CRUCIAL SO-CIAL CONCERNS OF THE AMERICAN WORKING CLASS.

During the summer of 1981, Group Material reached an impor-tant crossroads in its development. The Group had honed its abilities to communicate with a larger public, to produce projects with appeal for both art and nonart audiences, to articulate political ideas through art without the encumbrance of maintaining an art space. The Group, however, had not managed to overcome internal problems. Diversity, which had initially characterized the membership profile and contrib-uted to the strength of the collective, had grown into divisiveness. As is often the case with large collaborative bodies, levels of commit-ment varied, factions within the group formed, differences of opinion hardened, and conflict hampered collaboration. Disputes developed, first between the artists and the nonartists, and later between the "collaborators" and the "careerists." The final result was that the origi-nal group of fifteen members fragmented and broke apart, and Group Material emerged in the fall of 1981 as a very streamlined collective of three artists—Julie Ault, Mundy McLaughlin, and Tim Rollins. In 1982, Doug Ashford joined the Group, and the four collaborated until 1986. (In 1986, Mundy McLaughlin left to study law; in 1987 Tim Rollins left to devote more time to his work with "Kids of Sur-vival"; Felix Gonzalez-Torres joined in 1988; and in 1989, Karen Ramspacher began to work with the Group on AIDS-related projects.)

Rarely had behind-the-scenes struggles been discussed publicly, yet they marked key turning points in Group Material's evolution. In an interview in *RealLife Magazine* (no. 11/12, Winter 1983–84) with Peter Hall, the three core Group Material members broke the silence

and spoke about the difficulty of working with nonartists and those whose interests were at odds with the collaborative process:

> Tim Rollins: The first and second years after blast-off, after a lot of work and change, there began a stage by stage break-down. The first stage were the people who, for one reason or another, weren't really into it. Then another group got sick of it and they fell out. So now it's us. We always formed the center of the Group anyways.
>
> Mundy McLaughlin: There were always several groups, sub-groups threatening to split the whole thing up. It was a joke. There was a lot of disagreement about what the group should do, which is natural. But some people really cared about the group and some really cared about their own interests. The people in it now are the ones who wanted Group Material to do something.
>
> Julie Ault: It wasn't their politics that was the problem. It was that they weren't interested in making art. The four of us [including Doug Ashford, who had recently joined the Group] are artists. They were into curating educational exhibits, organizing, educating the public about feminism and different issues. Art was not their main interest.
>
> McLaughlin: They would have ideas that sounded alright, but then the way they would work with them would be totally different from the way we would. This became a problem. Another problem was the other faction that developed. These guys were artists, but they were more career oriented. They were more interested in using the group as a stepping stone to something better. That really wasn't our idea. If we want to have individual careers, we want that to be separate from Group Material.

The newly reformed Group Material differed from the first collective both in internal solidarity and artistic emphasis: its mature exhibition style came to fruition and the consensual, conceptual basis of its cultural activism was clarified, first and foremost, as an art activity. Members abided by principles that had been in place since the store-front days, and, by outward appearances, their practice remained

consistent with that established during the Group's first incarnation. They were committed to bringing well-rehearsed and responsible political information to art communities and the general public; to using art as a tool for understanding and redefining social relations independent of bureaucratic or institutional givens; and to juxtaposing work by artists and nonartists in careful orchestration with mass-produced objects, text, video, film, and other media, thereby creating semantically complex narrative and visual fields capable of generating multiplied meanings and sustaining contradiction in relation to a matrix of social themes.

If art was to function as an instrument for communication and change, if a truly political art was to be brought about, if art was to have renewed relevance in daily life, the question was asked, what kind of art would that be? What method of production, what channels of distribution, what mode of display would engender this new art? Group Material did not deploy art simply as a means to define social problems, to campaign for causes, or to convey messages about culture: art *was* the issue. The Group's "exhibitions" were not merely displays of art: they were works of art in and of themselves. That orientation had not changed; however, new emphasis upon the artistic value of the product affected its practice, particularly with respect to the nagging questions of distribution and display. In its formal properties, Group Material's art was indebted to tenets of Process art and Conceptual art. It challenged the status of the object over ideas; it rejected the worth ascribed to the individual creator over collaborative producers; it was positioned in opposition to the demands of the market for durable goods that retain their exchange value over time; it posited meaning as arbitrary, transitory, and contingent upon contextual relations rather than intrinsic and fixed. Group Material's institutional critique of art—the hierarchies, the value structures, the economy, the commodification—was interchangeable with a critique of dominant culture.

The most innovative aspect of Group Material's art was its strong dialectical component.

The most innovative aspect of Group Material's art, however, was its strong dialectical component, which resulted from a series of dislocations. Collaborative effort displaced emphasis from the individual

Group Material (Dennis Adams), *Subculture*, IRT subway trains, September 1983, New York City.

producer. Paintings and sculptures were included in installation projects, but their normative values were displaced within an exhibition environment that leveled difference and enforced parity between widely disparate classes of objects. These and other techniques had been the stock-in-trade of Group Material since its inception and continued as such after the re-formation in the fall of 1981. Under the direction of Ashford, Ault, McLaughlin, and Rollins, however, the progressive dislocation of artistic practice from commercial gallery space to alternative space to wide-open public space underwent considerable revision; in fact, this direction was reversed. Group Material projects began to appear in a variety of exhibition settings that once would have been considered antithetical to its philosophy of cultural activism.

In a key project of this period, *M-5,* ad space was rented for the month of December 1981 on Fifth Avenue buses (M3, M4, M5, M20) that serviced routes traversing the length of Manhattan from SoHo to 125th Street. Art works produced to conform to the physical dimensions of the card slots and emulating the appearance of regular print advertising carried meanings distinct from the commercial tableaux usually presented to commuters. Here was art that did not announce itself as art. Here was art that exploited the accessibility of the media to communicate ideas radically different from those that motivate advertising campaigns. Before the public could mount its accustomed resistance to contemporary art (It's alienating! It speaks a language I don't understand! It's not for me!), it had been afforded an art experi-

ence and, more important, a perspective on social issues that otherwise might receive very little play in the course of daily life. The art spoke about alienation from the workplace, urban fear, public education, the "new face of Uncle Sam," independence for Puerto Rico, and other political topics. The *M-5* model was implemented again in *Subculture,* which was installed during the month of September 1983 in more than 1,400 card slots in subway cars on the New York City IRT line. More than one hundred artists were invited by Group Material to participate in the "exhibition," each contributing a work in an edition of fourteen that was distributed over the same number of card slots. *Subculture* was also presented as a one-night exhibition at the Group Material headquarters, located at that time at 19 West 21st Street in Manhattan.

Another important exhibition model pioneered during Group Material's formative second public year and used in subsequent projects was the "opinion wall," or "democracy wall," first produced as *DaZiBaos* in March 1982. Derived from the Chinese words (*da zi bao*), for "big character poster," *DaZiBaos* consisted of huge red-and-yellow "propaganda posters" illegally pasted on the exterior of the old S. Klein building facing Union Square at 14th Street and Park Avenue in Manhattan. Unlike every other Group Material project, no other artists were invited to participate. Printed on the posters were twelve interrelated statements: six by organizations actively working on social and political problems and six by individuals Group Material members approached at random in Union Square and interviewed about the issues that the organized groups were addressing. The organizations included CISPES (Committee in Solidarity with the People of El Salvador, an agency working against U.S. intervention in El Salvador); the Home Health Care Workers Union; Planned Parenthood; the Prison Reform Board; and the New York State Division of Substance Abuse. The individuals, identified on the posters only by occupation, included an accounting supervisor (on abortion); a homeless person (on crime); a housewife (on government funding of the arts); an office worker (on unions); a receptionist (on U.S. intervention in El Salvador); and an unemployed person (on drug abuse). As Group Material member Mundy McLaughlin observed in *RealLife Magazine,* "It was one of the only things I've gone by and seen people actually

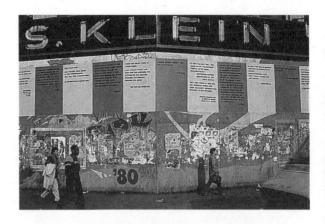

Group Material,
DaZiBaos, March 1982,
mounted on facade of
S. Klein building, Union
Square, New York City.

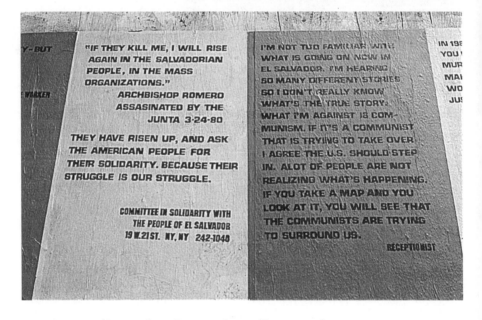

stopping, standing, and reading. . . . It was like a cross between pro-
paganda, a gossip column, and Conceptual Art."

Tactical Maneuvers: The Politics of Place

Contrary to the initial policy of the collective, Group Material began
to produce projects in collaboration with a variety of institutions,
including established alternative spaces and major museums, and to
participate in prestigious exhibitions such as Documenta and the
Whitney Biennial. Crossing institutional boundaries became as much

a political statement as the social themes the Group addressed. As the ideological basis of art into activism, Group Material had always defined "alternative action" as distinct from prevailing systems of production, distribution, and display; yet, it stopped short of advocating the complete overthrow or elimination of those systems. The decision to work directly with the institution was strategic, for it erased the moral undertones of an "us versus them" mentality that characterized the storefront activities. To perform an institutional critique from a position within the institution not only facilitated new dimensions of "complexity and contradiction," but it made them explicit. To the extent that we are all in complicity with the forces that fuel dominant culture, Group Material's blueprint for cultural activism suddenly assumed new relativity.

The Group's determination to use every means of distribution at its disposal rather than only those bearing the approved imprimatur of "alternative" or "grassroots" coincided with the art world's recognition of Group Material's practice and product as legitimate and profitable. Its resolve to join forces with the institution and, reciprocally, the institution's embrace of Group Material was efficient from the perspective of both parties. On the one hand, Group Material gained access to the distribution machinery of the institution by exploiting its desire to project an image of conscientiousness and political correctness. On the other hand, applying the logic of "biting the hand that feeds you," the official alternative spaces, major museums, and international exhibitions that commissioned, or permissioned, Group Material's critique were able to neutralize that critique with respect to their own policies and practices. In what can be referred to as "sleeping with the enemy," Group Material acknowledged the power of the institution in society as a cultural producer, and thus made a tactical attempt to appropriate its authority with respect to the social issues the collective addressed.

In following years, from approximately the mid-1980s to the mid-1990s, Group Material collaborated with public and private institutions to pursue objectives outlined in its earliest manifestos for cultural activism. From Conceptual art, the artists in Group Material had learned to question the nature of art by focusing on the institutional structures that frame and regulate the aesthetic situation. It had

applied those lessons to the sphere of social experience, thereby questioning cultural formations. Yet, to interrogate the relations inscribed in art and culture, and to claim to do so from a position deemed "alternative" or outside dominant culture, had proven grossly inefficient if not entirely fallacious in the assumption that the institution alone nullifies the political power of art and that art, if liberated, will automatically and altruistically speak on behalf of the disenfranchised and underprivileged members of society. In collaboration with the institution, Group Material resolved the biggest thorn in its side—the problem of distribution and display that previously had drained its resources and, despite grassroots efforts, had failed to mobilize a proportionately large and active working-class audience that would not only appreciate Group Material's field activity but support it as well. By example of the Group's social experiment, perhaps we should reconsider the entire notion of a "political art" as defined in opposition to dominant culture and its institutions and, in this light, question whether independence from prevailing systems is at all desirable or even possible.

In its "institutional" phase, Group Material braided together the most successful elements of earlier projects to develop a repertoire of installation models and outreach projects that included the timeline, the opinion wall, the town meeting, and community service announcements that appeared in leased ad space. The impetus of its work was informational and was orchestrated to bring together in any one exhibition the voices of many individuals and groups and, on the basis of its own cachet, to introduce subjects seldom, if ever, discussed in the rarefied precincts of the institution. With approximately thirty exhibition projects to its credit (dating from 1984 to 1994), Group Material succeeded in bringing to the public the social issues and debates that had been outlined by the original collective as priorities in questioning the entire culture we take for granted.

A number of exhibition projects were devoted to two themes in particular: AIDS and democracy. Variations of *AIDS Timeline* were produced at the Matrix Gallery of the University Art Museum, University of California at Berkeley (November 1989–January 1990); the Wadsworth Atheneum, Hartford (September–November 1990); and the 1991 Biennial Exhibition at the Whitney Museum of American

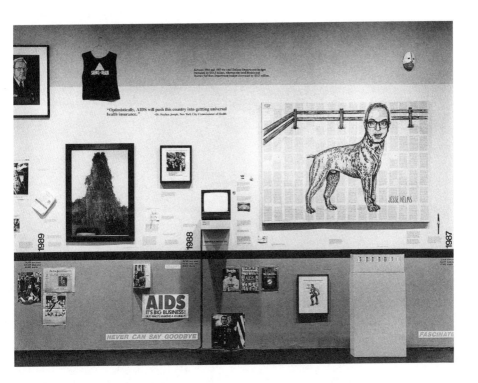

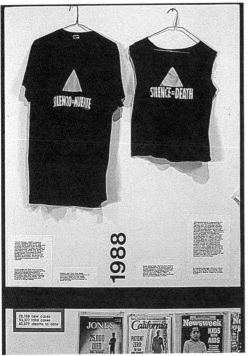

Group Material, *AIDS Timeline,* November 1989, Matrix Gallery, University Art Museum, University of California at Berkeley.

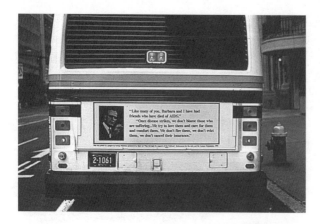

Group Material, *AIDS and Insurance,* city bus posters, September 1990, Hartford, Connecticut. Sponsored by Real Art Ways, Hartford.

Art, New York (April–November 1991). Related projects include *AIDS and Democracy,* Neue Gesellschaft für Bildende Kunst, Berlin (January 1989); and *AIDS and Insurance,* a public installation on city buses produced in conjunction with Real Art Ways, Hartford (September–November 1990). The *AIDS Timeline* projects provide a chronicle of the AIDS epidemic drawn in relation to cultural and historical contexts; responses to the crisis on the part of the federal government, political leaders, and society at large; grassroots efforts to mount organized resistance; and the experiences of those infected with the disease, and their families, loved ones, friends, and collaborators. In Group Material's words, the *Timeline* "indicts the government's inaction on AIDS and society's complicity in that inaction," but it accomplishes far more than that. It is brutal in its anger over the government's criminal negligence and discriminatory policies; it is touching in its re-creation of the sociosexual indulgences and naivete of the late 1970s; it is poignant in its reflection of innocence and complicity and the dawning realization that life would never be the same—for anyone; and it is ambitious in its presentation of a wealth of material brought to bear on the subject.

Installation of the Berkeley *AIDS Timeline* extended far beyond the physical walls of the gallery. On the facade of the building, Group Material produced an "opinion wall," fashioned in the *DaZiBaos* mode originated in 1982, that consisted of quotes from Berkeley residents and reflected the level of AIDS awareness in the Berkeley community. In the November 10, 1989, edition of the *Daily Californian,* the Group issued an appeal for community activism with a half-

page graphic, commissioned from the New York activist group Gran Fury. In it, the readership was urged to get angry, to end the apathy, and to fight back. At the University's Recreational Sports Facility, an extensive video program was presented that included documentaries of AIDS protests, children talking about AIDS, homoerotic art, and demonstrations of safe sex. The *Timeline* incorporated such a plethora of art works, everyday artifacts, popular culture references, historical documentation, educational information, and voices of experience that its political message could be heard by all.

Did the eventual appearance of the *Timeline* at a major museum's most prestigious exhibition—the 1991 Whitney Biennial—constitute "sleeping with the enemy"? Was it more legitimate to present the *AIDS and Insurance* project in collaboration with Real Art Ways, an alternative space in Hartford, than it was to produce an installation at the powerful Whitney Museum of American Art in New York? Would the *Timeline* have been more authentic as "political art" if it had struggled to life in an "alternative-alternative" space in an economically depressed area? The answer to all the above is a resounding "No." Perhaps the social relations embedded in the institution didn't change very much. Perhaps the institution got high mileage from buying political correctness at a relatively low price. Perhaps the individual careers of Group Material members benefited tremendously from the collective validation they received. Those are the realities of "art and activism," but that is not to say that they compose a negative reality.

We might do well to reflect, briefly, on the position advanced by the utopian-minded artists of the historical avant-garde in the early twentieth century who thought in black-and-white and who could see but one option for political art: oppose the institution, put art in the hands of the proletariat, and join hands in the revolution. Whether that prescription ever worked in the modern world is debatable. Beyond a shadow of a doubt, however, that argument and the discursive structures upon which it is based are entirely inadequate to confront the complexity of the postmodern world. Those who championed Group Material's initial grassroots activism but condemned its later collaboration with the institutions of dominant culture; those who expect political art to transform rather than be consumed by the "superstructure"; those who believe that an art practice can be validated

Group Material, *Education and Democracy,* September 1988, part one of *Democracy,* the Dia Art Foundation, New York City.

Group Material, *Cultural Participation,* November 1988, part three of *Democracy,* the Dia Art Foundation, New York City.

by virtue of the political message it broadcasts—they are the ones who wave the "alternative" banner, who fall victim in droves to political correctness, and who fail to recognize the extent to which they have institutionalized the politics out of art by consigning it to fight battles it can never win.

When Group Material joined forces with the Dia Art Foundation in New York City to produce a four-part series entitled *Democracy* (September 1988–January 1989), its pedigree was already well established. It had been invited to *Documenta 8* (1987) and to the 1985 and 1991 Whitney Biennials; it had produced projects for major alternative spaces and university galleries across the country and had participated in several international exhibitions. This proven track record garnered Dia's attention and fiscal support. Dia didn't suddenly develop a political conscience: internal organizational changes and the shift from private to public funding necessitated that it broaden its programming to be "publicly responsible." Dia, then and now, is in the business of art, and it's safe to assume that on that basis alone it handed over the resources of its downtown gallery to Group Material for almost five months to produce *Education and Democracy, Politics and Elections, Cultural Participation*, and *AIDS and Democracy: A Case Study.* Group Material spread the wealth around, inviting dozens upon dozens of unknown artists to participate as "coproducers" in the project who otherwise would never have found entrée into Dia. The Group brought diverse groups of people into the gallery who ordinarily would never have set foot in SoHo or ventured into the world of contemporary art. It attempted to foster political debate and facilitate new alliances between the many factions and generations that comprise the art world, bringing into play the opinions of artists, dealers, curators, collectors, teachers, and students. It is a foregone conclusion that Dia considered Group Material's work certifiable "art." Did it matter whether or not social relations changed as a direct result of *Democracy*? In the eyes of Dia, probably not. Dia got exactly what it bargained for: a highly original and innovative contemporary art, and in a market that places utmost value on originality and innovation, the Group Material product was a very hot commodity indeed.

The four-part *Democracy* project epitomized the style and spirit of period postmodernism. Consumer culture and the commodification of art echoed thematically in the "high/low" montage of paintings and sculptures and mass-produced objects. Narratives gleaned from academia and popular culture, from theoretical treatises and television, demonstrated fluency with the most intellectual discourses that converge in late twentieth-century art. The vanguard art of the 1960s and 1970s—installation work, Process art, Conceptual art, Pop art, *and* "alternative" art (a grab bag that includes performance, video, political art, body art, collaboration, etc.)—was synthesized. Connections between such disparate movements having been made tangible, the history of the 1970s could be rewritten in more flattering terms than amorphous pluralism. Such was the product Group Material delivered, and for which it became famous.

Insofar as its political convictions were concerned, Group Material was both in and out of place in the market economy of art. On the one hand, the Group itself had become a commodity and an institution—an inevitable consequence of its success and its ambition to reach large audiences, to produce substantial multifaceted events, and to make its collective voice heard. On the other hand, the Group wanted to talk about democracy—the last thing the art world would consider marketable content. The electoral process? Public education? Housing and welfare? The Bill of Rights and the Constitution? How did that correspond to the discourse of postmodernism? What did

Group Material, *Democracy Wall*, October 1993, for *In and Out of Place: Contemporary Art and the American Social Landscape*, Museum of Fine Arts, Boston, Massachusetts.

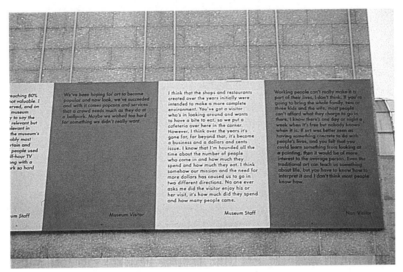

that have to do with Conceptualism or an institutional critique of art? For many the answer was, "Nothing at all."

To talk about the principles of democracy, to quote the "founding fathers," to organize town meetings on structural problems in public education, or to assemble a think tank on ways to improve the electoral process wasn't particularly fashionable. (The art community had its causes—AIDS, and, in general, cultural participation.) Group Material, nevertheless, remained true to its goals: to question the *entire* culture and the culture we take for granted; to reach far beyond the interests of the art world—(most apparent in aspects of the *Democracy* project)—and it was the art world that gave it the means

to do so. Group Material's statement, prefacing the publication of *Democracy* (Bay Press, Seattle; Dia, New York, 1990), begins with a quote from Judge Bruce Wright, New York State Supreme Court:

> Participating in the system doesn't mean that we must identify with it, stop criticizing it, or stop improving the little piece of turf on which we operate.

With this proviso, the text written by Doug Ashford, Julie Ault, and Felix Gonzalez-Torres is as true a manifesto as any ever produced by Group Material. (Ault was the one remaining member of the collective as formed in 1979.) In it, they describe their philosophy of cultural activism and offer a model of political art that is among the most comprehensive and lucid ever given in the twentieth century:

> Our exhibitions and projects are intended to be forums in which multiple points of view are represented in a variety of styles and methods. We believe, as the feminist writer bell hooks has said, that "we must focus on a policy of inclusion so as not to mirror oppressive structures." As a result, each exhibition is a veritable model of democracy. Mirroring the various forms of representation that structure our understanding of culture, our exhibitions bring together so-called fine art with products from supermarkets, mass-cultural artifacts with historical objects, factual documentation with homemade projects. We are not interested in making definitive evaluations or declarative statements, but in creating situations that offer our chosen subject as a complex and open-ended issue. We encourage greater audience participation through interpretation.

As of the summer of 1994, Group Material continues to develop projects, although far less actively than in the past. Gonzalez-Torres pursues a full-time career yet remains a current member of the Group. Ramspacher is an inactive member. Doug Ashford and Julie Ault are the sole truly active members. They occasionally initiate exhibitions and continue to teach and lecture on behalf of Group Material, but it is not economically feasible to give it their full-time energies. (Members of the Group were never salaried.) Although it resists closure, after fifteen years of practice Group Material is on the verge of becoming history; but the chapter it wrote on the theory and practice of contemporary art has shaped our common history and will be interpreted and debated for decades to come.

Jan Cohen-Cruz

The American Festival Project:

Performing Difference, Discovering Common Ground

The American Festival Project is in residence in eastern Kentucky. An African American actor leaning on a rustic-looking cane, dressed in a double-breasted suit, and wearing a pair of shades ambles across the makeshift stage. He begins by rapping, encouraging the audience to join in the refrain:

> Chicka chicka chicka chicka boom boom ahhh
> Chicka chicka chicka chicka boom boom ahhh.
> You cain't read a book by loookin' at the covah
> You can read my letter but you cain't read my mind
> If you want to get down, down, down,
> You got to spend some time.
> I wanna walk with you, I wanna talk with you,
> I wanna wanna wanna wanna be with you,
> Chicka chicka chicka chicka boom boom
> Chicka chicka chicka chicka boom boom.[1]

The man is John O'Neal. He is performing his *Sayings from the Life and Writing of Junebug Jabbo Jones* for high school students. He carves out an imaginary map of Louisiana in the space between the audience and himself and pinpoints the exact location of his tiny hometown. The kids laugh and nod their heads in recognition; they know about obscure small towns. The connection made, O'Neal moves from similarity to difference, from the shared experience of small towns to the different experiences of race.

The American Festival Project was conceived in 1982 by O'Neal, director of the African American Junebug Productions, and white director Dudley Cocke of the Appalachian Roadside Theater. O'Neal

John O'Neal as Junebug
Jabbo Jones, a character
created by members of
the Student Nonviolent
Coordinating Committee,
who represents the
wisdom of "everyman."

Junebug Productions and
Roadside Theater
perform their original
collaboration *Junebug/
Jack*, based on an African
American and an
Appalachian character
that resist domination.
Left to right are John
O'Neal, Kim Cole, Shawn
Jackson, Ron Short, and
Carl LeBlanc.

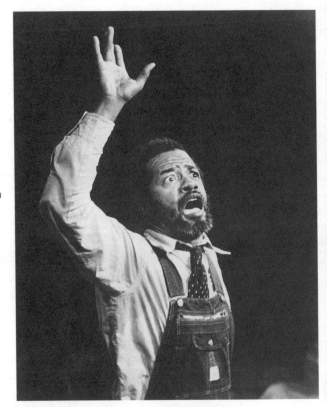

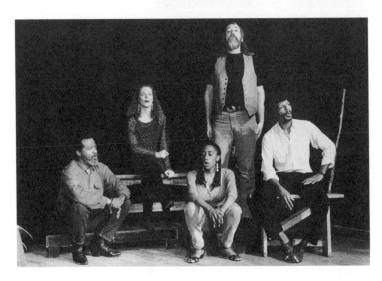

and Cocke saw that, for all their differences, both theaters had deep roots in their communities and regularly presented the lives and cultures of poor and working-class people on the stage. Concerned about the national increase in Ku Klux Klan activities, they had their companies perform in each other's communities as a way to recognize similarities and try to understand differences.

In 1983, Bob Martin invited Junebug and Roadside, along with A Traveling Jewish Theater and El Teatro Campesino, to the People's Theater Festival in San Francisco. More festivals followed, frequently in the context of residencies, produced on an ad hoc basis as forums of cultural exchange. These gatherings happened in different places in different ways, generated by someone who liked the idea or by the companies themselves, who wanted to interact with each other. They then decided to organize formally as the American Festival Project (AFP).

The AFP is a network of independent companies that do original work, share a background or affinity with a particular group of people, and have compatible political goals. Its nationwide coalition now includes Carpetbag Theater, an African American company from Knoxville; the Chicano music ensemble Francisco Gonzalez y su Conjunto, from Santa Barbara, California; El Teatro de la Esperanza (Chicano) and A Traveling Jewish Theater, both from San Francisco; Junebug Productions in New Orleans; Liz Lerman and the Dance Exchange, a multiethnic, multiage dance troupe based in Washington, D.C.; Pregones (Puerto Rican), Robbie McCauley and Company (interracial), and Urban Bush Women (African American), from New York City; and Roadside, from Whitesburg, Kentucky. The geographical diversity reflects the group's belief that culture bubbles up from the grass roots and is present everywhere; it is not just a bicoastal

Culture bubbles up from the grass roots and is present everywhere.

phenomenon. Caron Atlas, director of the AFP, who also does development for Appalshop, the Appalachian arts and education organization that is the AFP's base and Roadside Theater's home, elaborates:

> The AFP is committed to shining a light on local culture . . . where you are from has a profound effect on what you have to say. . . . Cultural and geographical diversity go together.[2]

The core of the American Festival is cultural diversity. This is reflected not just in the performances but also in the policy-making board, composed of one member from each of the companies, as well as several staff people and presenters. (The legal board is Appalshop's.) Atlas observes:

> That's a way for a multicultural project to say that its ownership is in the hands of the people in it, not a white board. And that we're not just about celebrating diversity, it's a given that we're diverse, just a starting point.[3]

According to O'Neal, each group involved in cultural exchange must be firmly grounded in its own group identity. Though each AFP company evolved in a singular way, O'Neal's experience with the Free Southern Theater (FST) illustrates the evolution of this principle. Created in 1963 as the cultural arm of the civil-rights movement, the FST set as goals to "stimulate creative and reflective thought among Negroes in the South,"[4] citing inferior education and media resources in the black community; to serve as an educational and cultural wing of the Freedom Movement; and to provide an outlet for undeveloped talent. O'Neal and cofounder Gil Moses envisioned the development of a theater form and style "as unique to the Negro people as . . . blues and jazz."[5]

However, an equally strong desire to present a model of black and white cooperation tilted the company's orientation. In 1964, Moses and O'Neal invited a young white theater professor from Tulane University, Richard Schechner, to come aboard as a third producing director. Whereas the fledgling company had initially planned to produce plays by "Young Black Cats who heretofore have not had the opportunity to have their plays considered for production" as well as "old established [black] cats,"[6] the new prospectus reflected an integrationist rather than African American emphasis. The FST's choice of plays included works by James Baldwin, Samuel Beckett, Bertolt Brecht, Ossie Davis, and Langston Hughes, and the genres encompassed musicals, comedies, classics, and improvisations. The goals, while continuing to stress education, included "to emphasize the universality of the Negro's problems . . . [and] to promote the growth and self-knowledge of a new Southern audience of Negroes and whites."[7]

As "the Negro's problems" had never been fully explored, who knew if they were universal? The definition of the concept of "universal," in fact, has historically been couched in the experience of the dominant class.[8] By the late 1960s, influenced in part by the growing Black Power movement, the FST returned to its original purpose and embraced a specifically African American agenda.

Under O'Neal's leadership in the 1970s, the FST remained in the black-belt South. Its organizational focus was threefold: community involvement, educational work, and touring. But as the decade wore on, the FST and the Black Power movement more generally suffered a "national backlash," according to FST associate Thomas C. Dent, "against black cultural activity which took a separatist, Black Pride direction and identified strongly with black political and economic gains."[9] In 1980, acknowledging the end of both the civil-rights and Black Power movements, O'Neal held a big, New Orleans–style funeral for the FST, soon reincarnated as Junebug Productions. This dramatized a shift in strategy for a post–civil rights, post–Black Power context, not a change in philosophy. O'Neal saw it as a way to leave a clear record of his work for the next generation, which would have to take up where he and his coworkers left off.[10]

The philosophical underpinnings of the American Festival Project are evidenced in the 1980s context of cultural diversity:

> Our organization exists within and depends upon a growing network of persons around the country who agree that the conditions and circumstances hindering Black people in the United States are the same in principle [to those] that limit oppressed people the world over. Regardless of ethnic origin or national identity, it is essential to build bridges of shared understanding and bonds of unity that reach across regional, national, ethnic or cultural boundaries—remembering always that strong bridges are firmly grounded on both ends.[11]

Like Junebug, all AFP companies are "firmly grounded" in a specific cultural identity—African American, Chicano, Jewish, etc.—that has traditionally been underrepresented or misrepresented, or both, in the United States. Within this context, "self-expression is a prerequisite for self-empowerment."[12] Once these specific identities are sufficiently explored, cultural exchange can take place.

Though promotion of intercultural respect weaves through all the projects, and residencies complement performances, the specific focus of each festival is conceptualized according to the needs and desires of the community in which it takes place. In rural Mississippi an AFP supported childcare programs, literacy, and economic development initiatives. In San Diego, the AFP helped people on both sides of the Mexico–United States border explore what it means to be "American." Atlas explains:

> The notion is that the community group sees the festival as a catalyst for something else they're trying to achieve, that our group supports and wants to help further. So we ask each potential host to come up with a mission statement and fit it into a long-term plan because we're not interested in doing events that don't have any impact.[13]

In keeping with the group's empowerment goals, AFPs are initiated by community-based groups such as cultural centers, theater companies, schools, churches, and organizations for peace and racial equality, that are already doing compatible cultural and political work and in a position to continue these efforts after the AFP leaves. Some AFPs have been initiated in part by member companies or by community activists familiar with their work. Sometimes a presenter produces one of the AFP groups and becomes interested in the multigroup festival. The AFP's spread is also the result of a strong network of cultural groups across the country that already feel an affinity. Given a community's goals and the companies' availability, the AFP advisory board selects sites. People at the sites, in consultation with AFP staff, decide which artists will participate. Sometimes the choice is based on compatibility with an issue—for example, groups of various ethnic compositions who share a facility for creating educational projects participated in the 1991 Arts-in-Education AFP in Seattle. Other times companies are selected because they share a cultural grounding with a local organization.

The grounding in local organizations has been critical to the AFP's reception and impact in each town. As Lucy Lippard writes, "It is impossible just to drop into a community and make good activist art."[14] Change takes place over time and needs to be sustained. The community hosts provide local partnership and continue the work

after the AFP leaves, thus serving as a significant alternative to the one-night-stand model of touring theater. At the same time, the hosts need the festival to bring new energy and input, both artistic and political.

The activating goal of AFPs is also accomplished by their structure—they are multiphase processes that engage communities before, during, and after performances, not single events for anonymous audiences in dark rooms. Thus, to appreciate the American Festival, one must recognize the power of not just the pro-ductions but the whole performance process. AFPs are the result of more than a year of planning and typically take place over several months or even years. They regularly include conceptual meetings, performances by AFP and regional artists, workshops, collectively generated plays with local people, panel discussions, and follow-up activities. Every phase of the work, from exploratory meetings to postperformance activities, is conceived as part of the joint art making/politically activating event.

> One must recognize the power of not just the productions but the whole performance process.

Not coincidentally, the structure of AFPs closely resembles that of other social processes intent upon change.[15] Community organizing, for example, begins by generating grass-roots support. The appeal is to people's direct and concrete self-interest.[16] Both community organizing and American Festivals are planned and carried out with a maximum of local participation. Long-term effects of political actions are intended to "have the potential to engage [people] beyond it."[17] The AFP also strives for long-term impact by trying to identify those most likely to continue the work: what AFP choreographer Liz Lerman calls "figuring out where the juice is," be it a schoolteacher, a community activist, or someone from the arts community.[18]

Rita Hardiman and Bailey W. Jackson's oppression/liberation development theory describes another transformative process that corresponds to American Festivals. Hardiman and Jackson identify "resistance" as the first step in unlearning oppression. It leads to redefinition of one's social group, in the search to answer "Who am I?" Often a "separatist" period, this phase is characterized by initiating a dialogue with other members of the same culture and leads to an understanding of the interrelatedness of different manifestations of

oppression. The last stage is "internalization," as the person moves out of the separatist context because he or she carries the renewed identity inside. In these terms, community groups that approach the AFP are already in a resistance stage. Their work with AFP artists of the same cultural identity coincides with the self-redefinition process. Intercultural exchange, such as the festivals themselves, signals entry into internalization and the move out of separatism.

The American Festival Project, like community organizing and the steps described by liberation theory, are participatory processes through which people can take some control over issues that shape their lives. Rather than a formal conception of art in a static relationship to a community, the AFP embodies art functioning dynamically in the ongoing contexts of people's lives, thus engaging them actively as subjects/doers, not objects/consumers. The partnership structure of the AFP sets up an active host-guest dialogue rather than a passive spectator role for the host and an aggrandized role for the "great artiste." The AFP's joint fundraising and decision-making process with local groups assures shared power and control at every level.

The idea of becoming the active subject of one's life is developed in *Pedagogy of the Oppressed*, Paulo Freire's treatise on his approach to the education of Brazilian peasants in the 1960s. For Freire, learning takes place through dialogue rather than by filling passive students with information from "experts," what he calls the "banking method of education."[19] Freire's work is in fact the model for AFP member Urban Bush Women's Community Engagement Project, developed in New Orleans in conjunction with educational consultant Lloyd Daniel:

> A people's legacy and culture are considered the foundation for the development of a sense of history—and hence self-esteem. . . . Students are encouraged to assess their own knowledge and then to value and expand upon it, fostering an experience of education as a process that occurs in a variety of environments, not just the classroom. Curriculum areas include: dance, theatre, music, visual arts, writing, critical thinking, and audio and video production.[20]

Freire describes the act of self-liberation as "learning to speak with one's own voice and say one's own words,"[21] a stance that further validates locally developed performance.

Brazilian director and theorist Augusto Boal translated Freire's ideas into a *"theatre* of the oppressed,"[22] using performance to engage people in their own liberation process. The Theatre of the Oppressed is predicated on the transformation of passive spectators into what Boal calls "spect-actors." To that end Boal created techniques such as "forum theatre," in which spectators are invited to intervene in the action of a play in order to try out alternative solutions to a collective dilemma. While Boal works differently than AFP artists, they share a belief in performance as a process through which people can change their lives.

I turn now to two examples of American Festivals. The 1993 Louisville AFP was particularly successful at integrating the guest artists into every phase of the process. In contrast, the 1991 AFP in Philadelphia was equally important for its degree of local artistic participation.

The Louisville American Festival (1993)

Incidents of ethno-violence and rape on the University of Louisville campus led to the opening of both the Multicultural Center and the Women's Center in 1993.[23] Despite the goodwill reflected by the opening of these centers, issues of race and gender continued to un-settle the university. Many black students still felt alienated by the university experience; their concerns were insufficiently reflected in the classroom, and they felt isolated, comprising only 9 percent of the student population.

Representatives of the university contacted the American Festival Project, which agreed to work with them, selecting African American writer and actor Robbie McCauley as the central AFP envoy. Thus began the preperformance phase of the project. For several months, McCauley met with students, professors, staff, representatives from the Women's Center and the Multicultural Center, and local people, especially artists, of various races. First she urged everyone to abandon the idea that art is removed from everyday life. Then she used her performance training to get people talking about their own experiences of difference:

> By listening and trying to find out what was going on with the people in the room, the AFP work began. As an actor, I always

Robbie McCauley (right) and Jeannie Hutchins in *Sally's Rape* at the Louisville American Festival, 1993.

use dialogue and stories to find out who "others" are, any others than myself. Actors have these skills. And they translate into social skills, because art is not boring, it uses humor and stories to get at charged issues like race and sex.[24]

McCauley believes that listening and speaking together is a way to understand racial and cultural "others" without the familiar pitfalls— "like who's right and who's wrong, and self-censorship around charged issues, and having rules like don't blame anyone when we have to, and like we're all equal when we're not."

The next phase of the work was organized around performances, all chosen for their relevance to the issues that had brought the AFP to Louisville. For example, *Sally's Rape*, McCauley's examination of the sexual vulnerability of slave women, uses stories of the lives of

Thomas Jefferson's mistress Sally Hemings and McCauley's own grandmother Sally. It also addresses the different experience of black and white women as concerns sexual violence. The audience at the University of Louisville Women's Center sat riveted as McCauley, enacting a slave, stood naked on an auction block. In character, McCauley described the slave auction process while white actress Jeannie Hutchins led the audience in the refrain, "Bid 'em in, bid 'em in." Later in the piece, Hutchins climbed onto the block and revealed a little shoulder and leg. A familiar image of white woman as commodity, it was nevertheless not as horrific as the literal buying and selling of the black woman slave. McCauley asserts:

> The use of art in this dialogue is so valuable because artists make things beautiful. I'm talking about beauty as a function: if I want to tell you something I want to seduce you so you listen. Theater is different from a political forum but the subject matter can be essentially the same.

Linda Wilson of the Multicultural Center felt *Sally's Rape* was particularly effective in light of the painful stories of feeling invisible that black women had shared in the meetings. It also served a goal of the Women's Center's to be more inviting to women of color by acknowledging their different experiences.

Performances, including *Sally's Rape,* continued and intensified the dialogue already engaging local people. The show is an hour long; the postperformance conversation was an hour and a half. McCauley compares this experience in Louisville to a conventional touring gig of the play in Santa Fe:

> The audience was numb. Someone said, "What are we supposed to do with this?" In Louisville, people were prepared with questions and at the same time able to be surprised. They were ready for the charged issues, so they were less reactive, more open. By preparing we set an atmosphere where things could happen.

Involving local people in the preliminary phase also resulted in the integration of performances into nontheater settings. Professors invited AFP artists into their classrooms; for example, Naomi Newman of A Traveling Jewish Theater spoke in a Politics of Identity

John O'Neal at the Louisville American Festival, 1993. The AFP logo preceded by the name of the site appear on the T-shirt and publicity material of each festival.

class. The local Interfaith Center and Hillel House hosted an international dinner in conjunction with *Crossing the Broken Bridge*, a piece on strained Jewish and African American relations by Newman and John O'Neal. Roadside Theater swapped stories with the university staff, and the Multicultural Center sponsored a brown-bag lunch on the subject of incorporating diversity into the curriculum, making performances like Brenda Wong Aoki's exploration of her Asian American experience, *Queen's Garden*, immediately relevant.

The Louisville American Festival corresponds to the stages of Jackson and Hardiman's liberation theory. Representatives from the Women's Center and the Multicultural Center were already in a resistance stage when they approached the AFP. Much of the subsequent work served the purpose of self-definition, strengthening separate identities such as African American, Asian American, and women. The performances were as much a step toward internalization as was the university's use of the residencies to promote diversity in the classroom. Linda Wilson of the Multicultural Center asserts that the festival furthered intercultural work that she was trying to do and resulted in broader input to the center.[25]

Urban Cultures Festival: The Philadelphia AFP (1991)

Whereas the Louisville Festival provides some answers concerning the guest artist's role in community activism, the Philadelphia AFP raises equally valuable questions concerning the participation of local

emerging artists. Speaking for oneself is important; however, it takes years of training to "speak" an aesthetic language. How much guidance from outside artists is paternalism, and how much is necessary to make the statement effective? And what if the resulting performance is questionable aesthetically or politically?

Philadelphia's AFP, the Urban Cultures Festival, was initiated by the Painted Bride, an alternative (originally visual) arts center founded in a former bridal shop. The Painted Bride's goal was to strengthen its alliances with community-based organizations. It coordinated publicity, hosted some of the festival performances, and helped match local groups with AFP artists of the same culture. The local organizations, in turn, wanted to further their own culturally grounded artistic development. After AFP companies had worked with their hosts intermittently over a six-month period, public showings of works-in-progress took place at two of the sites, FrankfordStyle and the Village of Arts and Humanities.

FrankfordStyle is the joint community arts project of four Methodist churches in Philadelphia's Frankford section, a neighborhood of about 3,000 middle- and low-income residents. Though historically Frankford is interracial, a major thoroughfare now separates the black residents from the white, and efforts to reintegrate the white section in recent years have led to violence. In response, the Frankford Human Relations Coalition intensified its efforts in crisis intervention and in the fall of 1987 created FrankfordStyle, with city support.[26] The project's mission is "to provide open access to all our offerings, and to bring residents of different racial, ethnic, and class backgrounds together through the arts."[27]

Works-in-progress created by FrankfordStyle participants with American Festival artists from Junebug and Roadside were performed at the church that houses FrankfordStyle. John O'Neal began the presentation by leading the audience in the singing of a spiritual. He then told the story of learning that song in 1963, when he was a freedom rider in Georgia and worked largely out of churches. A Student Nonviolent Coordinating Committee (SNCC) worker had just been shot, and civil-rights activists were meeting to decide what action to take. Before leaving, they sang that spiritual. O'Neal asked the audience, nearly half of whom were local people, to sing it with him now:

Guide my hand while I run this race
Guide my hand while I run this race
Guide my hand while I run this race
'Cause I don't want to run this race in vain.

Stand by me while I run this race
Stand by me while I run this race
Stand by me while I run this race
'Cause I don't want to run this race in vain.

Then O'Neal asked the audience to hum it. Over the humming he talked about the choice of the word "I" in the song, explaining that we each have to make a personal commitment to the struggle, but in so doing we are not cutting out the group—we become a group of "I"s. O'Neal thus used the spiritual to link the congregation to the church's historic role in civil rights and thereby reframed the works-in-progress that followed from rough, amateur community theater to a significant step toward racial harmony.

A performance by FrankfordStyle's Adult Drama Group that followed was the result of several play-building sessions with actors from Roadside and Junebug. Previously, the content of FrankfordStyle presentations had been more conventional; their last piece was called *Broadway Memories* and featured songs from an array of popular musicals. The theme selected this time was the local mural that community people had made the previous summer. It represents the history of Frankford from the first European settlers to the present. Seven people did a staged reading of the work-in-progress, most of it first-person accounts of different aspects of the mural project. A man in his forties began with a Broadway show-stopper rendition of "Gonna Build a Mountain," expressing the community's determination. Frankford-Style director Martha Kearns praised the efforts of a local nineteen-year-old who raised $1,800 from local businesses to buy the materials. The visiting Welsh muralist who directed the community's efforts attested to how hard everyone had worked. A woman in her sixties recited a poem that she had written expressing how nice it was for blacks and whites to work together. They ended with everyone singing "Gonna Build a Mountain" together.

My initial response to the project was somewhat ambivalent. While certainly a step toward self-expression, it struck me as overly self-congratulatory; and though its theme was community material, it seemed to model itself on Broadway rather than to find a meaningful indigenous form. Director Kearns explains:

> What was important *was* to be so proud of it. To reclaim the history and our own buildings. Because Frankford has gotten bad press as many working-class neighborhoods do. It's like blaming the victim. People can't pay their bills and some houses deteriorate and then the community is blamed for that, rather than looking at how it occurred. . . . Frankford used to be a showcase. So the mural was fighting back, having a public work of art to show the beauty of the community and the architectural nobility. It was a way of saying that we're not going to take other people's image of ourselves; we're going to do something about it. Yes, we *are* self-congratulatory about the mural. It was important as an action against apathy and against other people's image of who we are.[28]

Given the significance of knowing this context, is the performance relevant only for people involved within that community? Or if the work has a potentially larger audience, does it rely on a partnership with trained artists to help communicate the story? Like much art, does it simply depend on previous knowledge on the audience's part? How much does appreciation depend on understanding the social as well as aesthetic goals of the piece?

In later discussion, an African American woman involved in an upcoming AFP in Mississippi emphasized the developmental value of basing a community project in the participants' experience, something missing in existing dramatic texts. She saw it as a good model for the black kids she works with, who have little self-esteem. Through the gathering of oral histories, they were beginning to develop a sense of cultural pride, but the enacting of stories seemed to her a wonderful next step.

O'Neal writes about the need for the critic to understand how a particular work might be useful to a particular audience. He decries critics who "arrogantly presumed that the standards and values of the

Local Puerto Rican youth perform original works-in-progress created under the guidance of El Teatro de la Esperanza, in partnership with El Taller Puertoriqueño, at Philadelphia's Urban Cultures Festival, 1991.

oppressors applied without qualification to the artistic product of the oppressed."[29] I considered the difference between how I habitually assess performance and what was appropriate in this context. First, the situation calls for a true commitment to process and a sense of patience concerning the product. The performers have only begun to develop storytelling skills. Second, the miniresidencies with O'Neal and Roadside had introduced FrankfordStyle to working with content from their own lives, which Freire considers a step toward self-liberation. Finally, the performance was important to its intended audience—the immediate community and AFP organizers.

Two more works-in-progress took place at the Village of the Arts and Humanities, an African American cultural center that housed the semiprofessional Jaasu Ballet. A stage had been erected in the center's large community garden. The first part of the program featured staged readings by members of a local visual arts collective, El Taller Puertoriqueño (Puerto Rican Studio), developed with a writer and a director from El Teatro de la Esperanza. One of the pieces is about a man and a woman, both virgins, who are about to be married after a long courtship. While on a business trip in Puerto Rico, the man has his first fling with a woman, who turns out to be his fiancée's sister. Ten days before the wedding, the man confesses the affair to his fiancée, just at the moment her sister arrives. After much squabbling, the man and his fiancée reconcile and the sister leaves feeling abandoned by both.

All of the pieces were performed with admirable commitment and to the apparent delight of the audience. However, I found the negative portrayal of women's relationships with each other—evidenced in the scene described above—disturbing. While conscious of their subordinate position as Latinas, they had presented perhaps an unconscious but nevertheless oppressive image of women.[30] Gil Ott, coordinator of the Urban Cultures Festival for the Painted Bride, played down the sexual politics of the undertaking, emphasizing the importance of the performers' initiative to create their own theater:

> Social change means different things to different people. In this city with a major Puerto Rican population that's very insulated, very politically isolated, social change simply means expression of Puerto Rican identity. It's a radical move just to talk Spanish.[31]

The second part of the program featured Urban Bush Women's work with community people. Urban Bush Women artistic director Jawole Willa Jo Zollar sees a continuum between popular forms of movement and dance as art. This is brilliantly expressed via Urban Bush Women's dance-theater piece *I Don't Know, But I Been Told, If You Keep on Dancin' You'll Never Grow Old*, structured to integrate any rehearsed movement sequences that community people do into the set choreography of the company. In Philadelphia local input included double-dutch jump roping and karate; a plan to incorporate the Challenge Precision Drill Team never quite jelled. Musical accompaniment was provided by three local drummers with such exuberance that the audience was left howling for more.

Several months later, representatives of the four host groups—FrankfordStyle, El Taller Puertoriqueño, the Village of the Arts and Humanities, and the Meredith School[32]—met with Gil Ott and Caron Atlas to appraise the festival. Some problems articulated included insufficient communication between guest artists and community people during the preparatory period and among the community groups during the festival, and insufficient time with the artists. Addressing positive aspects, all were grateful for the exposure and the incredible degree of community participation that the project gave their organizations.[33]

As for long-term impact, Kearns has since shifted the emphasis at FrankfordStyle to collectively created material. Ott believes that El

The Urban Bush Women about to perform *I Don't Know, But I Been Told, If You Keep on Dancin' You'll Never Grow Old* with local people in the community garden outside the Village of the Arts and Humanities during the Philadelphia Urban Cultures Festival, 1991. Artistic director Jawole Willa Jo Zollar at microphone.

Liz Lerman learns to jump double-dutch at the Meredith School in Philadelphia, during the Urban Cultures Festival.

Meredith School students take over the library in a dance by Liz Lerman, using the entire school as the stage.

Teatro de la Esperanza was the catalyst for the several Latino theater groups that have since sprung up in El Taller Puertoriqueño's neighborhood. The Urban Cultures Festival thus may be seen in these two neighborhoods as a catalyst for the self-definition phase. Where this phase will lead has yet to be seen.

"Working the Sweet Brown Spot"

American Festivals have taken place in fifteen states; four multiyear projects are now in progress. In Miami, the Urban Bush Women and the Carpetbag Theater are beginning work with people from the conflicting Haitian and non-Haitian black communities. In New Orleans, Junebug is cosponsoring an AFP on environmental racism, the tendency for local toxicity levels to correspond to what artistic director O'Neal calls "the color of the community one lives in."[34] An AFP in the multiethnic working-class communities of Lewiston and Auburn, Maine, focuses on current economic difficulties and plant closings. Centered on a massive oral history project, it features people of all ages and backgrounds telling stories as a means of imagining a new future for these towns. In the statewide Montana AFP, a gay and lesbian story network is playing a significant role in the legal battle to decriminalize homosexual activity.

The Montana project also includes voices of the homeless, facilitated by John Malpede and the Los Angeles Poverty Department (LAPD). While not a core member of the AFP, the LAPD is an example of a company that AFP artists feel such respect for and affinity with that they seek opportunities to collaborate. Malpede studied philosophy in college and was an up-and-coming performance artist in New York City during the 1970s. But he had an increasing feeling that the same people's stories always get left out. What difference did one more New York performance artist make? Visiting Los Angeles during preparations for the 1984 Olympics, he was horrified to see police virtually hiding the homeless to "beautify" the city. In response, he began working as a paralegal with the Inner City Law Center. In 1985 he founded the LAPD, the first performance group in the nation made up mainly of homeless people.

Like AFP groups, the LAPD performs in a range of venues, from Skid Row to art museums. Whether he is working in a place likely to attract artists or homeless people, as actors or audiences, Malpede asserts that he is making art. He decries the tendency to perceive community art as about memory and "real art" as about imagination:

> People assume that all the stuff we do is autobiographical. But we're not interested in reducing people down to the tragedy of their lives, or giving street people a soapbox to stand on. We're interested in finding out who these people really are and what makes them special. The work comes out of that discovery process.[35]

The resulting performances individualize and humanize the homeless cast members, thereby challenging the stereotypes many of us carry.

LAPD Inspects America, like the Urban Bush Women's *I Don't Know, But I Been Told*, is an interactive framework that integrates LAPD members with local people. Besides their primary work in Los Angeles, Malpede and company do residencies in various cities, recruiting homeless people and artists for collectively created performances. Ongoing local performance groups are often generated as a result. These artist-nonartist collaborations are quite promising: the artists' skills strengthen and support the self-expression of the untrained people. According to Malpede, theater, as "a social, collaborative process," provides "a way of learning how to function in a group."[36] Reciprocally, the artists are stretched in unexpected ways. Working with inner-city Philadelphia kids, for example, stimulated Liz Lerman to think about popular dance idioms in a way that she had not done before.[37] For Malpede,

> I felt I was getting real isolated. Ezra Pound said artists are supposed to be the antennae of the race. And what I saw were artists sitting at home adjusting the antennae on their TV sets so they could make spoofs of Tammy Faye. I thought that artists should be out there doing primary research and not just getting their ideas off of newspapers and televisions.[38]

This conception of artists as deeply involved with the life of their times links community-based artists of any medium, be it performance or visual. In a clear break with modernist concepts, the purity

Artistic Director Liz Lerman (center) and Dancers of the Third Age, 1981. In 1975, Lerman created a dance about her mother's death with people from a Washington, D.C., senior center. They remained together, performing and teaching, until 1993, when they were integrated with Lerman's other performers into one cross-generational company, the Liz Lerman Dance Exchange.

of the self-involved art form is cracked open. This overflowing beyond the traditional boundaries of its form links the American Festival Project with much contemporary activist visual art. Douglas Crimp's description of the postmodern resituating of work "between or outside the individual arts"[39] is as illuminating for visual artists moving between, say, photography and performance or film, as for performers moving outside art into organizing or education.

One of the issues that remains controversial is whether AFP artists stay in the communities long enough or participate in organizing fully enough to achieve their social goals. Gil Ott of the Painted Bride wonders if visiting artists are too much like "superstars, jetting in and out."[40] While seeing the value of AFP artists as facilitators, he remains ambivalent about the value of importing people from the outside for any long-term change.

Liz Lerman acknowledges that AFP residencies do not make community—that takes much longer. Rather, she states, "we're making connections and teaching tools and much can come of it." In fact, she has found advantages to being from outside the community. In Lewiston, for example, the Dance Exchange worked for a week with a group of sixth-graders. There, "problem kids," whether developmentally disabled or lacking discipline, are mixed in with students from the regular classrooms. Lerman and company didn't

The Liz Lerman Dance
Exchange in *This Is
Who We Are*, 1994,
choreographed by Liz
Lerman.

know which kids were which, and thus had no expectations. As it happened, all the kids did fabulous work. In that case, *not* knowing the community worked to an advantage.

At the heart of the American Festival Project is the centering of art in the concerns of the community. Neither the dramatic text nor the artistry of actor, director, or designer is assessed according to fixed standards but rather on what the work achieves in each specific context, on communication with real groups of people rather than an a priori idea of "good art." That notwithstanding, AFP companies are by and large recognized nationally for their high artistic attainment. They both meet professional standards and remain profoundly connected to their cultural sources. O'Neal looks at the relationship among performance content, skills, and audience as three overlapping colored circles—red, blue, and yellow: "Where all three circles overlap is a brown triangle. The task of the critic is to help all parties concerned to find and work 'the sweet brown spot.'"[41]

> **At the heart of the American Festival Project is the centering of art in the concerns of the community.**

The centrality of community signals a particular aesthetic philosophy. According to O'Neal:

> There are those who view art as the exclusive province of the individual . . . to express their feelings and views. There are others who see art as a part of the process of the individual— in the context of community—and the community coming to consciousness of itself. In the first case, the artist is seen as a symbol of the antagonistic relationship between the individual and society. In the second case, the artist symbolizes the individual within the context of a dynamic relationship with a community. . . . Obviously the latter view is the one that I identify with.[42]

Being community-minded does not mean leaving out the individual. Ron Short of Roadside, for example, told a storytelling class at Cornell University that we must "examine our own stories before we can understand other people's."[43] John Malpede teaches a performance workshop the purpose of which is "to create a strong grounding from which to engage with others without losing yourself."[44] The art making at the AFP's core incorporates the personalization often

missing in purely political approaches to conflicts around difference, in which problems are articulated and solutions proposed but without a process that deeply engages people. AFP artists know that people are more likely to recognize the history of others if their own stories are not left out.

For Robbie McCauley, the question at the heart of the American Festival Project is: How can you be with your own and with the world? "What makes you able to invite others in, do the multicultural thing, is being nurturing of yourself. And this is the craft of acting." The AFP's structure takes advantage of all the phases of performance—preliminary meetings that incorporate local voices through story-telling and establishing dialogue, community performances that facilitate local expression, professional productions that address local issues, and postshow discussions that reinforce the significance of the work for the particular community. The American Festival Project provides ways to express oneself and one's group, and to engage in cultural exchange, thus translating Freire's insistence on dialogue into a culturally generated exploration of difference and common ground.

5 Eleanor Heartney

What do artists have to offer environmental movement?
How is Harrison's work art + not science

Compare their work to other "land" artists

Ecopolitics/Ecopoetry:

Helen and Newton Harrison's Environmental Talking Cure

art leading to 'conversation'

John 5... nature

Postmodern theory relegates nature to the junk heap of outmoded concepts. Declaring that "the jungle ride at Disney World may in fact be more real to most people than the real jungle in the Amazon,"[1] the prophets of simulation within the art world and the enthusiasts for industrial development without happily embrace a future in which nature is reinvented on a daily basis to conform to the requirements of technology and commerce.

Back in the discredited "real world," however, the ozone layer continues to thin, rain forests turn into deserts, toxic waste threatens the groundwater upon which our cities depend, and species that may contain the cure to cancer or AIDS disappear before their beneficent properties can be discovered.

In light of such unhappy developments, an international environmental movement has emerged over the last three decades that seeks political and social changes in our treatment of the environment. Because of the complexity of the problems, a diverse and occasionally conflicting set of agendas and prescriptions has been set forth by various environmental groups. The Green Party, which has become a fixture in North America and Europe, espouses a platform of environmental action, conservation, deindustrialization, land reclamation, and social justice. Green Party candidates have been elected to political office in Canada, England, and Sweden, and the party has emerged as a major political player in Germany.

While the Green Party seeks politically viable approaches to environmental problems, other groups stake out less palatable philosophical positions. Movements like deep ecology and ecofeminism argue against the anthropomorphism and patriarchal bias embodied in our

141

practices of land use, noting that there is a connection between Western culture's exploitation of women and its exploitation of the earth. At the furthest extreme are groups such as Earth First that take the radical position that humankind has abdicated its rights to the earth. They advocate drastic population reduction and a return to a preindustrial state.

In the United States, environmental consciousness waxes and wanes with changes in the political climate. After an early surge of interest in environmental problems that culminated in the creation of the Environmental Protection Agency in 1972, the business-oriented Republican administrations of the 1980s attempted to portray environmentalism as a choice between owls and jobs. In the 1990s, politicians have discovered that an expression of interest in an environmental agenda is frequently very attractive to a public disaffected with the politics of consumption that dominated the last decade.

An international environmental movement has emerged over the last three decades that seeks political and social changes in our treatment of the environment.

Among the general public, environmental consciousness has tended to oscillate between the two extremes of ecological despair (to borrow a phrase from artist Robert Smithson, who was himself an early advocate of land reclamation through art) and blind faith in technology's ability to save us from ourselves. Well-publicized scares—Love Canal, the odyssey of the garbage barge, the discovery of mercury in tuna—create momentary frenzies of ecological concern, but too often the apparently insurmountable problems that humankind's stewardship has visited upon the earth lead instead to a state of passive resignation.

Art has always had a special connection with the natural landscape. Is there an equally sympathetic place in the environmental debate for artists who wish to move beyond simple expressions of concern toward a more active and activist stance? Responding to this question, a small group of contemporary artists with roots in the activist tendencies of the 1960s and 1970s has begun to explore the possibility of practical links between art and ecology.

They argue that the artist's habits of metaphor, cross-reference, inclusiveness, and holistic thinking may help unclog a discourse that often finds itself mired in the narrow channels of technological and bureaucratic thinking. They hold that new conceptualizations of intractable environmental problems may lead to new solutions. And they have committed themselves to exposing to public view the debates that surround these issues in the belief that common sense and a proper understanding of our collective self-interest are the most potent weapons in the battle for ecological sanity.

Helen and Newton Harrison: Taking the Long View

Among the first and the most visionary advocates of this approach are Helen Mayer Harrison and Newton Harrison. A husband-and-wife team who shared a teaching position at the University of California in San Diego from 1969 to 1993, the Harrisons first began thinking about ecological issues in the early 1970s. This was a period when artistic opinion about the environment was dominated by artists such as Michael Heizer, whose *Double Negative* (1969) involved the displacement of 240,000 tons of earth in the Nevada desert; Walter De Maria, who set 400 steel poles in straight lines over a square mile of the New Mexico desert to draw lightning to his *Lightning Field* (1977); and Robert Smithson, whose *Spiral Jetty* (1970) was a giant coil of rock stretching from the shore into Utah's Great Salt Lake. Created to move art out of the gallery into the real world and to defy the turning of art into a commodity, projects like these also had a less savory side in their tendency to usurp the earth as just another kind of raw material available for artistic transformation and exploitation.

By contrast, the Harrisons took a much more beneficent and systemic view of the natural environment. An early ecological work was included in the Los Angeles County Museum of Art's 1971 *Art and Technology* exhibition, a show that matched artists and scientists in collaborative teams. The Harrisons' work, entitled *Notation on the Eco System of the Western Salt Works with the Inclusion of Brine Shrimp*, studied the interaction of *Dunaliella* algae and ocean brine shrimp. This was a far cry from the repositioning of mounds of earth in the desert or the dredging of the ocean floor.

The Harrisons' growing interest in the complexity of ecological systems can be traced in *Lagoon Cycle*, an environmental narrative that they developed over the years 1973 to 1985. The earliest texts of *Lagoon Cycle* focus on the search for an organism that can live under museum conditions; as the narrative proceeds, however, the Harrisons continually widen the scope of their environmental concerns until they conclude with a discourse on the greenhouse effect and a consideration of the ecosystem of the entire Pacific Ocean. In a sense, *Lagoon Cycle* also chronicles the evolution of the Harrisons' environmental consciousness as they become increasingly aware of the need to think big and to question the ideas of specialists working on environmental problems. This outward expansion has led them into discussions with specialists from a variety of scientific, political, and sociological fields. And it has led them to promulgate ideas that have been adopted in part or in toto by city officials, despite the fact that they may contradict conventional wisdom.

Over the years, the Harrisons have developed a unique ecopolitics, couched in the form of an ecopoetry. Combining text with photographs, drawings, and maps, the Harrisons employ the language of storytelling to present the results of their investigations into a particular problem or a specific ecosystem. Each work is presented as a poetic dialogue woven together from diverse voices, including those of planners, ecologists, botanists, foresters, the artists themselves, and even the rivers and waterways whose histories and futures are under consideration. Borrowing promiscuously from other disciplines, the voices use metaphor, irony, and analogy to suggest new ecological strategies and approaches.

For example, in a 1992 work entitled *The Serpentine Lattice,* which deals with the Northwest rain forest, the Harrisons draw from the language of aesthetics to create a potent image of a new relationship between humankind and nature: "A new reversal of ground comes into being where human activity becomes a figure within an ecological field as simultaneously the ecology ceases being an ever shrinking figure within the field of human activity." In their *Great Lakes Proposal* from 1977, the authors reach into the world of geopolitics to make the argument, only partially tongue-in-cheek, that political boundaries should be redrawn along ecological lines. And in a third

work, *Sacramento Meditations*, also from 1977, they make use of the economist's language of cost-benefit analysis to argue that current flood-control policies are efficient only when such long-term effects as wetlands contamination and salinization of the soil are suppressed.

Though the Harrisons have occasionally dealt with issues like the deforestation of the Pacific Northwest, the defensive psychology of urban design, and the possibility of a memorial to the victims of Nazi atrocities created from rubble and scrub flowers on the former site of the SS headquarters, the Harrisons' most consistent subject has been a systemic analysis of watersheds here and abroad. They take issue with conventional thinking about flood control, irrigation, and land use, arguing that efforts to change the course of waterways, to make dry land productive, or to dry out wetlands to enable the expansion of urban boundaries ultimately breed disaster for both the land and its human inhabitants. Instead, they advocate various forms of restoration and reclamation to bring human needs back into synchronism with natural processes.

Sacramento Meditations: Assessing the Cost of Belief

In 1976, the Harrisons created a work they regard as having been pivotal for their subsequent watershed investigations. *Sacramento Meditations* (1977) is a critique of the irrigation policies of the Sacramento–San Joaquin watershed in Northern California. This multidisciplinary project, which included a sixty-four-foot mural, a series of billboards, radio and television performances, a poster campaign, and a graffiti campaign, became a model for thinking about the relationship between ecology and urban development. The work's overall question, as stated in a series of posters plastered around San Francisco, is: "What if all that irrigated farming isn't necessary?" Within the San Francisco Museum of Modern Art, the mural, comprising a series of nine texts accompanied by various mappings of the state of California, made the case for replacing the usual short-term thinking and special-interest politics with an understanding of the area's problems on a macro scale.

> **The Harrisons advocate various forms of restoration and reclamation to bring human needs back into synchronism with natural processes.**

"Somebody's crazy! They're draining swamps and growing rice on the desert." So read Helen and Newton Harrison's graffiti scrawled on San Francisco streets during the 1977 run of *Sacramento Meditations*, their many-pronged attack on the folly of irrigation practices in the Sacramento–San Joaquin watershed in Northern California.

The second text of the work powerfully reveals the fallacies of conventional thinking:

"VISIONARY" PLANNERS INGENIOUSLY USING MODERN TECHNOLOGIES TO SECURE THE INHABITANTS OF CALIFORNIA FROM FLOOD AND DROUGHT HAVE CONTROLLED THE FLOW OF WATER IN THE CENTRAL VALLEY DEVELOPING A COMPREHENSIVE INTERCONNECTED ARRAY OF RESERVOIRS DAMS POWER STATIONS PUMPING STATIONS DITCHES AND CANALS TO IRRIGATE THE CENTRAL VALLEY AND TO SEND WATER OVER THE TEHACHAPI MOUNTAINS TO THE METROPOLITAN WATER DISTRICT IN THE SOUTH CREATING THE LARGEST IRRIGATION SYSTEM IN HISTORY GENERATING AN EIGHT BILLION DOLLAR INDUSTRY THAT SUPPLIES FOOD AND FIBER TO THE STATE THE NATION AND THE WORLD

AN IMPROVABLE PROFITABLE EXPANDABLE SYSTEM

"TECHNOCRATIC" PLANNERS SUBSIDIZED BY THE TAXPAYERS OF THE NATION AND IN HIDDEN INTEREST GIFTS BY THE STATE AT THE EXPENSE OF NONIRRIGATED FARMING ELSEWHERE PRIMARILY FOR THE PROFIT OF A FEW LARGE LANDHOLDERS AND AGRIBUSINESS HAVE TURNED THE ENTIRE WATERSHED OF THE CENTRAL VALLEY INTO ONE LARGE IRRIGATION SYSTEM SERVING OVER SIX AND ONE HALF MILLION ACRES COMPOSED OF DAMS THAT BECOME USELESS THROUGH SILTING A PUMPING SYSTEM THAT

WILL USE MORE ENERGY THAN IT CREATES AND A DIKING
SYSTEM THAT REQUIRES ONGOING REPAIR THAT IN CON-
CERT REDUCE THE QUALITY AND LONG TERM PRODUC-
TIVITY OF BOTH THE LAND AND THE WATER THROUGH
PROGRESSIVE SALINIZATION

AN ENERGY EXPENSIVE SELF-CANCELING SYSTEM

Noting that the results of such current practices have been salt-
contaminated land, the creation of deadly wetlands as pesticides and
herbicides flow into the mouth of the reversed river, and several severe
droughts brought on by evaporation resulting from wasteful irriga-
tion processes, the Harrisons suggest in the mural text that we must
shift from a paradigm of "Exploit and Consume" to the paradigm of

Newton and Helen
Harrison pose before
a wall of maps inside
the Los Angeles
Institute of Contempo-
rary Art during a
1979 presentation
of *Sacramento
Meditations.*

"Appropriation and Beneficial Use." They argue for the reinstatement of natural ecologies and the detachment of irrigation from processes of flood control.

With their exhortations in *Sacramento Meditations* to "pay attention to the cost of belief," the Harrisons deconstructed conventional planning language in a way that makes its contradictions evident even to the nonspecialist audience. In subsequent work they have continued to position themselves as mediators between the conflicting demands and interests represented by such diverse groups as official planners, the present and future human inhabitants of an ecosystem, and the natural world itself. Likening their process to the flow of a river, they talk about "conversational drift" and suggest that their ultimate goal is to "change the conversation." This figure of speech captures their sense that change on a large scale happens only when the underlying metaphors that shape public belief are subtly altered and internalized.

Pasadena Projects: Healing Wounds, Creating Refuges

The open-ended nature of the Harrisons' thinking is evident in a series of projects that brought them back to the same ecosystem over a period of years. In the Pasadena projects they investigated the watershed system providing flood control for the entire Los Angeles River basin. The Harrisons' first exploration of this area, *Gabrielino Meditations* (1975), was an essentially speculative application of the ecologically beneficent practices pursued by the nearly extinct Native Americans who once inhabited the Los Angeles River basin. The Gabrielinos practiced a form of slash-and-burn agriculture that controlled forest growth and replenished the land. The realization that at this site humans once lived in harmony with nature where they now have all but obliterated it remained a potent undercurrent in the Harrisons' Pasadena projects.

In 1984, they returned to the area at the invitation of a local garden club to give a lecture on their work. They were taken on a tour of the popular recreation area along the lower Arroyo River and were surprised to discover that running through the valley, apparently all but invisible to the local inhabitants, was a concrete channel lined on both sides with barbed wire. To the Harrisons, the straightened,

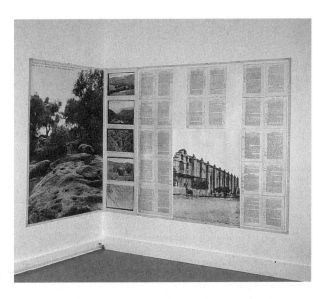

Helen and Newton Harrison, *Gabrielino Meditations,* first presented at the art gallery of Long Beach State University, 1976. The installation combined vintage photographs with excerpts from letters written in 1850 by journalist Hugo Reed and published in the *Los Angeles Star.* This work tells the story of the Gabrielino Indians, who flourished in the Los Angeles River basin before the advent of Spanish missionaries and practiced ecologically sound forms of agriculture.

concrete-lined channel substituting for the original river was a wound in the land.

In *Arroyo Seco Release/A Serpentine for Pasadena,* a work initially presented at the Baxter Art Gallery of the California Institute of Technology in early 1985, the Harrisons presented their plan for healing that wound. Reviewing the history of the Arroyo, they discovered that the once powerful river had been dammed, diverted, and forced into the concrete channels to manage periodic flooding. Changes in flooding patterns had greatly decreased the diversity and abundance of wildlife native to the area. Since a variety of considerations made it impossible to return the river to its original state, they proposed instead that the channel be capped with concrete and covered with topsoil. A serpentine low-flow streambed on the surface would wind through the valley from the Devil's Gate Dam upstream to the Los Angeles River downstream, in the process creating a series of intimate natural spaces. Meanwhile, the resulting overflow at flood time would bring back the original wetlands habitat while leaving the now hidden channel functional and unobstructed.

The text accompanying the maps and photographs in this work presents a basic principle:

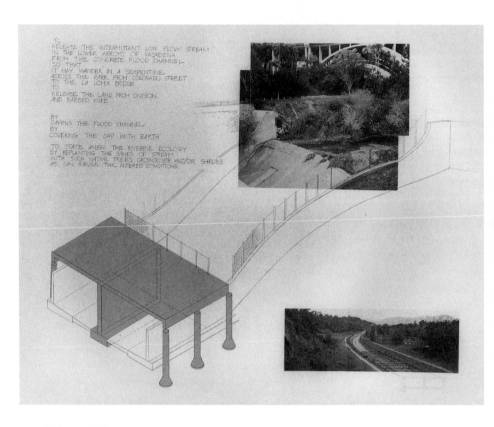

TO
RELEASE THE INTERMITTANT LOW FLOW STREAM
IN THE LOWER ARROYO OF PASADENA
FROM THE CONCRETE FLOOD CHANNEL
SO THAT
IT MAY WANDER IN A SERPENTINE
ACROSS THE PARK FROM COLORADO STREET
TO THE LA LOMA BRIDGE
TO
RELEASE THE LAND FROM DIVISION
AND BARBED WIRE

BY
CAPPING THE FLOOD CHANNEL
BY
COVERING THE CAP WITH EARTH

TO STATE ANEW THE RIVERINE ECOLOGY
BY REPLANTING THE BANKS OF STREAM
WITH SUCH NATIVE TREES GROUNDCOVER AND/OR SHRUBS
AS CAN SURVIVE THE ALTERED CONDITIONS.

Helen and Newton Harrison, *Arroyo Seco Release/A Serpentine for Pasadena,* 1985. This excerpt details the Harrisons' plan to cap the existing flood channel and rebuild a viable ecological system across its top.

> Let a grand restitution take place
> Let the process of flood control
> Be separated from the destruction of rivers

The Harrisons' concluding text expresses a hope that their suggestions might serve as a model for future planning in the entire area:

> If you stand on the Colorado Street Bridge
> You can image this restitution of the Arroyo
>
> If you fly high enough
> You can image the same
> For every stream and river in the basin.

Despite the great interest in the project among local officials, the discovery of structural problems in the Devil's Gate Dam at the head of the lower Arroyo River made it impossible to realize. Returning to Pasadena in 1986, the Harrisons turned their focus to the dam and the debris basin stretching from its base to the foot of the Santa Gabriel Mountains, where they discovered a new set of problems. Because the dam was deemed vulnerable to earthquakes, the basin was drained and kept empty of water and had filled with rubble deposited by water cascading down the Santa Gabriel Mountains. This accumulation produced unfortunate aesthetic consequences obvious to all the urbanites who flocked to the lower Arroyo for a glimpse of natural beauty. The ecological impact included the hindrance of water percolation into the underground water basin that served as a water source for nearby communities.

With their first concern being to restore this severely damaged area to some semblance of its natural ecology, the Harrisons focused on both the creation of streams and lagoons and the replanting of native plants, which would attract wildlife while slowing the flow of debris into the basin. Through these measures, they argued, the area could also become more useful to human inhabitants. Earth removed from the debris basin could be used to create new commons and ridges. A new streambed could gradually refill the underground basin. In turn, this streambed would make the widening of channels below the dam unnecessary, avoiding the concomitant environmental damage. A series of trails and parks along the new streambed would enhance the area's recreational value.

An aerial view of
Pasadena's Devil's Gate
Dam circa 1986 reveals
the drained debris basin
and rubble pile the
Harrisons encountered
when invited to develop a
watershed restoration
plan for the area.

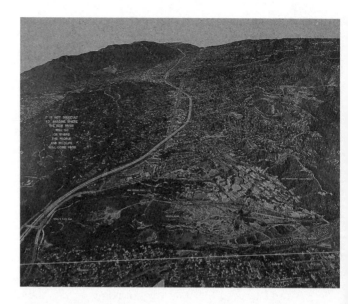

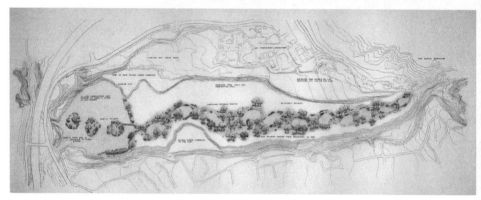

Helen and Newton
Harrison, *Devil's Gate:
A Refuge for Pasadena*,
1986. "A String of
Emeralds" was the
Harrisons' metaphor for a
chain of interconnecting
streams and lagoons they
proposed. They argued
that this new ecosystem
would slow the flow of
debris from the Devil's
Gate Dam while creating
a wildlife refuge and
recreation area.

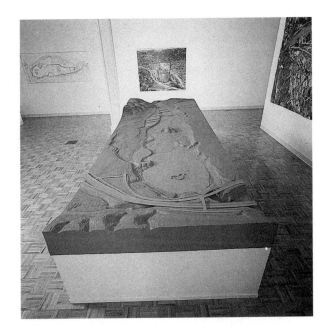

The architectural model for the Harrisons' Devil's Gate project was an important element in the presentation of their ideas to local government and ecological groups.

While the Harrisons' introduction to the Los Angeles River basin came from the Garden Club of Pasadena, by the time they began working on Devil's Gate, they had begun to garner considerable support among local government and citizen groups. The city of Pasadena, the Friends of the Arroyo, the Pasadena Men's Committee for the Arts, and the Community Action for the Parks all contributed funding and services toward the completion of the proposal, which was presented at the Pasadena Gallery of Contemporary Arts and the Art Center College of Design. Restoration of Devil's Gate had been named a priority in the city of Pasadena's strategic plan, and many aspects of the Harrisons' plan were subsequently adopted by the city of Pasadena. The Harrisons were invited to speak at the opening ceremonies for the Hahamungana Watershed Park, which, in a satisfying circularity, was renamed in honor of the original Gabrielino Indians, whom the artists had celebrated in their first Pasadena piece.

Sava River: Expanding to a National Scale

In the 1989 project entitled *Atempause für den Save Fluss* (Breathing Space for the Sava River), the Harrisons again widened the scope of their inquiry. This work takes on the environmental problems that

Helen and Newton Harrison, *Atempause für den Save Fluss* (Breathing Space for the Sava River), 1989. The Harrisons' plan for the Sava River included a proposal to create a nature preserve for migrating waterfowl in an area currently containing large fish ponds.

Noting that runoff from the chemical fertilizers employed in the farms that line the Sava River jeopardizes the water-shed, the Harrisons proposed the replace-ment of current practices by organic farming.

plague the entire length of the Sava River, which runs through the former Yugoslavia. Initiated during the artists' residency in Berlin under the auspices of the D.A.A.D. (German Academic Exchange Program), an artist fellowship and residency program funded by the German government, this work was sparked by conversations with the German botanist Hartmut Ern about the doleful state of the Sava River. The Harrisons discovered that, although the river and its floodplain had been damaged by the practice of industrial farming, a process that leaches toxic fertilizers into the soil and water, the damage was reparable. The environmental burdens of the new intrusions on the river—a paper mill, a coal mine, an atomic energy plant, and a fertilizer factory—had not yet succeeded in polluting the entire river. The Harrisons ascertained that, in fact, only four or five purification systems would be required along the one-hundred-mile length of the river to restore it to a state of reasonable health.

Again, they searched for natural means to restore the river. They proposed, instead of building dams and canals and draining the swamps for flood control, creating a nature corridor to insulate the river from unnecessary contamination. A series of ponds would provide a reedbed purification system that would clean the water in swamps and water reserves. These in turn, the Harrisons claimed, would serve as havens for the wildlife that was rapidly disappearing from the area. They suggested that the industrial farming practice be replaced by organic farming, which would end the discharge of toxic chemicals into the watershed, and that produce yielded by organic farms in the area could be profitably sold by local farmers at the local organic produce market.

The Harrisons' reaction to the atomic energy plant and its impact on the Sava River illuminates the flexibility of their thinking about technology. Strengthened by the Chernobyl debacle, local representatives of the antinuclear movement were calling for dismantling the plant in favor of a series of hydroelectric dams. However, the Harrisons concluded that although the plant was relatively safe, the effects of a series of new dams on the river could be devastating. They proposed that the plant remain and that the warm water created by its cooling process serve as the source for a fish hatchery.

As with all the Harrisons' projects, their work on the Sava comprised two parts. The first involved the actual conversations with the planners, scientists, and ordinary people they encountered during their investigations and the reverberations these conversations set in motion. Prior to the tragic outbreak of hostilities in the former Yugoslavia in 1992, this project had received considerable support from scientific and governmental bodies in the area. The Zoological Society and the Nature Protection Agency had agreed to fight for an enlarged nature reserve, and the Croatian government was considering presenting the plan to the World Bank, which had agreed to fund a river purification program. The second part of the project consisted of the visual record that the Harrisons produced in the form of an installation of maps, text, and photographs. First exhibited in the Neuer Berliner Kunstverein in Berlin, this work wraps around the gallery walls. Viewers follow the course of the river visually as they read the texts in which the Harrisons meditate upon the specific problems and solutions at various junctures. Perhaps more than any other narrative by the Harrisons, this project captures the conversational nature of their work. Sections of the text are written as dialogues between the artists and various individuals whom they encountered in their investigations. We hear from a botanist about the dangerous effect that modern flood-control methods were having on the native stork and sea eagle population. They present concerns of a young ornithologist who was also working with the concept of reedbed purification systems. They talk with a landscape architect engaged in mapping the current floodplains of Europe against the vastly more extensive ones that originally existed there.

We become aware of a multiplicity of perspectives and possibilities for this river.

We become aware of a multiplicity of perspectives and possibilities for this river. In order to emphasize the idea that the future is not fixed, the Harrisons talk about past and future alterations of the river's course and surroundings as forging a series of new histories. They urge a responsibility toward its future history:

> There is still time for a new history for the Sava
> which, while corseted within levees
> is not channeled in concrete.

There is still time for a new history for the Sava
for its alluvial wetlands
while shrunken
are larger than any in Western Europe.
There is still time for a new history of the Sava
for its dams are modest and covered with growth.
There is still time for a new history for the Sava
for its flow is not swallowed or reversed.

There is still time for a new history for the Sava
which, while polluted, is not poisoned.

Bitterfeld: Ecology and Economics

The full title of this project, *Ruminations of the Closure of the Open
Pit Mines at Bitterfeld and the Condition of the Waters, the Earth and
the Air* (1994), offers a hint of its scope. Responding to an invitation
from the Chamber of Architects of Hessen, Germany, to participate
in a seminar held at the Bauhaus in Dessau, the Harrisons found
themselves part of a team of architects, landscape architects, and
students. The group gathered to consider possible plans for restora-
tion of the nearby Bitterfeld coal mines, essentially a twenty-four-
square-kilometer excavation pit and a thirty-six-square-kilometer
earth pile resulting from the recent closing of the mines.

The Harrisons quickly found themselves at odds with most of the
other participants, who were exploring conventional "art" solutions
such as the creation of sound sculptures from abandoned machines,
the arrangement of markers to create a line of sight across the land-
scape, or the creation of a lake within the empty pit. A cursory exami-
nation of the surrounding ecosystem informed the Harrisons that
forming a lake spelled potential disaster, thanks to the presence of
nearby toxic chemical dumps, which contaminated the groundwater
that would seep into the pit.

They proposed dealing with the contamination problem first by
installing a series of small water-purification systems to extract the
toxins so that the purified water could be allowed to rise safely in the
proposed lake. Next they turned their attention to a feature of the
landscape that had not even been considered a problem by the semi-
nar planners. The air above Bitterfeld was heavily polluted from 150

The practice of strip mining in the former East Germany produced many barren landscapes. At Bitterfeld, the Harrisons formulated a plan to restore a devastated piece of land and sky through purification of polluted groundwater and air.

years of burning coal. The Harrisons suggested that a giant spiral of trees be planted to pull the carbon accumulations from the air while beginning the process of regenerating the surrounding earth.

An important aspect of the Harrisons' proposal was their argument that what made ecological sense was also economical. They noted that in the long term, it made more sense to put money into water purification and recreational development of the area than into accident insurance. They suggested that the skills and techniques developed in restoring the land and air could become very valuable commodities in a future in which environmental cleanup is sure to be a major growth industry. Similarly, if properly managed, the forest planted to purify the air could also serve as the basis for an ongoing timber industry. And finally, the Harrisons encouraged planners to think about costs and benefits as part of a larger economic system, noting in their text: "NOW IT DOES NOT SEEM UNREASONABLE THAT THE CHEMICAL COMPANIES THAT PRODUCED MOST OF THE TOXIC WASTE DUMPS BE HELD IN PART RESPONSIBLE FOR THIS CLEANUP."

As a result of the Harrisons' proposal, which was reported and discussed in the local press, the West German company that was created to deal with the Bitterfeld site dropped its plan for a potentially poisoned lake until the problems of toxic groundwater seepage could be solved. Meanwhile, a prize was awarded to the Harrisons for

their proposal from the local minister of ecology. At this writing, the Harrisons are engaging in further discussions with local officials on the means of implementing their plan.

Questioning the Orthodoxies

Although the Harrisons work with specific sites and particular problems, they also take a long view, using these situations as case studies with which to explore the larger economic, philosophic, and cultural assumptions behind environmental policy. Implicit in each project is a critique of conventional thinking about environmental problems.

For instance, *Sacramento Meditations* challenged the assumption that natural ecosystems can and should be radically altered to serve ever growing populations. One line of graffiti the Harrisons wrote on the sidewalk as part of this piece suggests the absurdity of this kind of thinking: "Somebody's crazy! They're draining swamps and growing rice on the desert." Underlying this work is the unspoken question: Without restraint of population growth, do efforts at restoration and reclamation only delay the inevitable?

In Pasadena, the Harrisons' successive reengagement with the Los Angeles River basin made them aware that environmental problems are rarely self-contained and obedient to the boundaries imposed by local government. Instead, each problem opens up a series of others as one traces it to its original causes. Yet local power struggles and conflicts about jurisdiction may make it difficult to address the larger problems. As a result, most successful reclamation and restoration projects deal with limited land areas, despite the obvious advantages of thinking bigger. In the end, then, the Harrisons' Pasadena projects open up the question of scale: Are land and water restoration possible on a large scale or must they be limited to small, exemplary pieces of the landscape?

The Sava River project was an attempt to answer the first part of this question affirmatively. Here, the Harrisons took on a river that stretched the length of an entire country. That they came as close as they did to affecting national policy on the river is a tribute to the possibilities of large-scale thinking.

Finally, as with many other projects but in a particularly potent way, the Bitterfeld project dealt with questions of the economic

viability of ecological policies. Here the Harrisons presented an economic calculus that makes the case that jobs and environmentalism are not incompatible. A similar thinking underlies their suggestion in the Sava project that the higher prices available for produce from organic farms might offset the loss of productivity when pesticides are abandoned. Such calculations are, of course, highly speculative, and as long as population levels remain high and continue to increase, it will be difficult to be persuasive on this point.

In the end, although the Harrisons point with pride to those situations in which their ideas have been implemented in some form or another, this process of raising questions and challenging assumptions is more central to their work than are any concrete results. Ultimately they are artists, not scientists or administrators, yet this distinction remains one of the most misunderstood aspects of their work.

But Is It Art?

Not content merely to challenge the orthodoxies of environmental thinking, the Harrisons also raise important questions about the nature of art. Critics within the art world frequently object to their work, claiming that it belongs more properly to the realm of science than art. What sort of formal criteria, they ask, can be brought to bear on work whose subject matter involves issues such as groundwater purification and wetlands restoration, with presentations relying heavily on maps, and aerial photographs and drawings that have clearly been selected for their informational rather than aesthetic value? Granted, the Harrisons' ideas about reforestation, floodplain restoration, and habitat generation are useful, but by what stretch can they also be termed "artistic"?

Although it is true that the Harrisons' work does not resemble art in any traditional sense, it employs a multilevel, metaphoric kind of thinking that differs sharply from the more linear and instrumental approach of conventional science and technology. This can be seen not only in the kind of language employed in the Harrisons' written texts but also in the ease with which the artists are able to shift paradigms, moving between the notion, for example, of nature as the figure as well as the ground of human activity or reversing the percep-

tion of flooding as a problem to its being regarded as the potential solution to the creation of a viable local ecology.

As children of the Conceptual art movement of the 1970s, the Harrisons have well understood Conceptualism's lesson that the meaning of an art work is to be found not in the object itself but in the physical and conceptual frame that surrounds it. In its more orthodox commodifying form, Conceptual art involves a critique of the institutions of the art world. It questions commodifying art, the separation of art from life, and the barriers set up between art and audience by museums and galleries. In an analogous way, the Harrisons remove the frame from the environment, critiquing the institutions that have been set up to manage land use and natural resources. As landscape artists of a new kind, they propose that nature is best comprehended not as a collection of landscape features to be memorialized in paint but as a set of interrelationships among the forces of biology, climate, and technology.

But if there are powerful philosophical reasons for insisting on their status as artists rather than ecologists or planners, there are important practical reasons as well. The Harrisons function as outsiders to local politics. They become engaged with a situation or, in their terminology, "enter a conversation," when they are invited by a local arts organization. In almost every case the art world has provided their initial entry into a project, whether by providing funding to support research, as was the case with D.A.A.D. and the Sava River, or by asking the Harrisons to prepare an art project that deals with local ecology, as was the case in Pasadena. Once they have begun thinking about a problem, they contact specialists and local authorities. While they may later work directly with local planning agencies or city officials, their initial plans are drawn up independently of local politics. They may eventually be presented in city hall, which was the case with the Devil's Gate proposal, but they are born from a different milieu.

> **As landscape artists of a new kind, they propose that nature is best comprehended as a set of inter-relationships among the forces of biology, climate, and technology.**

The maintenance of such freedom from local pressures to, for example, center their plan on a proposed golf course rather than designing a plan directly addressing their interest in responding to the area's crisis ecology, jibes with the Harrisons' overall philosophy. Every aspect of their approach to an environmental "conversation" is designed to circumvent the exclusionary tendencies of contemporary city planning. They refuse to be bound by the rules of any specialized field or the political needs of any special-interest group. As a result, they are able to transcend political boundaries and conceptual divisions that make it impossible to confront the causes of environmental problems.

Equally important to the Harrisons is the issue of access. They object to the complexities of specialized planning language, arguing that its primary purpose is to lock out the nonexpert. This is why they have consciously cultivated an accessible and inviting form of storytelling in the texts that accompany their proposals. It is also the reason that they rely on aerial photographs to explain their proposals rather than the plan and section format of conventional planning—photographs are more accessible to the layperson, and their use allows proposals to be read and understood by the nonspecialist public.

Public "Art" Versus "Public" Art

The thrust and the success of the Harrisons' work cannot be fully understood without a consideration of recent changes in the definition of public art. Having progressed beyond so-called "plop art," a derogatory term for the kind of large and often ungainly outdoor sculptures that adorn too many public plazas and lobbies, to the notion of "site specific" art works that address the physical nature of the space around them, discussions about public art have of late begun to center around a form of social or political site specificity. What links an art work to a place, according to this thinking, is not its physical presence but rather its interaction with the social, political, and economic forces that shape the life of any community.

As a result, works of "public art" in the new sense no longer need to be physical objects that are clearly visible in a public space. The definition has been stretched to include community projects whose public aspect is the artists' interaction with community members;

interventions in the mass media, which may take the form of artist-designed billboards, radio or newspaper spots, or television commercials; or artists' participation in developmental planning boards or public works projects.

This shift in the definition of public art clearly embraces the approach the Harrisons have evolved over the last twenty years. Although the physical result of their process is often simply an arrangement of text, photographs, and maps that appear in their gallery installations and catalogs, the public aspect of their work has more to do with the way in which they have been able to insert their ideas into policy discussions. Given the inevitable process of negotiation and compromise attending the disposition of any large area of public land, the Harrisons' comprehensive proposals are never likely to be adopted wholesale. They do, however, become part of the planning process to the extent that their assumptions are internalized by decision makers who come to view suggestions stimulated from the Harrisons' work as their own. Thus, in a sense, each project has both a visible and an invisible life as it participates in the ongoing "conversation."

In an article on the Harrisons in *Art Journal,* Craig Adcock cites the often repeated charge that the Harrisons' work hides itself within the cloistered setting of the gallery and museum context. He quotes their reply in this snippet of conversation:

N.H.: The Harrisons would counterargue that the museum is a safe place for a town meeting—

H.H.: —a safe and neutral place—

N.H.: —and that their works in Baltimore, Pasadena, Berlin, and Yugoslavia became forums for storytelling. In those places, the museum setting enabled their projects to move toward realization.[2]

Is that enough? Despite a great deal of lip service to openness and accessibility, the art world has a notoriously poor record when it comes to breaking down the barriers between contemporary art and the non-art-educated audience. The Harrisons have done a remarkable job in getting their message heard by planners, architects, ecologists, and other specialists. One senses that despite their devotion to democratic ideals, it has not been so easy to reach the "ordinary citizen" who does not frequent art galleries.

This is the dilemma that has faced many adherents to the new public art. In their efforts to bridge the gap between art and life, they have begun to argue against the idea of the "public" as the faceless mass of an anonymous citizenry and against the idea that public art is art created for this entity. Rather, they argue, there are many publics, all representing different constellations of needs and desires. Genuine public art, then, becomes art that acknowledges and attempts to mediate between these different agendas. According to this definition, public art is not limited to a particular kind of physical site. Instead, what distinguishes it is a way of thinking about politics, community, and society.

In keeping with this redefinition, the Harrisons suggest that the most important issues surrounding the environmental debate involve the dissemination of power. Their work asks: Who shapes the ecological discourse and why? As spokespersons for future generations as well as for contemporary noncommercial interests, they inject seldom heard voices and seldom discussed considerations into the ecological debate. They address decision makers from a point outside the usual perimeters of environmental discussion. In the process, they provide a model for a "talking cure" that may help us break out of the self-destructive channels of thought that now govern environmental policy planning and point us toward a much more productive relationship between humankind and the environment.

6 $\mathscr{P}atricia\ \mathscr{C}.\ \mathscr{P}hillips$

Maintenance Activity:

Creating a Climate for Change

Art can give us new air to breathe.

—Mierle Laderman Ukeles

The Scale of Maintenance Work

One day in the fall of 1993, Givors, a small communist town near Lyons, France, was the site of a remarkable series of activities orchestrated by a visiting artist from New York. In a culminating and appropriately theatrical event organized by the city's Institute for Art and the City, the night waters of the Rhone River were temporarily illuminated by a mysterious specter. Installed on a barge, a large cone of broken cobalt blue glass (recycled from a local factory) was directed out into the channel. As the sun faded and the hulls of the accompanying boats and barge were obscured in darkness, the translucent pyramid became a flowing, luminous, and disembodied form.

Coordinated by artist Mierle Laderman Ukeles in collaboration with the citizens of Givors, this romantic nocturnal event concluded a sequence of activities involving such apparently prosaic subjects as municipal maintenance. Earlier in the day, the artist had led a pedestrian and vehicular parade through the town down to the riverfront. Like a magnet, the procession drew townspeople to the concrete and stone embankment, where a company of sanitation trucks and other municipal vehicles performed a choreographic display with a grace of movement and eloquence of design unexpected in the cumbersome contours of vehicles that sweep the streets, trim the trees, and manage the solid waste of Givors.

The Givors project, *RE-SPECT* (the title representing both regard and a reexamination), was a major community enterprise witnessed by a curious, responsive media as well as throngs of women, men, and

Mierle Laderman Ukeles, *RE-SPECT*, October 28, 1993. Multimedia performance on the quai and Rhone River, Givors, France. Invited by the Institute for Art and the City to develop a city-based project, Ukeles planned this one-day event during three separate weeklong visits to Givors. She welcomed this short-term, ephemeral situation as an opportunity to test new ideas and to create a project informed by more immediate impressions and observations.

Mierle Laderman Ukeles, *RE-SPECT*, 1993. For this event the mayor released 80 percent of the city's service vehicles and most of the sanitation/maintenance staff. The artist's choreography of vehicles transcended their normal functions to reveal the magnificence hidden in the daily routines of the city.

Mierle Laderman Ukeles, *Pit/Egg: A New Low for Holland*, 1992. Earth pit, geosynthetic liner, rafts, netting, and work gloves, 360" x 960" x 480". The artist's installation at Floriade, a major horticultural exposition in Zoetermeer, the Netherlands, explored the pragmatic interdependence and philosophical significance of water in this low-lying country. The work struck an ominous note concerning industrial waste from other European countries that is now polluting Holland's water.

children. Given the situations and objectives of most of her art productions, this is not atypical for Ukeles, who may well receive more general press coverage than most other artists. She makes news, and not only in the art and culture pages. In fact, it is essential to the realization of her projects that they are newsworthy. In *Touch Sanitation,* one of her most ambitious, far-reaching projects, the media had particular significance. But whether building a major construction in a lagoon in the Netherlands (*Pit/Egg: A New Low for Holland,* a project created for *Allocations,* a group exhibition organized in conjunction with the International Horticultural Foundation Exposition/Floriade) or meeting with groups of schoolchildren living in housing projects who had never visited the center of their city, as she did in

Givors as part of the planning process for *RE-SPECT*, Ukeles is a powerful, persuasive communicator.

The artist's conspicuous presence and availability during the production process encourages active, ongoing participation from members of the community. While Ukeles is very much the director of these major public performances and constructions, the ultimate realization and resonance of the work is dependent on the willingness of many to plan, participate, and publicize. Even in communist Givors, a process of participatory democracy was among the raw materials manipulated by the artist.

For Ukeles, public art must stimulate and sustain a civic dialogue. The immensity and urgency of the issues that she engages (city viability, active citizenship, environmental awareness) demonstrate that, for her, contemporary activism means a comprehensive, compassionate response to a complex, multivalent world. There is no isolable, single cause in Ukeles's projects; even her earliest aesthetic investigations were marked by an inventive synthesis of human factors, cultural initiatives, and environmental issues. For her, the expression of activism requires the harmonics of a full orchestra rather than the singularity of a solo performance. "The planet's maladies are too complex and its cultures too diverse to rely on any single line of attack."[1]

> Activism requires the harmonics of a full orchestra rather than the singularity of a solo performance.

In addition to her interest in the dialogue that is so instrumental to an effective participatory process, Ukeles remains the creator of forms and spaces. Never simply a rhetorical or textual undertaking, her complex, intellectual, and instrumental projects require direct involvement with materials and construction techniques, the systems, spaces, and citizens of communities. In fact, a great deal of her research and inquiry involves specific materials and processes, as well as an analysis of the character of sites for public use.

In this way, art and activism have been indivisible from the beginning of Ukeles's career. A skeptical consideration of the structures of art, the nature of creative production, and the social dimensions of environmental problems forms the foundation for the art work Ukeles

has produced in the past two decades. Every project, performance, or installation is shaped and informed by an impressive synthesis of social, political, environmental, and feminist theory. Ukeles's concept of activist art orchestrates the psychology of creativity with the practices of its production in space, and involves the humanization of institutions, systems, and spaces. The artist's own family dynamics and personal observations underlie the authenticity of her inherently public work, which seems a more effective way to respond to cataclysmic, unanticipated shifts. In fact, this byplay of private-public, the mixing and merging of formerly oppositional designations, has stimulated a wider reconsideration of institutional systems while supporting a process of feminization in the public realm, animating the popular slogan "The personal is political." From this perspective, a serious analysis of the work uncovers a profound dynamic joining an individual narrative with an intellectual consideration of contemporaneity. The artist's experiences as a woman in society affect not only her ideas about cities and work, but also the global environment.[2]

> Formerly each society to which history gave rise within the framework of a particular mode of production, and which bore the stamp of that mode of production's inherent characteristics, shaped its own space. We have seen by what means this was done: by violence (wars and revolutions), by political and diplomatic cunning, and lastly, by labour. The space of any such society might justifiably be described as "work." The ordinary meaning of this term, as applied to an object emerging from the hands of an artist, may very well be extended to the result of a practice on the plane of a whole society.[3]

As an art student in the early 1960s, Ukeles was unwilling to accept art and life, public and private, as discrete categories. Having completed an undergraduate degree in history and international relations at Barnard, she began studies in the visual arts at Pratt Institute. Her early art work was restless and experimental, clearly falling between the disciplinary conventions that articulate most art schools. As she proceeded with her studies in painting, her work became more spatial, visceral, and sexual as she began to stuff and shape canvases into sensual, bodily forms. Ukeles reports that with each innovation, the faculty became increasingly alarmed.[4]

A growing dismay with repressive national policies, the escalation of the Vietnam conflict, and the material excesses of capitalist culture led Ukeles to keenly question the nature, production, and pedagogy of art. Why make more things for a regulated market of privileged consumers? Could artistic practice be unaffected by—even exempt from—the surrounding national turmoil? Rejecting the exclusive, imperialist influences on culture—the production, distribution, and collection of select objects—she looked for more inclusive, negotiable alternatives. She made a series of adaptable pieces that could be inflated to fill an entire space, then deflated and folded into a transportable parcel. She envisioned an art of general availability and endless flexibility, accommodating its forms and functions to different conditions.

> **Art registers the messy vitality of the world.**

The inflatable object—or "instant" environment—may seem tangential to current questions of art circulation and conversation, but it served as an important step toward the reevaluation of art's instrumentality. Inflatability engaged questions of change, chance, transformation, flexibility, and permanence. Displacing the stasis of conventional formal analysis and fixed forms, situational issues—and the *relativity* of art—moved to the center of critical discourse.

Context, once an invisible subject, became essential in the intentions of many artists and the interpretation of art. Its impact not only laid the groundwork for a burgeoning range of installation art, but raised questions about enduring and ephemeral work, human experience, and aesthetic value itself. Ukeles (along with many other artists) began to see the transitional object as a mediator between the artist and audience, artist and site. Art was no longer fixed, immutable, and complete; the role of the artist was less privileged and detached. Art registers the messy vitality of the world.

The Emergence of Maintenance Art

In the late 1960s, two significant events occurred in Ukeles's life. In 1968, she gave birth to her first child and began to experience firsthand a classic, but personally unacceptable, range of conflicts. Like many women (and some men), the tensions of producing creative

projects and responding to the unrelenting responsibilities of raising children led her to question the polarization of art and life that made pleasure and productivity in either area so problematic. Using her own life as an experimental setting, she examined the assumptions that estranged her work as an artist from her work in the family in order to envision more cohesive, integrated alternatives. The artist began a sophisticated investigation as she sought the reality underlying her multiple roles. What did household maintenance and creative activity share in common? Were there social and intellectual traditions, perhaps unacknowledged by modernism, that justified a reconciliation of these "opposing" forces? Were not these contributions, these essential activities, of equal value?

A year later, in 1969, Ukeles wrote "Manifesto for Maintenance Art." The culmination of research and introspection since the birth of her child, it remains a seminal document that has influenced the content and direction of her work for twenty-five years. In this brief, incisive text, Ukeles challenged the modernist myth with its dualistic assumptions privileging linear progress over the repetitive tasks required to maintain people, places, cities, and environments. In art, for Ukeles and many women artists, this dichotomy privileged the disputable notion of pure creation over an organic, cooperative, and renewable concept of aesthetic work.

> Avant-garde art, which claims utter development, is infected by strains of maintenance ideas, maintenance activities, and maintenance materials. . . . I am an artist. I am a woman. I am a wife. I am a mother. (Random order.) I do a hell of a lot of washing, cleaning, cooking, renewing, supporting, preserving, etc. Also, (up to now separately) I "do" Art. Now I will simply do these maintenance everyday things, and flush them up to consciousness, exhibit them, as Art.[5]

The idea that people are diminished by recurring, repetitious work is a prevalent and often unquestioned one. In "Manifesto for Maintenance Art," Ukeles proposed instead that enormous potential for creativity lay in the willingness to accept and understand the broad social, political, and aesthetic implications of maintaining. Proposing a constructive oxymoron, Ukeles's manifesto brought "maintenance" and "art" into a provocative affiliation.

The text also challenged mythologies that had dominated and governed the art world and the careers of artists for many years. It exposed the gender biases embedded in the myth of the independent artist. Reinforced by her own experiences as an art student, Ukeles recognized that people held an incomplete picture of artistic freedom. The careers of most successful male artists are supported by a whole roster of personal and professional assistants. Wives, lovers, technicians, and fabricators fuel the fantasy of independence. Ironically, it is this very support that allows the practice of art making to appear as the ultimate expression of individual freedom.

> If the very notion of the avant-garde can be seen as a function of the discourse of originality, the actual practice of vanguard arts tends to reveal that "originality" is a working assumption that itself emerges from a ground of repetition and recurrence.[6]

A philosophical consideration of maintenance not only enabled the artist to reconceive her own life as a more coherent, conceptually aligned series of activities and exchanges, but presaged a significant new connection between feminism and the public world. Acknowledging the natural coalition of women and service, whether in the home or the public domain, whether involving the care of a child or a city, Ukeles used this as a structure and subject for art.

The indispensable, unrecognized tasks that sustain families, communities, and cities were the ligament that strengthened and attached emerging feminist ideas to art theory as well as to the larger culture. In the same way that a concept of maintenance in the health professions has encouraged preventive medicine, the support of wellness, and more assertive recipients of health care, it also enables art to be a more instrumental intermediary in a sustainable future. Ukeles turned "women's work" from a disparaging remark to a creative resource and powerful metaphor for change.

Curiously, at the same time that many artists were fleeing urban areas in order to build magnificent earthworks in the seclusion of spacious sites, Ukeles saw the city as the ideal context for the deployment of an art committed to the maintenance of public life. For Ukeles, the same restrictions that drove some artists to seek the freedoms symbolized by open expanses and rural settings offered the

most productive laboratory in which to pursue the formative ideas of her manifesto.

So Ukeles stayed at home in her work, accepting New York City as the optimal site for it. Employing maintenance activities to confirm the ecological bonds linking people and places, her projects domesticated and humanized the city. They also raised ethical and moral questions that continue to drive her work: Is all maintenance helpful and constructive? How is maintenance used to sustain the status quo and to defend reprehensible practices and institutions? When does maintenance become a form of domination, a mania to control?

The development of structures that are open and supple enough to accommodate the intentions and actions of many people is an unbreachable, animating feminist principle of Ukeles's ephemeral performances, as well as of her ongoing projects. The typically distinct classifications of audience and subject are concertedly undermined by Ukeles's proposals; the audience acts as an active participant influencing the direction and duration of her art. Every production not only uses the agency of the viewer/audience/subject, but accepts these elements of fortuity inherent in any public practice. Events that activate a public life necessarily call for many variables, of the kind observed by Henri Lefebvre:

> The "moment" which he interpreted as fleeting but decisive sensations (of delight, surrender, disgust, surprise, horror, or outrage) which were somehow revelatory of the totality of possibilities contained in daily experience. Such movements were ephemeral and would pass instantaneously into oblivion, but during their passage all manner of possibilities—often decisive and sometimes evolutionary—stood to be both uncovered and achieved. "Moments" were conceived of as points of rupture, of radical recognition of possibilities and intense euphoria.[7]

Utilizing her fascination with linguistics and the meaning of words, in 1976 Ukeles produced *I Make Maintenance Art One Hour Every Day*, an exhibition/project for a branch of the Whitney Museum of American Art. Ukeles used the entire site—on the ground floor of a large office building—as the context for her work. Interested in the human resources required to maintain large corporations, she chose to

engage the 300-member maintenance staff—the women and men whose quiet, self-effacing work kept the building clean, repaired, and efficient. While everyone recognizes the imperatives of maintenance work, few people want to actually see it. The maintenance staff who work the night shift, as well as their activities of picking up, putting away, and throwing out, are designed to be invisible.

As a part of locating her project in the offices of Chemical Bank, Ukeles interviewed the maintenance staff about their experience of work and traveled with them throughout the building, entering even some of the most restricted areas. She discussed her ideas about maintenance art with the employees, challenging the usual separation of these two words. She distributed letters inviting every maintenance worker to help create "a living Maintenance Art work" during September and October. She asked them to designate one hour each day of their normal tasks as art. When the employees punched out at the end of the workday, they were asked to fill out a form identifying when and how they performed art (dusting, floor washing, elevator repair, etc.).[8]

> The maintenance staff and their activities are designed to be invisible.

For the duration of the project, Ukeles visited the building every day. She took Polaroid photographs of women and men doing routine chores, asking them if they were engaged in "art" or "work." The photographs, with the employees' forms and remarks, were exhibited at the Whitney. During the five weeks of the project, the museum's walls filled with the collected daily documentation. Not surprisingly, there were curious juxtapositions. On many occasions, maintenance workers performing identical tasks described them differently. For one worker, washing a window on the south facade at 10:00 a.m. was "art"; for someone else performing the same task alongside, it was "work." With this simple rhetorical question, Ukeles challenged the truth of language itself—and its role in the construction (and perpetuation) of cultural values and meaning. As a result, the project enhanced the value of work while making art more accessible.

The branch of a museum located in a commercial building offered Ukeles one unusual opportunity to construct a project on the perception of art and maintenance. In 1973, at the Wadsworth Atheneum in Hartford, Connecticut, the artist was able to observe and disarm

the maintenance structure of a major art institution. She soon discovered just how prickly questions raised by her work can be in a cultural site. Organized in three parts, the first portion of the project involved cleaning the steps at the museum entrance. In the performance, *Washing Piece*, the artist scrubbed the front hall as well as the outside steps of the building, performing a task that may have been included neither in the building maintenance program nor as a part of the museum audience's typical art excursion. The piece confronted the general perception that this kind of work is done "after hours," not when art is available for observation or study.

A far more witty and incisive component of her tripartite performance was *Cleaning of the Mummy Case*. Very concise guidelines regulate the care of art and the systems of display within the museum. While maintenance workers may (and must) clean display cases, only art conservators are permitted to handle the art. Using a linguistic strategy (what do we agree to name as "art"?) to set off a series of changes in the care and management of the institution, Ukeles designated the display case itself as a work of art. It remained the same case, serving the same function in an unaltered setting, but its recategorization now required an abrupt revision of museum procedures for its care and conservation. A vitrine now deemed a work of art could be handled and cleaned only by a conservator. It is not difficult to imagine the far-reaching and bizarre circumstances that such a shift in nomenclature could produce. If sinks were declared art objects, for instance, would conservators become the guardians of public washrooms? And how would that influence the public's role and experience of art?

Ukeles's final and most aggressive event at the Wadsworth Atheneum was entitled *Keeping of the Keys*. Those who regulate access and maintain security in institutions control the keys. For a single day, Ukeles held the keys of the museum, locking and unlocking doors at will. People were temporarily excluded from or enclosed in particular areas; security was enforced or broken depending on the artist's will and whim. Ukeles recalls that the moment of greatest outrage was when she attempted to lock the doors of the curatorial area. Not forewarned that they too might be part of the artist's aesthetic investigation, the curators balked, complained, and left the office in a frenzy

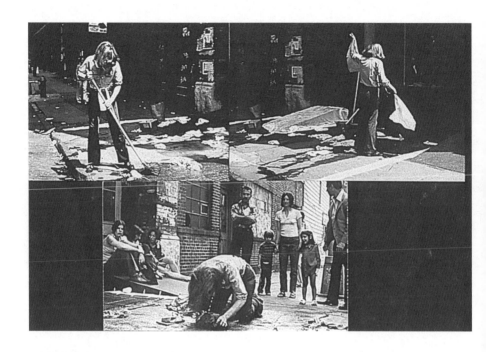

Mierle Laderman Ukeles,
Wash, 1973. Sidewalk
performance at A.I.R.
Gallery, New York City.
The artist's obsessive
pursuit of cleanliness
evoked responses from
pedestrians implicated in
the piece. Amused by the
sight of Ukeles scrubbing
the sidewalk, children
teased her with their dirty
footprints. A neighbor in
the rag business
contributed old cloth for
the artist's use.

before the door was locked. Ukeles did not expect this kind of reaction, but it stands as a revealing episode in the conventions of behavior and the social hierarchies of institutional cultures. Despite her disappointment with the response of this group of museum employees, its intensity confirmed the authenticity of her aesthetic practice. Clearly, the artist's inquisitive, invasive actions raised questions about art, work, implied power, right, and privilege.

Expanding her inquiry beyond the internal culture of the corporate office and the art museum, Ukeles constructed a street performance at the A.I.R. Gallery in New York City in 1973. Organized as a women's cooperative and supported by the efforts of artists themselves, A.I.R. was a very appropriate place to examine "women's work" in the disorderly urban context. *Wash* engaged viewers in an evaluation of their own preconceptions of maintenance work as the artist performed within the obsessive, authoritarian dimensions of a maintenance routine. Having placed a table and chair on the sidewalk in front of the gallery, Ukeles interviewed pedestrians. Adding an oddly empirical element to the poll-taking, the participants were asked to weigh in before and after their interviews. The artist reports that, in some cases, an individual's weight dropped, as if a frank discussion of maintenance work actually unencumbered the interviewee.

As she had done at the Wadsworth Atheneum in Hartford, Ukeles also washed the public space in front of the gallery. Unlike the private entrance of the museum, this city sidewalk situation was staunchly public. All kinds of people walked through Ukeles's performance site, inadvertently participating in the work. Working on her hands and knees with rags and a bucket of soap and water, she was tireless and single-minded in her tasks. She actually hounded people as they walked on her cleansed site, immediately scrubbing away any trace of their footsteps as their feet left the pavement.

The artist's frenzied, aggressive pursuit of cleanliness became a compulsion that controlled the space and people's freedom to move. The obsession with hygiene served not only to illuminate the dark side of maintenance as domination and control, but also raised questions about the nature of public space. What are the rights of individuals? How does a public space become the platform for a private and authoritarian monologue? And how do the unspoken conventions

Mierle Laderman Ukeles, *Touch Sanitation: Handshake Ritual*, 1978–79, New York City. Citywide performance involving 8,500 sanitation workers. Dismayed by the derogatory, disrespectful treatment of "sanmen" by members of the public, as well as the media, Ukeles countered with thousands of handshakes as a gesture of recognition.

of maintenance control a (reportedly) public space? For example, is the removal of homeless women and men from city parks and streets a compassionate initiative or an insidious demonstration of cleanliness as control? Although the performance took place twenty years ago, the questions Ukeles raised during this sidewalk event continue to have an expanding and disturbing relevance for all public spaces.

Artist-in-Residence with the Department of Sanitation

A common theme in all of Ukeles's work is the power and possibility of transference. While the artist serves as an agent, the potential for activism is realized and resides most conclusively in the work's subjects and participants. The work is simply not actualized without this essential partnership; people are stakeholders in the artist's aesthetic enterprise. This complex pas de deux has been performed with exceptional virtuosity with the "sanmen," the municipal employees who pick up after the rest of us in order to maintain a viable, livable environment. As the unsalaried artist-in-residence for the New York City Department of Sanitation since 1976, Ukeles has worked with thousands of employees and five different commissioners. Her long tenure in this city agency has been a sustained aesthetic commitment supported by the subjects and recipients of the work. Empowered by this cooperation, the artist, in turn, has accepted extraordinarily ambitious projects.

Her creative work with the Department of Sanitation has largely found its expression in three major projects. One, *Touch Sanitation*, comprising many different components, stretched over a period of six years (1978–84) and included performances and exhibitions. Another project, begun in 1983, *Flow City*, is sited on the Hudson River; it remains a work in progress, with its construction proceeding in fits and starts as funding is expended and reappears. Ukeles's most recent project, *Fresh Kills Landfill and Sanitation Garage*, was awarded in 1989. It is at the preliminary research stage.

Ukeles works at such an ambitious scope and scale that it is not unusual or surprising that each project takes years of planning and development. The Department of Sanitation is a multifaceted agency; within it, consultations and conversations occur at every level. Then, outside the department, the artist must also cooperate with many other public and private agencies in order to initiate, let alone complete, a city-based art project. The coordination of sites, people, materials, and equipment is every bit as complex as making a major film or a large building.

While the Department of Sanitation has assisted the artist's work with office space, in-kind services, materials, contributions, and a high level of moral support, Ukeles generally seeks additional projects, as well as individual support, from state, federal, and private foundations. In fact, she is an indefatigable fundraiser. The entire scope of her efforts to realize a project reliably represents the enormous range and complexity, the unending tasks, and the size of a work force required to manage solid waste in contemporary cities.

The maintenance and management of an entire city is a continuous activity. In New York, the collection and transportation of solid waste occurs twenty-four hours a day, 364 days a year (Christmas is the only holiday that is observed). One needs only to have witnessed a garbage strike to understand that sanitation is an endless epic that is central to the well-being, vitality, and appearance of a city. Yet the people who perform these tasks receive, at best, scant recognition for their efforts and, at worst, ridicule and humiliation.

Touch Sanitation was Ukeles's first project at the Department of Sanitation. A piece with many trajectories, a performance component

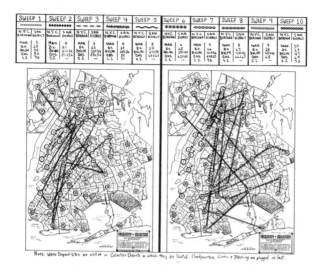

SWEEP 1	SWEEP 2	SWEEP 3	SWEEP 4	SWEEP 5	SWEEP 6	SWEEP 7	SWEEP 8	SWEEP 9	SWEEP 10

Mierle Laderman Ukeles, *Touch Sanitation: Handshake Ritual*, 1978–79. Knowing that she could not reach every "sanman" in the city in a random manner, Ukeles devised a sophisticated cartographic system of "sweeps" to map her routes. Sweep 1 involved the first sanitation district in each borough, Sweep 2 involved the second, and so on. She worked days, nights, and sometimes successive shifts to complete the performance.

entitled *Handshake Ritual* (1978–79) remains one of the artist's most memorable, arduous, and controversial works. Because it was supported by grants to the artist from the Cultural Council Foundation and the National Endowment for the Arts, those intent on disabling federal and state funding of the arts sometimes cite this project as an extreme example of wasted money. Fortunately, others see it as an important performance piece with far-reaching social and aesthetic implications. *Handshake Ritual* was based on a functional form of cartography—an animated map of the city, its five boroughs, and fifty-nine community districts. To map this piece, Ukeles drew ten circles—sweeps—from which she plotted her activities, to match up with the schedule of maintenance crew shifts and the location in borough districts of the Department of Sanitation.

The performance involved Ukeles's collaboration with 8,500 city workers, the objective being to shake the hand of every sanitation worker. Prior to the commencement of *Handshake Ritual*, Ukeles distributed a letter to all employees describing her intentions.

> I'm creating a huge artwork called TOUCH SANITATION *about* and *with* you, the men of the Department. All of you. Not just a few sanmen or officers, or one district, or one incinerator, or

one landfill. . . . I want to try to "picture" the entire mind-bending operation. To try to face each one of you, to shake your hand.[9]

For over a year, the artist moved in a deliberate, calibrated manner throughout the city. As concerned with the management and schedule of the project as she would be with any ambitious architectural construction, Ukeles mapped the city and the routes that she traveled, and negotiated sites and schedules in what she describes as a series of aesthetic deliberations and decisions.[10] Cartography is an inherently imaginative and ideological process, and because they are representations of the world, maps invoke countless narratives about place. While a museum or gallery installation involves the alteration of a received site, this project required the articulation of an entire metropolitan area's random conditions, with innumerable variables.

Although artists frequently enter performance and installation sites to implant their own language, the public realm is not an empty, blank space. There, the single voice can be overwhelmed or even become authoritarian. In contrast, *Handshake Ritual* required the artist to adopt and accept the rhythms and routines of an established workplace, a site intrinsic to the public domain. Unlike her projects at the Whitney and the Wadsworth Atheneum, where she could employ her own systems of linguistics, inquiry, and production to exhume the central issues of each project, *Handshake Ritual* required her to embrace a prevailing public language in order to realize the year-long piece.

Whereas the language of institutions, while frequently complex, calls for a single tone of convention, public communications are polychromatic. In the public realm, the artist encounters more variables and restrictions, as well as a panoply of unknowns. For example, the incalculable responses of individuals must be orchestrated within the confines of preestablished schedules. Since the unplanned inflects even the most orthodox municipal system, it is precisely this potent mixture of the unexpected and the nonnegotiable that illuminates the possibilities for a significant public art. These early lessons in the language and *time* of public life have been applied and expanded on by Ukeles in subsequent projects.

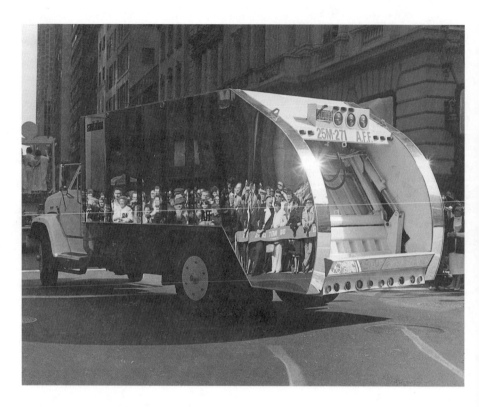

Mierle Laderman Ukeles,
The Social Mirror, 1983.
Tempered glass, Plexiglas
mirror, 338" x 126" x
100", on 20-cubic-yard
sanitation truck. Ukeles
installed mirrored sides
on a "garbage truck" in
order to reflect the
environs of the city and to
remind the public that
everyone has a stake in
sanitation.

Handshake Ritual involved a cogent, caring, and comprehensive engagement with a municipal system—a complete immersion in the culture of sanitation work. The intent of these thousands of handshakes was to honor and confirm the dignity of maintenance work as a life-sustaining, life-enhancing activity. As the work took place, the artist's research and discussions with "sanmen" and their families confirmed many damaging, humiliating misconceptions. Ukeles recounts the stories of workers who never told their neighbors what they did for a living, or those who would never dry their uniforms on outdoor laundry lines for fear of castigation. Others reported the epithets and insults they had experienced while collecting and hauling garbage in the city's streets. The term "garbage man" still remains part of the nation's vernacular, with the material collected becoming the descriptive adjective for an individual. Historically employed to signify the conclusion of a dispute, the handshake here offered the hope of suspended hostilities. Negotiating from the scale of the individual to vast municipal systems, this common gesture nurtured—humanized and feminized—the city.

Handshake Ritual involved a cogent, caring, and comprehensive engagement with a municipal system.

> I've talked a lot about "hands," to "handle" waste, "handling" the pressures and difficulties of the job, and finally—about "shaking, shaking, shaking hands." This is an artwork about *hand-energy.* What you are expert at, what you do every day. The touch, the hand of the artist and the hand of the sanman. I want to make a chain of hands. . . . A hand-chain to hold up the whole City.[11]

The handshake that Ukeles extended to thousands of employees of New York City was a greeting, an expression of gratitude, a sign of respect, and an acknowledgement of the significance of their efforts. Garbage remains an awkward social and cultural subject. Few have any interest in it, but all of us produce it. Most avert their eyes from it, yet everyone participates in the construction of some of the world's largest environmental sculptures—landfills. Garbage is what each individual creates, rejects, and refuses. No one takes pride in it.

Mierle Laderman Ukeles, *Touch Sanitation: Maintenance City/ Sanman's Place*, 1984. Two-part installation with an opening performance at Ronald Feldman Fine Arts, New York City. *Maintenance City* included towers of videos showing sanitation work in the city as well as an enormous overhead map representing all of the sanitation districts and facilities of New York City. The installation depicted the scale, energy, and repetition of maintenance work.

In fact, it is the consumption patterns, questionable success, and unimaginable excesses of capitalist cultures that have made maintenance such a necessary activity. To those men (and now women) who perform the solid-waste management of communities and cities, Ukeles's handshakes conveyed a revised, more open, and realistic conception of the function of work in modern societies. Maintenance workers are guardians. In New York, the work may begin in the streets, but the effect of their efforts has repercussions for the private lives and public health of an entire region.

Touch Sanitation had other components, including an exhibition—*Maintenance City/Sanman's Place*—and the performance *Cleansing the Bad Names*, at Ronald Feldman Fine Arts, a commercial gallery with an impressive roster of artists, many of whom produce work of social and environmental significance that is not easily sold or distributed. Also, in a marine transfer facility on the Hudson River

that was scheduled to be razed for the construction a new building, Ukeles created *Transfer Station Trans Formation*. Including many passages, cages of recyclables, displays of sanitation tools, equipment, and old work gloves, the piece presented the scale and texture of sanitation work. On the day of the opening, Ukeles choreographed *Marrying the Barges*. Based on a colloquialism concerning the transportation of solid waste downriver, the nautical ballet of six barges and the two tugboats used to haul them displayed a grace of movement that enhanced a consciousness of function. Poetry was discovered in the dailiness of collecting and hauling solid waste.

Never incidental to Ukeles's public work, the media played an intrinsic role in *Touch Sanitation*. During the planning and preparation of its various stages, the artist began to believe that the media had rarely taken the time and care, nor felt the responsibility or necessity of conveying an accurate, informed image of the Department of Sanitation, the "sanmen," and their essential contributions to the city. Consequently, throughout the project she informed, engaged, challenged, and occasionally criticized the press for its superficial treatment or absolute neglect of a profound subject.

Ukeles's philosophy of public art is not easily distilled down to sound bites, nor are the consequences—the real effectiveness—of projects meaningfully assessed based on numbers of response or the immediate, observable actions of individuals. The work requires time—to analyze, publicize, and absorb. The efficacy of public art cannot be gathered through a poll or gleaned in statistics. That a change of consciousness, an enhanced awareness of public life, takes place is unassailable but never instantly provable.

The Environments of Public Life

At the same site as *Transfer Station Trans Formation*, a new 59th Street Marine Transfer Station has been constructed as planned. The new facility includes Ukeles's *Flow City*, an ambitious public art and access project that she has been working on since 1983. Using the culture of sanitation work as an allegory of global environmental management, the project reflects Ukeles's commitment to bring citizens to a visceral, participatory experience of the scale and issues of solid-waste

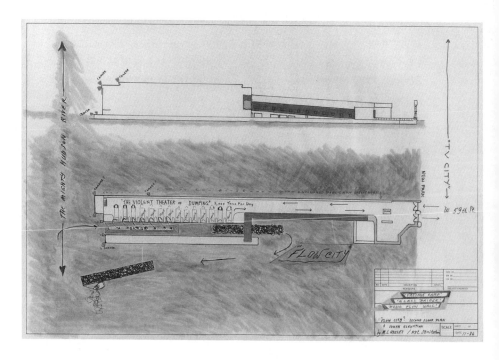

Mierle Laderman Ukeles, *Flow City*, begun 1983. Public art/video environment at 59th Street Marine Transfer Station, New York City. *Flow City* brings members of the public face-to-face with the drama of sanitation and solid-waste management. A corridor made entirely of recyclables carries visitors to a viewing platform/proscenium overlooking the facility's vast tipping floor to observe enormous barges being filled with the city's garbage.

management in New York City. As always, the social, political, and environmental issues are inextricably connected.

Marine transfer facilities are noisy and dirty sites. Projecting into the river like shipping piers, this facility receives an unbroken stream of sanitation vehicles that pull in and ascend a ramp to the elevated tipping floor. The trucks then turn and back into a low retaining wall on the sides of the long platform. Here, the garbage collected from households and businesses in the city is dumped with a thunderous crash into awaiting barges. When a barge is filled, a tugboat is summoned to pull it to the Fresh Kills Landfill site on Staten Island. On any given day, the barges form a quiet, methodical procession down the river.

When completed, *Flow City* will bring citizens into a site they are normally excluded from or forbidden to enter. From the West Side Highway, visitors to the 59th Street Marine Transfer Station enter through a pedestrian corridor at the south end of the facility. As they walk up an enclosed passage made entirely from recyclables, visitors can see passing trucks through viewing windows. The walls and ceiling of the passage are constructed in a corkscrew pattern which spirals on up to a viewing pavilion. These variegated, textured surfaces carry visitors through a journey that engages many senses in the active encounter with solid-waste management as an essential environmental and civic process.

At the top of the ramp, visitors turn south onto a glass-enclosed platform offering three unique but related views. To the east lies a city panorama of skyscrapers. Perhaps the most stereotypical view, it is abstract, pristine, distant, and dramatic. In contrast, the view to the west faces the watery channel where the barges are filled. Viewers observe the relentless disposal of garbage, meanwhile possibly sensing the sounds and smells of this grand, perpetual saga of waste relocation. Along the south wall of the platform is a grid of stacked videos for changing art and environmental education programs. Artists, scientists, ecologists, and others will be invited to develop video projects for the site. Several of the monitors will present continuous views of the Hudson River recorded by cameras mounted on the exterior wall of the facility.

The site of *Flow City* represents the essential connection of the city and the river, the constructed environment and natural ecologies of the region, sanitation work, and urban viability.

With these three elevations, Ukeles modulates the abstract, the visceral, and the representational, allowing viewers to arrange and assemble information regarding what they can see as well as what they can perceive of their own role within these vast activities. Will the opportunity for observation provide new interpretations and insights? Will the direct witnessing of sanitation activities stimulate a sense of responsibility and activism that had not existed before? Clearly, none of these rhetorical questions can be answered, but Ukeles's decision to include the public in a formerly hidden-from-sight context has opened a range of new possibilities. She advocates that if people can directly observe how the city works, they can then direct their actions and ideas toward the construction of a meaningful public life. By creating a point of access, Ukeles enables members of the public to make more incisive connections with the physical dimensions of their urban and natural worlds. Both the city and the river are seen as relational; *Flow City* serves as the suture that draws the extremes of the nature-culture dialectic into visible coexistence.

Given Ukeles's commitment to bring people into places formerly unavailable to them, she has also explored the growing phenomenon of visitors' centers. Based on her research, she observes that many of these sites are not truly points of access, but simply lobbies offering highly controlled, preordained, and mediated experiences. In her most ambitious project to date, Ukeles herself will need to resolve this dilemma, as well as other monumental issues. As an example, among Ukeles's most recent commissions is a project that asks her to creatively

engage her ideas—and the public—at the city's final point of destination for discarded waste: the Fresh Kills Landfill on Staten Island.

It is difficult to imagine a more challenging social or environmental site than a landfill. While artists have become increasingly interested in rejected, refused, or difficult sites (abandoned quarries, strip mines, and former industrial areas), the Staten Island landfill is a simmering stew of problems and potentialities. Consisting of four mounds ranging in height from 350 to 470 feet, it is the largest solid-waste landfill in the United States and possibly even the largest human-made construction. In addition to its titanic scale, the context of Fresh Kills abounds with enormous contrasts—residential and commercial developments are set cheek by jowl alongside unusual, fragile environmental systems. On one side, the Staten Island Mall, then sprawling residential areas—and on the north end, four varieties of wetland.

Embracing a site that may be one of the last places most people would want to visit or explore, Ukeles envisions this compressed, congested place as a rare opportunity to actually experience the collective pressure of material culture and its impact on the environment. Made of nothing but the detritus and castoffs of daily life, landfills are a form of social sculpture. In fact, archaeologists have begun to study both historic and active sites, sifting through the layers of discarded artifacts that witness changes in consumer patterns and disposable products.

Mierle Laderman Ukeles, *Fresh Kills Landfill and Sanitation Garage Project*, begun 1989. Landfill site on Staten Island, New York. This Percent for Art project was awarded through the Department of Cultural Affairs. Ukeles has done extensive research on landfills as well as on the circumstances of this site.

Mierle Laderman Ukeles, *Danehy Park*, 1990–93. Glassphalt path, plantings. Fifty-five-acre former landfill, Cambridge, Massachusetts. Employing the practical and metaphorical implications of glassphalt, Ukeles created a gently inclining pathway that is accessible by wheelchair.

The Fresh Kills project is in its infancy, and it may well be a life-long pursuit for the artist. At this point Ukeles is engaged in reconnaissance, researching, and observing the complexities of the area, meeting with environmental specialists, and working more closely than ever with the Department of Sanitation. She will need to assimilate data from a vast range of fields and specialists in order to construct a coherent vision of place—an enormous task, inherent to this kind of activist endeavor.

The most significant issues are how, where, and why to involve members of the public in the 3,000-acre site. The size of three Central Parks, the landfill will have to be penetrated at strategic points where opportunities for observation and participation, when conceptually assembled, will begin to reveal the epic dimensions of solid-waste management.

Artist as Agent: Art, Action, and Education

Education may be Ukeles's most powerful recipe for quickening others' activism. Always open-minded and never didactic, she is engaged in an active learning process—a critical pedagogy that asks participants in her projects to also be clients, collaborators, and discussants. Just as research, experimentation, testing, and analysis are central to her creative process, the experiencing of the work requires similar levels of involvement from viewers. Whether enduring or ephemeral, Ukeles's projects and performances are deliberately pro-

vocative catalysts designed to stimulate conversation and exchange among members of the public as well as the "specialists" who work in these highly sophisticated, rarefied fields.

At Mayor Thomas W. Danehy Park in Cambridge, Massachusetts, Ukeles has had an opportunity to test her germinating ideas concerning landfills on a more discrete scale and in a less demanding context. Compared to the Fresh Kills site, Danehy Park is diminutive. Completed in 1993, the fifty-five-acre knoll project is surrounded by sports fields and other playing grounds. Only seventy-two feet high, it still provides a panoramic view of the Cambridge-Boston area. Working with landscape architect John Kissada of Camp Dresser & McKee, Inc., and with the support of the Cambridge Arts Council's program Art Insights, the artist designed a simple path system that winds gently around the knoll, bringing visitors to the top. The gradual incline makes the entire site wheelchair-accessible.

Part of the project's program involved educational presentations with community children and adults. For the glassphalt used to construct the path, the glass component came both from bottles the children had collected and a week's collection from the city. The metaphorical dimension of glassphalt accommodates many levels of understanding. In older landfills used before recycling (like the Danehy site), glass was one of the disposable products and actually constituted a significant component of most landfills. Resting on the surface of the landfill, now reconstituted as park, the glassphalt is a hinge between the past and present of solid-waste management. Once a discarded item, glass is now a leading recyclable. Given the thick skein of streets and highways in the national transportation system, asphalt may be this country's most commonplace, banal material. With glassphalt, the addition of colorful pieces of broken glass not only pragmatically recycles, but adds a more variable, visual experience as small particles catch the changing angles of light during the day. The glass encourages an intimate encounter with the ubiquitous.

Entitled *Turnaround Surround*, the work offers visitors an experience focused on the summit and its environs. Planting and vegetation along areas of the one-half-mile glassphalt pathway offer a moving, aromatic experience of the natural world. In addition to the *Smellers and Wavers*, Ukeles's name for the horticultural aspect of the project, a

Mierle Laderman Ukeles,
RE-SPECT, 1993. From a
performance on the quai
and Rhone River, Givors,
France.

final stage of the project will include *Community Implants/Transplants*, disk-shaped reliquaries representing the ethnic composition of the local community and holding objects of significance contributed by them. This dimension of the project involves psychological reclamation, the repossession of a rejected site as a meaningful, interactive public place. There are at least fifty cultures represented in the surrounding community; each of the fifty relics recalls specific individuals as well as diverse cultural traditions of the region. The relics personalize public space so that a stewardship, a sense of entitlement and responsibility, emerges.

> Perhaps we would be happier in our cities were we to respond to them as to nature or dreams: as objects of exploration, investigation and interpretation, settings for voyages of discovery.[12]

The haunting image of an illuminated mountain of broken blue glass hovering above the waters of the Rhone River is a vision worth maintaining. Ukeles's particular pursuit of activist art metaphorically invites the public to participate in "voyages of discovery." As she brings both intellectual and instrumental predilections to a generous range of circumstances (municipal agencies, landfills, solid-waste management), she constructs "settings" that people can occupy, transform, imagine, and maintain in order to develop new visions of their place and role in a world of change. A dedicated creator of forms and spaces, Ukeles remains committed to the use of art for social purposes. Talking, inventing, healing, planning, improvising, and making, Ukeles's performances of creative work produce memorable forms of public service.

Is It Still Privileged Art?

The Politics of Class and Collaboration in the Art Practice of Carole Condé and Karl Beveridge

One of the problems today is that art exists as something "external." We use "universal" and institutionalized standards to evaluate the art work, rather than considering how it affects a specific community, or gives "expression" to that community's needs.
—Carole Condé and Karl Beveridge

The Homecoming

On January 24, 1976, an exhibition of recent works by Carole Condé and Karl Beveridge, *It's Still Privileged Art*, opened at the Art Gallery of Ontario in Toronto. Since their decampment from Toronto to the New York City art scene in 1969, Condé and Beveridge had accrued reputations south of the border as Minimalist/Conceptualist artists, and their homecoming was expected to bring local veneration for art work already validated (in that inevitably Canadian way) elsewhere. To the surprise of the audience and the institution, however, the exhibition revealed a radical shift in aesthetic orientation. Rather than encountering sculptural works exploring questions of perception and materiality, the audience was greeted by large banners extending the length of the gallery walls with slogans announcing "ART MUST BECOME RESPONSIBLE FOR ITS POLITICS" and "CULTURE HAS REPLACED BRUTALITY AS A MEANS OF MAINTAINING THE STATUS QUO." Underneath the banners, a series of silkscreened works featured the artists in various "heroic" poses transplanted from Soviet and Chinese workers' posters. In keeping with the ephemeral and

unconventional nature of the exhibition, a book work designed in the style of Chinese comics was produced in place of the traditional catalog.

The book work for *It's Still Privileged Art* served to document the artists' politicization, and to question the underlying assumptions of an institutionalized art practice. Within its pages, cartoons illustrate the artists' everyday activities (such as their studio production, interactions with collectors and curators, the raising of their children) and trace the development of a visual strategy capable of expressing the importance of art as a social practice. Short

> **Culture has replaced brutality as a means of maintaining the status quo.**

texts accompanying the cartoon images break open the hermetic seal of artistic discourse to provide discussion on a wide range of issues affecting art practice, from competition and individualism to gender inequality and cultural revolution. In one of these texts, Condé and Beveridge address the context for the reception of overtly political images, speculating upon the reactions their work might provoke from the Art Gallery of Ontario audience. They imagine that some artists will find the work an embarrassment ("they'll fall on the floor laughing"), while others will try to reduce their politics to fashion ("so now you're doing 'Political Art'").[1] As it turned out, the actual exhibition proved more controversial and its reception more adversarial than Condé and Beveridge had envisioned. It was one thing to be an artist with poli-

Carole Condé and Karl Beveridge, *Social Practice*, 1976. Ink on paper, 6" x 4". Illustration for the book *It's Still Privileged Art*. The drawings trace the politicization of the two artists.

The poster on which it is based depicts two artists concerned with a social practice rather than 'self-expression'. We use ourselves as subjects to make the work specific, rather than abstract, or universal.

tics. It was another matter altogether to incorporate a call to social revolution as the transparent theme of an exhibition.

Crossing the boundaries of "art" as defined by an international art market, and breaking with conventions of form and content, the didactic nature of the exhibition met with hostility and silence. Written commentary tended to be dismissive in tone, with one local critic decrying the work as "a vapid and gullible recycling of someone else's propaganda."[2] For the most part, however, critique of the work took place around kitchen tables and to the artists' faces. Art pundits and colleagues alike attacked the use of agitprop and social realism as a naïve and crude political posturing. Condé and Beveridge's insistence that a radicalism of ideas without a radicalism of society ended up reinforcing rather than disrupting a cultural status quo was interpreted as a betrayal by those artists who viewed participation in the art world as subversive rather than complicit. Touching on issues of gender, class, community, and identity, *It's Still Privileged Art* no longer spoke the language of the art world and the connoisseur, but that of political activism and the *agent provocateur*. In so doing, it set the stage and the parameters for Condé and Beveridge's subsequent cultural practice. Taking seriously their own rhetorical call for art to "become responsible for its politics," Condé and Beveridge returned permanently to Canada at the end of 1977 to initiate a series of community arts projects with a focus on developing collaborative works with the Canadian labor movement.

By choosing the trade union movement as a primary site of cultural production and reception, Condé and Beveridge sought to anchor the theoretical analysis of *It's Still Privileged Art* to an institutional space in which issues of class form a practical basis for organized resistance to capitalism. From their first collaborative project with a union, *Standing Up* (1981), a chronicle of women workers' fight to win a first contract, to *OSHAWA* (1983), a photographic history of United Autoworkers Local 222, in Oshawa, Ontario, to *No Power Greater* (1991), an examination of the impact of industrial globalization and technological change on the unionized workforce, their work reflects an ongoing commitment to ground their images in the specific political arena of struggles between capital and labor, individualism and collectivization. Formally, this process has taken

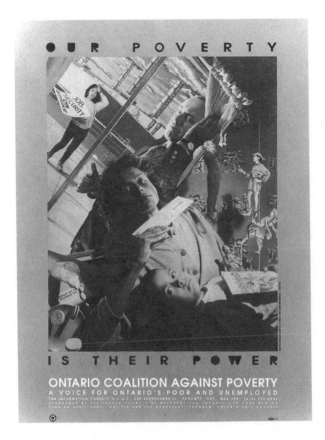

Carole Condé and Karl
Beveridge, *Our Poverty
Is Their Power*, 1992.
Offset black-and-white
poster, 16" x 20".
Produced for the Ontario
Coalition Against Poverty
with the Labour Council of
Metropolitan Toronto.

shape through the use of highly stylized photo-narratives that com-
bine sets, props, actors, and photomontage to "restage" the oral histo-
ries of union members as told to Condé and Beveridge. Conceptually,
these narratives provide an ideological space that is class identified
and community based. Working in consultation with trade unionists
to produce images that represent their point of view and their stories,
and to circulate these images in their workplaces and union halls,
Condé and Beveridge explicitly counter the effacement of class divi-
sions endemic in both the mass media's populist appeal and the art
museum's sanitized presentation of "culture."

Setting the Political Stage

While *It's Still Privileged Art* signaled the future directions of Condé
and Beveridge's representational strategy, it also reflected, Janus-like,

the many debates over aesthetics and politics integral to the turbulent New York art world of the 1970s. From 1969, when Condé and Beveridge arrived in New York City, until their departure at the end of 1977, the SoHo art scene of downtown Manhattan was witness to the crumbling edifices of a modernist orthodoxy. Formalist camps of hard-edge painting and Minimalist sculpture ran aground against a dematerialization of the art object that encompassed everything from Andy Warhol's films to body and performance art. Conceptualism as an art movement took hold, leading toward a cul-de-sac in language games in which the extrapolation of the idea from the object left artists owning concepts and spinning visual cobwebs. The art market, while adaptable enough to support the dematerialization of the object, went through its own convulsions in the wake of a recession precipitated by the oil crisis of 1973. A heady measure of anti–Vietnam War sentiment, Maoist ideals of cultural revolution, and feminism contributed to this ferment, as well as to a sense of the New York City art world as a closed shop of aesthetic intrigues and jangling politics.

Like another famous Canadian couple before them, Michael Snow and Joyce Wieland, Condé and Beveridge came to New York in order to achieve recognition as "international" and "avant-garde" artists and were radicalized by the process of confronting this mythology. When Snow and Wieland returned to Canada, it was as cultural nationalists. Condé and Beveridge's embrace of a community-based art and the labor movement reflected a similar anti-imperialist stance and in addition the influence of the feminist and Marxist debates unfolding in New York City during this period. For Condé, politicization began with her involvement in the ad hoc Women Artists' Committee, a group of New York–based women artists whose protests against the art world's systematic exclusion of women included weekly discussion groups, street actions, and a boycott of the 1970 Annual Exhibition at the Whitney Museum of American Art. On Beveridge's part, his friendship with the New York City component of a Conceptualist collective, Art and Language, led to his participation in their increasingly politicized discussions concerning rhetoric and power. By 1975, both Condé and Beveridge were working through the implications of

gender inequality on the home front and attending editorial meetings for Art and Language's publication, *The Fox*.

Published three times before the group disbanded in 1976, *The Fox* is a rare artifact of the period of fractious and internecine political discourse that gripped SoHo by the mid-1970s. In its voluminous pages, artists such as Ian Burn, Joseph Kosuth, and Mel Ramsden thrash out the finer points of Marxist-inspired theory and ponder their role as nonproletariat petit-bourgeois artists with revolutionary sympathies. Editorial meetings often lasted for days at a time, with the ensuing discussions about workers' consciousness and social trans-formation adroitly captured in a transcript published in the third issue of *The Fox*, entitled "The Lumpen-Headache."[3] By the time of *The Fox*'s demise, serious rifts had occurred between members of the collective, and splinter groups had formed over such issues as group hierarchy, the need to abandon individual artistic identities, and male chauvinism. Some members declared themselves anarchists and unwilling to submit to collective discipline. Others, including Beveridge, Condé, and Burn, sought to push the implications of a class analysis of culture further, producing another magazine, *Red Herring*, that was less theoretically dense and more historically grounded than *The Fox*. Surviving for only two issues, *Red Herring* featured articles on art and unions, Langston Hughes's poetry, denun-ciations of capitalist exploitation, calls for anti-imperialist strategies, and a comic strip by Condé and Beveridge.

Carole Condé and Karl Beveridge, *The New Rymans*, 1976. Ink on paper, 6" x 4". Illustration for the book *It's Still Privileged Art* that was published to accompany an exhibition at the Art Gallery of Ontario in 1976.

After lunch they go to the galleries to keep up with what's going on. The new Rymans' are damn tough, push-ing the 'materiality' of the paint even further. On the way home they meet a Collector and invite him over.

In contrast to the otherwise solemn tone and earnest stance of
the publication, Condé and Beveridge's comic strip offered a humor-
ous testimony to SoHo's uneasy mix of art and politics. Thinly veiled
autobiography, the cartoons underscore the tensions experienced
by artists whose advocacy of a theoretically inspired socialism con-
trasts starkly with their day-to-day lives as middle-class consumers.
While the cartoon characters themselves arrive at no resolution of
their ideological impasse, the artists associated with *Red Herring*
continued to struggle with the widening gulf between practice and
theory. Some decided to abandon art altogether, leaving SoHo to
work in factories and experience proletarianization firsthand. Others
muted the pitch of their militancy and slipped into a lifestyle attached
to the idea of revolution and to the comfort of SoHo loft spaces.
Condé and Beveridge found themselves in Newark, working with a
group led by Amiri Baraka, an East Coast Black Power poet turned
Maoist. It was at this point that the tensions between an articulated
commitment to a politicized art practice and their displacement as
expatriate Canadians became most acute. As Condé tells it, "One day,
we were deep in the Bronx meeting with African American militants
when I looked around and realized it was time to go back to Canada
and begin to build a local culture there."[4]

In *It's Still Privileged Art*, Condé and Beveridge's musings over the
contradictions of "living in the middle of New York and talking about
decentralization; showing at the Art Gallery of Ontario and talking
about not being in institutions; living in the art world ghetto and
talking about getting out and working in the 'real' world,"[5] led them
to declare that their politicization as artists could have only taken
place in New York City. Just as paradoxically, it was by engaging the
specific conditions of Canadian culture that Condé and Beveridge
put into practice the political lessons learned during their eight-year
sojourn in America. As a periphery of the American empire, Canada
in the early 1980s was at once influenced by the center and distanced
from a globalizing, free-fall economy, defending its sovereignty
through state-supported culture and a state-brokered economy. In
contrast to New York with its art world's confluence of money and
hype in ascendancy during the Reagan years, Canada lacked an inter-
nal art market. Moreover, the nature of Canada's entrenched funding

of the arts mitigated the harshness of the New Right agenda felt more directly in the United States. Thus fleeing the influx of European painting that swept through the U.S. art market in the late 1970s, Condé and Beveridge headed north of the border to a cultural climate where arm's-length arts councils and peer assessment juries offered the potential to sustain a commitment to oppositional culture.

While the anomaly of a socialist cultural infrastructure coexisting within a neoliberal capitalism left Canadian artists less vulnerable to the vagaries of an international art market than their American counterparts, it also tied them more closely to the historical legacies and ideological constraints of state patronage. Paul Litt, a Canadian historian, observes that "some nations develop a culture through centuries of accumulated custom and achievement; others forge an identity through revolution or war. Canada established a Royal Commission."[6] Known as the Massey Report, this Royal Commission had presented recommendations to Parliament in 1957 that formalized a role for subsidized culture as the guardian angel of national identity and led to the founding of the federal funding agency for the arts, the Canada Council. In the process, it also drew a dividing line between high art and popular culture—the former designated as Canadian and in need of state patronage, the latter as the vulgar materialism of an American consumerism in need of state regulation. Positioning state funding of the arts as simultaneously anti-imperialist and anti-populist, this policy officially sanctioned distrust of mass culture and initiated a series of contradictions between elitism and democratization of the arts that deepened over time.[7] And it is specifically this contradictory inheritance of subsidized culture and elitist rationales that Condé and Beveridge confronted in their efforts to democratize the production and reception of their art from within the Canadian context.

In choosing the institution of trade unions as a site from which to democratize culture, Condé and Beveridge also had to contend with the historical legacies and ideological constraints of the labor movement in Canada. Echoing the paternalism that engineered the development of a national culture, the Canadian state has played a highly interventionist role in "managing" working-class militancy. From

> It was time to go back to Canada and begin to build a local culture.

the Industrial Disputes Investigation Act of 1907, in which the federal government appointed itself as mediator for labor conflicts, to a Social Contract in Ontario in 1993 that imposed wage restraints on all public-sector union employees, government has restrained rather than opposed union authority through legislation. In return for collective bargaining and the right to association won in the 1940s, trade unions are expected to keep rank and file in line and to maintain shop-floor discipline. Welfare-state policies of the post–World War II era have also soothed labor antagonisms through the introduction of concessionary wage increases, pension plans, universal health care, and educational subsidies. Since the time of Condé and Beveridge's return to Canada, however, this Keynesian harmony has come unraveled at the edges. Technological shifts in production, recessionary economies, and globalization of markets and labor are enacting a growing toll upon concessions wrung from reluctant employers, leading one labor historian to describe the years 1975–90 as "ones of permanent crisis."[8]

Constructing a Collaborative Process

Stepping into this history, and into this crisis, with their decision to produce work in collaboration with the union movement, Condé and Beveridge in their art practice reflect a complex negotiation of possibilities along broad cultural and political boundaries. In a preface to *First Contract: Women and the Fight to Unionize* (1986), a book project based on the *Standing Up* photo-narrative, Condé and Beveridge offer an impression of how this process of negotiation unfolds. Describing their initial meetings with union representatives, they note that when the term "art work" comes up, union members are hesitant and puzzled. Assurances from Condé and Beveridge that "for us this means art about the lives of working people . . . [about] how you yourselves see things,"[9] do not immediately ease a general distrust; nor does their explanation that the proposed collaboration has received arts funding from the Canada Council. For the union local, the idea of getting involved in an art work is a hard one to embrace. Historically, the largesse of subsidized culture has not benefited their community, while the idea of art carries with it an indelible stamp of class privilege. In order to create confidence in the process of

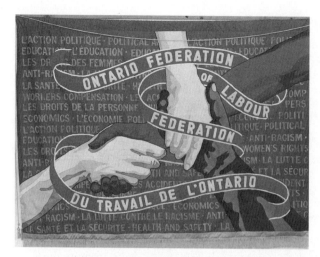

Carole Condé and Karl Beveridge, *OFL Banner*, 1991. Fabric and paint, 84" x 60". The banner was commissioned by the Ontario Federation of Labour. The arms are red, white, black, and yellow, the colors used by Canada's First Nations peoples to depict the peoples of the world.

collaboration, Condé and Beveridge not only have to convince the unions of their sincerity as artists, but also to convince them that the end product may have some meaning and validity to their membership.

In practical terms, confidence in the collaborative process is developed through a specific framework of participation and clearly defined divisions of labor. When Condé and Beveridge first approach a union local with an idea for an art work, they bring to the bargaining table several important components of the project. Primary funding for the production of the work is secured from arts-council sources rather than from union dues. The themes and directions for the proposed art work are discussed and agreed upon in consultation with union members. In return, the union is asked to provide information resources, including access to its archives and permission to interview its members. Once the general parameters of the project have been established, visual interpretation of the material is entrusted to Condé and Beveridge. With creative control and copyright resting with the artists, Condé and Beveridge enjoy substantial leeway in the construction of their images.[10] The result are large Cibachrome tableaux that intentionally engage the vocabulary and visual style of advertising in their use of staged photography to sift oral history and archival evidence through the codes of popular culture. With hints of Brechtian theatricality, Soviet avant-garde photography, and social-realist iconography, their images also reflect formal devices present in earlier

works such as *It's Still Privileged Art*. The resulting merger chips away at the perception that art is inaccessible and elitist and seeks to recast a cultural equation that has the rich attend art galleries and the working class watch television with the production of an art work that can be equally at home in a union hall or on an art gallery wall.

Bringing to the process of collaboration a cultural perspective formed by a modernist art training and an engagement with contemporary artistic and political debates, Condé and Beveridge's distinctive photo-narrative style is also shaped by the direct input and feedback of union members. For example, in their first formal collaboration with the labor movement, *Standing Up* (produced with the United Steelworkers of America in 1981), the documentation of women workers' fight to unionize Radio Shack brought with it certain constraints. While the women were willing to be interviewed and to discuss the difficulties, both emotional and political, of fighting for a first contract, they faced potential reprisals by the company if they could be personally identified in the work. Thus, in order to protect the women, Condé and Beveridge decided to re-create rather than document their experiences. Adopting strategies that subsequently became their trademark style, they shaped composite characters from individual testimonies and used actors and props to stage a visual narrative. Similarly, the artists' decision to define clearly the division of labor between union participation and artistic production originated in the responses of union members to a more hands-on collaboration. As Condé and Beveridge explain in *First Contract: Women and the Fight to Unionize*:

> A few years ago we were doing a project with women who were organizing a union. We had these vague notions about involving them in the actual production of the work until one of them pointed out: "Look, we're skilled in what we do. We know what we're dealing with. You're skilled in what you do. I wouldn't know one end of a camera from the other and I don't particularly want to. As long as you do a good job, we'll do our part." It wasn't that they weren't interested, particularly in the use of media, which they understood. It was that their time was taken up with the union, their job, and family.[11]

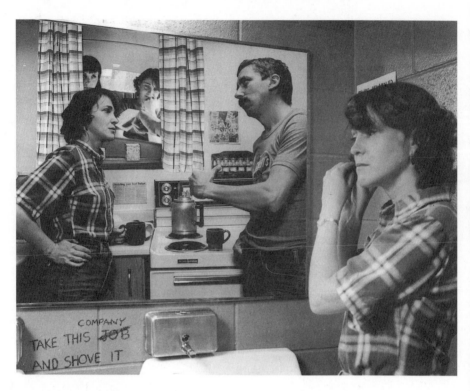

Carole Condé and Karl
Beveridge, *Linda No. 2*,
1981. Cibachrome color
photograph. One in a
series of three narratives
depicting women on strike
for a first contract. The
series was published as
*First Contract: Women
and the Fight to Unionize*,
a book created with the
help of the United
Steelworkers.

For Condé and Beveridge, the process of negotiation that frames their collaborative relationship with the labor movement also stretches beyond the actual production of art works to encompass a variety of union-related activities. Predating the formal collaboration with unions that began with their *Standing Up* project, Condé and Beveridge were involved with a drive to organize farmworkers in Ontario, and in English as a Second Language programs. Producing posters and pamphlets in solidarity with these activities, Condé and Beveridge have continued this tradition to the present day, creating posters, buttons, and banners for a number of different union locals and activist concerns. In 1982, a number of artists and labor representatives, including Condé and Beveridge, attended a symposium sponsored by the Ontario Arts Council on the role of popular movements in the development of Swedish culture. Timothy Porteous, director of the Canada Council at the time, proclaimed from the floor that a community-based art practice did not exist in Canada, nor—given the fact of state support for the arts—should it have to. Prompted to action by this cavalier dismissal, Beveridge, Condé, and other symposium participants retired to a local bar to found the Labour, Arts and Media Working Group (LAMWG), dedicated to forging closer ties between the labor community and artists.[12] Working in cooperation with the Canadian Labour Congress, and later the Ontario Federation of Labour and the Labour Council of Metropolitan Toronto, this ad hoc committee has since then spearheaded a number of activities, encouraging unions to mount exhibitions of contemporary artists in union halls and workplaces, and to participate in sponsoring art-related activities.

The most public manifestation of the LAMWG's promotion of community- and labor-based cultural activity is the Mayworks Festival of Working People and the Arts, held annually in Toronto since 1986. A monthlong extravaganza of music, visual arts exhibitions, cabarets, theater, artists' talks, and gallery tours, it brings cultural activities into the unionized workplace and unionized workers to events held in the downtown gallery district. As founding organizers of Mayworks, Condé and Beveridge have been instrumental in its growth, lobbying the labor movement and the arts councils for funding support and facilitating various events over the years. In conjunction with the

growing success of Mayworks, LAMWG has also succeeded in establishing an Artists and the Workplace Program at the Ontario Arts Council that funds collaborative projects between individual artists and unions. With projects ranging from archival photographic research to murals to theater workshops, this program directly challenges the parameters of state support for the arts that discourage a collectivization of resources (as opposed to individual production for the market) and a community-based culture. On the labor side of the cultural equation, Beveridge has also been active as a board member of the Workers Heritage Centre, an organization of cultural activists, labor historians, and trade-union members founded in 1986 to work toward the opening of a workers' museum in Ontario.

As a parallel to the inroads made by LAMWG into the infrastructure of the art world, Condé and Beveridge are also committed to organizing a collective negotiating voice for artists. Founders of the Independent Artists Union in 1984, they sought to formalize a bargaining relationship between state funding and artists, recruiting members on a platform of a guaranteed minimum wage for artists, unemployment and pension benefits, and legislative recognition of artists as cultural workers. Unfortunately, the failure to achieve any concrete realization of its goals led to the demise of the union by the early 1990s. In its initial stages, however, the Independent Artists Union provided a political space for discussion around issues of gender and racial equity that are now central to debates concerning state funding and the politics of difference. And during the peak of its activity as a lobbying group, the Independent Artists Union was a key pressure point in the art councils' decision in the 1990s to prioritize access to funding for racial minorities, and to incorporate community context and community representation as legitimate considerations in the peer jury process. Condé and Beveridge are also long-standing members of A-Space, Canada's oldest artist-run center. In this capacity, they were instrumental in shifting the orientation of the gallery from a theoretically based postmodernism to a community-based activism in the late 1980s. In organizing a community arts committee for the center that incorporates a number of different artistic expressions into the programming agenda, including Caribbean dub-poetry, community theater, and political video, Condé and Beveridge have

made the local art scene as well as trade unionism a conceptual space of cultural democratization.

By extending the range of their involvement with trade unions beyond the production of art works to embrace the cultural and social organization of the labor movement, Condé and Beveridge construct an art practice that is simultaneously reflective and activist in conception. Here, representation of a collective self-identity (in this case, trade unionism) is balanced by the artists' active engagement in shaping community involvement. Cultural production is anchored in a process of reciprocity, in which a space is created for dialogue and exchange, rather than one limited to explication and appropriation. As Condé and Beveridge suggest, there are many organizations for artists to work with: "churches, community centres, political organizations, various social movements, and so on. . . . The main thing is that you identify with them, share the same goals—or you can forget about the trust. It's important that you feel a part of whatever organization or group it is."[13] In contexts like these, commitment to the dual principles of trust and reciprocity shapes not only the context of their community art practice, but mediates the form and content of the art works themselves. As artists offering their expertise to unions, Condé and Beveridge receive in return the willingness of union members to share knowledge and resources. And as active participants in the making and remaking of their cultural representations, union members exercise an influence over both the thematics and the formal structures of Condé and Beveridge's artistic productions.

Constructing Representational Strategies

The importance of this reciprocal process of dialogue and exchange in their work is underlined by the problems raised in an early photonarrative piece, *Maybe Wendy's Right* (1979). Completed before they established a formal collaborative relationship with the labor movement, *Maybe Wendy's Right* features Condé and Beveridge enacting a fictional scenario of "working-class," everyday life. Without any direct input from or consultation with the workers they sought to represent, however, Condé and Beveridge ended up producing a pastiche of what they imagined the working class to be. Speaking for rather than with their subjects, Condé and Beveridge literally

transposed the domestic environment of a middle-class artist couple like that in *It's Still Privileged Art* with one of a working-class family. In *It's Still Privileged Art*, Condé worries about cleaning and cooking although she wishes she were in the studio. The serene breakfast table scene, we are told in the cartoon caption, "is not really like this. In fact their mornings are neurotic and tense, but it's an image they all maintain."[14] In *Maybe Wendy's Right*, domestic tensions are foregrounded in the visual narrative itself. Wendy and Bill worry about mortgage payments, the price of food, and whether Bill should go out on strike or accept a wage settlement worse than the old contract. The result, in comparison to later works, is a crude caricature of a "working-class" world. *Maybe Wendy's Right*'s emphasis on the domestic setting, however, and its concern to render visible a relationship between gender and class conflict, reveals a feminist perspective that is an important dimension of their cultural practice.

> **Domestic tensions are foregrounded in the visual narrative itself.**

In subsequent works, Condé and Beveridge traded in their impersonation of the working class for the production of images that are mediated by oral history and union participation. In turn, they bring to their projects a sensitivity to gender issues that reflects their own experiences and struggles to work together as artists. As such, their external collaborations with unions mirror an internal commitment to the collective process of questioning and discussion in their own art. The result is a dramatization of union stories that holds itself accountable for dialogue taking place at both the personal level (between the artists) and the political level (between the artists and the union local). Constructing "positive" and didactic portraits of the labor movement that simultaneously explore the contradictions and conflicts of workers' lives, the content of the pieces reflects the dialectical nature of the working process. Seeking to redress women's historical absence from traditional labor historiography and to reflect women's increasing presence in the workforce, Condé and Beveridge have chosen to emphasize women's roles in the labor movement, as both behind-the-scenes and frontline organizers. Their photonarratives point to the importance of women in contemporary union

militancy as well as to the tensions that occur as gender roles are redefined in the workplace and in the home.

In *Standing Up*, the concern to privilege a feminist perspective is formally inscribed through the juxtaposition of staged settings that construct an interior space of domesticity with a contrasting exterior world represented by photographic inserts. In each of the three photo-narratives making up this piece, these images are combined with first-person testimony to explore the private/public dichotomies that fracture working-class lives and paradoxically give women the strength and determination to unionize. In the case of Natalie, her kitchen table becomes the visual focus of the narrative, as photographic scenes of the job site and striking women are mapped onto a picture window in the background. A single mother, Natalie voices her concern over the effects that the working conditions on the job and the violence of the strike have had on her children, who are harassed at school by the manager's kids and on the telephone at home by union busters. Linda, whose story unfolds in the company washroom, is in conflict with her husband over her union activities. Here, the bathroom mirror becomes a window on external forces, with photographic scenes revealing confrontations with her husband and the solidarity of her fellow women workers on the picket line. Vicky, featured working alone in the Xerox room with photographs of the company boss appearing above her on the television screen, exemplifies the company tactic of isolating workers.

In a similar vein, *OSHAWA* privileges the domestic environment and the woman's point of view as it retells the history of United Autoworkers Local 222 in Oshawa, Ontario, the center of Canada's automotive industry. Divided by decades into five sections from 1934 to 1984, *OSHAWA*'s narrative structure hinges upon the dramas that unfold in the workers' kitchens and living rooms over union organizing, the intrusion of technological change in the home and on the shop floor, and the internal struggles faced by the union during the Cold War. With intensive archival research and over thirty interviews conducted during the project, Condé and Beveridge discovered that despite one-sixth of the workforce being composed of women there was no photographic evidence of their existence. In response, Condé

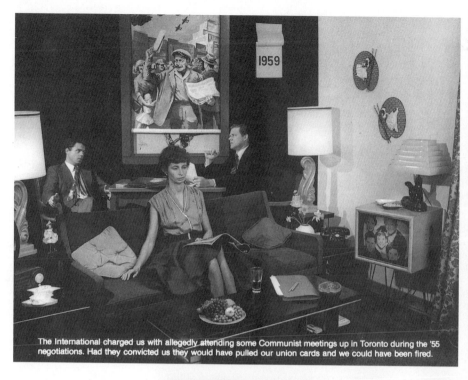

The International charged us with allegedly attending some Communist meetings up in Toronto during the '55 negotiations. Had they convicted us they would have pulled our union cards and we could have been fired.

Carole Condé and Karl Beveridge, *OSHAWA, 1959, No. 1*, 1983. Cibachrome color photograph. The first of two in a series of sixteen images for the 1950s showing the hunt for left-wing unionists in Canada by U.S. union leaders. The project as a whole includes over fifty images.

Carole Condé and Karl Beveridge, *OSHAWA, 1959, No. 2*, 1983. Cibachrome color photograph. The second image showing the hunt for left-wing unionists. The *OSHAWA* series is on permanent display at the Canadian Auto Workers Education Centre in Ontario, Canada.

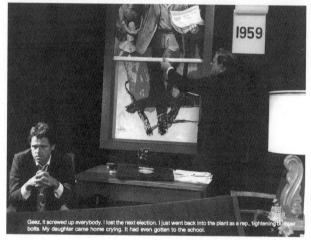

Geez, it screwed up everybody. I lost the next election. I just went back into the plant as a rep., tightening bumper bolts. My daughter came home crying. It had even gotten to the school.

and Beveridge took as their central organizing theme a trajectory tracing the roles of working women from kitchen-table organizers in 1934 to frontline workers on the assembly line in the 1980s. Here, the mapping of exterior upon interior spaces and the use of period props make explicit not only the relationship between gender and ideology, but also between culture and consciousness. In the post–World War II period, for example, Condé and Beveridge's tableaux become metaphors for the chill of a Cold War ideology and the rise of a mass culture that released women from wartime factory jobs only to return them to homes filled with "labor-saving" appliances and television sets. By contrast, an image from 1959 represents another casualty of the Cold War. In it, a union boss from the American head office accuses local members of communist sympathies while pushing up a blind to unveil the predominance of American Abstract Expressionism over local culture.

Exploring the Contradictions of Class and Ideology

This visual exposition of the ways in which technology and culture intertwine to enforce an ideological status quo in a postindustrial society is also central to a 1986 work addressing the nuclear power industry, *No Immediate Threat*. In contrast to most of their photo-narrative projects, *No Immediate Threat* was not a direct collaboration with a union local, but grew out of a summer theater project written and produced by Catherine Macleod. Following their work as visual consultants on Macleod's play, a community-based production about the everyday lives of the nuclear plant workers in her hometown of Kincardine, Ontario, Condé and Beveridge expanded the stories they heard to produce a project examining the unspoken tensions and unmentionable environmental hazards that shadow the lives of these workers. Perhaps owing to the fact that they are some of the highest-paid unionized workers in Canada, nuclear industry workers form a tight-knit intergenerational group whose routine exposure to radiation is accompanied by a collective denial of the health risks they face and an acquiescence to company "safety" standards. Choosing to focus on this denial as the central trope of the piece, Condé and Beveridge create a metaphor for the ways in which ideological contradictions are

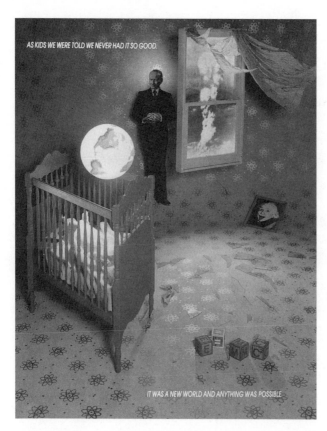

AS KIDS WE WERE TOLD WE NEVER HAD IT SO GOOD.

IT WAS A NEW WORLD AND ANYTHING WAS POSSIBLE.

Carole Condé and Karl Beveridge, *The Crib, 1945*, 1986. Cibachrome color photograph. One of eight images in a photo-narrative titled *No Immediate Threat,* on the nuclear power industry.

internalized and reproduced, in this case literally slipping under the skin and into the cells of the nuclear industry workers.

Visually, *No Immediate Threat* is the most striking and evocative of their photo-narrative works, incorporating social and political references that reach beyond the specific environment of these workers to address the global context ushered in by the nuclear era. Using painted backdrops rather than reconstructed settings, Condé and Beveridge create a free-form spatial field in which cultural icons and historical references can bump up against each other like particles in a cloud chamber. Einstein and Freud make appearances here, and so do a United Nations flag and a board game designed by Ontario Hydro. Almost baroque in its effect, *No Immediate Threat* is thick with allusions to the grand twentieth-century narratives of science and progress, technology and prosperity. By weaving these narratives through the twin sites of the nuclear family and the nuclear industry,

however, *No Immediate Threat* exposes the promises of an industrial dream of unlimited resources and rising profits as illusionary. The end of modernism, with its attendant belief in a utopian future, is bathed here in a translucent radioactive glow. Juxtaposing the symbols of a brave new world with unfolding familial arguments over dose limits and radiation showers, Condé and Beveridge point to the working class as frontline casualties in a new era of nonrenewable resources and global restructuring.

In choosing to depict union history and union struggles within this shifting cultural landscape, Condé and Beveridge straddle both modernist and postmodernist approaches to a complex intersection of ideology and representation. On one hand, their narratives are informed by a modernist desire to assert a representation of the "working class" that is absent from the dominant culture of North America. On the other, their visual vocabulary of montage and juxtaposition signals a postmodernist impulse to interrogate structures of

Carole Condé and Karl Beveridge, *Play Zap*, 1986. Cibachrome color photograph. From the photo-narrative series *No Immediate Threat*. The background is based on an actual board game given to young visitors to Ontario Hydro's nuclear power plant.

representation as themselves in complicity with the construction of economic and social realities. In so doing, the competing paradigms incorporated in their work raise several issues about the strengths and the limits of the work's reception. Locating in culture a key site of political contestation and in trade unions a key site of political intervention, Condé and Beveridge's photo-narratives have the potential to function at cross-purposes. The institutionalized site of their artistic collaboration lends itself to the production of "official" images for the labor movement that can themselves end up substituting as new cultural authorities for grass-roots mediation. At the same time, their use of an artistic vocabulary to represent working-class issues is potentially alienating to an audience that has internalized a "classless" and populist MTV culture. Restaging the issue of class as a cultural as well as economic and social category, Condé and Beveridge perform a difficult balancing act between criticality and intentionality, in the process running the risk of slipping into cultural prescription and a reification of working-class struggles.

Confronting the New World Order

While the working process of dialogue and outreach developed by Condé and Beveridge in collaboration with the labor movement provides an internal antidote and safeguard against such risks, the external geopolitical and economic changes of the 1990s threaten to destabilize the balancing act they have worked so hard to achieve. As nationalist aspirations and ideological bipolarity give way to a post–Cold War era of globalization, capitalism, in the words of political theorists Scott Lash and John Urry, is being "disorganized."[15] In a global context, the net effects of this disorganization include the deunionization and internationalization of labor, the deconcentration and transnationalization of capital, the dismantling of the social safety net, the decline of traditional sectors of organized labor such as trade and manufacturing industries, and the growth of new "social" movements, such as women's liberation, environmentalism, and identity politics, that fragment class solidarity. In the local context, the cultural and political infrastructures that frame the production and reception of Condé and Beveridge's work are in crisis and under siege. With state intervention in the public sector in full retreat, cultural funding in Canada is being

squeezed and scrutinized. Private-sector industries are being downsized and restructured. Public-sector industries are being cut back and privatized. The traditional power configurations that supported trade unionism as an organized site of class resistance are being eroded and disarmed. Correspondingly, the equations of art and politics, class and culture, representation and resistance, that Condé and Beveridge have so carefully negotiated over years of collaboration no longer add up in quite the same way.

As they confront the fallout from this global restructuring, Condé and Beveridge focus in their most recent work on the ways in which corporate culture has appropriated and transfigured representations of class struggle. Both *No Power Greater*, completed with the Canadian Auto Workers in 1991, and *Class Work* (1990), an educational book project produced for the Communications and Electrical Workers of Canada, take as their central theme management's imposition of the "team concept" on the shop floor. A reconfigured Taylorism, the "team concept" replaces the regulation of work through production quotas with a ubiquitous field of ideological persuasion. Rather than answer directly to a boss, workers are encouraged to monitor each other's productivity and to participate in a "team" effort to eliminate inefficiencies (with the unstated costs being their jobs and their union seniority). For example, in 1990–91, McDonnell-Douglas, the aerospace company that is the subject of *No Power Greater*, mailed a video to every worker's home extolling the virtues of "empowerment" through the team concept. Appropriating the political language of union organizers and the visual codes of television, McDonnell-Douglas's video pictured management as being on the side of the workers, urging them to work "cooperatively" with the company to increase their productivity and the company's profitability.[16]

In response to this barrage of old-fashioned "scientific management" dressed up in a high-tech wrapping, the photo-narratives of *Class Work* and *No Power Greater* seek to expose the consequences of being a team player. Homelessness, underemployment, and fear are represented as the endgame of corporate restructuring. Union organizing is counterposed as a form of collectivized opposition to a corporate reconfiguration of labor. On a visual plane, Condé and Beveridge downplay the advertising "look" and the formal Constructivism of

earlier works, choosing to counter the slickness of the corporate soft
sell with hand-painted sets and cutout figures reminiscent of nine-
teenth-century working-class graphic and vaudeville stage traditions.
Mapping onto these homespun sets highly manipulated and digi-
talized images of computer-driven industries, Condé and Beveridge
create a visual metaphor for the transition from an industrial to an
information society. In their evocation of the legacy of nineteenth-
century labor radicalism that has been papered over by a mass con-
sumer culture, these photo-narratives assert a representational field
diametrically opposed to the seamlessness of the corporate spin doctor.
Here, intentionality is privileged over criticality, and a modernist
strategy of intervention is proposed in place of a postmodernist inter-
rogation of corporate culture.

Pulp Fiction, completed in 1993 in collaboration with the Paper-
workers Union, extends the visual logic of hand-painted sets and
cutout figures to chronicle an agitprop history of a pulp and paper mill
in northern Ontario. Taking as its central focus an examination of the
ways in which corporate culture positions the working class as an
obstacle to a progressive agenda of change and innovation, *Pulp Fic-
tion* addresses the current politics of the Canadian forest industry,
where the jobs of unionized workers are pitted against the struggles
of environmentalists to preserve natural resources. While not down-
playing the tensions that arise over issues like clear-cutting and acid
rain, Condé and Beveridge present a counternarrative to the negative
media charge of forest industry workers as "rednecks" hostile to the
environmental movement, tracing the ways in which the pulp and
paper union has attempted to work, both historically and in a contem-
porary context, to protect the environment.[17] Similar to the issues
addressed in *Class Work* and *No Power Greater,* the central concern of
Pulp Fiction is to examine the paradoxical position of "class" as a site of
resistance in the New World Order of globalized capital. For as manu-
facturing and resource industries downsize, and information networks
and automation proliferate, labor as a site of collective organizing is
increasingly fragmented. And with shifts in technology ideologically
reinforcing individualism, and the redundancy (or unsustainability) of
certain types of work becoming conflated with a redundancy of the

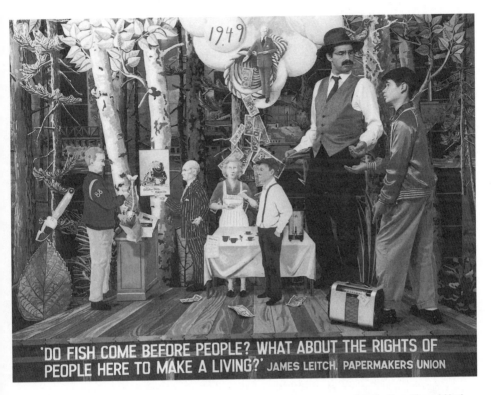

'DO FISH COME BEFORE PEOPLE? WHAT ABOUT THE RIGHTS OF PEOPLE HERE TO MAKE A LIVING?' JAMES LEITCH, PAPERMAKERS UNION

Carole Condé and Karl Beveridge, *Pulp Fiction, 1949*, 1993. Cibachrome color photograph. From the series *Pulp Fiction*. The series will be used by the Paperworkers Union to deal with issues of the environment in local public schools.

working class, labor as a site of collective resistance is increasingly associated with an anachronistic and reactionary worldview.

As such, the political and cultural stakes of a labor-based art practice have increased considerably since Condé and Beveridge first started making collaborative work with the trade unions in the early 1980s. In a corporate culture where unionized workers have come to embody a paradigm of organization that is no longer politically or economically viable, Condé and Beveridge are battling for image recognition in an increasingly hostile field of representation. In response to the obstacles they face as activist artists producing class-identified narratives, Condé and Beveridge have not succumbed to the malaise of a postmodern syndrome that equates the end of history with the end of social activism. On the contrary, with one foot in the union hall and the other in the art world, Condé and Beveridge counterpose an aggressive corporate takeover of culture with a persuasive reminder of the importance of collectivized resistance and a collaborative cultural practice. Their works, easily reproducible, easy to transport, and easily transformable into educational pamphlets and books, become conceptual counterparts to a capital that slips across borders with ease and infiltrates mass culture and consciousness. Taking the union local as their immediate site of cultural representation and the social and economic effects of globalization as their subject, they not only record union history and culture, but become advocates of cultural opposition and political consciousness-raising. In so doing, the question Condé and Beveridge posed almost twenty years ago of whether "it's still privileged art" reemerges not only as a rhetorical concern but as a pressing necessity. In the context of the stress lines of a globalizing economy and homogenizing ideology, the community-based representations they produce are one of the few barricades being erected against the onslaught of a cultural corporatism that seeks nothing less than the eradication of class consciousness.

Jeff Kelley

The Body Politics of Suzanne Lacy

In 1976, the Biltmore Hotel in Los Angeles was undergoing a full-scale renovation—everything from frescoes to pillowcases. A local landmark dating from 1923, the Renaissance-style building originally contained 1,500 rooms and boasted a 1,700-seat theater, demolished by the late 1960s to make way for the construction of the Music Center nearby. In 1976, the hotel reallocated its spaces by reducing the number of its rooms and by creating Biltmore Place, an office tower and a court for retail businesses. This renovation was chronicled in the local press with the metaphor of choice for the hotel being that of an old woman. Alongside photographs of the hotel exterior were front-page headlines such as "There May Be Life in the Old Girl Yet" and representations of its shape and facade as that of an aging woman's face about to get a public make-over.

There was nothing intentionally mean-spirited about this association of an old building with an old woman: the newspaper was merely repeating an old stereotype. Besides, for generations in private and public speech women have been associated with ships, trains, planes, and automobiles—that is, with objects of possession in a male-dominated culture. For most people reading the newspaper description of the Biltmore renovation, the analogy of the building as a mythic feminine presence reclaiming her youth passed before them without the slightest blink of irony.

What struck Suzanne Lacy after reading about the Biltmore renovation was not only the sexist, condescending metaphors in the press, but the relative absence of any public awareness of aging women. With the sudden front-page visibility of the "old girl" of downtown hotels, it seemed older women received more public notice as architectural metaphors than as people. They had no place in public consciousness.

The invisibility of women—or their visibility beyond the stereotypes of femininity—had been an important theme in feminist art theory and practice since the early 1970s. Many of the exhibitions and performances of that period were expressionistic and revelatory in character, opening up to view the domesticated interior lives of women. Such household tasks as ironing and scrubbing, the biological processes of menstruation and giving birth, family relations and gender-based roles, and the violent transgressions of spousal abuse and rape became the subjects of feminist art, subjects that were often expressed in the forms of rituals, exorcistic performances, group consciousness-raising sessions, and storytelling. In *Ablutions*, for example, a well-known performance by Judy Chicago, Sandra Orgel, Aviva Rahmani, and Lacy, nude performers were bathed in washtubs filled with blood, eggs, and wet clay while kidneys were nailed to the wall and a tape was played in which women told stories of having been raped. This was radical art making at a time when the Expressionism of the 1950s was thought to have run its course, replaced by the psychic neutrality of Andy Warhol, the ironic detachment of Jasper Johns, the cerebral indifference of Marcel Duchamp, the affectless icons of Pop, and the monolithic forms and industrial materials of Minimalism. The relatively hot subjects of feminist art—drawn from the everyday experiences of women—were seen by many as excuses for a retrograde, ritualized Expressionism that was cathartic at best and indulgent at worst. "But is it art?" was not an uncommon question at the time.

> For generations, women have been associated with ships, trains, planes, and automobiles—that is, with objects of possession in a male-dominated culture.

The first feminist art program was begun by Judy Chicago at California State University at Fresno in 1969. It was here that Lacy, a graduate student in psychology, made her transition into art. Although associated with an educational institution, the program took place off campus in a private studio for women. Chicago's purpose was to allow women to come together in a safe place—that is, outside the framework of male-dominated culture—to experience themselves more authentically as women, to raise each other's consciousness, and then to use those experiences as a source from which to make art. In

1970, Chicago began working with Miriam Schapiro at the California Institute of the Arts (Cal Arts), a new art school north of Los Angeles, and together they founded the Feminist Art Program. It was indicative of the breadth of the women's liberation movement that there were simultaneously women's programs in writing, literature, sociology, and design (which Lacy studied with Sheila de Bretteville) at Cal Arts, making the atmosphere ripe for interdisciplinary collaboration among feminists. In the fall of 1971, Schapiro, Chicago, and their students established Womanhouse, a project in which they transformed a deserted residential building in Hollywood, creating a series of art environments throughout the building as well as a space for performances that ran for the month of January 1972. That same year, the Feminist Studio Workshop was founded by Chicago, de Bretteville, and Arlene Raven, and soon became an educational program of the Woman's Building, which was established in 1973 and moved to its permanent location near downtown Los Angeles two years later.

Although in the beginning this cluster of women's art projects, programs, and spaces in and around Los Angeles was attended by both women and men, a perception of feminist separatism developed among many in the art world. While there were indeed radical separatists among women, and while the Woman's Building seemed to some a women-only place in the mid-1970s, separatism among feminist artists was for the most part limited to the initial "healing" phases of the movement, when it was necessary to experience oneself—often for the first time—outside the roles and identities imposed upon women by masculine culture. In fact, there was always a second impulse among feminist artists, and that was to move out beyond the "safe" institutions and support groups they had formed and into the world of dangerous roles, places, and people. If feminism in the arts was to open a truly healing discourse, it had to communicate its experiences and ideas about the emerging subjecthood of women beyond its own ritual circles. At the same time, women artists hoped not to lose touch with the aesthetic qualities of their art. This ambition to apply feminist social theory in general to the specific practices of the arts is perhaps the basis for the distinctive strategies of feminist art—including, to quote Lucy Lippard, "collaboration, dialogue, a constant questioning of aesthetic and social assumptions,

and a new respect for audience." At the core of these strategies was not separatism but rather an insistence upon practicing art on a social scale.

The reason for this may be that feminist art emerged in response to a social movement (women's liberation) and not from within the arts. Schapiro and Chicago were mainstream abstract painters before they became feminists, and others were trained in fields such as social work, design, and psychology before becoming artists. Lacy had been a pre-med student with a particular interest in psychosomatic illness before attending Fresno State. Also trained in political and community organizing, she came to Cal Arts in 1970 as a graduate student in social design. Hers was the perfect composite background for the heady inter-disciplinary atmosphere of Cal Arts, and though her interests in medicine and social design propelled her in seemingly opposite directions—toward the interior of the body and the exterior spaces of community, society, and politics—they were, for Lacy, one and the same.

The creed of 1970s feminism, after all, was that the personal is political, and it takes little more than the synthesizing force of an individual's experience to meld what the culture says should be separate. Perhaps the value of art for feminists was that it provided them with a category of professional activity into which the knowledge and experience of other professions could be meaningfully absorbed and used. To be an interdisciplinary artist means more than mixing up the fine-arts genres; it also means gathering from fields of knowledge and experience outside the arts, whether medicine, the social sciences, politics, religion, or education. The infusion of these into and their reinterpretation through the arts makes art relevant to something other than itself. Feminists of the early 1970s did not abandon aesthetics for activism; they activated aesthetics by drawing upon their own experiences as women, experiences that some of them—and especially Lacy—extended as art works on a social scale in the forms of visual images, press releases, community meetings, letters to police chiefs, ritual performances, self-defense classes for women, public spectacles, media events, videotapes, networking among social-service agencies, and as curricula for inner-city teenagers on how to critically evaluate the mass media. These forms of social

The creed of 1970s feminism, after all, was that the personal is political.

extension seldom come from art; they come instead from experiences and professions beyond the arts. The activist artist activates the points of contact between them, as well as among the audiences and constituencies they represent. She networks. Networking, medicine, and social design, for Lacy, are healing processes in which the dismembered members of the social corpus are rejoined. Hence, Suzanne Lacy's activism these past twenty-five years can best be understood through the metaphor of the body. Hers are, so to speak, body politics.

Lacy was greatly influenced in this regard by Allan Kaprow, with whom she studied at Cal Arts. Famous as the late-1950s inventor of "Happenings"—forms of avant-garde performance in which commonplace actions, sounds, smells, and so forth were scripted, much like musical scores, allowing for random events and usually requiring the audience to do something—Kaprow had long trusted

the body as the arbiter of experience. By composing with actions and events as well as with materials and spaces, he learned to envelop the "viewer" in ways that invited a fuller play of the body and its senses in the experiencing of a work, whether by eating apples, moving furniture, calling to a partner in the woods (and listening for a response), or pushing one's way through a roomful of crumpled newspaper and chicken wire. Like any art form, a task can become a metaphor in the way, for instance, that trading buckets full of dirt of equal value may signify the system of currency exchange or the way prices are determined for works of art. By enacting such a trade, the participant will have "embodied" the artist's metaphor, reinterpreting it according to his or her own experience. Kaprow calls this "participation performance," which results in "emergent content," that is, meaning that arises through an experience of participation, of actually doing something. In this way Kaprow shifted the site of aesthetic meaning from the privileged expressions of the artist to the common experiences of the participants.

What Lacy learned from Kaprow was that a performance could take place outside the dramatic boundaries of theater and even avant-garde performance art, and that the body, heretofore a medium of acting, or at least of acting out, could be extended through the participation of others into a social setting without dissipating its physicality and, ultimately, its capacity for empathic connection. Indeed, that capacity could be deepened and widened. While Lacy's "metaphors" were more loaded than Kaprow's with moral, social, and political overtones (this loading came largely from her work with Chicago), both shared a fundamental faith in the body as the site of experience and in art making as a healing process. (It is also interesting to note that Lacy studied medicine, and Kaprow spent his first fourteen years at a ranch for sickly children in Arizona, where he learned to constantly monitor his body for signs of illness and health.)

Lacy's background as a premed student and her particular interest in psychosomatic illness predisposed her toward a view of the body in which the inside and the outside are in constant, sometimes deceptive, play. For her, the body exists at a juncture between one's inner and outer lives—the place where psychological and social phenomena meet in a physiological embrace—and is an instrument that measures

the exchanges between the self and others. Even before the feminist movement, Lacy had learned to see the body as a personal site for the physical manifestation of subjective experience. By 1970, she had also come to see it as a social site for the imprinting of cultural values. Her sense of the dialectic between inner and outer realities was riven with politics and relations of power.

In *A Gothic Love Story* (1975), a series of six photographs with underlying texts, Lacy paired the phrase "she gave her heart away" with a picture of a jar with a heart in it being handed from a woman to a man. In subsequent pictures, the man tosses the jar in the air ("He treated it carelessly"), it hits the ground ("One day . . . "), it shatters ("he broke it"), and the heart is sutured ("She pulled herself together"), and fitted back in a smaller jar ("but she was never quite the same"). In "Falling Apart," an article in *Dreamworks* from 1976, Lacy tells a story, "a tale of four bodies, or parts of bodies, or even single body pieces," accompanied by four torn, black-and-white photographs of herself jumping naked through the air, arms and legs

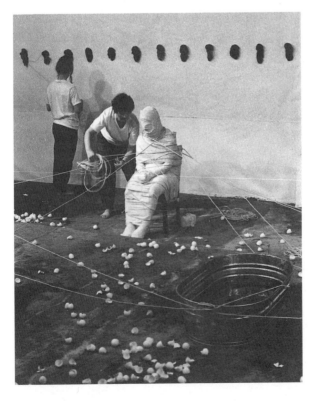

Suzanne Lacy, Judy Chicago, Aviva Rahmani, *Ablutions*, 1972, Venice, California. Lacy nailing animal organs to the wall.

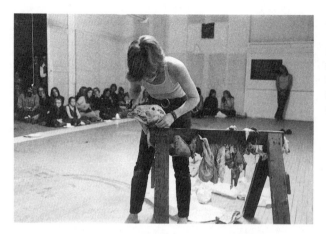

Suzanne Lacy, *Lamb Construction*, Woman's Building, 1973, Los Angeles. Lacy cobbling together a "lamb," using sheep innards and a sawhorse.

splayed in the effort, tongue out, eyes tightly focused, with color pictures of sheep guts seeming to spill out through the tear in the paper, through the artist's body. During the 1970s, it was not uncommon for Lacy to "spill her guts" or "tie her stomach in knots" during performances. (It was she who nailed the beef kidneys to the wall in *Ablutions*.) Underlying this ironic, funny, painful, and sometimes transgressive exploration of the inside and outside of the body—and especially the female body—is the leitmotif of making the invisible visible.

Consequently, Lacy was particularly attuned to the absence of any public awareness of older women, almost as if they no longer had bodies. If feminists felt that women were socially invisible except as the objects of male sexual desire, then older women, having outlived the clichés of feminine beauty, were doubly invisible. This led Lacy to plan a performance in which older women would be invited to participate. It was called *Inevitable Associations* and was intended for the lobby of the Biltmore Hotel.

As an artist, Lacy insists upon the symbolic integrity of the visual images in her work. Like public emblems, they convey a generalized sense of the work's meaning. For the performance of *Inevitable Associations,* she wanted her participants—about ten older women, some of them friends, but most of whom she had come to know through the Fairfax Jewish Community Center—to wear black, thereby expressing the condition of invisibility, especially in the dimly lighted hotel lobby. Not surprisingly, one woman objected because of the

inevitable association of the color with funerals. Lacy was troubled, wondering how to reconcile her own experience of the pending spectre of aging with a sensitivity to the cultural stereotype the black clothing might represent to her participants. Upset by the implications of this oversight, she proposed a second part of the performance in which three of the women, dressed as themselves, would sit in special red chairs and talk about their lives and experiences of aging among groups of younger women and men. The red chairs and the public dialogue would be declarative forms of visibility intended to counterpoint both the symbolism of the black clothing and the drama of the first part of the performance.

What followed was a midday performance inside the hotel lobby in which Lacy was given a public makeover. Instead of being made to look younger, however, she was made to look old. This process took nearly three hours, during which Cheri Gaulke, a collaborator dressed as a saleswoman, passed out literature on the hotel renovation while

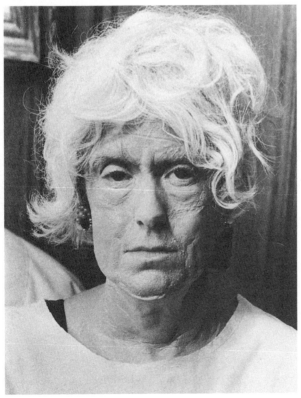

Suzanne Lacy, *Inevitable Associations*, 1976, Biltmore Hotel, Los Angeles. Lacy being made over as an older woman.

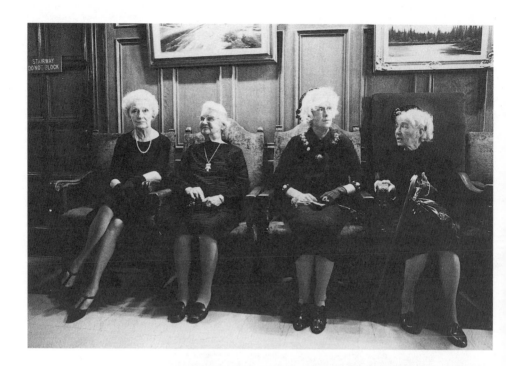

Suzanne Lacy, *Inevitable Associations*, 1976, Biltmore Hotel, Los Angeles. Lacy with her collaborators in the Biltmore lobby.

Suzanne Lacy, *Inevitable Associations*, part two, 1976, Biltmore Hotel, Los Angeles. Lacy with a collaborator speaking about growing old (Allan Kaprow is sitting at left).

another collaborator, a plastic surgeon's assistant, distributed information about cosmetic surgery. Lacy, of course, was the center of attention, especially as hotel employees and guests began noticing that she wasn't getting any younger. Meanwhile, several older women who were dressed in black had been quietly entering the lobby throughout the performance and, as seats became available, sitting down in a row of red chairs directly opposite Lacy. They went largely unnoticed until they reached a kind of critical mass and became visible to those in the lobby. It seemed they had been there all along. When Lacy's makeover was complete, the older women stood up in silence and surrounded her, dressing her in black clothes. She had symbolically taken away their invisibility—taken it upon herself. If an aging hotel could only be portrayed in the press as a mythic "old girl," then Lacy's performance had returned the hotel to its proper role as a setting in which her participants could present themselves as elder citizens— maybe even as elders. Moreover, they could do so in the framework of a performance that, with its metaphors of makeover and plastic surgery, chided the whole epidermal culture of Hollywood—showing *it* to be the real local myth, and skin-deep at that. When the performance was over, Lacy—still in character—and her friends all went out for lunch.

Inevitable Associations was a pivotal work for Lacy. In the development of her thinking as an artist, it occupied a midpoint at which an interior and exterior experience of the body converged in a public place. In earlier work, she had seen the body—her own, mostly—as a medium of performance, but her performances had generally taken place within feminist communal contexts, schools, or art spaces. Now, Lacy was working in a public space that reflected her expanding sense of the body as a metaphor for social and political spheres beyond the self. It also required of her a much greater degree of social organization, as in negotiating the use of the hotel lobby with the Biltmore Public Relations Department, conducting research into cosmetic surgery and special-effects makeup, and—most important—in getting the older women to participate. These, in turn, added urgency to long-standing feminist questions about the differences between an audience and a constituency, the nature of participation, and the authorial role of the artist in a public, participatory

process. Lacy's challenge—as her Biltmore experience made clear—would soon go beyond simply working in a public space; it would involve the invention of social processes that would be politically viable, publicly visible, and, not least, aesthetically meaningful.

One of the significant transformations in outlook that marks the onset of a postmodern consciousness in American art is that aesthetic, abstract "space" and its temporal correlative, "timelessness," are now understood and experienced as concrete social situations. The space of art filled up with people, processes, politics, messages, memory, institutions, events, experiences, communities, and other such phenomena of the everyday. This had been happening since the 1950s, but 1970s feminism took the avant-garde impulse to move beyond the gallery all the way to the steps of city hall itself. This requires the help of others. When space is no longer empty, the processes that unfold within it are no longer the artist's alone. Participation in the socioaesthetic processes of activist art is what makes it public, not just the fact that its site is now the street and not the gallery.

The scope of Lacy's involvement with others outside the feminist art community changed with the Biltmore piece, going beyond friendship or sisterhood. It asked people uninterested in art to be the public subjects of somebody else's art. In crossing this threshold, Lacy began to realize that, for her, participation meant getting people to agree to do what she wanted them to do, and then finding ways to do it together. The key was to be open about your motives, to say: "Okay, here's what I want and why." Openness is what distinguishes participation from manipulation. This is how Lacy approached the older women for *Inevitable Associations*. They agreed to participate because they agreed with the artist that older women were being used in the culture as metaphors in a disrespectful way and that they, indeed, felt invisible as citizens. When the disagreement over the black clothing emerged, Lacy did not simply strip away at her aesthetic design but added to it by providing the red chairs from which her participants could speak out and be seen, thereby representing themselves. Participation, then, was an ongoing process of negotiation *without a hidden agenda*. The artist's motivations, ideas, and symbolic language—as far as she understood them herself—were all out front. This does not mean, however, that participation is simply a matter of

agreeing with the artist at the outset of a project or of her agreeing with her participants. Rather, participation is a dialogical process that changes both the participant and the artist. Like the art, it is not fixed, but unfolds over time and in relation to the interests brought to bear upon it. For the artist, those interests represent perspectives and values previously unconsidered or overlooked. They add to her as she adds them to her art.

Three Weeks in May (1977), Lacy's first full-blown public work, began as a private process performance, not unlike the "being tied to a partner for a year" or "following people around the city" pieces that artists such as Linda Montano or Vito Acconci were then doing. She intended to record specific instances of rape on a daily basis and make rape visible as a social phenomenon by posting police reports about them on the wall of a gallery. Even before *Ablutions* in 1972, Lacy had participated in the emerging feminist investigation of violence against women. With the publication in 1975 of Susan Brownmiller's book *Against Our Will*, the many strands of violence against women had

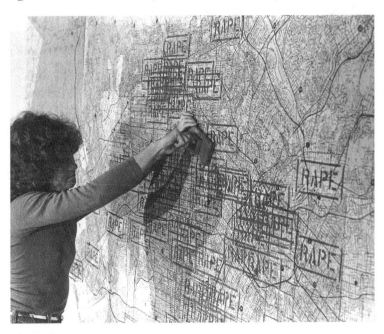

Suzanne Lacy, *Three Weeks in May*, 1977, Los Angeles. Lacy stamping the map.

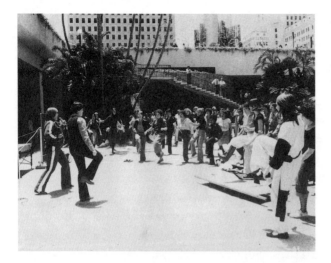

been woven into a centralizing feminist theory that Lacy wanted to make public through her work. In time, the idea of making rape visible on a social scale took the more public form in Lacy's mind of a large map of Los Angeles upon which the word "RAPE" would be stamped each day in red block letters at the approximate sites of rapes reported to the Los Angeles Police Department. Because she felt that a model of positive action should accompany such a graphic revelation of the problem, a second identical map would be installed next to the first, listing the names, phone numbers, and approximate locations of the various rape intervention agencies throughout the city.

In order to secure a site for her proposal, Lacy approached several shopping malls about displaying the map but none would touch the subject matter. Then, through a curator friend whose father was the director of public works in Los Angeles, Lacy was given a large wall space in the City Mall, a subterranean complex of fast-food outlets and retail businesses primarily intended to serve city and county employees who worked in the buildings above. Although initially reluctant to "place reminders of women's vulnerability in a place where they might already feel insecure," Lacy chose the site because the advantages of being sanctioned by city hall far outweighed the relatively lighter foot traffic and visibility of the underground mall. In fact, Lacy's association with the city government served to further sanction the project, by then called *Three Weeks in May*, ultimately giving it greater access to the police and fire departments,

the Department of Building and Maintenance, the City Engineering Department, members of the Los Angeles City Council, and, through them, to the local print and electronic media. Ironically, the underground City Mall, with its relative lack of visibility, positioned the artist and her project in the middle of a network of people, agencies, and funding sources that contributed to a greater degree of public visibility for the project—and for its subject—than otherwise could have been imagined.

With the help of collaborators Barbara Cohen, Jill Soderholm, Melissa Hoffman, and Leslie Labowitz (with whom Lacy would continue to collaborate for several years), Lacy also designed numerous media events, performances, ceremonies, and self-defense rallies in order to "activate" public awareness of the maps and to call attention to the reality of rape as a social phenomenon. The events that took place during *Three Weeks in May* included: an opening press conference called at the recommendation of the city attorney and attended by the deputy mayor, Lacy, and Jim Woods of the Studio Watts Workshop (which, with the Woman's Building, was cosponsoring the project); a business- and professional-women's luncheon during which the project and its upcoming events were presented; a Women's Coalition luncheon (during which one woman attacked Lacy for not doing any more than "art" on the problem of violence against women); a moment of silence held throughout area churches for the victims of rape; the installation ceremonies for the maps, during which representatives from sponsoring and participating agencies—and most prominently City Councilwoman Pat Russell—spoke to an audience of employees returning from lunch, ceremonies that were covered by a local newspaper, one television station and two radio stations; a performance and a banquet prepared and performed by Gaulke and Smith for women whose organizations—including the Los Angeles City Commission on the Status of Women, the Sheriff's Department, the American Civil Liberties Union, Women Against Violence Against Women, and the Ocean Park Battered Women's Shelter, among others—were working on the same problems but from different perspectives and political frameworks; a slide presentation by women of the Rape Hotline open to employees of Southern California Edison, a utility company; an informal discussion of the

aesthetic and organizational aspects of the project with art students from the Feminist Studio Workshop of the Woman's Building; a three-week exhibition in the Garage Gallery in which notes, artifacts, photographs, and other documents were addressed primarily to an art and feminist audience; a private ritual performance for selected women called *Breaking Silence,* with the artists Anne Gaulden and Hoffman exorcising their own experiences of rape; a radio program in which women of color explored the racial implications of their rape experiences; a fifteen-minute reading by Lacy over KPFK-FM radio of the rape statistics compiled as of May 16 (halfway through the project); four public lunchtime street performances on successive days by Labowitz, including *Myths of Rape,* in which facts were used to contradict stereotypical notions of rape, *The Rape,* which was collaboratively performed by Labowitz and the Women Against Rape, Men Against Rape organization, representing the double victimization of women who are raped and then treated suspiciously by the police and others, *All Men Are Potential Rapists,* created and performed with several men in order to show rape as a form of violence that reinforces the cultural values of masculine aggression, and *Women Fight Back*, a performance covered by local television in which women symbolically helped each other resist rape; self-defense demonstrations for women presented in the employees lounge of the ARCO Plaza; a rape prevention workshop at the county offices with speakers from the sheriff's department and the East Los Angeles Hotline, as well as a self-defense demonstration, which was used by Women in County Government to rally support for their organization; an "emotionally exhausting" Rape Speakout sponsored by the Rape Hotline Alliance at the Woman's Building in which thirty to forty women were encouraged to share their experiences of sexual violation; a self-defense demonstration for senior citizens at City Hall; the closing ceremonies, on May 26, which involved speakers, a performance, a self-defense demonstration with over one hundred women, and the presentation of the maps, by now layered in red ink, to the Los Angeles City Commission on the Status of Women—an event that was covered by three major television stations and several newspapers; a ten-step personal exorcism ritual by artist Laurel Klick; and finally, a series of guerrilla actions on May 27, after the close of

the project, in which Lacy and others outlined a woman's body in chalk on sidewalks near the approximate locations of reported rapes, writing the words, "A woman was raped near here. . . ."

In addition to organizing a framework for these events, Lacy performed her own three-part work, *She Who Would Fly*, at the Garage Gallery on May 20 and 21. In part one she sat each afternoon for several hours listening to women talk about having been raped, stories that she then encouraged them to write on maps of the United States that covered the gallery walls. Part two was a private ritual among Lacy and four performers, all of whom had experience with sexual violence, in which they prepared the space, talked, ate food, and anointed each other's bodies with red grease paint. The third part involved opening the gallery to three or four people at a time who, upon entering, were confronted with a large lamb carcass adorned with wings and suspended, as if in flight, between the floor and ceiling. On the walls around the lamb were the maps with their

Suzanne Lacy, *She Who Would Fly*, a performance for *Three Weeks in May*, 1977, Garage Gallery, Los Angeles, California.

stories of rape. As Lacy recalls, "After being in the space for several minutes, the viewers generally became aware that they were being watched from a perch above the door. Looking up, they were shocked to discover that their watching was being watched by four women, nude, their bodies stained bright red." Lacy thought of these "bird-women" as "avenging angels, metaphors for a woman's consciousness which splits from her body as it is raped."

From the private ritual, then, to the public self-defense demonstration, from the discussions among art students to the negotiations with the police department, the events woven throughout the three weeks of this project constituted a bold new model of public activist art. Expanding Kaprow's idea that art could take place in the context of everyday life, Lacy conceptualized a "map-in-time," a grid of unfolding art and political actions laid over the city and county of Los Angeles. To contest public myths about its subject—rape, in this case—it projected proactive images and information throughout a network of sites, events, organizations, media, collaborators, and audiences that made its subject visible on a truly social scale. Its visibility, however, was neither a statistical abstraction nor simply a result of the media attention it received over a three-week period. More concrete was the result that rape became visible as a social phenomenon because the project made possible countless empathic connections among individuals, whether artists, police, hotline counselors, self-defense instructors, politicians, or the women who shared their stories about rape. These connections are what heal the broken members and unhealthy organs of the body politic. Without them there is no public meaning, only publicity.

It was also with *Three Weeks in May* that Lacy, together with Labowitz, began to get media-savvy in a proactive way. Initially they thought the press would provide publicity by simply showing up and recording events, but such public personalities as City Attorney Burt Pines and Councilwoman Pat Russell brought with them an additional level of press attention that reflected on the project, forcing the artists to think in more sophisticated terms about how to manage the media in order to project a feminist viewpoint through its lenses. This concern with the media representation of women found its expression later that year with *In Mourning and in Rage*, a public "media event"

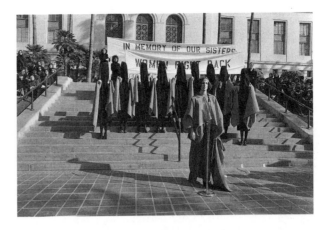

Suzanne Lacy and Leslie Labowitz, *In Mourning and in Rage*, 1977, on the steps of City Hall, Los Angeles.

staged specifically for the press on the steps of Los Angeles City Hall. The event was in response to the sensationalistic news coverage of the so-called Hillside Strangler murders, a case in which ten women were found raped and murdered along populated hillsides in suburban Los Angeles in 1977. What bothered Lacy and Labowitz was that in its zeal to provide dramatic coherence for the isolated facts of the case, the local media insisted upon ransacking the past histories of the victims in its search for some common behavioral flaw (at first they thought the women were all prostitutes) that might account for why these particular women had been murdered. In so doing, reporters inadvertently reinforced popular myths about sexual violence, maintaining all the while that with more information about the details of the murders, women could better protect themselves. The effect, according to Lacy, was to feed women's hysteria, especially since there were few if any substantive media images of women defending themselves. Moreover, the "search for Jack-the-Ripper"–type narratives that underscored the reporting disallowed any serious analysis of the social, political, and even mythological conditions in which this climate of violence and fear could so rivet the attention of a city— indeed, of a nation.

On the morning of December 13, 1977, a funeral motorcade of twenty-two cars filled with women followed a hearse from the Woman's Building to City Hall, at which point nine seven-foot-tall veiled women, their veils draped around their heads in the angular shapes of coffins, emerged from the hearse and took up positions on

Suzanne Lacy and Leslie
Labowitz, *In Mourning
and in Rage*, 1977, Los
Angeles. An image of the
performance on the local
nightly news.

the steps facing the street. Women from the motorcade filled in behind them and unfurled a banner that read, "In Memory of Our Sisters, Women Fight Back." Then, with City Hall behind them and the assembled local press in front, the first mourner walked to the microphone and said, "I am here for the ten women who have been raped and strangled between October 18 and November 29," after which she was echoed by the chorus of mourners who chanted, "In memory of our sisters, women fight back." In succession, each of the nine veiled women made statements that connected the Hillside Strangler murders with the larger social and political issues of violence against women, and each, in turn, was echoed by the chorus in the performance of what Lacy called "a modern tragedy."

In Mourning and in Rage was a media event designed to project images of strong women taking positive action in defense of themselves. Rather than depending upon the press to report on the performance per se, the performance was itself a kind of ritualistic press conference designed to capture and fix media attention by anticipating and appealing to its journalistic conventions, including the need for bold, simple images (larger-than-life, black-and-red-robed women), concise statements (sound bites, declarations of rage), a familiar dramatic narrative (a funeral), the repetition of images over and over for maximum press consumption (the mourners speaking ten times, the echoing chorus), the same images set up for every possible camera angle so that the pictures on the nightly news would all show what the artists intended (the resolute delegation of "unified woman-strength"), the "establishing" background shot (City Hall, which would confer authority upon the performance), and the postevent session with city politicians in which the themes of the performance would be stated over and over, thereby aligning "official" sentiment with a heretofore "radical" cause. This project, one of the earliest examples of performance art's intervention into popular media, had immediate effects on the Los Angeles community: ransom money (for capture of the Hillside Strangler) was redesignated for self-defense classes for women, rape hotline numbers were listed in the Yellow Pages (after some initial resistance by the phone company), and several subsequent discussions were held between the artists and representatives of the media about the media conventions being used to report

sexually violent crimes. Moreover, images and information about *In Mourning and in Rage* were broadcast on prime-time television across the state and appeared in national and international news accounts. While Lacy and Labowitz were not naive enough to believe that their performance would change the way the popular media covers instances of violence against women, they did want to demonstrate a strategy for media intervention that artists and activists might use in their attempts to project alternative voices into the public domain.

Since the late 1970s, Lacy has continued to develop forms of public ritual performance in which participants appear, by choice, in culminating spectacles that frame them as subjects. Unlike theories of the spectacle as a disembodied form of passive consumption, Lacy's are concrete social occasions in which the subjects are proactive participants, not disaffected spectators. Like the rings of a tree, the "public domain" in Lacy's work extends out from her at the center through collaborators (those who help design and run the project); performers (usually the subjects of the performance, like the older women at the Biltmore); contacts (among the organizations and agencies involved with the project); spectators (those who come to see the spectacles); the art audience (which hears of the projects through gossip, reviews, lectures, and other forms of documentation); and the audience at large (which sees news spots on television or reads stories in the newspaper). Meaning, not just an aesthetic emotion, cuts across these rings from the center to the farthest edge. The artist is connected with every point along the line, which is part of what makes the work public—as well as private. She can choose to emphasize different rings depending on whom she is addressing at the time, be it members of a city council, fellow artists, teenagers and their teachers, or her own body. The meaning of today's best public art is not all "out there" in the so-called public domain (wherever that is) but in the resonance with which it cuts across the grain of human experience, exposing the common fiber that connects the personal body to the body politic.

In the pragmatic tradition of much American art, doing is knowing.

Still, it is easier to see the public dimension of public art—the outer ring, as it were—than those that lead back to the artist's core.

Too often the outer ring is taken to represent the whole tree. Meaning, then, is seen in one-dimensional terms, as only social or political or historical or feminist or multicultural, and so forth. Its "aesthetic" layers are lost, which is fine with social activists who think that art is politically ineffective and proof for academic artists of the aesthetic poverty of so-called political art. Indeed, for some in the arts public spectacles of the kind Lacy does must surely relinquish the artist's claims to aesthetic identity, seeming instead to give the art away to the audience, or the object to the subjects. In lieu of some objective solid (like a painting) that might otherwise give it body—and thus a framework for subjectivity—an art work that unfolds in social time and space, or across a network of people and agencies outside the arts, is regarded as merely "conceptual," that is, as being beyond the senses.

Experience is the medium of Suzanne Lacy's art. Though one may learn something by reading about her work in the art press, or be moved by watching a procession of older women walking down to the beach as the audience applauds, or be inspired by the videotape, it is through more concerted forms of experience that one is likely to fully "embody" the metaphor of a given project. The more you give the more you get. Like Kaprow, Lacy believes that meaningful experience is the most effective way to change consciousness. In the pragmatic tradition of much American art, doing is knowing. In order to "do" in the arts, one must either be the artist (a painter can "do") or be willing to participate in what another artist does. Participation does not mean pretending to be an artist if you are a rape counselor; it means agreeing to become involved with an artist's project *as* a rape counselor—as yourself. Art doesn't have to be seen as art to be meaningful. It can be seen as social organizing, curriculum development, or providing opportunities for people to speak. Art is not the only meaningful thing. By bringing her artistic practice into alignment with the meaningful practices of others, Lacy not only extends the social effectiveness of art, but she acknowledges the meaningfulness of what others do. This is appropriate, even generous, but not naive. Artists like Lacy are not Utopians but pragmatists—they want to create social, political, and aesthetic processes that work. They will not save the world, but they will get something done. Those who participate in the processes of public activist art will experience—will embody—what they mean,

Suzanne Lacy, *Whisper,
the Waves, the Wind*,
1984, La Jolla, California.

whether they appear in the culminating performance, attend planning meetings, make telephone calls, give presentations to local school officials, or argue with the artist about the costumes, images, or choreography of a spectacle. No one, however, will experience the full range of meaning more directly than the artist.

Those who perform in Lacy's spectacles always do so as themselves. There is no acting involved (and in this Lacy continues an investigation into the unaffected aspects of everyday experience that has been carried on by American artists since the nineteenth century). In *Whisper, the Waves, the Wind*, for example, a 1984 performance at the ocean's edge in La Jolla, California, 154 white-clad women age sixty-five and older took part in a ritual procession. They walked from a nearby convalescent center through a waiting crowd of perhaps 1,000, down the steps and onto the beach below. Some were assisted by younger volunteers; all were applauded as they passed. On the beach, the performers were seated in groups of four at small white tables where they talked among themselves about death, the body as an aging shell, prettiness, nursing homes, leaving a mark on life, feminism, traditional roles for women, sex, face-lifts, the kind of strength that comes with age, personal tragedies, the need to identify with younger people, and the myth that only the aged die. As their conversations unfolded, the several hundred spectators who had come to witness the performance from the cliffs above were invited onto the beach to mingle and talk with the performers. The key interaction of the piece, this conflation of performers and spectators dissolved the differences between aesthetic artifice and social process. Whether dealing with such themes as international women's culture (*The International Dinner Party*, 1978), equal rights (*River Meetings: Lives of Women in the Delta*, 1982, New Orleans), immigration and racism (*Migrants and Survivors*, 1984, Los Angeles, and *The Dark Madonna*, 1986, University of California at Los Angeles), aging (*The Crystal Quilt*, 1987, Minnesota), or international peace (*The Road of Poems and Borders*, 1992, Finland), Lacy's works have consistently revealed a spectacle of social realism.

Of late, Lacy has completed several public installations dealing with domestic abuse; in them, members of the audience are invited to take positive action on behalf of themselves. In the summer of 1993,

Suzanne Lacy and Carol
Kuwata, *Underground*,
1993, 3 Rivers Arts
Festival, Pittsburgh. The
telephone booth from
which battered women
could contact a network
of social services.

for example, she installed a public work called *Underground* in which she laid several hundred feet of railroad track across the lawn of Pittsburgh's Point State Park, a popular park overlooking the confluence of the Allegheny and Monongahela rivers, where they meet to form the Ohio. Three wrecked cars were placed along the track's length, variously labeled with statistics about domestic violence or heartrending statements of the victims (such as "He didn't know what he was doing" or "Am I giving up too soon?"), or filled with lists of what they were able to take with them when they went "underground." Routed into the wooden railroad ties were the words and phrases of an epic poem written by the artist about a woman escaping domestic violence. In order to read the poem, one had to walk the tracks, at the end of which was a working telephone booth where one could seek advice from a coalition, formed for the project, of volunteers from police departments, the legal and medical professions, and survivors themselves who staffed the phone lines of a local domestic-violence shelter. In addition, callers could leave recordings of their own experiences, and listen to the voices of other women.

As the cars signified battered bodies, and as the tracks signified terrible journeys (not to mention the fact that the Point had been a nineteenth-century destination for the Underground Railroad), so the phone booth signified the body at a fateful juncture between alienation and connection. An actual point of contact between individual members of an audience for public art (of which there were

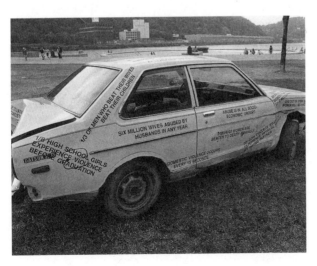

Suzanne Lacy and Carol Kuwata, *Underground*, 1993, 3 Rivers Arts Festival, Pittsburgh.

perhaps 500,000) and the network of social agencies that assist the victims of family violence, it was a door to the underground, which is where women escaping their abusers are too often forced to go. At the end of the line, the artist seemed to say, "there is hope."

This kind of public outreach to anonymous battered women (who may have been thinking of going underground) extends the range and even the meaning of participation in Lacy's art. The audience is drawn to an art space where they can observe the spectacle or, if need be, pick up the phone. For those women who did—Lacy received hundreds of messages from her phone booth—the empathic connections were made beyond the metaphors. The healing rituals of communal feminism have been extended to the scale of particular communities or to individuals most of whom the artist will never know—thereby affirming simultaneously Lacy's desire for social contact as well as the peculiar itinerancy it fosters.

The issues of race, sex, age, and class that fill our social spaces today can be traced to political alienation on the outside and self-alienation on the inside. Between them stands the body. For over twenty years, Suzanne Lacy's performances have represented a panoply of alienated (arguably self-alienated) subjects, including black inner-city teenagers, older women, victims of rape and spousal abuse, female prisoners, prostitutes, the homeless, and women of different racial, cultural, and economic backgrounds. Taken together, these subjects represent the wounded body politic of American life.

The healing rituals of communal feminism have been extended.

Perhaps, as she moves from city to city, from prison to high school, from art critics to battered women, Lacy can be described both as an itinerant public artist and as a postmodern country doctor. Throughout her career her prescriptions for healing the American body have been to turn the inside outside, make the invisible visible, restore its voice, exercise its organs, challenge its self-image in the mass-media mirror, and—most important—to provide opportunities for empathic connection among its members.

Lacy's public activism is predicated on empathy. It involves an experience of physiological transformation, of becoming in some sense the other—though never completely or enough. When she

was publicly made over as an old woman at the Biltmore Hotel, she wanted to know whether she would feel older if she looked older to others. This exploration of identity as an elusive interplay of internal and external perspectives may be seen by some as an appropriation of another's experience, but only if one sentimentalizes "the other." Lacy is never sentimental about the lives or experiences of her participants. What she hopes for is the mutual creation of some common ground, which if it happens, usually does so in the wake of much debate, struggle, and—in the final analysis—good faith. Empathy is not the appropriation of another's experience. It is an experience of appropriate connection with others. Lacy does not appropriate, but insists—sometimes quite forcefully—on the possibility of empathic connection. These connections are the "public" domain of Lacy's work. The body is their common juncture. Empathy is not a function of the mind over the body, but of the body *as* mind.

Suzanne Lacy's fundamental interest as an artist, then, might be defined as the philosophical pursuit of meaning from inside a physical body. Her works are the social frameworks for that pursuit. Through empathic experience the personal body merges with the body politic. Perhaps because of this, we see the public level of the work more easily than the private. But it's there, in her guts—and there, too, in its connective tissue, is the "public" in public art.

9 *Andrea Wolper*

Making Art, Reclaiming Lives:

The Artist and Homeless Collaborative

In 1972, the sculptor Robert Smithson noted, "Art should not be considered as merely a luxury but should work within the process of actual production and reclamation."[1] Although Smithson was referring particularly to land reclamation, within about a decade it had grown clear that in addition to poisoned, devastated plots of land (and abandoned, "bombed-out" buildings), people, too, had become part of the detritus of the nation's commodity-driven, progress-obsessed social structure. By the mid-1980s, hundreds of thousands of people without homes of their own were living on the streets and in parks, in shelters and welfare hotels, in cars and abandoned buildings, under bridges and underground.[2] To the rest of society these were bag ladies, beggars, bums—labels that in recent years have been subsumed in the more general and constituent-referenced "homeless," a term that, though an improvement, nevertheless remains problematic not only for its lack of precision but also for implying homogeneity among people temporarily or chronically without homes of their own. Whatever the appellation, these are a community's excommunicants, its untouchables, the people from whom society at large averts its eyes, giving them little more consideration than it does wasted, ravaged plots of land.

If, as Smithson suggested, art can serve as a means of reclaiming areas of land devastated through misuse or neglect, can similar applications be made where people are concerned? Can art help society's "throwaways" to reclaim positions as independent, functioning members of the community? Can it provide a means for people living on the edges to participate fully in their own reclamation, becoming the codesigners rather than the mere recipients of programs created to

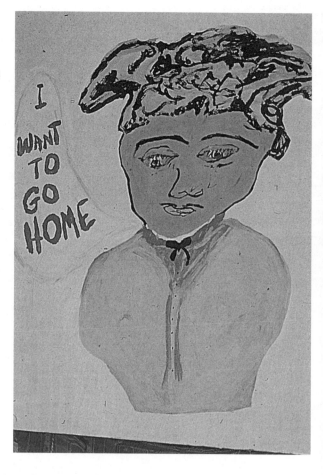

Gerti C., *I Want to Go Home*, 1990. Acrylic on cardboard, 48" x 48". Houses painted on cardboard by Park Avenue resident artists were mounted on sticks and carried in a candlelight procession as part of the *Day of the Dead* exhibition at the Alternative Museum. Gerti, who had described herself as a "shy artist," contributed two houses and this portrait.

facilitate their reintegration? Can art—whose practice often is considered a luxury, and whose product, at least in recent years, may be considered solely for its market value—have any appreciable impact on the lives of people struggling merely to survive? Finally, can art function as a kind of operating theater in which the often polarized segments of a community come together to create something not seen before?

Hope Sandrow, founder of the Artist and Homeless Collaborative (A&HC), would surely say it can. An affiliation of artists and arts professionals and women, children, and teenagers living in New York City shelters, the A&HC is an ongoing, interactive project that neither abandons nor alienates the art work from its social context. Art is made *with* rather than *for* shelter residents, who become the very cocreators of the project's output.[3] "The relevancy of art to a commu-

nity," according to the A&HC's statement of purpose and history, "is exhibited in artworks where the homeless speak directly to the public and in discussions that consider the relationship art has to their own lives." The practice of creating art, the statement continues, "stimulates those living in shelters from a state of malaise to active participation in the artistic process." Indeed, the assumption that getting people in crisis up from their narrow dormitory beds or away from common-room television sets and into the process of making art is transformative seems frequently to have been borne out. According to Sandrow, a large number of those residents of the Park Avenue Shelter for Homeless Women (the locus of most A&HC activity to date) who have been most actively involved with A&HC programs have managed to make their way out of the shelter and into apartments or subsidized housing; some continue making art on their own and some also work with the A&HC as volunteers or paid assistants. Sandrow attributes this progression, at least in part, to the collaborative art making, which she believes offers residents a positive experience of self-motivation and helps them regain what the shelter system and the circumstances of their lives conspire to destroy: a sense of individual identity *and* confidence in human interaction.

The A&HC's articulated goals are to help shelter residents cultivate personal and community self-expression, to provide the means for residents' self-representation, and to create a more stimulating shelter environment. But any inquiry into the nature of the relationship between the community and public or activist art is incomplete if we assume that the sole purpose of such work is to enrich or transform the lives of a constituency targeted to "receive" the work's intended benefits. If we are to avoid reinforcing the rift between the haves and the have-nots, we must consider as well whether the professional artist can be reclaimed, set free from the ivory tower art world and notions of "hotness," rescued from what Martha Rosler has called "museums built to contain and amuse the professional managerial sector plunked down in the middle of moldering center-city decay."[4]

By myth and romantic tradition, artists have lived on the *bohème*-like fringes, sacrificing material comfort to the pursuit of truth and beauty. While indeed many artists have lived on the financial margins (and even today few can survive on the sale of their work alone), the

1980s saw, concurrent with the explosion of homelessness, the emergence of art stardom, a phenomenon that rendered numerous artists the darlings of the very society whose social, artistic, and cultural temperature it might be said was their responsibility to take, whose strictures and conventions their duty to puncture. If Art with a capital A began losing stature when Pop art and the social revolutions of the 1960s helped bridge the gap between high and low culture, art (little "a") grew more accessible, gaining a measure of general acceptance and even respectability. Over the next two decades, artists, more visible than ever and more secure in the legitimacy of their endeavor, learned to turn out marketworthy products to be snatched up by collectors, museums, even speculators.

Can art have any appreciable impact on the lives of people struggling merely to survive?

No longer a rarefied pursuit existing apart from quotidian concerns, the process and product of art became subject to the same mood swings as society at large did, and by the time the market hit its peak in 1989, the idealism of the 1960s had turned to the disillusionment of the 1970s, to the cynicism of the 1980s. Art had become, in the words of critic and historian Allan Schwartzman, "a commodity within a system of commodities."[5] To say that the making and marketing of art was not immune to the kind of general cynicism expressed everywhere from Madison Avenue to Wall Street is not to imply that artists are wrong to seek and receive recognition and fair compensation or that the only "true" artist is a starving—or better yet, a dead—artist. (There are, it seems, those who would disagree. Schwartzman, writing about the artist Jenny Holzer, notes that in the 1980s, successful artists experienced an ironic fate: "The art market turned them into celebrities, then savaged them when they became too big.")[6] Nor is it to say that art comprehension should remain the exclusive property of the intelligentsia, art ownership of the wealthy. But, as Schwartzman points out, as "art" became aware of its own investment potential, its values and identity shifted.[7]

What concerned Sandrow (who was having a show, it seemed, every time you turned around) is that in many cases the makers, sellers, and consumers of art that addressed vital social concerns grew increasingly isolated from the works' subjects, remaining safely en-

sconced within the boundaries of privilege. Sandrow was disturbed by what she considered a genre of art that addressed social issues while remaining, along with its makers, largely isolated and insulated from the realities of those very issues: "There was a lot of discussion about the problems, but artists assumed the authority of speaking about people and issues they had no firsthand experience with. I saw art works produced within the isolation of the studio, and exhibited in places many of those affected by the issues do not have access to." Works of art whose very raison d'être was to incite political, social, and cultural conversation went to galleries, museums, private collections—end of discussion. Certainly there have been exceptions. John Ahearn's decision to distance himself from the world of art-market privilege is in itself a political choice, and Ahearn apparently is most comfortable when the art he makes in the Bronx neighborhood where he lives, works, and finds inspiration stays close to home. Both Jenny Holzer and Barbara Kruger have continued producing provocative works, much of it for public spaces; even if it's true—and I'm not sure it is—that a majority of viewers "don't understand what's going on,"[8] Holzer's *Torture Is Barbaric* and Kruger's untitled billboard that asks, "Who speaks? Who is silent?" have a political bite that is hard to ignore.

Yet even if gallery and museum walls were to come tumbling down, it would be a mistake to assume that art that documents, interprets, or comments upon society's ills offers a complete picture of those ills; such works, though significant, can be considered only part of the conversation about social problems, and perhaps a relatively small part at that. Thus, while a picture of a homeless person (for example) may provoke, move, inspire, enrage, engage, etc., such an image is homelessness *interpreted;* as such, it offers a fixed, limited understanding of the condition of homelessness. The homeless person, merely the subject of the photograph, has been effectively left out of the conversation. As the photographer Mel Rosenthal points out, the more he wanted someone to make "a magic picture that could be used to help end homelessness," the more he doubted the possibility of realizing such an endeavor. Studying his own and other photographs of homeless people, Rosenthal observed that "the people seemed almost pinned to the paper."[9]

Andres Serrano came under some criticism for his 1991 *Nomads* series, in which his subjects—homeless people photographed against portable backdrops that separated them from any context—appear as objects of near-heroic beauty. Such pictures may serve to enhance their subjects' self-esteem and allow the viewer to see people without homes in a new, more dignified, light; they say nothing whatsoever about the conditions of poverty, discrimination, violence, addiction, lack of shelter. Similarly, Krzysztof Wodiczko's *Homeless Vehicle* and proposed *Union Square Projections* make powerful statements but are open to misunderstanding and misinterpretation. The vehicle, designed with Rudolph Luria in consultation with homeless men Alvin, A., Ian, Oscar, and Victor, might be a practical temporary solution for those in need of safe, mobile shelter; or it might be a metal cage in which to confine undesirables while absolving society of responsibility for finding lasting solutions. For *Union Square,* Wodiczko proposed projecting onto that park's heroic and allegorical sculptures images of bandages, wheelchairs, shopping carts, and other accoutrements of homelessness in order to bring attention to the plight of already displaced people further displaced by revitalization of the park and gentrification of the neighborhood. Again, the images may not have conveyed the intended message with sufficient clarity, and the project, though provocative, goes only so far, as Vivien Raynor's halfhearted praise suggests: "As a proposal, it does nothing for the homeless, but as art it is entertaining and poignant."[10]

> **The Artist and Homeless Collaborative is Sandrow's attempt to close the gap between art making and social action.**

In her own art making, Hope Sandrow takes a more impressionistic approach to social issues, resulting in works of a less overtly political nature. At first glance her photographs and photographic compositions, which began attracting attention in the early to mid-1980s, turning up in the company of more established artists like David Hockney, Annie Liebovitz, and Robert Mapplethorpe (at the University of Pennsylvania's Institute of Contemporary Art in 1984), and Frank Stella, Robert Morris, and James Turrell (in the Hirshhorn Museum's *Directions 1986*), seem to be of a very personal nature; works with titles like *Truth Artfully Engaged, Act Like He Wants,* and

Memories Incapable of Proof offer deliberately obscured, fragmented views of existence, connection, and memory.

Uninterested in freezing moments on celluloid, Sandrow uses her camera to explore reality's ambiguous, experiential qualities. Seen through her lens, life does not unfold in clear and logical sequence, nor is it easily or immediately interpretable; and in contrast to most photography, in her work time almost never stands still. Sandrow, whom one reviewer called *"une virtuose de bougé,"* (a virtuoso of movement)[11] was making work another called "extremely perplexing."[12] These writers may have grasped something essential about the work that others who gushed about its "romantic" or "nostalgic" qualities perhaps did not. *Hope & Fear,* a series of arranged and composed pictures taken in the Metropolitan Museum of Art, which Sandrow considers the ultimate expression of society's Big Lie—that life is ordered and aesthetically categorizable, that good and evil can be clearly delineated, that reward and punishment are fittingly conferred—juxtaposes the museum's version of reality with Sandrow's own. Acknowledging that everything is subject to interpretation, Sandrow makes no pretense of clear-eyed objectivity. That hers are substantial works of art, that they say something, seems sure—precisely *what* they say may indeed be too perplexing to be understood by most viewers. As Sandrow herself has said, her social commentary is "not that apparent because my work seems more abstract. But the world is abstract. The more I observe the world, the clearer it is that there's never one truth."[13]

Perhaps it is unfair to hold artists like Wodiczko and Serrano responsible for not having a greater impact on society's ills, or for their inability to control the way their work is understood, or to fault Sandrow for failing to make more obvious ties between the personal and the political; the artist's primary responsibility, after all, is to make art. The Artist and Homeless Collaborative, however, is Sandrow's attempt to close the gap between art making and social action. If the work itself consists of bringing arts professionals and shelter residents together to make art, it is less about social change on the grand scale than about empowering individuals and eliminating the boundaries that keep the privileged and the underprivileged so far apart. For Sandrow, the A&HC is a means of extending her own

artistic dialogue to the people who experience some of the very ills she sought to address as an artist and citizen:

> I'd been doing so many exhibitions, and wanted to get more involved in the community. . . . I felt that if I was creating art about issues, it had to be connected to real people and real things. . . . [Homelessness] was an issue I saw every time I walked out the door. . . . I wanted to know how it came about that [people] had lost their homes, were no longer part of their families. I wanted to understand, but I never knew what they thought—I could only read about them. I thought that art, which was what I had to offer, could be a means for them to speak for themselves.

Sandrow began her inquiry in 1987 by volunteering at the Catherine Street Family Shelter in Chinatown. There, while making art and producing a resident-written newsletter, she learned that "homelessness" is hardly the most accurate of terms. Rather, the state of homelessness should be seen as a potential result of combining *poverty* with any of a host of other conditions (among them job loss, domestic violence, racial and sexual discrimination, addiction, economic violence, immigrants' needs, illness, and injury).[14] Without question, homeless people need decent, affordable housing; still, the failure for many years of both politicos and advocates to acknowledge the connection between homelessness and related conditions is evident in the fact that after more than a decade, the situation has little improved and has probably worsened.[15]

As Peter Rossi explains in *Down and Out in America: The Origins of Homelessness*, "Homelessness is more properly viewed as the most aggravated state of a more prevalent problem, *extreme poverty*. . . . *Literal homelessness*, as I have come to call having no home to go to, is a condition of extreme deprivation, but it is only a step away from being *precariously housed*—having a tenuous hold on housing of the lowest quality."[16] While acknowledging the weight of economic factors in creating homeless populations, Rossi asserts that it is certain personal characteristics (and, it should be added, conditions) that will likely determine who among the extremely poor is likely to become literally homeless.[17] Though there is debate about whether *some* of those characteristics and conditions (e.g., extreme depression, drug

abuse, low self-esteem, mental instability) are the causes or the consequences of homelessness, one thing seems clear: those problems, as well as domestic violence, sexual abuse, illness and injury, job loss, learning disabilities, and so forth, occur in all strata of society. But when one is *extremely poor*, there may be no safety nets: no family to turn to for temporary housing or financial or emotional support; no savings account to draw from or credit cards to borrow against; insufficient social services and little awareness of, or tools for accessing, services that do exist. Even the shelter system, while providing "three hots and a cot," may offer little else in the way of services that would contribute to the alleviation of homelessness.

Sandrow was appalled by what she saw at Catherine Street, where, she charges, male recreational aides distributed supplies to female residents in exchange for sex; goods donated for residents were taken home by staff members; and each classroom in the former school building housed as many as a dozen people. "It was really horrific," she recalls. "Young girls having to get dressed in front of strange men, couples having sex when others were in the room, people fighting in the hallways, drug overdoses." Deeply affected by the misery that was Catherine Street, Sandrow recalls that it often took days to recover from her visits. Still, not until 1988, when her blossoming career suffered a derailment after an accident destroyed two years' worth of work she had made for a solo show in New York and an installation at the Amsterdam Art Fair, did she finally began to understand how it felt to have no control over one's own life; the incident, in fact, triggered a bout of post–traumatic stress syndrome related to what she describes as a "challenging" childhood and young adulthood. (Later, working on biographical art pieces with residents of the Park Avenue Shelter, Sandrow discovered that many had experienced sexual abuse; a survivor of rape and sexual abuse herself, she began to see how much she had in common with the women there.)

Sandrow threw herself into her work at Catherine Street until, in 1989, a conflict with an otherwise supportive and appreciative director forced her to leave. (The problem, says Sandrow, was the director's attempts to censor the art work and resident-written newsletter.) The Human Resources Administration's Adult Services Division (which handled homeless services prior to the creation of the Department of

Homeless Services in July 1993) offered her other sites, and Sandrow chose the Park Avenue Armory, which houses women over the age of forty-five. At first, Sandrow had a hard time convincing the residents that art could have an important place in their lives. The irony, she recalls, was that "our conversations paralleled those that were going on in the country in general—this was around the time of the National Endowment for the Arts (NEA) controversy over the funding of a Mapplethorpe exhibition. The women, like much of the general public, couldn't understand the value of art in their lives." Eventually, Sandrow's persistence (visiting the dormitory, she would go from bed to bed, individually inviting each woman to participate) paid off, and each week several women gathered to make art. As the Park Avenue projects grew in scope, and Sandrow invited other artists to participate, raising money became necessary. (Visiting artists receive a $1,000 honorarium, which some have donated back to the organization, and $500 for art supplies.) The politics of grant-seeking—the NEA, in fact, awarded Sandrow her first shelter project grant—required that Sandrow's efforts be formalized; a board of directors was created and the nonprofit sponsorship of the New York Foundation for the Arts established. (The organization was granted its own not-for-profit status in 1992.) Thus, the Artist and Homeless Collaborative was born.

By bringing other artists and organizations to the shelter, residents were exposed to a variety of media and artistic and political sensibilities. Artists Kiki Smith, Keiko Bonk, John Ahearn and Rigoberto Torres, Pepon Osorio, Whitfield Lovell, Simon Leung, Vince Gargiulo, Ida Applebroog, Judith Shea (these last two are A&HC board members), and others have collaborated with participants on everything from life drawing to plaster casting, transfer printing to landscape painting, ceramic tile work to doll making. A collaboration with the Guerrilla Girls resulted in the creation of posters addressing rape, domestic violence, and homelessness, and Visual AIDS hired Park Avenue residents to make that advocacy group's ubiquitous red ribbons. In 1990, Dina Helal, coordinator of Family and Community Programs at the Whitney Museum of American Art at Philip Morris, proposed the creation of an arts education program for homeless children. Sandrow agreed to supply the children if Helal would take

"I've begged."

"Yes, I have eaten out of garbage cans.
I've had coffee thrown in my face.
They tell me to get a job.
They don't know your problem.
If you stand in a food place looking
pitiful enough, someone will
buy you a sandwich.
I've had people buy me a meal and
bring it back to me, throw it in
the garbage and tell me to get it."

—RESIDENT OF N.Y.C. WOMEN'S SHELTER
IN COLLABORATION WITH

GUERRILLA GIRLS

AND

ARTIST &
HOMELESS
COLLABORATIVE

The Guerrilla Girls and Park Avenue Shelter residents, 1992. One of three posters made following discussions about rape, physical abuse, and homelessness.

adult women as well, and the two designed the After School Art Education Program, in which children from the Regent Family Residence gather at the Whitney at Philip Morris to study, discuss, and make art. Helal and visiting visual and performing artists lead the programs, assisted by women's shelter residents who have been trained and receive stipends to work as teachers' aides; more recently, four teenagers from the Regent have also been hired to work as aides. For six months in 1991, a Warhol Foundation grant provided the A&HC with seed money to collaborate with the Museum of Modern Art and the Whitney on the development of a model arts education program. Nonartists as well have elected to jump on Sandrow's collaborative bandwagon, and the project has grown to become the umbrella for several short- and long-term projects, including yoga classes, a literature club, a newsletter, lecture series and seminars, and

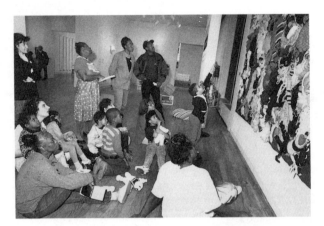

Children from the Regent Family Residence discuss Mike Kelley's *More Love Ours Than Can Ever Be Repaid* and *The Wages of Sin* with trained teachers' aides from the Park Avenue Shelter and staff from the Whitney Museum of American Art at Equitable.

résumé-writing assistance, this last at the Lexington Avenue Shelter for homeless women, which houses women who are employed or deemed employable.

So much disparate activity renders the A&HC rather amorphous; its activities and sometimes even its purpose are not easily categorized or understood. (Sandrow views this state as a natural result of the organization's fluidity, which she considers a necessary adaptation to the transient nature of shelter life.) But no matter what the organization's activities, its heart is collaboration, and that is loosely defined. It may mean the collaborative creation of a "traditional" art object such as *The Four Seasons,* a four-panel acrylic painting by visiting artist Keiko Bonk and resident artists Lonzetta P., Audrey J., Olivia S., Geraldine W., and Maxine L. It may consist of individually executed components that together make a single art work, such as *Three Views: The Life of Geraldine Womack.* An assemblage that investigates both portraiture and the way society typically views the poor and disenfranchised, the work's three framed pieces include an essay about the life of resident Geraldine Womack, written by Sandrow in the style of a typical news feature and printed to look like a published article; a palladium print portrait of Womack by Michael O'Neill; and a self-portrait "quilt" of color Polaroids by Womack and Sandrow. Collaboration may branch in several directions, involving the participation of a variety of individuals and organizations: Visiting artists Julie Carson and Aaron Keppel organized AIDS education seminars that were conducted by members of ACT-UP and the

Julie Carson, Aaron Keppel, Amy, Brelzie, Claudia, Dorothy, Edna, Geraldine, Gerti C., Harparkash, Kachi, Lucille, Maxine, Olivia, Pearl, Polly Ann, and Shirley, *Self Taught/Self Represented: Homeless Women and AIDS*, 1990. 16" x 22". This AIDS awareness poster, the result of a mega-collaboration, lists resources for treatment. English and Spanish text, provided by residents, includes: "If he doesn't want to use a condom, he can forget about me."

Self Taught/Self Represented
Homeless Women and AIDS

Women's Health Education Project, after which Carson and Keppel and resident artists designed, using text supplied by residents, a poster entitled *Self Taught/Self Represented*. Visual AIDS donated funds to reproduce the poster, and several thousand copies were supplied to shelters and social service organizations throughout the city. In other cases, collaboration means making separate art pieces that, seen together, become something quite different: children in the after-school program sculpted self-portraits that, seen individually, are interesting and fun; displayed together, all in a row, the little clay heads take on weight, a kind of historical grace and power.

Under the A&HC's generous wingspan, collaboration is both organized and informal. The Résumé Project, conceived as an art work to be included in an exhibition of A&HC art works at the Henry Street Settlement, embodies both characteristics: members of the Women's Action Coalition (WAC) visited the Lexington Avenue Shelter on a

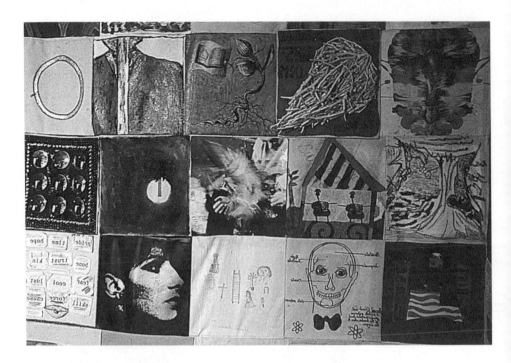

Something Lost, Something Gained (detail), 1993. Representative of nomadic housing, a symbol of shelter that presents no clear boundaries between inside and outside, this twelve-foot-high tent comprises approximately 150 ten-inch squares contributed by Artist and Homeless Collaborative resident and visiting artists, as well as by artists all over the country. Organized by Robin Tewes, the tent was installed at the Henry Street Settlement's *On the Way Home* exhibition, which also featured art work by resident artists and résumés from the Résumé Project.

weekly basis to create professional résumés for residents, and the résumés were exhibited under the title *Positions Wanted/Opportunities Needed.* Subsequently, individual WAC members, having seen the résumés, hired some of the women or recommended them for jobs, and two Park Avenue residents were hired to work as hosts/security guards at WAC meetings. Other WAC members organized a business-apparel clothing drive, GED tutoring, and computer training. Whatever the form, the emphasis is on the kind of collaboration that allows participating shelter residents, who suffer from, but rarely have the opportunity to enter public discourse on, homelessness, unemployment, domestic violence, rape, racism, sexism, etc., to speak for themselves. If we think we know, for example, that people who live in shelters are lazy, nonproductive, uneducated, or completely disadvantaged, we will be surprised by the employment and educational histories some of the résumés reveal.

That the majority of shelter residents are neither trained nor define themselves as artists raises a number of questions, not the least of which is whether the A&HC's efforts are less art making than they are social work or art therapy. Certainly, if making art is what drives the A&HC, the derived benefits may be considered therapeutic. As Linda Burnham points out in a 1987 essay about "the interaction between 'non-artists' and art-world refugees" in several programs not unlike the A&HC, "they are making *art,* not therapy (though the results are undeniably therapeutic)."[18] Arlette Petty, a former Park Avenue resident who now serves on the A&HC board of directors and works as an

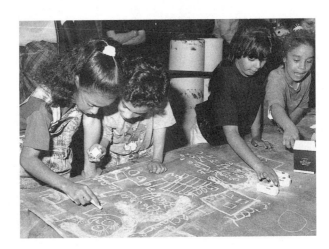

At the Whitney Museum of American Art at Philip Morris, children from the Regent Family Residence make chalk erasure drawings in a workshop led by visiting artist Gary Simmons, in conjunction with his exhibition *The Garden of Hate.*

Julie D'Amario, Michelle Marozcik, Bessie B., Yvonne D., Jackie D., Alice D., Lydia E., Tony F., Vassie J., Charlene L., Georgina M., Florence M., Louise R., Theo F., Merriann S., Maryann S., and Lilian W., *Park Avenue Shelter Portraits,* 1992. Hand-painted copper plate etchings, 9 ¹/₂" x 7".

aide in the A&HC/Whitney Museum at Philip Morris After School Art Education Program, recalls that as she became more involved with the art projects:

> I started to express myself more freely; [working with the A&HC] just opened me up. I had become very lethargic— a shelter can do that because you're in crisis. It's a very draining experience, so it's easy to just go to bed; a lot of that is depression.

Working with the A&HC, Petty told me, may have provided her with the drive to get herself out of the shelter system and into public housing, a labyrinthine task that requires great patience, persistence, and a well-developed sense of the absurd.[19] "My self-esteem was heightened. And even though I had known what to do all the time, I didn't have the energy to do it. So they motivated me and probably didn't realize it."

After losing her home to a fire, Jackie McLean turned to the shelter system as a last resort. As she describes it:

> I was very, very upset. I felt like I was at the bottom of the barrel. When you first go into a place like that not knowing what to expect, it's like a horror show. All I wanted to do was turn around and run. [McLean admits she was] feeling a little sorry for myself. But some people saw I was in a little shell and they told me about the art projects. Meeting Hope, then Frank and Patrick [Frank Moore and Patrick O'Connell from Visual

Lise Prowse and Curt Beshel, Bernadette, Judy O., Yvonne D., Jackie D., Winnie, Jenny, Gerti C., Bessie, Barbara, Doris, Elizabeth, and Vassie, *Park Avenue Shelter for Homeless Women*, 1991. Ceramic tile glazed and mounted on wood. Since many nearby buildings are marked by plaques, visiting artists Prowse and Beshel suggested marking the shelter. Not wanting to see the words "Homeless Shelter" every day, resident artists recommended taking an abstract approach.

AIDS] was a godsend. The Ribbon Project gave me something to do, something to look forward to, and made me feel a little bit independent. It changed everything.

McLean's expectedly brief stay stretched into fourteen months as she tried to make her way through the system and into permanent housing. When at last the city offered to place her in a Single Room Occupancy (SRO) hotel, McLean was horrified: "I didn't come from that, and I didn't see why I should go there." Instead, she eventually found her own apartment, which she shares with a friend she made at Park Avenue. With the shelter behind her, McLean nevertheless stays in touch with Sandrow and the A&HC. "Not only did [working with the A&HC and Visual AIDS] help get me back to being me, but I learned a lot of things, and it helped me communicate. I never thought I could speak in public, but Hope asked me to speak a few times, and I found I enjoyed it and was pretty good at it."

Maria left her Missouri home when, after rearing five children and having been deserted by her husband, she was called to "do the work of the Lord." She'd been in and out of the Park Avenue Shelter since arriving in New York in 1989 and, although service to the Lord is her first priority, Maria now draws and paints regularly, allowing that making art "makes you feel better about yourself, especially when you

have people that put you down and act like you can't do anything. I spent my life raising a family, but I knew there was things I could do, given a chance." Gerti C., like Petty a former Park Avenue resident and an After School program teacher's aide, says she was always writing, sketching, and painting, but was too shy to share her work. Making art with the A&HC seems to have given her the confidence to "come out" as an artist, and it is that state, and not homelessness, that is elemental; today the once "shy artist" (as Gerti describes her former self) says, "I hear people say they can't become an artist. I'm not here to *become* an artist. I was made that way. I was born that way. If I die, I'll come back as an artist."

"I'm not here to _become_ an artist. I was made that way."

Assessing on artistic merit alone the results of collaborations between so many artists with varying degrees of experience and natural ability may prove difficult; it seems likely that one's response to any particular art work will be colored by an awareness of the merits of its message and the process of its actual creation. But assessing the works' artistic quality and considering their social value need not be mutually exclusive, nor should such considerations be confused with an understanding of the works as art objects. If there is any difficulty in accepting the works as legitimate art, the problem may lie less in the pieces' provenance or quality than in traditional methods of critical evaluation. If we look beyond traditional (and traditionally polarized) understandings of both art and social action, as Allison Gamble points out in her examination of Sculpture Chicago's 1992–93 series, *Culture in Action,* we see that "community-based collaborative works . . . are investigations into the space between private experience and public life."[20] Such an understanding becomes particularly interesting in relationship to shelters, where one's private life is all too public: at the Park Avenue and Lexington Avenue shelters, anywhere from a handful to sometimes more than a hundred women may sleep in a single room (in Lexington Avenue's approximately fifty-bed "drill room," the lights are left on at night; the reason, depending on who is explaining, is to enhance security and ensure fire safety, *or* to discourage sexual activity and to create as dehumanizing an atmosphere as possible). There are no private bathrooms (at some shelters, residents

Pepon Osorio, Brelzie D., Diane D., Gerti C., and Maxine L., *Homeless Blues,* 1990. Mixed media. The first picture, taken in September 1990, shows a holiday greeting written into the dirt on the wall of the TV room at the Park Avenue Shelter. The second view shows the same room two months later, after its transformation. The installation takes its name from a poem by Diane D., which is painted along the valance. When parts of the shelter facility were repainted some two years later, the installation was removed and never restored. The room is now beige.

have had to negotiate with staff for "amenities" like toilet paper). At Lexington Avenue, a male guard sits in full view of a room in which women gather to iron clothes, set their hair, etc. The residents are dependent on public funding for food, housing, and needed services; in order to receive those services, it may be necessary to prove "worthiness" by discussing entirely personal details of one's life and circumstances with strangers. Quite simply, entering the shelter system means relinquishing all rights to privacy.

And yet, living with so many people in such circumstances can be terribly isolating. Recall Arlette Petty's words about being depressed and in crisis, then imagine being sent to live in an armory or old school to share bed and bath with dozens of strangers, to be watched over by guards, to constantly have to justify your right to receive food and shelter, indeed, your very right to exist. Imagine the nights, as

described by Maria: "Most of the ladies are in their right state of mind, but a few of them aren't, and some of them in the middle of the night will scream and holler." Maria also describes the days: "I feel sorry about some of the people in the shelters. They're not given much of a chance. They're branded and a lot of times ridiculed and treated very badly by some of the staff." Maria tells me several times that most of the staff members and guards are very nice, "but some are not kind at all." And though Maria, who doesn't know me well, leaves herself out of the discussion, it seems clear—and Sandrow later confirms—that she has not escaped mistreatment.

Making art may or may not be the best way of addressing the problems of shelter residents, but for many it may be the only method available, one that allows them to make contact without having to be outgoing, to speak English or read or write well, to reveal anything they want kept private. Women are among the hardest hit yet least visible victims of poverty and numerous other social ills, all of which may pave the road to homelessness: domestic violence, age discrimination, insufficient family planning services, racism, homophobia, insufficient addiction-recovery services, etc. Being an undocumented domestic worker whose employer dies (leaving no references or benefits), suffering illness or injury (and being too poor to pay for housing *and* medical care), being unable or unwilling to turn to abusive family members for help in a time of need—these are situations that can lead to homelessness. The women may desperately need permanent housing, training, jobs, and social programs, but the A&HC responds to equally vital, if perhaps less tangible, needs, and, as noted earlier, this may play a significant role in the eventual acquisition of the more tangible needs. Theo, a former longtime Park Avenue resident, appreciates the art making as "a source of entertainment. I'm not well enough to go to parties or anything, so I have to be in all the time. This helps me a lot." The enormity of Theo's statement may not be readily apparent, but visiting artist Peter Krashes notes that although some of the women see the art making primarily as a diversion, its very process offers considerable benefits: participants gain from watching a work of art take shape as a result of their own efforts; women who didn't know one another's names work together toward a common goal; the site of the art making is infused

with the spirit of cooperation as the workshops offer the women a rare opportunity to work as a community:

> The dynamics of the shelter are such that very close bonds develop, but only between two or three women. They can't make much noise, and if a group develops, a guard wanders over to see what's going on—a group is assumed to mean a fight.

E. G. Crichton's observation about the NAMES Quilt might as easily have been made about the A&HC:

> What the NAMES Project Quilt has in common with feminist, environmental, ancient, tribal, and Chilean art is a tradition of collaboration, a mixing of media, and an emphasis on process that makes the reason for the art just as important as the finished product.[21]

This emphasis on process is not intended to diminish the significance of the finished product, which, when displayed in the shelter, can improve the dismal surroundings and be a source of pride for the residents who made it—as well, sometimes, as those who merely watched as the work was created: a spirited debate about placement erupted among numerous Park Avenue residents when it came time to hang *The Four Seasons,* which had been painted by one visiting artist and five resident artists. Because the other women had watched the painting come to life, Sandrow recalls, "they all considered it their painting." By that she means each one, individually.

In fact, *un*like the NAMES Quilt, of which Crichton says, "The individual artist's identity is less important than the purpose of the art in the life of a community or people,"[22] here, for women living without their homes, jobs, families, personal possessions, the right to food preferences, etc., individual identity is paramount. Well aware of the stigma attached to living in a shelter, fearful of bringing shame to themselves and their families, most of the resident artists sign their work using only first names and last initials; nevertheless, the art projects allow each resident artist to portray herself, her life, her concerns, as she wants them portrayed.

My own experience working with Janet (not her real name)—who, the night I visited the Lexington Avenue Shelter, made art almost in spite of herself—may be instructive. The project under way (Sandrow

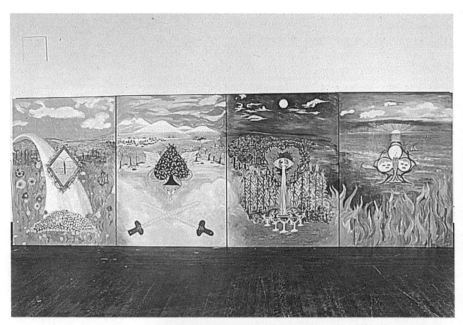

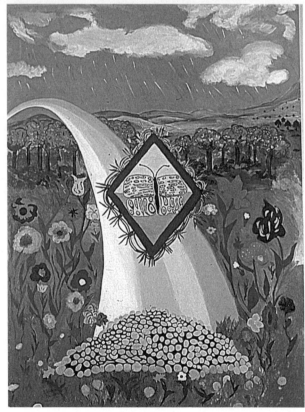

Keiko Bonk, Audrey J., Geraldine W., Lonzetta P., Maxine L., and Olivia S., *The Four Seasons,* 1990. Acrylic on canvas, 240" x 84" (detail right). The passing of the seasons was a subject all the women could relate to. The painting incorporates symbols from the Tarot, another common interest. The painting now hangs at the Park Avenue Shelter.

began conducting workshops at Lexington Avenue in January 1994) was the creation of a community quilt. Each resident artist, working with a volunteer, constructed a section made of five Polaroid pictures mounted on acetate sheets with handwritten text. The sections, created over a period of six months and based each week on an issue of importance to the quilt makers as women, ultimately were assembled into one large quilt. The previous week, Janet had made a section of pictures in which she appeared holding photographs of her son, her friend's child, and her son's favorite stuffed animal. This night, with female sexuality the focus, Janet insisted on changing into a borrowed black evening gown. Enthusiastic, she nevertheless seemed unable to articulate any particular concept or point of view for her section; it was clear only that she wanted to pose and have her picture taken. As directed (by Janet), I took shots of her vamping in her Vampira dress and then tried to sneak a few candids, hoping to capture the natural ebullience that inevitably burst forth the very moment *after* I released the shutter. To say that Janet was more excited about being photographed in a kick-ass sexy dress than about making art may sound patronizing, and in truth, I wondered whether this experience qualified even as the cultivation of self-expression, not to mention art. Without doubt, the project allowed Janet to express a side of herself that shelter life and poverty do everything to suppress. When we

If, as I believe, all human beings are born with the ability to sing, dance, and make art, the A&HC may help reawaken what our repressive, violent world most often puts into a state of dormancy.

finished shooting, Janet, as instructed, chose five of our ten shots for the quilt, and five to keep for herself; she took her favorite and showed it to everybody in the room, saying she was going to show it to her father, who wouldn't believe his little girl could look like that. This surprised me, since Janet is obviously a grown-up, attractive woman, a self-assessment she, like so many women, apparently was unable to make without the help of bare skin and cheesecake. I found myself wondering if she—or almost any woman in the United States, for that matter—would be able to get beyond such imitations of femininity if she had more frequent opportunities for the safe, enjoyable expression of her adult sexuality. And if Janet

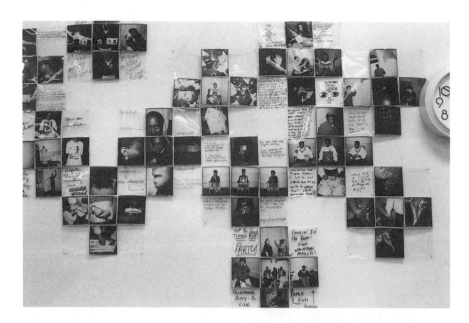

Hope Sandrow and Lexington Avenue Shelter residents, *Community Quilt,* 1994. Polaroid quilt making calls on a traditional form of community art making and allows resident artists to address issues significant in their lives. Here, the quilt hangs on a wall at the Lexington Avenue Shelter.

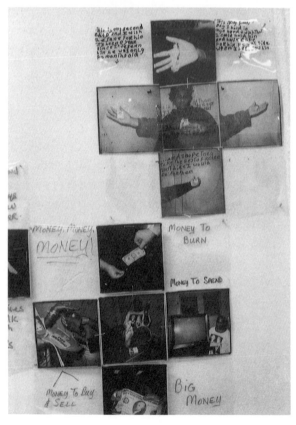

could make art for more than two hours a week, I wondered, what might she be able to do? In the end, her arrangement of the photographs she had selected for the quilt, including a self-portrait (made by holding the camera at arm's length) captioned, "I wanted to see the inner beauty," makes a powerful statement, particularly when considered alongside her quilt section from the previous week. What Janet and the other women are saying, says Sandrow, is what's on their minds.

> In the first piece, Janet chose to demonstrate that even though her son isn't with her, she's a caring, loving mother, and in the next piece, that she may have been stripped of everything, but she's a sexy, attractive woman—this is actually heroic to me. Those are identities the shelter system strips away. And the art work gave her the opportunity to reaffirm those identities and gives viewers the opportunity to see past their own stereotypes and assumptions.

If Janet's pictures express what is important to her without revealing the specific circumstances of her life—that her child is not living with her, that she is poor, that she lives in a shelter, that she does not normally have the opportunity to dress up or that the black gown does not even belong to her—some of the quilt photographs address the realities of the women's lives quite directly. The week after I met Janet, the group settled on money as the topic for the night's quilt making. Two residents collaborated on a picture in which one pretended to be a phony blind beggar. Meanwhile, across the room, Gerti (the former resident who is now an A&HC volunteer) and I worked with Veronica, who, for the most part, sat by passively, unable, uninterested, or unwilling to take an active role. As Gerti and I set up and shot a few pictures, we tried to interest Veronica, who responded to our questions largely by shrugging her shoulders and saying, "I don't know." Finally, nearing the last of our allotted ten shots, I insisted that Veronica actively participate; she had me photograph her holding a sign on which she had written, "I need money. Can somebody please tell me where can I get some?" Next to Gerti's interesting but complicated collage contrasting homelessness with the real estate market, and my shot of coins ever so artfully strewn across

a carefully arranged piece of gold velvet, the photograph of Veronica, sign in her hands, rueful expression on her face, seemed to say it all.

Are Janet and Veronica and the other participating shelter residents artists? Are their Polaroid quilts, "doll" figures, life drawings, self-portraits, posters, and etchings art? The A&HC's process and product may raise such questions, challenging participants and observers alike to move beyond the safety of neat, polarized concepts of art and nonart, artist and nonartist, of "artist" and even "homeless" as expressions of one's essential nature, as sort of Aristotelian identity marks. If, as I believe, all human beings are born with the ability to sing, dance, and make art, the A&HC may help reawaken what our repressive, violent world most often puts into a state of dormancy.

Although many resident artists have approached the workshops with the same kind of limited assumptions most people have about what constitutes art (if-you-can-draw-this-you-too-can-be-an-artist), some of the participants have surely come to think of themselves as artists. Former Park Avenue resident Maria, who as a child loved to draw (but had neither the training nor adequate supplies to develop her talent), became a dedicated attendee of life drawing workshops led by Oliver Herring and Peter Krashes. Since official A&HC visits were curtailed beginning in the summer of 1993 while the shelter underwent repairs, Maria, Oliver, Peter, and resident artist Theo have continued meeting once a week, either at the shelter or at the studio Herring and Krashes share. Maria and Theo continue doing portraiture, for which they receive small commissions; much of their earnings go right back into art supplies. Gerti, who once was too shy to show her sketches to anyone, now lives independently and not only paints as often as possible but also exhibits and sells her work. Gerti, Theo, and Maria may not be part of any particular art scene, but the bare facts indicate that they are indeed artists, and professional ones at that. In the end, quibbling about the relationship between social programs and the A&HC's art making, making categorizations based solely on a qualitative evaluation of the project's end products, even defining art and artists, all seem beside the point, for the A&HC appears to have an enriching, expansive effect on the lives of just about everyone it touches. Besides, as far as Sandrow is concerned, the

A&HC itself—which she calls, alternatively, a live art work, a theater for action, and a process piece—*is* the art work.

If creating "a more stimulating environment in the shelters" and "inspiring people who have lost their homes to envision a more promising future"[23] is on the agenda of Sandrow's big art project, so is closing the gap between the art world and the world of the homeless. Sandrow's ambivalent relationship with the former (which she is a part of, and which she respects but finds limiting) had as much to do with the creation of the Artist and Homeless Collaborative as her concern for people living in shelters; she actually draws a distinction between the A&HC's official goals and her own quite personal one, which is, simply, "to explore the relevancy of art to people's lives." As a "theater for action," the A&HC is about bringing people together and seeing what happens. Thus, introducing artists to life in the shelters is every bit as essential as introducing shelter residents to art; when Sandrow first was offered the opportunity to take her work-shops to Park Avenue, the irony of the have-nots sharing a zip code with the haves was not lost on her, the chance to bring to the Park Avenue Shelter artists whose work might well be hanging in Park Avenue salons too rich to pass up.

For the uninitiated, shelter visits can be eye-opening. At Lexington Avenue, residents enter through a hallway filled with garbage bags, then pass through a metal detector; every time the women enter and exit the building, these are the sights that greet them. Most visitors to the Park Avenue Armory enter through that building's ornate foyer on their way to art and antiquities fairs, to benefits and balls, to the tennis courts, to dinner at the Seventh Regiment Mess, a half-timbered bad dream whose most prominent decorative feature is a row of mounted moose heads strung with Christmas lights. Bad taste notwithstanding, the building's grandiosity, its excesses, are nowhere in sight of the shelter residents, who enter through a separate metal-detector-equipped, garbage-filled, basement-level entrance and are allowed only on the third and fifth floors.

Sandrow is the first to say that everything she has learned in seven years of making art in shelters feeds right back into the work she does in her studio. If her visual style remains oblique, her vocabulary

Vince Gargiulo, Aida, Doris, Geraldine, Hazel D., Jackie D., Jenny, Judy O., Lucille L., Vassie, and Yvonne D., *Soft Entry,* 1991. "Recycled" socks woven into a steel facade. Most visitors to the Park Avenue Armory enter through its grand foyer; shelter residents must use this basement-level entrance (edge of metal detector can be seen at left of first view) and, in fact, are threatened with transfer to another facility if they do not comply. Some shelter personnel thought socks shouldn't be wasted on art. Although the socks had been treated with fire retardant, the installation was said to be a hazard and eventually was removed.

Judith Shea and Park Avenue Shelter residents, 1993. Mixed media. What was originally conceived as an opportunity to make prototypes of dolls that could be reproduced and sold to benefit resident artists, this figure-making workshop stretched into a six-month-long collaboration. Resident artists, approaching the work with great freedom and creativity, made something extraordinary, and the project took on a life of its own.

largely symbolic, she has chosen nevertheless to tackle her issues more directly. Her current work, a trilogy (begun in 1991) in which images on photographic paper are peeled from their backing in thin layers and then reconstructed, tacked onto boards, holds suggestions of violence and tearing apart, as well as of erasure and embrace. For the first series, *Memories Untitled (Skinned),* Sandrow drew directly on life experiences shelter residents shared during art workshops, while the second part, *Spaces,* echoes the Christian religious imagery many residents hold dear.

Working in shelters, says Oliver Herring, "really changed my work." For his current conceptual projects, Herring roams the city collecting plastic bags and other discards, which he cleans and turns into useful objects, "the way a homeless person might do." He and Peter Krashes value not only their work but also their friendship with Theo and Maria and have, Krashes notes, taken a certain sense of permission from the women: "I've learned that you don't have to question so much what you do, that doing art has a lot to do with self-esteem and self-recognition. . . . It's been a big breakthrough to learn to allow myself to do what I want." Most important, says Krashes, is the opportunity to develop friendships "with people we wouldn't ordinarily know—and to find out we have so much in common." Similarly,

Hope Sandrow (center) with resident artists Patricia and Gabriella at the Lexington Avenue Shelter art workshop.

Judith Shea, while less certain about whose work influenced whom, found the women's sheer *willingness*, despite their lack of technical training, "very freeing. . . . The power of what I saw was inspiring to me." Shea, who has been teaching for years, readily acknowledges that although she tried to go into the shelter without a lot of assumptions, "whatever assumptions I did secretly have were just twisted around."

But while the A&HC has succeeded in bringing together professional artists and shelter residents (Sandrow estimates that to date some one hundred or so professional artists and perhaps 2,000 shelter residents have worked with the A&HC), its momentum has slowed in recent months. In mid-1993, the board of directors elected—temporarily, perhaps—to stop sponsoring projects not related to art. Ironically, if that decision was reflective of the board's desire to keep the focus on art making, the A&HC's art workshops ground to a near halt when, in August 1993, the Park Avenue Shelter population was cut by well over half so that building repairs could be made. Scheduled projects were put on hold and, told several times that the situation would revert to normal "next week," Sandrow, Krashes, and Herring waited in a kind of limbo. In the meantime, Herring and Krashes, as noted earlier, continued working with resident artists Maria and Theo (both of whom moved into a new SRO residence in the summer of 1994), and Sandrow, tired of waiting, began holding art workshops at the Lexington Avenue Shelter. The presence of a new city administration since January 1994 and the subsequent reordering of city agencies and impending budget cuts, along with the imminent privat-

ization of some city shelters, including Lexington Avenue, have made it difficult to make definite plans, and so to write grant proposals, further impeding the organization's progress. "We're taking it step by step," says Sandrow. "Like shelter residents, we deal with uncertainty. You have to be very fluid when dealing with the city."

But identifying the exact source of the A&HC's troubles isn't easy: as in Sandrow's photographs, truth is many-sided, reality multilayered. While city and shelter bureaucracy have *never* made it easy for the A&HC to do what it does, internal conflicts have contributed to the general—and, in all likelihood, temporary—slowdown of A&HC activities. Certainly, Sandrow wanted her project to grow in particular ways: she wanted to bring in other artists, she wanted those artists to be paid, and she wanted to reach as many shelter residents as she could. (The organization would also like to train and pay shelter residents to lead workshops and is attempting to raise money for this purpose.) But as Sandrow puts it, the project "snowballed—all sorts of people wanted to get involved and follow their own agendas. I thought it was interesting to learn how to orchestrate all these people and at the same time to learn how to compromise." The failure of the organization to hire a full-time director (they didn't have the funds to do so) has meant that Sandrow has had to function as an executive director, a responsibility she does not want and has accepted only in order to keep the A&HC functioning. To avoid being consumed by her directorial role, Sandrow realized, she had to "let go."

A young organization tries to bring together three disparate worlds to make art.

Letting go meant, among other things, allowing the board to set its own agenda. And therein lay the dilemma. By 1993, the A&HC had grown too big to qualify for small, grassroots-type funding, yet had a budget too small for it to qualify for many larger grants. Caught in the crunch, the board president (who has since stepped down) favored a more ambitious budget, a decision several other board members considered inappropriate. Sandrow takes pains to clarify the difference between her own plans for the A&HC and those of the board of directors, some of whose members, though compassionate, might not fully grasp the immediacy of shelter residents' needs.

Happily, at the time of this writing (late July 1994), the situation seems to have taken a turn for the better. The search for a full-time director to manage day-to-day operations is at last under way, seed money has been secured, and Sandrow has been elected board president, a position that should allow her to steer the A&HC's overall and, most important, artistic course. There are indications that with the imminent return of temporarily relocated residents, art workshops may be resumed at the Park Avenue Shelter. (Unfortunately, in July 1993 the Giuliani administration's reorganization of city agencies resulted in termination of the Lexington Avenue Shelter's Survival Skills program, which had sponsored the A&HC there.) The creation of seven collaborative site-specific art works commissioned for the Food and Hunger Hotline's One City Café means a new collaboration between resident and visiting artists will soon be under way, and Sandrow has been in conversation with a member of the city's Human Resources Administration about expanding the A&HC's role within the shelter system.[24] Further, Sandrow believes the A&HC once again will be able to sponsor (although it will not provide funds for) the kind of nonart projects that were suspended.

In the end, the difficulties the A&HC has experienced may have been little more than the growing pains of a relatively young organization, one that tries to bring together three disparate worlds—the art scene, city government, and the world of the dispossessed—to do something really rather modest: make art. Making art, it's true, doesn't put food in the mouths of the women and children who live in the Park Avenue Shelter, at Lexington Avenue, at the Regent Family Residence. It doesn't give them keys to their own apartments, doesn't pay for medical care, doesn't provide shoes and coats, scarves and mittens. And yet, perhaps Robert Smithson was on to something: perhaps art need not be "considered as merely a luxury." For Arlette Petty, the Artist and Homeless Collaborative "gave me hope. Hope for the future . . . and also I was lucky enough to meet Hope Sandrow. So it turned out to be the most positive thing that happened to me in the shelter. It's sort of like a double hope."

[handwritten margin notes: How has the relationship between the public life & private changed over the 20th city?]

[handwritten margin notes: How has Peggy Diggs addressed this change in her art?]

Peggy Diggs:

Private Acts and Public Art

Public and Private

In 1930, the French architect Le Corbusier completed a design
for an apartment and adjoining roof garden in Paris for Charles
Beistegui, an art collector who had amassed an enormous collection
of Surrealist art. Although the project no longer exists, black-and-
white photographs reveal the outdoor space as a disquieting, incon-
gruous environment, even if representative of the collector's psycho-
logical and aesthetic predilections. As an architectural link between
the domestic interior and the modern city, the roof garden presaged,
in its blurring of private and public realms, the spatial ambiguity that
has become increasingly evident in the late twentieth century.

In one particularly poignant image of the Le Corbusier design,
the roof garden is vacant except for an ersatz hearth and two empty
chairs. The surrounding walls are a discomfiting height, too tall to
offer an easy, unobstructed gaze toward the city beyond, but too low
to eliminate its unruly presence entirely. In an uncanny but no
doubt premeditated juxtaposition, the top portion of Paris's Arc de
Triomphe peeks over the wall, establishing an indelible correspon-
dence between its powerful public iconography and the roof garden's
theatrical fireplace. In fact, the angle of vision is such that the scale
of these two archetypal forms is not only compatible, but nearly
interchangeable. The Arc de Triomphe, that resplendent emblem of
the ceremonial, civic life of the city, establishes a relationship with the
hearth, the warm, evocative sign of the domestic environment. Like
a single image that slides in and out of focus, these polarized yet
typologically related symbols of public and domestic life confirm a
complicitous relationship that recalls a historical legacy only to signify
a moment of radical change.

Le Corbusier, roof garden
for Charles Beistegui,
1930–31. This austere
image of the roof garden
(which no longer exists),
captures the interchange
between domestic and
urban space in the
twentieth century.

By now, we have experienced firsthand many aspects of the spatial changes only foreshadowed by Beistegui's private garden. The "out there" and "in here" of public and private are no longer adequate to describe or provide perceptual or political information. The clear opposition of public and private spaces has been succeeded by an adjustable series of the most subtle and exacting gradations. In fact, the implied boundaries of this continuum challenge prevailing assumptions. The public has become "privatized" in both a macro- and micro-gestural manner. The private control and surveillance of designated public spaces now influences the behavior of large groups of people. As examined in Richard Sennett's *The Fall of Public Man*, for example, a reliable taxonomy of public behaviors has deteriorated, leaving only private, idiosyncratic gestures as the primary method of communication.[1]

Concurrently, the private has become the new public space, the point of reception for most news of the world. People retreat to the privacy of their homes to learn of events in the world at large. The most typical experience of public life occurs behind closed doors, as women, men, and children, protected by the physical though illusory sanctuary of their domestic environment, gather the news of the city, the nation, and international communities through vast information systems. This is the public world that most people feel they know with certainty but which can never be observed or witnessed collectively. Unlike the social gatherings of people that may occupy a street or other site at a specific moment for a parade, ceremony, or spontaneous event, our prevailing and instrumental model of what is public has come to be chronologically and geographically dispersed—and nearly invisible. Fragmentation and isolation are the common bond of contemporary communities.

In this new spatial environment, ideas about the identification of art and the conditions of its existence have also changed. Public art and activist art are normally defined as categorically distinct. As in a Venn diagram, although issues and objectives may overlap, essentially two separate spheres—production and reception—exist. However, for an increasing number of theorists, critics, and artists, a conflation has occurred in which public art and activist art are inseparable, united in an inherently cooperative model of social-aesthetic practice. Explicit

in this model is the notion that art is "public" based not on *where* it is, but on what it *does*. Public art encourages the development of active, engaged, and participatory citizens, a process which generally can occur only through the activism of an artist and the provocation of art.

If, according to this new model, public art is activist art, then by definition no one can be an activist artist without accepting the conditions of contemporary public life. This coalition of ideas certainly characterizes Peggy Diggs's projects; the creative and distributive strategies that she uses not only accept but exploit the spatial continuum of public and private. Her work transforms individual stories into public narratives. The private is public.

These significant paradigmatic shifts provide the structure and background for the leading ideas in Diggs's work. Exhuming the practical and theoretical implications of a private-public progression, she engages in the domestication—the institutionalization—of activist art. For Diggs, activist art involves intimate, prolonged investigation rather than volatile, ephemeral demonstration. Her recent work expresses and embodies the paradoxes that complicate and question the concept of activism in contemporary cultures, and in contrast to more stereotypical visions of a direct, aggressive activism, is characterized by a quiet, restrained tone. While the work itself is not without strong emotional and psychological content, the artist's routine methodologies are very calculated. The body of work that Diggs has created over the past eight years raises significant, perhaps essential, questions regarding the definition of activist art, its operative historical origins, its instrumentality, its effectiveness, and its ability to accommodate the social, political, technological, informational, and distributive systems of the late twentieth century.

Art is "public" based not on *where* it is, but on what it *does*.

Diggs's most recent work emerges from a creative process involving direct, personal conversations with individuals who are chronically unrepresented in political discourse. The oral histories Diggs collects provide the structure for a public art that requires community response and reaction in order to be fully realized.

Still, as a community-based activism of highly personal and intimate means, the long-term consequences of the work are difficult to access. Paradoxically, while the production of the work engages the disenfranchised in a reinvigorated social dialogue, there is little concrete evidence of a sustained process with clear results. The data require a longer time frame to develop—the real time of response and reaction. Diggs is involved in shifting the consciousness of a subject or audience, always an imprecise endeavor. While the immediate impact of her projects may generate more calls to hotlines for help, for example, Diggs remains suspicious of quantifying responses to either substantiate or dismiss her work. She is far more interested in long-term, often immeasurable effects.

Domestic Violence as a Public Subject

> This apparent inattention to the problems of the "physical and sexual assault" of women and children may have been just that—apparent. The same reluctance that prevented a direct struggle against the perpetration of intimate violence kept those who suffered from realizing that their problem was much more than a personal one.[2]

In a project concerning domestic violence, Diggs chose to employ a circulatory system already in place in the public domain as a conduit for activist art. Individual narratives provided the background that confirmed how public life is constructed and manifested in the domestic context. Diggs directed her attention to the ordinary culture of private homes when they do not protect but in fact may provide cover for threat, harm, and isolation. She focused on women for whom domestic life does not mean rest, respite, or protection from the world, but is a forced retreat—a desperate, conditioned response to a state of siege.

Before initiating her later public work on domestic violence (the *Domestic Violence Milkcarton Project*), a piece that reached hundreds of thousands of homes, Diggs produced several works and installations that represent different points in her field of research and include her own visceral response to the subject of abuse. Reflecting the intellectual as well as the more intimate contours of the artist's pursuit

Peggy Diggs, *Objects of Abuse*, 1991. Mixed media on steel grid, 48" x 96" x 12". A display of domestic paraphernalia held in restraint on a metal grate offers a grim taxonomy of the instruments of violence in the home.

of the subject, the projects explored the abuse of women and children as atrocities distinctive to domestic violence. They have a specificity that is inappropriate, if not impossible, in a public project.

In 1992, Diggs exhibited *The Domestic Violence Projects* at the Alternative Museum in New York City. One project used a heavy metal grate as the armature for a mixed-media installation entitled *Objects of Abuse* (1991). Strapped to its surface was a bizarre and ghastly collection of objects used by abusers to control, attack, injure, or kill their partners or children. These commonplace accoutrements of the home—all items and appliances otherwise routinely and reflexively used—suddenly became a bleak trail of evidence when held up before an audience. Arranged with meticulous care, these objects—a hairbrush, a boot, an enema bag, a lamp, a pillow—formed a tidy, scientific display of selected specimens of domestic warfare. The artist's detached, objective management of the assorted props appropriated for abuse gave a shocking, unrelenting resonance to the project. Ordinary domestic paraphernalia became deeply sinister instruments of repeated, wretched assaults.

More subtle, but equally disquieting, *Memorial* (1991) employed a single gesture to detonate the tranquil vision of an innocent, protected childhood. Diggs chose a dress for a toddler—a "classic" much like those that many of us wore as little girls. With a round collar, short puff sleeves, smocking across the breast, and full skirt, the dress signifies the bright expectations held for children in our culture. But the comforting, gender-specific references of the little dress were dashed by the artist's powerfully simple presentation. It was mounted on a background of black fabric inside an ornate gold picture frame and protected by a sheet of Plexiglas. Two-thirds of the way down, Diggs cut a circular hole, creating the illusion of a bull's-eye or some bodily orifice. A section of the hem of the dress was gathered and wired into a tight cylinder the size of an index finger or a small penis. This phallus of cloth projected through the hole in the glass.

Not only was the notion of a protected and hermetically sealed art object dismantled, but the glib assumption of a safe, carefree childhood was replaced by the grim recognition that this is a period of unspeakable misery for some young girls. The lovely dress itself was lifted, grabbed, and made to form the instrument and environment

Peggy Diggs, *Memorial*, 1991. Baby dress, wire, frame, Plexiglas, 29" x 35 $^1/_2$" x 3". Gathering the hem of the skirt into an erection of cloth subverts the security and sanctity of both protected childhood and preserved art, leaving an indelible visual metaphor of the horrors of family violence.

of either the child abuser or the pedophile. Starkly shocking, either possibility is repugnant. The penetration of the hem of the dress through the glass inscribes a physical abuse that not only harms the victim but renders the concept of childhood innocence obsolete.

The *Domestic Violence Milkcarton Project*

The artist's decision to pursue domestic violence as subject matter for her work was followed by a period of intensive research. Immersing herself in a topic about which she was initially only somewhat knowledgeable, she not only read extensively, but also interviewed psychologists, therapists, and other health-care workers who work with victims subjected to violent behavior and the suffering of domestic abuse. Undoubtedly the most intellectually challenging and profoundly moving passage in this research involved the artist's extended consultations with two women in a maximum security prison in Rhode Island. Both women had experienced serious, prolonged abuse. One was actually tried and sentenced for a murder that her abusive mate had committed.[3]

These readings and interviews enabled Diggs to comprehend the magnitude of this crisis. Many desperate, personal stories shaped a harrowing anthology of public proportion. Yet despite the immense scale and scope of the problem, Diggs was struck by the paradox of private isolation as a public condition. Many of the women she met began passages of healing and recovery only after they realized that their dreadful experiences were not isolated, unusual, one-of-a-kind horror stories. The realization finally dispelled the mistaken notion that no other women were suffering such psychological and physical indignities. Recognizing this, it became Diggs's intention to distill the stories of many abused women into an indisputable public image.

> As a result of the structural isolation of women and children in nuclear families, the feeling that problems that affect one personally are personal in origin and in solution, and the anticipated negative consequences of revealing "taboo" information, victims are culturally deprived of that resource most likely to facilitate their experiencing of injustice and effective action: other people's alternatives and an experience of collectivity.[4]

Peggy Diggs, *Domestic Violence Billboard*, 1991. Paper, ink, 240" x 120". A billboard installed at three sites in Berkshire County, Massachusetts, represented private atrocities as a community concern.

One of the women interviewed at the Rhode Island prison confirmed another perplexing paradox embedded in Diggs's project. How does an artist make a public project that reaches the subject of the work, the victims scattered throughout our nation's communities, especially when these members of the public must maintain secrecy in order to survive? How does an artist get the message to this exiled and fractured constituency? Diggs realized the limitations of traditional art production and exhibition for a marginalized audience unable to participate fully or eagerly in the world of galleries or museums, much less see the public service graphics on the city streets. Although the artist was working on a billboard on domestic violence (*Domestic Violence Billboard,* 1991), she sought in the normal patterns and routines of these women's lives a potential clue to an alternative, subtly subversive form of art distribution.

Everyone has to eat; most women regularly go to a grocery store to shop for their families. Diggs decided not only to locate her project in commercial environments of this kind, but also to "plant" it on an item that most shoppers would purchase and take home. Selecting half-gallon milk cartons as her prototypical vehicle, the artist devel-

oped four different graphic concepts for a single side of a carton. Each image confronted the specter of domestic violence but differed in design and directness. The graphics were obvious, employing common typefaces, singular images, and simple silhouettes. Three of the concepts were explicit, even aggressive. They referred specifically to violent acts, hitting, and physical and psychological restraint. A fourth design discreetly inquired about arguments that habitually escalate. All of the designs included the telephone number for the National Domestic Violence Hotline, 1-800-333-SAFE.

With her four prototypes, Diggs met with dairy companies and distributors in the New York metropolitan region seeking support for her efforts to place these images in women's homes, to locate them in the darkness of domestic abuse. Diggs pursued at least eight major dairies. There were great reservations, little interest, and few encouraging words. Most organizations found the topic too volatile to promote; they feared a decline in image and sales. But Diggs's ninth contact, Tuscan Dairy in Union, New Jersey, agreed to print cartons with her designs. Several years earlier, Tuscan had represented the crisis of homelessness on its milk cartons. Diggs's project appealed to the company's vanguard image in addressing public issues.

It had been the dairy's initial intention to use all four designs, but when the proposal was brought to executive committee, the members balked at the explicitness of three of the images. They agreed to print only the most subtle and understated concept, in which the text, "When You Argue at Home, Does It Always Get Out of Hand?" was overlaid on the silhouette of a hand partially clenched in an angry or imploring gesture. Diggs's image was printed on one-and-a-half-million milk cartons and distributed in New York and New Jersey in late January 1992 for a two-week period. Creative Time, Inc., a courageous organization that has organized and encouraged public, activist, and performance work for nearly twenty years, sponsored the project.

In addition to the fact that milk may be the most ubiquitous item on American shopping lists, there was a particular irony to the milk carton as vehicle for Diggs's message. Milk is consistently promoted for its wholesome qualities. Few can dispute its nutritional value or symbolic integrity. It is the family-values food, representative of all that is healthy, harmonious, and productive in the conventional

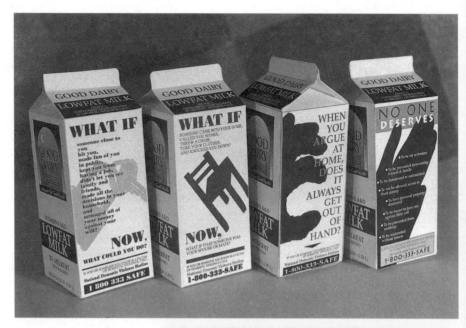

Peggy Diggs, *Domestic Violence Milkcarton Project*, 1991–92. Cardboard, ink on half-gallon containers, 3 ³/₄" x 3 ³/₄" x 9 ¹/₂". Knowing that supermarkets were commonly visited by abused women, the artist developed four designs for milk containers to be sold to consumers.

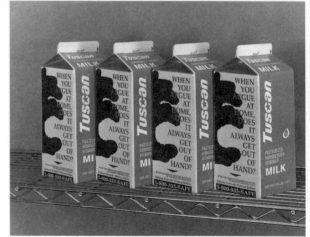

Peggy Diggs, *Domestic Violence Milkcarton Project*. This prototype was selected and distributed by Tuscan Dairy to bring a family-violence message home.

nuclear family. Diggs's appropriation of this dairy product exploited all of the ironic potential of a temporary partnership between conflicting and discordant symbols. The images invaded the milk cartons like a virus, using the bright virtues of the consumer product as a highway to the center of the dark realities of family violence in the United States.

Audience and Distribution

Diggs's savvy poaching of a ubiquitous, commercial system to disseminate information marks an important moment in activist work. Rather than employing the direct hit of the streets or the press, she has selected a more oblique, "invisible" assault. While the site of confrontation and perception differs dramatically, Diggs's project bears a familial resemblance to the Spectacolor Signboard Series that New York City's Public Art Fund sponsored for six years in the 1980s. For this huge, computer-animated lightboard on the north elevation of One Times Square, typically programmed with advertising, the Public Art Fund commissioned artists to develop twenty-second spots to be displayed intermittently throughout the day for a month. These projects, many of which addressed contemporary urban social and political issues, were shown alongside advertising for banks, furniture stores, and other metropolitan enterprises.

The rapid-fire delivery and brief life span of these projects confirmed a compliance with commercialism and made the artists' projects both subtly incongruous and invasive. While the intentions and motives were dissimilar, both Diggs's and the Public Art Fund's appropriation of a normative, commercial methodology effectively registered the disquieting insinuations of an alien, activist art. By conforming to the circumstances of product advertisement and distribution, activist art accepts—and subverts—an institutionalized system as a vehicle for social change. The poignancy of Diggs's strategies of distribution in the *Domestic Violence Milkcarton Project* is that an immense process of delivery concluded with an intimate encounter with the product. The vast network ultimately reaches the home. Still, it is impossible to evaluate empirically the effectiveness of Diggs's large-scale, short-lived project. Although increased calls were reported by the National Domestic Violence Hotline, the actual

individual effects must remain elusive. No doubt a certain percentage of these revised cartons went unnoticed, the milk consumed, the

carton crumpled and discarded without a glance. Their material presence was dramatically, disturbingly brief. Yet what are the immaterial consequences of this work? Undoubtedly, many of the cartons were seen and studied, and a public recognition of private misery was strongly communicated. Perhaps help was sought and the solitary confinement of unreported misery was broken.

> **Activist art accepts—and subverts—an institutionalized system as a vehicle for social change.**

Perhaps among the abusers and the abused, some got the message.

However it is mediated, public life is experienced in most homes through television, video, and computer. While individuals may take the initiative to turn on the equipment, their encounter with the "reality" it delivers remains indirect and impersonal. Diggs chose a more intimate, personal, and guerrilla-like method. Consumers don't expect to encounter provocative information on the sides of food containers; they don't expect to discover public messages as they sift through the refrigerator or sit at the kitchen table. But Diggs imagined that for a woman pouring a glass of milk late at night or drinking a cup of coffee in early morning, a serendipitous moment of recognition would occur. The final paradox of the *Domestic Violence Milkcarton Project* is that it did not become an activist, public project until it had invaded the sanctuary of the home.

The *Hartford Grandmothers' Project*

A tested form of documentation and historiography, the oral history uses single stories or a collage of multiple voices to construct a nuanced, complex narrative. It personalizes history, balancing its more objective methodologies with a variegated texture of voices, memories, experiences, and emotions. Like a historian or a cultural anthropologist, Diggs has chosen to use this methodology to research, document, and analyze. As an artist, she too finds that the process supplies the raw materials for creative production. In a recent project in Hartford, Connecticut, she gathered the stories of a specific group of women with a common plight to illustrate the general causes and crises of urban unrest.

The *Hartford Grandmothers Project* (1993–94) was organized when the Wadsworth Atheneum invited Diggs to develop a public project in Hartford in conjunction with an exhibition of her work. Through reading the city's newspapers, Diggs became interested in the subject of crime in the city and disturbed by its scope. She decided to examine what this meant for particular groups in Hartford. For almost a year, the artist met with and interviewed elderly women in senior citizen centers, churches, parishes, and in their homes. As the conversations continued with women from diverse ethnic and economic backgrounds, a collective rage was quietly and repeatedly expressed: retirement had not provided the once-anticipated freedom of time and mobility. Instead, these women were facing confinement in a city with violent gangs, hard drugs, and the social turmoil and individual anxiety produced by increasingly pervasive crime. Many felt imperiled, too frightened to venture into the streets of their own neighborhoods. Their anger was aimed at teenagers, who they felt were responsible for the escalation of violence.

In Diggs's domestic violence projects, the unnamed, silenced victims of violence were both the subjects of inquiry and the intended audience for the message in her work. For the Hartford project, the intended audience was not the older women with whom she met so frequently and who unmistakably recognized the jeopardy this growing urban problem placed them in. Rather, the chosen audience was the general population of the city and, more specifically, the teenagers precipitating many of the asocial activities these elderly women feared and loathed.

With the assistance of the Institute for Community Research, school officials, and members of the clergy, Diggs then also met with teenagers in housing projects. The voices of elderly women and angry teenagers formed a call-and-response chant in the artist's imagination. Combining this metaphor with the ubiquitous lottery ticket, Diggs created scratch-off cards in nine-by-twelve-inch perforated sheets, with each sheet containing nine cards. One side of each card included excerpts from an elderly woman discussing the decline of personal safety in the streets of Hartford. On the other side, when the scratch surface was rubbed, the words of a teenager on the subject of crime and the fears of the elderly were revealed.

Peggy Diggs, *Hartford Grandmothers Project*, 1993–94. Paper, ink. Twelve-by-nine-inch sheets of scratch-off cards distributed in the June 16, 1994, edition of the *Hartford Courant* represented a series of dialogues between teenagers and elderly women.

On June 16, 1994, the *Hartford Courant* distributed the sheets of scratch-off cards in its daily edition. At first reluctant to circulate the angry comments to the community at large, the newspaper later re-evaluated its role and responsibility in the representation of the city's realities for particular citizens. The project did not conclude at this point. Diggs had envisioned her role as a catalyst to create a meeting ground for these embattled constituencies. Throughout the summer and autumn, she returned to Hartford to coordinate meetings bringing together elderly women, many of them dismayed with teenagers, and teenagers, some of whom were the perpetrators of crimes.

The *Caracas Subway Project*

In 1992, Diggs was awarded an international residency. Developed by Arts International and supported by the Lila Wallace–Reader's Digest Fund, the residency program provides opportunities for artists, in partnership with United States organizations, to work in an unfamiliar culture and to share this experience in a project developed for their own communities. It is felt that artists stimulated by working in new surroundings will then be likely to return with enriched insights to the United States. Communities are the beneficiaries of the artists' intercultural experiences.

Having already visited Latin America on several occasions, Diggs was particularly interested in returning to study political and street art. She proposed to spend three months in Caracas, Venezuela. On her arrival, she discovered that her intended plans were not appropriate. Involved in a modernist/formalist tradition of art, Caracas had little art in the streets. Nor were art and politics seen as common or compatible partners. Looking for another lead, Diggs read the newspapers and became interested in a confederation of different women's groups working together in the city.

Without a fixed idea in mind for her project, Diggs sought out these groups and asked them to identify significant issues for women in their culture. With the assistance of the artist, the women cited the abusive behavior of men toward women as a prime concern in their lives. They asked Diggs to design a poster for distribution and display in the city subway system. Sponsored by INDULAC, the largest dairy

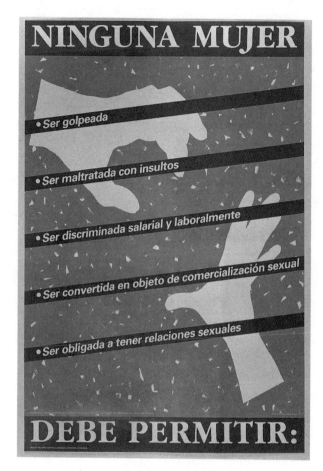

Peggy Diggs, *Caracas Subway Project*, 1992. Paper, ink, 29" x 41". A poster on women's concerns was placed in city subway stations in Caracas, Venezuela, despite some last-minute concerns with the awkward implications of the text.

in Venezuela, the poster identified types of abusive behavior and provided sources where abused women could seek support.

The text of the poster read: "No woman should let herself be hit, be mistreated with insults, be discriminated against in the workforce, be made into an object of sexual commercialization, be obliged to have sexual relations." After the posters were printed and shortly before their distribution in the subway stations, the participating women expressed reservations. They felt that the text was inappropriate, that the word "let" portrayed women as complicit in these exploitative situations. In spite of these doubts, the women decided to approve the installation of the posters. Both subway authorities and participating organizations reported an increase in telephone calls asking for assistance while the posters were in place. Unfortunately,

a coup that erupted several days after the posters appeared derailed a
more conclusive analysis of the project.

Activism in the Schools: Engaging and Empowering Students

In accordance with the residency conditions requiring a community
experience in the United States, Diggs developed several companion
projects on her return to northwestern Massachusetts. She sought
another overlooked constituency with which to generate a new series
of related activist works. Approaching four city and regional high
schools, she initiated separate local projects. While interest never
developed at one site, in three different communities, each based on
prolonged conversations with teenagers during their art classes, Diggs
helped students identify issues of central importance to them. As the
regional sponsor for Diggs's high school projects, the Williams Col-
lege Museum of Art helped to identify prospective sites, as well as art
teachers who might be interested in school-based public art.

Diggs began working in the three selected high schools in Novem-
ber 1992. Three school-based projects were completed shortly before
the end of the school year in June 1993. Following the initial discus-
sions, the process she followed moved from a theoretical to a practical
level. Once the subjects of concern were articulated, how could they
then be examined in more depth and communicated to a larger, di-
verse community? The students, at once the subjects of and collabora-
tors in this artistic process, then served as the arbitrators of the artist's
visual proposals. In each school questions were raised: What forms
should activist art take? Where should it be encountered? Should it be
centralized, or should its components be scattered throughout the
community? Who was the work intended for? How is an audience
identified and targeted? What makes visual images and messages
communicative and memorable?

Diggs's involvement with both her subjects and their communities
has characterized all of her recent projects. However, no predeter-
mined aesthetic formula guides the design and production of the
work. While the artist brings to the collaboration a strong conception
of community participation, sharpened by thoughtful, painstaking
methods of inquiry, the images—the art—are determined by the
particular circumstances of each situation. Each of the high school

projects had uniquely articulated objectives, audiences, and methods of production and distribution. Each one registered the concerns of its own community within a common regional context.

For example, Hoosac Valley High School students confirmed that their greatest preoccupation was the decline of personal conversation and public debate. Not only did they experience fewer opportunities, but they also experienced a growing reluctance from the adults in their community, whether parents, teachers, politicians, or clergy, to have frank, open discussions. To span this gulf of understanding between generations, Diggs, with the students' input, designed a billboard for a prominent traffic intersection. The statement "It Would Help If You Would Listen" articulated their understated and reasonable appeal. Accompanying the text was a photograph of students with a scattering of superimposed words concerning subjects of particular concern to them: drugs, drinking and sex, racism, and parental and peer pressure. By recognizing and then reminding the adults that, as the new generation, they would inherit the responsibilities of community service, and that productive citizenship results from an environment of open exchange, the students brought attention to the need for a shared social contract to enable the community to flourish. Their project was a poignant request for a sustained democratic discourse that would enable and empower them to be thoughtful, constructive agents in local public life.

The students in the other high schools where Diggs collaborated chose to address more concrete, specific issues. They also selected other strategies of distribution, determined by the issues of concern. The city of Pittsfield, Massachusetts, has, over the past decade, faced a dramatic deterioration of its industrial and commercial base. A drive through the city offers graphic evidence of the decline in the condition of its shops and businesses, abandoned homes, and blocks of neglected buildings. The students chose to articulate to the community their experience of loss and disappointment; their concern was the apparent fact that Pittsfield holds little promise of a future for them. A postcard, designed by Diggs to condense the information expressed in the many hours of meetings at the high school, was eventually printed and distributed to 15,000 households in Pittsfield. Diggs and the students sought a comprehensive distribution to

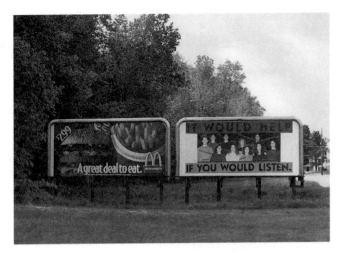

Peggy Diggs, *Hoosac Valley High School Billboard Project*, 1993. Paper, ink, 240" x 120". A billboard on the disenfranchisement of teens, installed at a prominent intersection in Adams, Massachusetts, raised questions about a community's responsibility in the construction of future participatory democracies.

Peggy Diggs, *Pittsfield High School Bulk Mail Project*, 1993. Paper, ink, 7" x 3 ¹/₂". The project depicted the decline of opportunities for teens. Sent to households in the city with a request for response, over one hundred notes were returned.

correspond with the alarming extent of the city's economic plight.

At Drury High School in North Adams, Massachusetts, drinking and driving was a significant concern. Diggs and the students chose to attack this growing problem at the critical sites—local bars and taverns—as well as at some of the fast-food franchises where teenagers frequently congregate. Paper drink coasters were distributed to bars in the area; table tents were placed in Dunkin Donuts, Burger King, and other busy hangouts. Both the coasters and the table tents had a colorful, game-board-like pattern of alternating rectangles, which were captioned either "Drink" or "Drive." The one notable exception stood out: it included the text "You Lose." Set on the diagonal, another text read, "Drury students urge you not to play this game."

These collaborations with students were not easy or effortless. Diggs has described the blankness and disbelief she encountered when she first began working in the high schools. She was perceived as just another authority figure who would preordain and control the environment of the classroom along with what might be produced there.[5] In all of the high schools, the artist recalled that a significant turning point occurred when she brought in four or five rough drafts for project prototypes. In her presentation, she described what she believed she had heard students say, and what issues, ideas, and images provoked their responses. She then asked for the students'

critical input. With the presentation of the images, followed by participation in their development and modification, and the probability of an actual product, the students began to envision and play an active, indispensable role in the process that Diggs had initiated.

Planting Possibilities for Awareness

While high school is a link between childhood and adulthood, many students feel a sense of futility and powerlessness. Equipped with an enhanced knowledge of the world and region, they are frequently frustrated by an inability to influence not only the environment of their school, but their communities. Through these projects, students not only confirmed their ability to identify and confront difficult issues in their own lives and communities, but began to experience the effects of their own actions in the formation of new, positive visions of public life. Through Diggs's insistent, inquisitive manner, they learned that "public" is not a passive, fixed idea; it must be vigilantly invented and reconstructed by each generation and all individuals. Public life assumes many forms; through these collaborative projects, high school students began to influence and shape an urgent, impassioned conception of public vitality in their own schools and communities.

As with her other projects, the results are intangible. Many of the high school students with whom Diggs collaborated have graduated, and it is difficult to follow up. Some of the teachers the artist spoke with felt that the students would not fully understand the scope of their accomplishments until they were older. While the students were pleased with the objects produced and distributed, they seemed unable to embrace or extend the potential of this cooperation between art and politics, theory and practice. As in many of Diggs's projects, the high school works sowed seeds of community activism. And although focused on one major subject, the artist's methodology introduces many subtexts for consideration. Inevitably, there is some immediate response. Ultimately, the work plants the possibility for each individual's active participation in a more enduring, long-term democratic process.

> **"Public" is not a passive, fixed idea; it must be vigilantly invented and reconstructed by each generation.**

The Site of the Body

For Diggs, activism is not a process restricted by the physical limits of scale or site. Although many of her public projects—including the high school works—develop initially from the personal voices of beleaguered individuals, other projects revisit the private site—at the intimate scale of the body from which individuals first delineate their conception of public and private. In the mid-1980s, following her career as a painter, Diggs shifted the direction of her creative work. She has described a temporary move to Madrid as marking the beginning of her political and public consciousness, of an emerging awareness that art could support and encourage a dynamic public culture.[6] There, as an American woman in an unfamiliar setting, she learned to live with the liberties and limitations of the expatriate, the exile. In a way resembling the intentions of the Arts International/Lila Wallace–Reader's Digest residency that sponsored her trip to Caracas, travel enabled Diggs to reexamine her role as an artist and community member. The issues that had been excluded from a more conventional studio practice began to affect her life and penetrate her art.

For a feminist, the culture of Madrid can be difficult and puzzling. Embedded in the traditional structures of society, women are granted only a very constricted role. These questions of gender codes and sexual conformity became an absorbing preoccupation for the artist. While in Madrid, she produced a series of handmade, fluted fans that, when held closed, looked like the lovely objects often used to embody the conventional and seductive gestures of femininity. But Diggs transformed these gender-coded objects by covering their opened surfaces with pornographic images. It was her first work addressing the deception of cultural symbols, the injustices of social codes and customs.

Almost ten years after she made these fans, Diggs revisited the site of the body to address the derisive power of gender stereotypes. As she listened to the freely expressed concerns, complaints, and appeals of these Massachusetts teenagers (particularly young women), the codification of sexual expectations and behaviors emerged as a consistent theme. Drawing on these personal encounters, she designed the *Sex Bias Shirt Project* (1993), tailored to contrast the sexual labels

Peggy Diggs, *Sex Bias Shirt Project*, 1993. Recycled white dress shirts. Employing the conventions of fashion and the symmetry of the body, Diggs decorated men's dress shirts with the epithets of sexual stereotyping.

inscribed for young men and young women in many of our cultures. A sexually active young woman frequently suffers a loss of her reputation with her peers and societal disapproval. A sexually active young man, however, enjoys the accolades of friends as well as the indulgence, if not admiration, of society, all effectively enhancing his reputation.

The artist collected one hundred used white dress shirts and employed the formal conventions of male fashion to describe the double standard of society's responses to sex for male versus female teenagers. "She lost it. He got some. Hear the difference?" was printed over the breast pocket. On the back of each shirt, a centerline separated the categories "Male" and "Female." The male side is articulated by only two adjectives: "stud" and "man." On the female side is a spill of slanderous words and phrases used to characterize sexually active young women: "whore," "cunt," "slut," "cum-dumpster." By transposing idiomatic public expressions to a public article of clothing, Diggs derails the public/private debate.

Like the signs of change inscribed in Le Corbusier's Paris roof garden, Diggs's work tests the pliability of private and public spatial parameters. Her work articulates the public world through the details of the private. Seeking out the silenced and unspoken for, she "publicizes" the broad scope and common ground of their experiences. While she remains a sensitive, resourceful, and tenacious scavenger, collecting the stories of members of the public who are often unacknowledged, she also takes these fragile tales and uses them to stimulate work that extends beyond the personal narrative to a public text. At the same time, her most aggressive and powerful scrutiny occurs within the existing systems and institutions of commerce and communication—stores, schools, and postal systems, for example. Through the use of these forums, she transforms individuals' experiences into a compelling conception—and the real possibility—of an ongoing public activism.

Guerrilla Girl Power:

Why the Art World Needs a Conscience

I am in Montgomery, Alabama, civil rights landmark of the South, for a recent conference on women in the arts at the Montgomery Museum of Fine Arts. In conjunction with the event, a Guerrilla Girls retrospective is hanging in the pristine galleries of the museum. Tonight, two Guerrilla Girls, "Frida Kahlo" and "Romaine Brooks," are scheduled to provide the entertainment. (Each member gets a realistic gorilla mask and the opportunity to take on the name of a deceased woman artist.) The auditorium is packed. Kahlo and Brooks are on stage looking leggy and ferocious—Brooks in pants and Kahlo wearing fishnet stockings and high heels, the king and queen of the jungle. Brooks (or at least her mask) looks particularly vicious, as if she didn't get enough raw meat for dinner.

"You know," says Kahlo, stomping around the stage, "the funny thing is if I took off this mask none of you would listen to me." Nervous laughter rumbles through the audience. "I have to wear a hot, heavy gorilla mask on this stage to get your attention," says Kahlo, who's not laughing about her fashion statement. "Not to mention your respect," adds Brooks.

Kahlo hurls one of the bananas she's holding out into the audience and a group of people leap from their seats to catch the yellow phallus; everyone roars with laughter. The ape is feeding the humans.

For the next hour, the Guerrilla Girls have the audience eating out of their hands. They get a few insults, which are always welcomed into the act; the more abuse they get, the more fun they have dishing it out. The auditorium is filled with a few hundred people who have traveled from all over the South for the show. The Girls, as they call themselves, are prepared. They arrive in any given location armed with relevant statistics on the local cultural terrain. The Girls do their

homework before crossing state lines, researching and gathering information. Over the years, they have developed a popular show that's played to crowds around the world.

In Montgomery, they cover their usual subjects, including the biased history of art and the sexist treatment of women in academia. Then they move into an open discussion on civil rights in the South. When they discover a controversy brewing around "outsider" art (Morley Safer has just made an irritating sweep through town for *60 Minutes*), they delve into the subject, provoking a debate on the meaning of the term: Are women outsiders by definition? Why don't museums allow outsider objects to mingle with "insider" ones? Why are prices for folk art so much lower than those for fine art? This discussion segues right into the most divisive issue of all: the scant number of artists of color represented in this museum's very own collection. The Girls have the numbers, and they love biting the hand that feeds them. After all, they're only animals.

The act is a visual spectacle, including a range of media (video, posters, slides) and activities. At times the show turns into pure Oprah, with lots of audience participation and finger wagging. The Girls work the room, scanning for politically incorrect views. Their Montgomery show is a typical combination of new and old material. The Girls, depending on who performs, have a range of talents, so their live events vary with each performance. On a good night, men are lured onto the stage and encouraged to embarrass themselves to death—all in fun. The rhetoric in Montgomery, and I suspect elsewhere, is an orgy of political "isms," while the performance is savagely funny. Listening to a gorilla for an hour is disturbing, and the Girls' anonymity, which they have enjoyed since their inception, gives them all the freedom they need to be fearless. Guerrilla Girls aren't polite; one of their current goals is to unseat powerful men and move women into positions of authority. When the Girls leave town, the women left behind have been empowered to speak out, and there is no one to blame except a bunch of monkeys from New York.

> **The Girls have the numbers, and they love biting the hand that feeds them.**

One of the Girls posed in 1987 with a banana, a prop used in most performances.

In the Beginning

In the spring of 1985, the Museum of Modern Art opened a long-awaited international survey of painting and sculpture. The exhibition was a bombshell by feminist standards; less than 10 percent of the artists were women, and 100 percent of them were white. A protest in front of the museum had little impact. Women artists were furious, but no one was organized to do anything about it.

The Guerrilla Girls were born in New York that same year, at a time when feminism was out of fashion, and the art world was drenched in money and fame. The East Village was thriving, and collectors were as notable for their wealth as for the objects they were purchasing. Money was power, and collecting was treated like a new sport; sensitive "yuppies" needed to be surrounded by art, and no apartment was tastefully decorated without it. Wall Street was booming as lawyers moved into SoHo, transforming funky loft spaces into expensive condos and co-ops. Art was selling. What could be better for artists? Male artists, that is. "It was one of the most sexist periods in the art world," says a lapsed Guerrilla Girl, who still enjoys being anonymous. "Women were considered party girls, nothing more." Their art wasn't selling; it wasn't even showing.

Only a decade earlier, the Women's Art Movement had been the significant critical movement. During the 1970s, a period currently being rediscovered by art historians, women were making, showing, and frequently controlling the flow of their work, by exhibiting in alternative or cooperative spaces. The women's liberation movement was rushing through college campuses and the bedrooms, kitchens, and television sets of Middle America. Artists were demonstrating in the streets for women's rights and picketing museums for equal time. The art work reflected the same issues that women were raising in consciousness-raising groups across America. Women artists were in the throes of a separatist rebellion.

Critics (male critics) often claim that nothing innovative happened during the 1970s because there was no one aesthetic movement that dominated the art market. The Women's Art Movement was inclusive and pluralist in spirit. It was difficult to assess as a single movement and impossible to label in a single word. Feminist art was,

virtually by definition, disruptive to the commercial economy of art. By the early 1980s, dealers were frantically herding collectors toward a new group of young male stars, while women artists, even those who had enjoyed a certain visibility, were getting buried again.

The backlash against women emerged during the formation of the New Right, a solidification of religious and conservative groups during the Reagan era. The antifeminist ideologue Phyllis Schlafly organized a campaign that managed to defeat the Equal Rights Amendment, as media pundits happily announced that feminism was dead. Nancy Reagan set the tone for domesticity in the 1980s, polishing the silver in the White House. Current retro-wisdom argued that feminism (not to mention capitalism) had completely failed women of color and, perhaps even worse: Feminists were humorless.

The times demanded reorganization, new strategies. "A group of us got together out of sheer frustration and anger," says a Guerrilla Girl, one of the seven women who attended the first casual meeting. All of them were veterans of the women's movement and also artists. "We talked about maybe starting an artists' union. We needed to do *something* dramatic and we wanted it to be different. We wanted action— not consciousness-raising," she continues. "We didn't even use the word 'feminist' or any 1970s language. We wanted to be funny and sexy." Exactly what feminists were not supposed to be. **Women artists were in the throes of a separatist rebellion.** "You couldn't call a mass action in 1985 because no one would have come," she explains. There was little agreement on the Left, or among feminists, on precisely what the mass issues were. "So we settled on occasional guerrilla actions."

The Guerrilla Girls began as a small group, responding to the situation of women artists. Perhaps the easiest decision the Girls ever made was the initial one to keep their identities anonymous; it was unanimous, with little discussion. "When we attack something, we want what we're saying to be heard, not who's saying it," Rosalba Carriera (an early eighteenth-century court painter), told a reporter in *Artworld*, a Canadian magazine. "We didn't like the cult of personality that surrounded women artists in the 1970s," says another lapsed member.

"We were a little afraid for our own careers, but more important, we just didn't want any more Judy Chicagos. No more monsters."

The Posters

In the beginning, there was no long-term plan. When the group became notorious in the art world, virtually overnight, the Girls were stunned. Women artists especially were thrilled with the first street posters, which named names, clearly dividing the haves from the have-nots. Bold black type on white paper, the flyers were simple, polemical statements of fact meant to inform and incite pedestrians. The posters went up in the dark of night (the Girls did the postering themselves, making sure each placement was strategically located) in SoHo and in the East Village, where numerous galleries and clubs had revitalized the neighborhood. The New York art establishment was hit below the belt.

Posters by individual artists weren't uncommon in the streets, but these were unusual. They were group statements; they spoke with authority for a significant sector of the art population. The broadsides were never intended as art, but neither were Jenny Holzer's early poetic rants (now collector's items), which were plastered all over SoHo. Guerrilla Girl posters were activist statements that conformed to a distinct aesthetic format. It was obvious at a glance that the Girls were artists, yet these texts were pure propaganda. Part of their appeal was precisely the questions they posed, not only about the position of women in the art world, but about the very nature of "political" art. Questions instantly emerged about the conception of their work: Was it art? Was it advertising? Was it politics? "We were more interested in the content, the discussion of racism and sexism in the arts," says Brooks.

The posters kept coming, offering a critique of the art world that was not available anywhere else. A breathtaking series of art statistics demonstrated what everyone already knew but wouldn't admit: Women and artists of color were excluded from the system. The research was time-consuming but not impossible. Most of the statistics were available in annual reports and art magazines. If information from a gallery was needed, the Girls posed as journalists and called

HOW MANY WOMEN HAD
ONE-PERSON EXHIBITIONS AT
NYC MUSEUMS LAST YEAR?

Guggenheim	0
Metropolitan	0
Modern	1
Whitney	0

SOURCE ART IN AMERICA ANNUAL 1985-86

A PUBLIC SERVICE MESSAGE FROM **GUERRILLA GIRLS**.
CONSCIENCE OF THE ART WORLD

Guerrilla Girls, street
poster, 1985.
22" x 18".

dealers on the phone. "The statistics were perfect because they were shocking," says a Girl involved with the group for its first five years. "Dealers had been saying that these problems [gender bias] were all solved. They were critical of women for still kvetching about their careers. Then we came along and demonstrated that women had good reason to kvetch."

Artists, critics, and dealers eagerly waited for each new poster, although for different reasons. Lists went up of the most biased galleries, male and female critics who were not writing enough about women artists, and male artists who were in galleries where women remained unacceptable. One of the most scandalous posters (1985) asked: "How Many Women Had One-Person Exhibitions at NYC Museums Last Year?" The Guggenheim, the Metropolitan, and the Whitney had zero; the Modern had one.

"Dealers had fits," says an ex-Girl. "They called us Nazis, the art police. We'd be standing at openings and everyone would be discussing the posters and our identities. They assumed that we were anonymous because we were all so famous, which was infuriating." Famous women artists, of course, were few and far between. So, who were the members? "We were the girls who were watching the guys we all went to art school with rocket right into the system," says one Girl, "while we were working three jobs." The Girls give out no information about their membership. There have been women of color involved, but it would take a rival guerrilla group to get the exact statistics. How many Guerrilla Girls are there? The stock answer is: "Thousands."

Initially, the media was hungry for their story; the photo-op was irresistible. Articles popped up in papers ranging from the *Village Voice* to the *Daily News*; the Girls were modeling their masks in the pages of the choicest women's magazines, including *Mirabella* and *Ms*. Their résumé is impressive; the Girls have appeared on minor and major television networks and chatted on radio talk shows all over the country. There is nothing like having a talking gorilla on your couch for ratings. The costume was opening up doors for these angry feminists, and their message was breaking through barriers in the media. "We were completely recharacterizing the decade," says Frida Kahlo. The 1980s posters were a subversive art history lesson. The truth about the situation of women artists was now undeniable.

Success

"We had absolutely no idea it was going to take off," says Käthe Kollwitz. "We spent about two minutes deciding on the masks. The anonymity drove people crazy, as if it were a crime to be anonymous. We weren't initially wedded to it, but everyone focused on it and we enjoyed annoying people." For the first few years, there was continuous discussion about who they were and what they were saying. According to every Girl interviewed for this essay,[1] the intense response to their actions was an impetus to consolidate. The Girls became a family; members stick together and never denigrate the group to the press. They rarely discuss the group's progress with any outsiders. Even women who have left the group—and there has been a great deal of turnover—maintain open communication lines. "Our decisions have always been made unanimously," explains Romaine Brooks, which is remarkable for any organization with a ten-year history. "But there are controversial internal issues and lots of different points of view."

One of the most contentious areas has been the Girls' official relationship to the art world. Dealers, obviously, noticed their success, but the Girls have never sought representation to sell their wares. Their first year, 1985, they were offered the opportunity to organize an all-women's exhibition at the Palladium, a popular club in New York that had been showcasing male artists. The Palladium wanted to atone for its sins, and the Girls relished the opportunity to organize a corrective exhibition of all-women's work. After much discussion, the Girls went ahead with the project; they selected, with difficulty, one hundred women artists for the event. But the process was filled with tensions. The Girls were making arduous curatorial choices among women artists instead of orchestrating an open call. A batch of key members quit in protest. "We couldn't beat the system and join it at the same time," says one of the women who left. "The group was moving in the wrong direction."

> If there was enough passion in the group and people available to do the work, a poster was produced.

The Palladium dispute, however, did not deter a new crew from joining the group; the Guerrilla Girls remained strong and developed a policy on exhibitions. "We won't get involved in any project where

THE ADVANTAGES OF BEING A WOMAN ARTIST:

Working without the pressure of success.
Not having to be in shows with men.
Having an escape from the art world in your 4 free-lance jobs.
Knowing your career might pick up after you're eighty.
Being reassured that whatever kind of art you make it will be labeled feminine.
Not being stuck in a tenured teaching position.
Seeing your ideas live on in the work of others.
Having the opportunity to choose between career and motherhood.
Not having to choke on those big cigars or paint in Italian suits.
Having more time to work after your mate dumps you for someone younger.
Being included in revised versions of art history.
Not having to undergo the embarrassment of being called a genius.
Getting your picture in the art magazines wearing a gorilla suit.

Please send $ and comments to: **GUERRILLA GIRLS** CONSCIENCE OF THE ART WORLD
Box 237, 532 LaGuardia Pl., NY 10012

Guerrilla Girls, street
poster, 1991.
22" x 18".

we have to make choices between artists," explains Kahlo. "We have very few policies," she adds. "But that one has stuck with us." Two years later, the Guerrilla Girls were responsible for another kind of exhibition at the The Clocktower, an alternative space in New York. A counterpoint to the prevailing Whitney Biennial, *Guerrilla Girls Review the Whitney* was an information show, documenting the museum's record on artists of color and women. The statistics were embarrassing. Not only had the Girls exposed the Whitney, but they argued the radical notion that museums have social, even moral, responsibilities beyond pleasing their financial sponsors.

The Girls began traveling, primarily to universities, and continuing their line of black-and-white posters. In the early 1990s, they began focusing on issues outside of art, broadening their field of attack and their potential audience. Their process remained somewhat anarchistic. If there was a burning issue under discussion in SoHo, it was likely to turn up on a poster. One of the most visible shifts in the 1990s was the reemergence of a public discourse on politics. Artists were responding to the headlines, and some of their work was turning up in galleries. "It was difficult for us to witness the Persian Gulf crisis," says Alma Thomas, a Girl of color, "without doing something about it. So we did." If there was enough passion in the group and people available to do the work, a poster was produced.

The Bush years were an inspiration to activists. When women soldiers clamored to get on the front lines, the Girls asked: "Did She Risk Her Life for Governments That Enslave Women?" This caption appeared beneath a photograph of a soldier in guerrilla fatigues, a rifle hanging from her shoulder; double-humped camels, a clear sexual reference, walked across the desert in the background. The poster (1991) was a timely feminist comment on gender and war. But it was never posted beyond the streets of SoHo, never posted where there might actually be women considering whether to enlist.

The Girls refer to their posters as "public service messages." They have covered topics such as abortion, rape, cosmetic surgery, education, and the Clarence Thomas debacle in a series that comes out . . . whenever. The Thomas poster provoked the most debate, the only one in the group's history that was not unanimously approved. ("I thought he was innocent," says Anaïs Nin, the one holdout.) Regardless, the

The Guerrilla Girls want
to know if a woman has
to be naked to get into a
museum. This black-and-
white publicity photograph,
1987, is their version of
the classic nude.

poster is one of the Girls' most sarcastic works, turning a quote from Thomas, defending himself against Anita Hill, into an attack on the Court's stance on privacy and sexual preference. Thomas is depicted saying (as quoted in the *New York Times*), "I'm not going to engage in discussions of what goes on in the most intimate parts of my private life or the sanctity of my bedroom. They are the most intimate parts of my privacy and will remain just that." The headline on the poster shouts the good news: "Supreme Court Justice Supports Right to Privacy for Gays and Lesbians."

There were irregular forays into current political issues, but the Girls became known for their brilliant attacks on the male art establishment. Their most classic work is a poster that cynically describes "The Advantages of Being a Woman Artist." It was 1988, and there were thirteen points to celebrate, such as "working without the pressure of success" and "not being stuck in a tenured teaching position." The following year was a vintage one for the Girls. Seven posters went up attacking museums for their exclusionary policies, collectors for their refusal to purchase works by women, and Senator Jesse Helms, the most despicable enemy of the year. "Relax Senator Helms," the Girls advised. "The Art World *Is* Your Kind of Place!" There were ten reasons listed for the senator to back off the obscenity issue, among them the fact that the "majority of exposed penises in major museums belong to the baby Jesus."

Recent posters geared to the art world have been less outrageous and less successful. Leaning more toward parody than any critical or statistical information, the newest posters have failed to annihilate their targets or even expose new crimes. The Girls have begun to give out MacGuerrilla Foundation grants (a takeoff on the MacArthur "genius" awards). The first one went to Arne Glimcher, the notorious head of the Pace/Wildenstein Gallery, celebrating his "seminal talent" for getting publicity on the cover of the *New York Times Magazine,* as he closed a "$100 million merger" between Pace and Wildenstein Fine Arts. But the timing for the poster was off; it appeared weeks after the art world, organized by the Women's Action Coalition (WAC), a newly formed mass activist group, had already protested Pace's lack of interest in representing women artists. In effect, the Girls were just giving Glimcher more publicity.

This publicity photograph,
1987, of one of the Girls
wearing her diamonds,
appeared in numerous
publications.

WAC, during its brief peak, had the ability to act faster than the Guerrilla Girls and to mobilize hundreds of women—in just days—for a demonstration. While the two groups were supportive of each other, not competitors, WAC's success seemed to highlight problems that the Girls had learned to accept. Both groups were organized by women in the art world, yet WAC's mission was to contend with subjects outside of art. Even when the Girls dealt with nonart issues, the posters never reached out beyond the art world. All campaigns, regardless of their content, are put up in Lower Manhattan (SoHo and Tribeca).

In a sense, the Guerrilla Girls had become satisfied with reaching a relatively small, sympathetic audience, while WAC was picking up the slack, providing women, artists or not, with a new political vehicle to facilitate their notions of social change. WAC was demonstrating the potential for a progressive feminist movement that the Girls had never been able to organize, maybe even imagine. WAC wanted to break out of the constrictions inherent in the cultural arena—where the Guerrilla Girls seemed to live.

When an obvious art-world target came up for WAC, members looked to the Guerrilla Girls to collaborate. The opening of the downtown Guggenheim Museum, in SoHo (1992), was the ideal occasion. The museum planned to inaugurate its virginal galleries with a show of four or five white, male artists. The selection was an indication of how slack art-gender politics had grown. Word of the show was leaked at a WAC meeting and a protest was instantly planned for the opening-night party. Ultimately, Louise Bourgeois was hastily added to the exhibition list, but that was not enough to appease the 500 protesters who stood outside the Guggenheim that warm June evening, chanting:

> Hey, Hey, Ho, Ho
> White Male Culture
> Has Got to Go!

What was most memorable about the event was WAC's drum corps, a militant group of women with the motliest and meanest sounding instruments. This ragtag marching band embodied the angry, insistent spirit of a new downtown feminist movement, which WAC had come

to exemplify. There were few gorilla masks outside the Guggenheim; the masks were functioning better in performances than in demonstrations. WAC was more suited to the moment than the Guerrilla Girls. WAC membership was open, growing week by week, and identities were known, even flaunted.

But WAC would become relatively dysfunctional by the end of the year, while the Guerrilla Girls, as usual, were still answering their phone.

Hot Flashes

In 1991, the Guerrilla Girls published ten posters and made fifteen public appearances; the next year, they generated six posters and gave twenty-three performances; in 1993, the Girls put up only three posters and gave another twenty-three shows. They have traveled to Germany, Australia, Austria, Ireland, Canada, Brazil, Norway, England, and Finland. The Girls have discovered, as one of their posters states, that "it's worse in Europe." But the low status of women hasn't affected their popularity. "I felt like a rock star walking out onto the stage," says one of the Girls, describing a European trip. "The crowds went nuts over us."

In the 1990s, as the Girls moved into the national and international performance circuit, the posters became a low priority. But as the group's reputation began to wane in New York, it was picking up on college campuses around the country. The schools where these feminist terrorists have performed range from Harvard to Wichita State University. The posters became more visible as backdrops, projected on the stage behind their performances, than on the streets.

"It got harder and harder for us to poster," explains a current member. "The police became more attentive." The Girls stopped putting up their own posters and hired local experts, giving up control over placement. In the old days, postering was part of every new member's initiation; it was a bonding, frightening ritual, affectionately described in retrospect by several Girls. But members seemed to be losing interest in the posters and the postering, as flyers by WAC and a garden variety of blossoming feminist groups (WHAM!, the Lesbian Avengers, the New Freedom Riders) glutted the streets. In contrast to the didac-

tic statements on any Guerrilla Girls communiqué, these groups were mobilizing the troops, announcing actions that women and men could join. In New York, it was feeling more like the 1960s again, as posters—and demonstrations—became frequent spectacles. The Guerrilla Girls needed a new vehicle for their "public service messages."

Hot Flashes (a tabloid newsletter partly funded by the National Endowment for the Arts) grew out of their desire to find a new audience and, perhaps, to hold on to the old one. It was a way to get out of the streets and reach art-world members in their living rooms. It was a good idea. A newsletter offered the Girls the opportunity to go down on record, to get their information into libraries, to be read by the press, and to develop an ongoing dialogue with readers.

The first edition (1993) was entirely devoted to a critique of the art pages of the *New York Times*. Filled with statistical data on what critics choose to cover, it unfortunately contained no analysis of the content of any reviews or articles. (Roberta Smith, the only female critic at the *Times*, was suspiciously let off the hook.) *Hot Flashes* only confirmed what was already painfully obvious: male critics at the *Times* write about white, male artists. Readers were left with little understanding of the relationship between the *Times* art pages and the art economy; there was no discussion of any criteria used to select shows for review. Are, for instance, reviewers allowed to buy works from shows they write about? The Guerrilla Girls are a secret society with connections, we presume, all over the art world. Yet *Spy* magazine's insider column on the *Times* had more dish. *Hot Flashes* was a major disappointment. There was nothing of note in the issue to rock, let alone capsize, any boat at the *Times*. Nevertheless, according to Kahlo, more than 500 subscriptions rolled in after the premiere issue. The Girls celebrated.

The second *Hot Flashes* (1994) tackled the role of museums around the country, rating the various institutions by the gender of their directors and the number of women artists on their walls. "Women of color have a hard time everywhere," concluded the research on the front page, as if this were news. The museums were divided into four categories: "good," "mediocre," "bad," and "the pits." "Good" museums had women directors, showed women's work, and acquired "artists of color, even from their own region." The single

revelation in this issue was that New York museums, known for their authority all over the globe, received the worst report cards; the Metropolitan Museum of Art has "the all time worst record" in the country. The Girls renamed the Whitney the "Whitey" Museum of American Art.

There are tidbits, not unlike sound bites, throughout the newsletter. The Girls report, for instance, that Henry Kissinger heads the exhibition committee at the Met. *Hot Flashes* informs us that in 1992 the National Gallery of Art received $54 million from the government and did not exhibit one contemporary artist of color. In a column called "RX for the Future," the Girls suggest suing museums, throwing collectors off boards of directors, and "outlawing the cult of genius." The issue, as a whole, is amusing but thin. Disconnected one-liners and large graphics take the place of detailed research. While the message is clear, it's agonizingly redundant.

A Decade Old

After ten years, the complications of being a Guerrilla Girl are becoming apparent. The shift from the 1980s to the 1990s has altered the context for the Girls and their work. "We came up with the fishnet stockings and high heels when Madonna was hot," says a member, "but Kate Moss is the star today." Madonna's steamy bisexuality was subversive in the 1980s, as she explored her sexual fantasies before a mainstream audience. Her sexual appetite was able to keep right up with her commercial desires, which seemed insatiable. Madonna continued to reinvent herself, but eventually, every act became a vehicle for the star. The pop sex queen had her fifteen minutes, as young women began moving away from worshiping overt sexual stereotypes. Spike heels were getting replaced by Doc Martens.

With these shifting values, the significance of the gorilla mask also began to shift. In the 1980s, the mask was an ironic declaration of war, a pun that linked these feminist guerrillas to their subversive activities. In the 1990s, however, the hybrid construction of the animal head and female body began to read like a Darwinian joke about the nature of progress. The Girls looked, in part, stuck in the jungle, unable to metamorphose into full human beings—women.

To the distress of one member, the brown furry skin and fierce teeth have taken on racial assumptions that were entirely unintended. "The mask becomes a physical and psychological burden at times," Alma Thomas told me, "limiting our functions. It doesn't dictate our behavior, but it affects our bodies and minds. As an African American," she adds, "when I put on the mask, I look the way some people see me every day, unconsciously."

The Girls' strategy—to make learning about racism and sexism a pleasing, seductive spectacle—made sense in the male-dominated 1980s, when satirizing notions of femininity catapulted their act into the spotlight. But the gorilla needed the ability to evolve into a more complex being. Contemporary feminist artists began pushing conceptions of gender much further, beyond the dialectic between beauty and the beast and beyond the schism between nature and culture. Gender itself was suddenly unhinged from any loaded definitions and distinctions between men and women, as artists and performers dove into the murky abyss between the sexes.

The mask was a projection of racist fantasies for some, while for others it was merely a gimmick to exploit. The Girls had the good sense to turn down The Gap when invited to appear in an advertisement for the company. When The Gap calls, it's time to take another look in the mirror. The Guerrilla Girls had succeeded in becoming a mainstream phenomenon, but there was a price to pay; they were losing their impact on their target audience—the art world. As their own literature kept pointing out, things were not getting much better for women artists.

In Transition

The Guerrilla Girls burst onto the scene as a militant feminist clan with nothing but disdain for a system that has oppressed women for centuries. But inevitably, packaging their products—posters, multimedia performances, and political messages—as fun and games led the Girls to the established art track. There are, I'm sad to report, more advantages to being a Guerrilla Girl today than there are to being a woman artist. I suspect that many members have seen more of the art world dressed as gorillas than they have in their regular

attire. "If we were to reveal ourselves now," says Kollwitz, "it would probably help our individual careers." For Kollwitz, "this is a delicious irony." Success is never exactly a disadvantage. Traveling around the world, participating in shows with other art collectives, has given them a platform for their politics. But what do they have to say?

Guerrilla Girls Talk Back—The First Five Years, the exhibition I saw in Montgomery, was originally organized by Carrie Lederer, curator at the Falkirk Cultural Center in San Rafael, California. The show traveled for five years, despite the fact that the Girls themselves do not consider their work to be art. None of them, however, ever thought their posters would end up in frames, hanging on museum walls. The posters sell for twenty dollars apiece, and when I asked Kahlo who had the original, she said, "There is no original." None of the Girls, thus far, are interested in turning this loose group into an art-making collective, like Tim Rollins and K.O.S. (Kids of Survival), which produces gallery exhibitions. Rollins and K.O.S., represented by a commercial dealer (Mary Boone), make work to support their educational projects. The Girls have never been represented by a dealer or made works for commercial exhibition; all editions of posters are unlimited. Nevertheless, these posters have been on exhibit at the Whitney Museum of American Art, the Aldrich Museum of Contemporary Art, the Studio Museum in Harlem, and at a number of university galleries all over the country. The Museum of Modern Art, however, drew a clear line between art and activism at the Guerrilla Girls. According to Kahlo, the Girls' posters were excluded from *Committed to Print* (1988), a broad survey organized by Deborah Wye of activist works on paper because the work was not art. "It was politics," says Kahlo.

> The Guerrilla Girls burst onto the scene as a militant feminist clan with nothing but disdain for a system that has oppressed women for centuries.

The debate around whether the Girls make art or not becomes circular. But let's imagine them as a commercial artist collective. The biggest problem is their insistence on anonymity and their tendency to investigate any context they move into. On a purely social level, the market wants stars, individuals who can go to dinner parties and talk, which is difficult to do wearing a gorilla mask. Dealers do not let

artists see their books; they also demand original objects, which the Girls do not produce. There is a good reason that few, if any, all-women art collectives have achieved notoriety in the commercial art world. The Girls know this fact better than the rest of us. While rumor has it that the group is currently going through growing pains, I suspect they will not turn to the galleries for comfort.

Not surprisingly, the Girls are much more interested in their own, *real*, careers as artists, than in pushing the group in the direction of the art world. In their view, their mission is purely political and far from accomplished, which is why they have been attempting to "institutionalize" and survive. The Guerrilla Girls have a mailing address, a telephone number with a recorded message, and a publication. They are currently writing the group's autobiography for HarperCollins and working on the production of a (secret) CD-ROM. They are moving away from the art world, looking to develop a broader audience, while continuing to function as a secret society. When asked to attend a meeting on their book at HarperCollins, the Girls wore their masks and the editors were actually scared—the male editors, that is.

Outside of New York, the Girls continue to be in demand, getting abundant local press wherever they go. They argue that the group is needed more—away from home—where audiences have not yet felt the full force of a renewed feminist movement. "We are still reaching out to people who don't understand how sexism works," says Alice Neel. "And we've only begun to scratch the surface."

Anaïs Nin argues that racism in the art world, including New York, should be the Girls' most pressing issue. "We sometimes give up on targets when they let a few white women in, like the Brooklyn Museum, despite the fact that black women still aren't showing there at all." While every Girl answers questions for herself, not the group, there is general agreement that their essential focus should continue to be the art world. "It's an organic focus for us," says Alma Thomas. "We're artists."

The move into performance work and book production, which seems to have evolved organically (this is the way the group works), has taken the pressure off the New York art world. The Girls are moving into the realm of what they refer to as "education" and

"consciousness raising" in areas receptive to feminist entertainment. If the community they originally intended to serve is women artists, the Girls might argue that they now view that group on a national, even international, level. New York has seen fewer posters and guerrilla actions because the group has been writing, producing, and performing a show, which has become their main activism. But is performing inside institutions as they critique them an effective strategy? Members are so busy being Guerrilla Girls that there is little opportunity for proactive projects beyond their own gigs.

Success for the Girls is accompanied by the knowledge that they no longer pose a threat to the art world. Some of their fans, however, are disappointed. "We know that we're not as radical as our audience wants us to be, at this point," says Alma Thomas, who was heckled at a recent performance. If young feminists look to the Girls for leadership, they won't get it. "We simply keep up the resistance," says Anaïs Nin. Within the current spectrum of feminist artists, ranging from Karen Finley on stage to Sue Williams's porno-feminist discourses on canvas, the Guerrilla Girls occupy the center; they have grown more conservative over the years, functioning as an admission of guilt for the art world, assuaging its conscience rather than provoking it. Their fans, however, still want them to take their revenge on the powers that be in the art world, not work with them or make them feel better.

At the start, the Girls' maverick practices had a profound effect on a small, but internationally significant, New York art world. It was a moment when no dealer or curator would have been caught dead with an all-male show. But that time has passed. Dealers and museums are, to their credit, hanging more women in their exhibitions, but the museums aren't buying their work and dealers aren't letting the artists into their galleries at a young age—when all artists need support. In New York, we're currently seeing more work by women, but there is a recession—and nothing is selling. Moreover, there is still no reason to think that this work is going to make it into the art history books.

It was a moment when no curator would have been caught dead with an all-male show.

In 1989, with the advent of the Robert Mapplethorpe crisis, cultural politics changed in America. Conservative forces took over the

project of defining "radical art," as artists organized to protect their freedom to make work and have some place to exhibit it. In a country with no official arts policy, the situation remains a disaster as the National Endowment for the Arts (NEA) loses more of its budget and authority every year. These culture wars, as they are called, have affected, for better and worse, all "activist" artists. Art that really hurts the establishment or generates critical consciousness in a local community had no aesthetic or content restrictions prior to the Mapplethorpe crisis. The Guerrilla Girls have commented on this battle but never fought it. They have never been objects of derision, like Andres Serrano (for *Piss Christ*), David Wojnarowicz (for his lawsuit attacking the Reverend Donald Wildmon for stealing and altering his images), or Holly Hughes (for her lesbian performances), because their act pleases more than it challenges even the most exalted institutions. As hard as I tried, I could not get a curator at a museum to utter a nasty word (even off the record) about the Girls. And, more amazing, they have not received *any* significant bad press. The Girls have targets but few enemies.

The list of mainstream organizations and publications that have given the Girls awards includes *New York* magazine (a "Life of the City" award), Art Table (an organization of art business people—no artists allowed), the New York State Chapter of the National Organization for Women, and the NEA. The Girls are in danger of becoming part of a system that is growing more and more hostile to feminists, gays, or any person of color who makes "controversial" art. In the mid-1980s, their signs were considered the law. If something was wrong in town, we called the Guerrilla Girls. "No one cares about the Guerrilla Girls anymore," one dealer told me. "Most of us have adjusted our statistics."

The Guerrilla Girls deserve much of the credit for this adjustment. There has been a "new" acceptance of women artists in the 1990s. Thanks to the Girls, dealers were embarrassed into representing a few token women in their galleries, and all-male shows are getting harder and harder to find. "But tokenism is simply the containment of diversity," says Alma Thomas, who thinks the Girls are ripe for a major transition. "Embarrassment is a powerful tool," she adds. "But it doesn't change the world." What we all know is that the art world

still needs a conscience outside of its own body. "We have more than enough credibility to reinvent ourselves," continues Thomas. "We have understood brilliantly how to use the dominant culture against itself, but we don't need to be brilliant anymore. We need to be effective." The Guerrilla Girls have no intention of retiring. "We won't stop until the board of directors at the Metropolitan Museum is dominated by women," says one member. "Why should we stop?" asks Kahlo. "The phone is still ringing."

12 *Tracy Ann Essoglou*

Louder Than Words:
A WAC Chronicle

Women Strategizing in the '90s

In the fall of 1991, in rapid-fire order, a succession of events centering on gender violence took hold of both the minds and the media of the American public. Anita Hill stepped forward to contest the nomination of Clarence Thomas to the Supreme Court of the United States, revealing how she had been sexually harassed and intimidated during her tenure working for Thomas. William Kennedy Smith was accused and acquitted of rape. Boxing champion Michael Tyson, similarly accused, was convicted, reaffirming for many the racial nature of the distribution of justice. Across the country, in response to the nationwide media blitz on sexual violence, women's shelters and women's centers, rape crisis hotlines, health clinics, therapists, medical professionals, educators, television talk shows, and government agencies reported an escalation of phone calls, letters, anonymous inquiries, and emergency visits from women acknowledging their own experiences with assault and harassment.

The media set the pace, establishing Watergate-like coverage for Hill's weeklong testimony and interrogation by the Senate Judiciary Committee, an all-white male "jury" themselves politically immune to similar allegations by virtue of their government office. Character witnesses spoke for both sides, with Thomas's resentment toward the investigatory process increasing each day. Whatever the truth, Thomas's rebuttals showed him to be of the belief that he was suited only for one side of the bench. His obvious disdain for the proceedings, when subjected to the imprecision and inequity of the judicial process himself, made him an increasingly inappropriate candidate for the Supreme Court even among those who had previously favored him and had rejected Hill's testimony. His contempt culminated in a

single outburst when he accused the committee of executing "a high-tech lynching."

In those same few weeks, with the election campaigns of 1992 heating up, Robert Gates—ostensibly the most immediately vulnerable participant in the Iran-Contra scandal and one of President Bush's team players—was confirmed as director of the CIA with virtually no inquiry or media coverage as to his part in, or knowledge of, one of the most significant political manipulations of the decade. The Bush campaign could apparently afford to lose Thomas, whose qualifications for the position were considered mediocre at best by Republicans and Democrats alike, but it could not afford media and public scrutiny of Gates's activities. In retrospect, Thomas may well have been a fall guy in the Republican scheme of things. Rendered in the name of news, the multimedia contest that pitted Hill against Thomas without even minimum courtroom protocol was a disservice to all. Meanwhile, the topics of race and gender were volleyed about with little regard for their competing complexity, or for the fragmenting impact the drama had within the nation as a whole.

During this same period, two separate events for "women in the arts" took place in New York City. Both were attended by what was for the time an unprecedented number of women. At both, discussion of the expected art issues quickly turned into speakouts focusing on injustice, the apparent inability of legal and social systems to safeguard and ensure women's rights, the increasing threat to reproductive choice by antiabortion fundamentalists of the Christian right, and President Bush's re-election campaign.

The energy had changed. And for women in their late thirties, forties, fifties, and older, the feeling in the air was reminiscent of the social vitality and political outrage they had witnessed and/or participated in some ten, twenty, thirty years before. Conspicuous—and remarkable—was the presence of young women, women who had not lived through the 1960s and 1970s, women who had experienced neither the advent nor the aftermath of the women's liberation movement, the civil-rights movement, or the anti–Vietnam War movement. The "F-word," feminism, had lost its value for many of them—wasn't it backward, retrograde, and unnecessary? Their out-

rage and disbelief derived its force in part from a violation of their pre-existing sense of relative "untouchability."

The events of fall 1991 galvanized what was later to be called "The Third Wave"—a new generation of activist women declaring their fury, summoning accountability, and demanding representation. Even as the soon to be much-publicized "Year of the Woman" began, more and more women candidates came forward to announce their political intentions. The behind-the-scenes effort of women in electoral politics was coming to bear. For women in their thirties and forties, it was a second wind—more like a gale. It was an opportunity to articulate what had become all too apparent: that the victories of our various progressive social movements had been too few, and that despite more than twenty years of continuing struggle, hard-won civil rights had nonetheless been intentionally and successfully eroded on all sides by the combined Nixon, Reagan, and Bush administrations.

A new generation of activist women declared their fury and demanded representation.

On January 28, 1992, a meeting was called at the Drawing Center in lower Manhattan. A small group of ten to fifteen friends and/or professional acquaintances from the downtown New York arts community convened "Women Strategizing in the '90s" as a venue for finding out what "we" as women were thinking, interested in, and willing to do. Seventy-five chairs had been rented and all were filled. In ages ranging from sixteen to almost eighty, we came together. Standing room only became a condition that was to characterize WAC meetings from this day forward through the next eight months, even as we secured increasingly large spaces. What follows is the chronicle of one active participant. Personal and singular, it is but one narrative of that intensely active group, which quickly became the Women's Action Coalition (WAC).

The group was open to all women, and news of it traveled almost solely by word-of-mouth. The women who gathered were mostly white and shared certain socioeconomic conditions and perspectives. This, and the fact that outreach to already existent groups of women from other backgrounds was not done and/or was insufficient, was a blind spot that would come back to haunt us over the next two years.

In those first few weeks, discussion on the so-called "question of diversity" simply resulted in the well-intentioned refrain: "Call your friends." The fact was, that *in this context*, the statement implied, "Call your 'differently colored/cultured' friends." The sheer inadequacy and resounding offensiveness of this gesture seemed not to be understood by a majority of WAC participants. For many, confronting the diversity issue also meant facing the profoundly segregated nature of life in the United States, in their own circles of friends and contacts, and in their own lives.

Within two and a half hours we voted to become a direct-action group, borrowing heavily from precedents set by ACT-UP and WHAM! We determined our first action, named ourselves, established the four working committees that would become the backbone of WAC—creative, legal, logistics, and media—and adopted the initials WAC. (We would later hold a large and heated discussion as to whether the A stood for "artists" or "action.")

By evening's end, we had voted in favor of staging a protest in front of the Queens County Criminal Courthouse, where the remaining defendant in the St. John's rape trial, a member of the St. John's University lacrosse team, was the last to be tried for the sexual assault of a young woman of Jamaican descent. We wanted both to support her and to put pressure on the legal process: none of the assailants had so far been convicted of any significant wrongdoing, despite the fact that two of the male participants admitted to the attack and named the other offenders.

Within six days of the first meeting, we appeared at the courthouse. In order to call attention to the inability of rape laws to adequately define the crime as experienced by its victims, WAC fashioned the slogan, "Let women define rape." Our now seemingly infamous drum corps was also formed for this event, and the blue dot created by television networks to protect the identity and obscure the face of Patricia Bowman, the woman who was allegedly raped by William Kennedy Smith, was appropriated as our symbol. We took black and blue as our representative colors. (Later, in the summer of 1992, WAC Productions—our in-house video committee—created a proactive public service announcement using actual television footage of Bowman's testimony, merging it with WAC's own

WAC, *Blue Dot* series, February 1992. Cardboard pizza box disks, 10" in diameter, popsicle sticks. Painted blue on one side, these portable "dots" were very visible yet easily hidden during courtroom monitoring. The dot was appropriated from the television practice intended to provide confidentiality during the coverage of the William Kennedy Smith trial. Rather than using them to cover our faces, the dots, when flipped around, carried bold graphics and text, readily caught by television cameras during interviews and on-site broadcasts.

action footage of a demonstration. Over the voices of the women marchers a single voice announced, "We no longer fear recognition. We demand it.")

Equipped with banners, blue dots, lawyers, marshals, marchers, spokespersons, and drums, we were prepared to take on the media, which we had directed to the event by means of our first press release. That night we were on nearly every New York news network. We established what was to become our media stronghold.

Our coalition presence with WHAM! at the courthouse lasted several weeks, ending in what could hardly be considered a victory, as the last defendant, Michael Calandrillo, changed his plea from innocent to guilty, admitting in court to all of the charges against him in exchange for a sentence of 500 hours of community service.

The decision was a travesty: one of a type that occurs routinely across the country and around the world. In our summation to the media, we stated: "As women, we contest the ineffectuality of our legal system to contend with crime against women. In calling this action it is our desire to lend support and to acknowledge the courage and dignity of this woman."

WAC, *No Means No . . .* advertisement, February 1992. Newspaper advertisement, 11" x 17". This layout was placed in the St. John's University school paper, *The Torch*, by WAC during the trial of Michael Calandrillo, the last of a group of assailants to be sentenced. The ad included the names and numbers of organizations helpful to women.

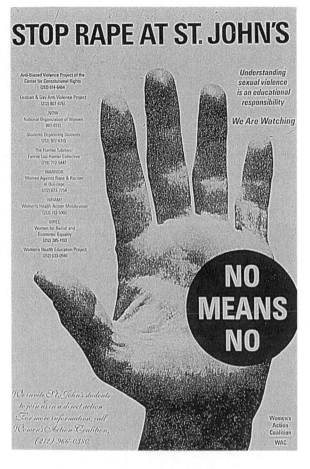

Meanwhile, WAC's graphics committee designed an advertisement that was placed in the St. John's student newspaper. Intended to promote discussion on campus and to force the university community, and the administration in particular, to grapple with the existence of sex and gender violence, the ad stated: "Understanding sexual violence is an educational responsibility." A hand pushed out from the page and in its palm were the words, "No Means No." The ad copy also provided the phone numbers of other organizations offering help and services to women. WAC had already contacted these groups to ask if they wished to be listed and to let them know that we would be paying for its placement. Such outreach was to become a key component in WAC's high-visibility combination strategy: creativity, education, logistics and planning, and media exposure.

Naming Ourselves a Community: Margins of Comfort, Margins of Privilege

It was several weeks before it came to our attention that among our ever-expanding membership we were divided on our name. Roughly half of WAC was identifying the letter A as "artists" and half was referring to A as "action." The discussion came to the floor. In naming ourselves the Women's *Action* Coalition, we were resolved to emphasize action over our loosely based affinity as artists. It was also suggested that referring to ourselves as artists was more passive, exclusionary, and limiting. The decision to stress action later proved very important, in that "nonartist" women across the country felt welcome to approach and appropriate WAC's model. Furthermore, as WAC New York grew, we were not so much artists as freelance workers. We were employed in the arts, media, graphic design, publishing, photography, and film, but we also worked in museums and law offices. We were authors, health practitioners, life-long activists, apolitical newcomers, students, professors, temporary workers, musicians, finance managers, production assistants, and roadies.

We were determined to take on as much as we could. Within the first few weeks, the media committee composed WAC's mission statement:

The Women's Action Coalition Mission Statement

WAC is an open alliance of women committed to direct action on issues affecting the rights of all women. We are witnesses to the current economic, cultural, and political pressures that limit women's lives and to the horrifying effect of these limitations. As current legislation fails to reflect the experience of women, we support the immediate enactment of an ERA initiative. WAC insists on an end to homophobia,[1] racism, religious prejudice, heterocentrism and violence against women. We insist on every woman's right to quality health care, childcare, and reproductive freedom. We will exercise our full creative power to launch a visible and remarkable resistance.

WAC IS WATCHING, WE WILL TAKE ACTION.

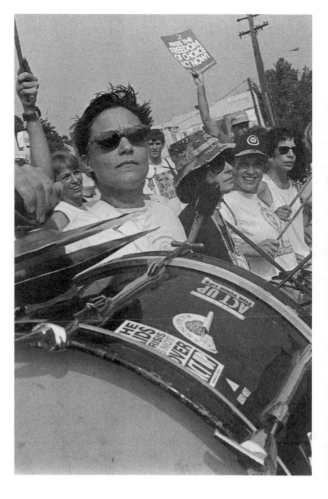

WAC drum corps, August 17–20, 1992, Houston, Texas. The drum corps fashioned extraordinary chants and slogans for each and every WAC action. Joining forces with WAC Houston, the drum corps not only attracted attention, but also was instrumental in directing protest energy and in keeping police and others at bay.
Photo Lisa Kahane

With few changes, the statement passed overwhelmingly and was eventually translated into Spanish as we sought to make our materials accessible to women who were non–English speaking.

Our freelance status was an especially important aspect of WAC New York, and as a condition of privilege it was often taken for granted. Though our freelance work brought many of us a fairly limited income, it also put us in the unique position of being able to schedule our own working days, hours, evenings, and lunches, providing the flexibility to rally during the day. By and large, we were not social workers or teachers, nor were we administering social services in shelters. In other words, we were not already committing forty, fifty, or sixty hours a week to institutionally directed social assistance.

Our critical engagement in WAC was, for most of us, something different from our professional obligations. And although our incomes were "limited," we were nevertheless mostly well-educated and multiskilled. As a group, we had significant resources at our disposal, including photocopy and fax machines, video cameras, silkscreen studios, computers, and answering machines, and we had the technological proficiency to use them and use them well. WAC's high percentage of arts- and communications-related professionals enabled us to get on our feet immediately in the creation of our high-profile, (multi)media-savvy public protest.

Sampling Diversity

We also appeared to be "fashionable," "confident" women. And although we never gave in to requests for a literal head count with respect to the number of women who considered themselves "lesbians," "women of color," "Jewish," "WASP," or "bisexual," we probably appeared more straight than gay and were more white than multiracial or multiethnic.

Our appearance was no doubt part of WAC's near-instant success. At the same time, it brought with it an unfortunate lesson (and/or reminder) that while appearances can be usefully deceiving, they are nearly always divisive. For example, we might like to forget that our first "write-up" independent of a particular action came in the then-new "Style" section of the *New York Times*.[2] It was a textbook example of media's depiction of women. Despite our literal impact on actual newsworthy events usually covered in the "Metro" section, as women we were immediately allocated to the "Style" section along with discussions of fashion and social affairs.

While many might earnestly disagree, our "appearance" was clearly a factor in WAC's being looked on favorably by the media in what has often been a notoriously lesbo- and homophobic—and racist—media practice. WAC seemed to be afforded attention not available to groups like ACT-UP and WHAM! Yet while members of ACT-UP and WHAM! expressed suspicion of the new kid on the block, WAC itself was divided between those more and less conscious of our progressive precedents and the responsibilities and benefits of building coalitions and alliances.

There was also a tendency to claim direct action as something distinct to WAC, when in fact it was more like a generous inheritance: old, powerful, and unwieldy. In June 1992, while defending greater New York's abortion clinics, we received instructions from members of WHAM!, who had long been involved with clinic defense, on where to rally and how best to protect clinic clients. In what was an unfortunate, if telling, moment, we voted to go against the requested directions and to take another route, a route suggested by two women who only after the action revealed their affiliation with another organization. In that single impetuous vote, we not only alienated our coalition relationship with WHAM! but also allowed ourselves to be misled, demonstrating a certain political naïveté and resulting in a situation that under other circumstances could have had disastrous consequences. It was after this incident that WAC incorporated a disclosure policy under which anyone suggesting a course of action was requested to acknowledge their affiliation with other groups.

WAC's claims to diversity were in fact sorely limited. We were easily more than two-thirds white women. Most of us were skilled professionals and/or had bachelor's degrees, and a substantial percentage of us had advanced degrees or were considered outstanding in our field. Just by virtue of living and working in New York City, we belonged to an already oddly elite culture of sorts. And no, despite all intentions, we never managed to offer childcare so that more women could attend WAC events, though some members felt compelled to say that we did. Then, beyond this, we had our "celebrities."

Celebrities brought and held media attention. Celebrities made money more readily available and gave us access to insider information and a profound pool of technical resources, and no doubt afforded certain other protections as well. Our ability to march and receive relatively little harassment from police and other like-minded functionaries inadvertently flew in the face of people whose similar attempts at exercising their rights were less welcomed and less well-attended, if not met with actual violence and socially sanctioned brutality.

Still, celebrity notoriety was a disservice to each of us individually in that it cast an uneven light on the workings of the group as a whole, elevating the seeming significance of some while obscuring the dedication of others. Those deemed celebrities themselves confronted

WAC flyer, March–April 1992. Printed handout, 11" x 17". This handout, featuring Louise from the film *Thelma and Louise*, was distributed to WAC women, friends, and the general public, urging participation in the national pro-choice rally, "March for Women's Lives," in Washington, D.C.

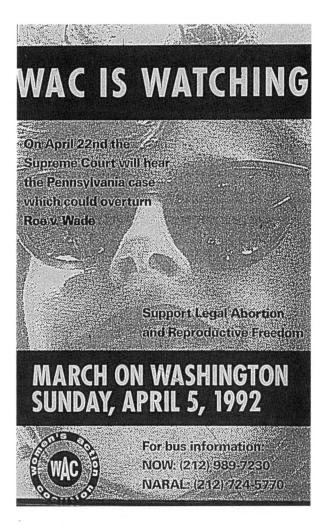

distortion from within and without. Each of us grappled with the conflicts. Some withdrew, some became more virulent. Some used their power blatantly, some felt a conflict, some were asked by other members to use their power on behalf of launching a proposal or stimulating interest in a vote, others were overlooked. In short, there were a range of behaviors, some more inspirational and socially generative than others, and it was not possible to be immune to the confusion created. No one could ignore the fact that some women were more emotionally skilled or politically able than others to deal with everything from their own fears of inadequacy to the need for self-restraint in the name of group growth. As similar as we were in

education, location, race, and gender, we did not always agree on strategies and obligations, and there were tremendous philosophical differences and recurrent pragmatic conflicts.

Moreover, questions like "What constitutes diversity?" were never directly confronted by the group as a whole. Was diversity to be understood as racial, cultural, religious, sexual, linguistic, economic, education-based, experiential, or hemispheric? Could it be seen, heard, identified in a group (close up or far away), and could it be measured? Was it fixed or relational, singular or multiple? Was it self-determined, or to be conferred by others within a group? And then how was it experienced, how was it shared? Were any of these even the right questions? Was diversity really the issue, or was our struggle instead about injurious assumptions, exclusionary and/or colonizing practices, self-determination, and privilege (skin color, access, the right to speak and to be heard, believed, and/or taken seriously)? Our sheer numbers, the uneven levels of experience and education among us, and our "action, action, action" tendency prohibited some essential dialogue on these questions from ever occurring on the floor.

> **Was diversity really the issue, or was our struggle instead about exclusionary practices and privilege?**

We had clearly taken on the issues of women, virtually all of those mentioned in our mission statement. But although it was, and continues to be, relatively easy for us to identify the "what" of women's issues, we were far less able to agree on the "how": how to define ourselves, how to prioritize, how to account for the differences of ability, insight, experience, age, emotional balance, and integrity, how to represent ourselves to other groups, how to build credibility, how to honor interests different from our own—individually within WAC, and as something called "WAC" in relation to other groups— even how to speak to one another.

Our vocabulary was often our own worst enemy. Most of us still could not speak adequately on the subject of race. In response to an observation that there were again too few images of women of color planned for the sound and light show being created for Houston, Texas, the week of the Republican Convention, in August 1992, it was said: "We know we need more images of racism." Had similar

phrasing been proffered to women by a group of men looking to improve their image on women's rights, no doubt most feminists—indeed, most women—would have bolted, leaving the menfolk to figure out for themselves that relating to women as women involves more than just addressing "sexism." And while most women in WAC felt justified in refusing to work with men in light of the inadequacy of their understanding, self-education, and effort—in fact, WAC elected within the first month not to allow men at our meetings for these very reasons—the tendency in WAC was to expect women of color in WAC to be patient and tolerant of such mistakes of language and failures of representation and inclusion. While the effort to redress this problem may well have been genuine, and most often I believe it was, the outcome was nonetheless the creation of an environment that was for many simply inhospitable.

While nearly everyone in WAC rushed to read Susan Faludi's or Naomi Wolf's bestsellers, far fewer of us bothered to read Toni Morrison's compilation of critical analyses on the impact of the Thomas-Hill confrontation, *Race-ing Justice, En-gendering Power,* or Patricia Williams's autobiographical phenomenology of racism, *Alchemy of Race and Rights.*[3]

Class analysis was no better developed in our group consciousness than diversity: most members, as economically privileged women, were unable to grasp the concerns of women with less. Similarly, in the area of sexual orientation, some heterosexual women expressed a much idealized longing to be "lesbian" so as to feel more "included." Eventually, a media event brought into consideration a question that had been silently harbored by some, more or less consciously all along: whether WAC should use more conventional-looking women in interviews in order to win the hearts and minds of "America." This possibility was not understood equally by all as being both an effective media tactic (though nonetheless dangerous and questionable) and a highly injurious, divisive, and manipulative source of discord among ourselves. This incident was to become one of the truly irreparable fissures in WAC New York's cohesiveness.

Rightly or wrongly, layers of complexity were balanced against available time and group motivation. Attempts to educate ourselves within WAC had to fight for time and attention already compressed by

the activities and demands of the election year. In some weeks there were as many as five actions, not including large and small group meetings. As some of us sought greater discussion and awareness, we were constantly forced to invent new and creative ways of reintroducing these (appropriately) unmanageable subjects: diversity, racial privilege, discrimination, lesbophobia and heterocentrism, classism, dissent, (self)consciousness-raising, and responsibility.

CODAI, the Committee on Diversity and Inclusion, was voted a regular slot in the weekly agenda for awareness building, and introduced words such as "privilege" and "accountability" to the group as a whole. Borrowing from a pamphlet created by a Canadian group, WAC's Lesbian Caucus produced a kind of lesbian "bill of rights" designed to open discussion and dispel myths.[4]

Our renegade potential was incredibly powerful, but we had to learn what, how, when, where, and with whom we could or should act. In exchange for knowing just what community we belonged to, or constituted ourselves, we won latitude. But in the end, latitude alone could not replace the urgency or substitute for the legitimacy associated with belonging to an identifiable and definable community. As outsiders—few of us were born in New York City—we also had to learn that we could not simply adopt any issue as our own: police brutality in Washington Heights, disposal of waste in marginalized neighborhoods, and, since most of us were not parents, city council educational policies were essentially off-limits unless we could establish appropriate community contacts.

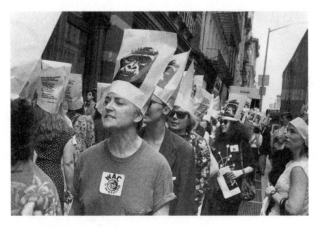

WAC and the Guerrilla Girls outside the SoHo Guggenheim Museum, June 25, 1992, New York City. The action took place after months of letter, phone, and fax zaps demanding the inclusion of nonwhite, non-European, non-male artists in the opening show and urging more diverse, community-responsible curating.
Photo Teri Slotkin

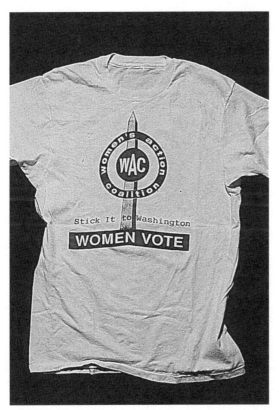

WAC, *Stick it to Washington . . . Women Vote* T-shirt, April 1992. One of several T-shirt designs made by WAC for the national pro-choice rally, "March for Women's Lives," in Washington, D.C. Another T-shirt featured British suffragettes and the words "Rescue Choice."

Had we chosen to do more work in our own backyard—in the art community—we might have been a more focused group with more obvious demands—like the Guerrilla Girls, with whom we had ongoing contact. But in fact there was significant reluctance in this area. In part this was due to our explicit desire to have an effect on larger issues and an impact on a wider audience. After all, we had already elected to be an action group rather than an artist group. However, there also seemed to be considerable fear of potential repercussions if more actions were to be initiated targeting people and places closer at hand in the art community itself. The eagerness with which we confronted the SoHo Guggenheim, *Documenta 9*, and the Pace Gallery on their neglect of artists not white and/or not male was not available for confronting equally exclusionary racist and sexist practices (or even violent acts) in our immediate art community and local galleries. The courage of one's convictions became a strangely mutable thing when one's own career or friendships were possibly at stake. The

extraordinary capacity of power to divide, if not conquer from within, was evident as we came to know each other more personally and witnessed the ebb and flow of our individual will and resolve.

WACing Injustice: Social Shaming and Communicating Outrage

Mobilizing our creative instincts and expressing our concerns with posters, buttons, T-shirts, temporary tattoos, banners, flyers, letters, fax and phone zaps, giant puppets, drum rhythms, chants, costumes, state-of-the-art communications technologies, and media protocol, WAC used direct action as a means of direct education.

We were extraordinarily visible, and from investigation of legal precedents to acquisition of permit rights, we were extraordinarily well-organized. We focused on the perpetrators of crime, ignorance, discrimination, and injustice. We mobilized our resources to direct media, public, and government attention to glaring discrepancies in democratic practice in law, health care, childcare, welfare, choice, freedom of expression, education, safety, housing, job security, and immigration, as well as on international human-rights incidents, including abortion rights for Irish teenagers and the seemingly ac-cepted use of rape as a war crime and terrorist tactic in the former Yugoslavia. Our issues, as I presented them to the media in Houston at the Republican Convention in the summer of 1992, were not simply "women's issues, they are the issues of any sound domestic policy and appropriate to national concern."[5]

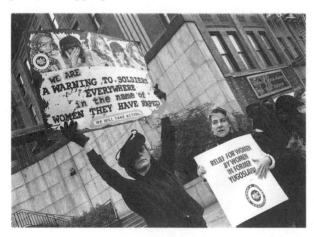

Women in Black, *We Are a Warning to Soldiers Everywhere...*, March 1993, New York City. Women in Black, one of several groups originally affiliated with WAC, held weekly vigils in solidarity with women in Belgrade protesting state-sanctioned violence against women.
Photo Lisa Kahane

Invoking a kind of social shaming, we updated a venerable tradition of demanding accountability from those in positions of power through public disclosure and media-wide confrontation. We were *not* ashamed of our demands. When Justice Figueroa stated that a mentally challenged woman's prior exposure to sexual violence rendered her more recent abuse less significant, we demanded that he retract his statement and remove himself from the sentencing proceedings. As with other actions, we warned, "WAC is watching. We will take action." In front of the Manhattan Criminal Courthouse, in our media "dunking" of the judge we created a public spectacle that enabled us to call attention to the horrifying implications of his logic: that once a woman is violated, any subsequent acts of sexual violence or physical transgression are somehow less significant and less worthy of being prosecuted to the fullest extent of the law. A short time later, at the "Women Tell the Truth" conference honoring Anita Hill at Hunter College, WAC received public acknowledgment and thanks from a

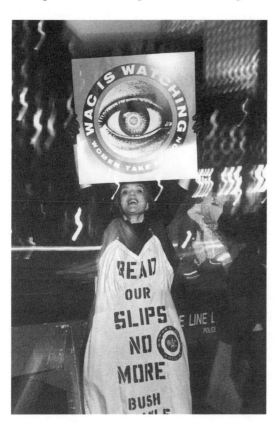

WAC, *Pink Slips for Quayle and Bush*, October 19, 1992, New York City. Women don pink slips protesting Vice President Dan Quayle's attendance at a Republican fundraiser, reminding him and others of the failure of the Republican agenda to address the needs of poor people, children, people of color, and women.
Photo Teri Slotkin

public defender for having "shamed" Judge Figueroa into stepping away from the case and for having made other members of the court more aware and more cautious. The extraordinary truth about WAC was that we had innumerable untold victories such as this.

By Design: A Volunteer Corporation

WAC mushroomed. More than one hundred women showed up for the second meeting, the day after our first action. By the third meeting two hundred women attended, and from the fourth meeting on into the summer there were approximately three hundred women in attendance every Tuesday night. Five hundred women came to hear Geraldine Ferraro and Liz Holtzman, two of New York's candidates for the U.S. Senate in 1992, who had asked to address WAC in May. From then on through September, attendance averaged between three and five hundred women per meeting. Our telephone network, the WAC phone tree, grew to several thousand women in New York City alone, enabling us to announce actions and/or initiate short-notice mobilization for rallies, phone zaps, emergencies, and reminders. Eventually, we voted to limit use of the phone tree simply because it had grown so large and, with WAC undertaking multiple actions per week, the task of communicating directly became impractical and untenable. By midsummer, we finally arranged to have a phone number with a prerecorded listing of upcoming events. However, the need to speak with someone for interviews, for how-to help to start WAC

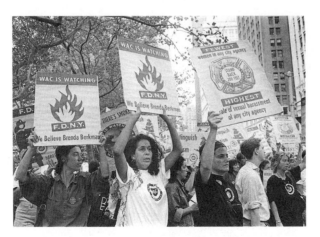

WAC action, *Fired Up and Burning Mad*, New York City, September 10, 1992. WAC rallies in support of female firefighters protesting sexually harrassment in the city's fire department.
Photo Lisa Kahane

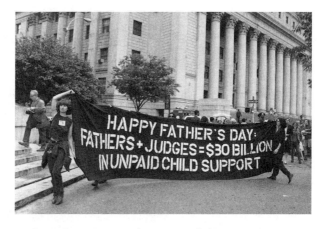

WAC, *Happy Father's Day: Fathers + Judges = $30 Billion in Unpaid Child Support,* cloth banner 240" x 48". WAC stands in front of the New York Supreme Court June 19, 1992 to insist that courts uphold child support rulings ensuring the rights and welfare of women and children through the nation's legal system.
Photo Teri Slotkin

in other towns, or for information on how to mobilize WAC on a particular issue continued to require direct access to members. Outgoing calls from my home, an unofficial "WAC Central," numbered in the thousands during the summer of 1992, with the ratio of incoming calls to outgoing calls averaging 7 to 1. It became literally impossible to bring all inquiries to the floor. In this sense, WAC as a whole was unable to experience itself, to know or even support its own weight. Involvement and perspective were various and distinct, depending on whether one was attending a meeting, participating in a planning committee, marching, working on external relations, or answering phones behind the scenes.

Our exponential growth forced us to alter our original design from a few core committees defined by specific responsibilities—legal, creative/artistic, media-based—to more and more committees focusing on specific issues and/or cases, such as the Pink Slip Action, the Democratic and Republican conventions, Clinic Defense, Mother's Day, Father's Day, Women Firefighters, the Glen Ridge Rape Trial, Rape Is a War Crime, Take Back the Night March, Stop Police Brutality, Tax Reform for Health Care, and more.

Media liaisons, lawyers, graphics and print artists, videomakers and photographers, and the drum corps worked literally around the clock trying to meet the needs of the various action committees. With the creation of the photography committee, WAC productions (video), the WAC archives, a phone hotline, a post office address, photocopy assistance, and training for facilitators and volunteer media spokespersons, WAC emerged as an elaborate volunteer corporation.

Pro-choice rally, April 5, 1992, Washington, D.C. Only three months old, WAC traveled 500 men and women strong to Washington. WAC carried an array of posters—many featuring the WAC "eye" and the declaration, "WAC Is Watching. Women Take Action"—demanding reproductive freedom. WAC's drum corps and puppet—emblazoned with the WAC symbol, a green solidarity armband, and the words "Pray for Choice"—made their national debut, drawing crowds and much media attention.
Photo Teri Slotkin

The WAC puppet, a reinforced papier-mâché figure, stood approximately fifteen feet high, with a reach between its spread hands of about forty feet.
Photo Teri Slotkin

WAC, *Pray for Choice* poster, April 1992. Ink on cardboard, 18" x 24". This poster, with an accompanying image titled *Keep Your Rosaries Out of Our Ovaries*, (not shown) was carried in Washington at the national pro-choice rally, "March for Women's Lives"; in front of St. Patrick's Cathedral; at the Democratic and Republican Conventions; and at corresponding WAC actions. Both posters were used continuously for clinic defense throughout the summer and fall of 1992.

Two Thousand Heads and the Creative Process

Amid all these structural changes, WAC maintained its commitment to its now-notorious methods of creative direct action. Ideas for actions were proposed to the whole group. Interested women met in smaller committees to discuss the specific issues involved, possible sites, coalition efforts, visual stimuli such as banners, posters, leaflets, costuming, and slogans and chants. They then returned to the "floor" (the large group meeting) with a plan, which was then presented, discussed, amended, modified, and finally brought to a vote for WAC endorsement and execution. The process itself was both fascinating and frustrating. The sheer number of events and participants makes it impossible to unravel and describe all the distinct moments and contributions that rightly constitute WAC's brief, labyrinthine history.

For example, the enormous puppet that eventually came to represent WAC at the March for Women's Lives pro-choice rally in Washington, D.C., in April 1992 was made despite WAC's "no" vote on the floor. Those of us who worked on it made it with the stipulation

among ourselves that if other WAC women still objected to it in Washington we would not carry it in the march. Instead, upon seeing the puppet, WAC women were elated, and it led WAC's 500 marchers and was considered one of the more poignant and effective symbols in the rally.

Our attempts to manage the complexity of social issues in symbols and slogans were both our nemesis and our hallmark. Balancing meaning and message, form and content, we had to come to terms with the demands of the media sound bite. Our posters promoted multicultural images that were often more inclusive and diverse than the participating artists. Short-term success was frequently in conflict with long(er)-term goals, as is often the case in agendas of great social change. These challenges deserved even greater attention and debate than we were able and/or willing to afford them. Driven by the rapid pace of the election process, we felt constantly obliged to act.

The creative process within WAC was itself an activist process.

And yet every week we made untold decisions in a large open forum. Even more negotiations were carried out in small committees, over coffee, and by phone and fax. It was never easy and far from flawless, no matter how well-prepared the proposal. Compromise in the process of making decisions, objects, or images was a profound strain, something few of us were accustomed to doing. Most of us were used to practicing our individuality and developing our ideas independently, especially those of us who were working artists. Collaborating aesthetically, trying to coordinate symbolism and meaningfulness, was awkward and unsettling. There were casualties. And even though our personal experiences might sometimes be tarnished in the process, our high-profile products and messages fared far better.

Collectively, our two thousand heads really were better than one, and great work emerged. Raw ideas were often refined and carried out at a new, more appropriate, and more insightful level. Even the WAC "eye" had to be reworked to eliminate blue from the center pupil area so as to be appropriately nonspecific in race. Images were added and taken away. Hundreds of voices argued and debated for months on end. The creative process within WAC was itself an activist process. As

assumptions expressed themselves clandestinely in the words and images we chose, a kind of polyvalent, multimedia Rorschach test emerged with each new action, so that in our pasteups and slogans, our assumptions, contradictions, and shortcomings were revealed. It was the concept of "the personal is political" in action. Individual prerogative and personal urgency were forged together with collective strength and group process.

In our accomplishment, however, we encountered another "danger." We found it was possible to seem more multicultural than we actually were. It was easier to edit our creative product—as we edited the multitude of women's voices in the compelling sound track for the Houston sound and light show—than it was to become a group that was conscious and responsive to the diverse conditions, perspectives, and requirements of women whose lives crossed social divides and definitions. It was a mixed blessing to be able to work and rework our text and our visual arrangements without having successfully identified, let alone incorporated, a politics of inclusion. In retrospect, it was good that we were able to produce such high-profile, inclusive images of all kinds of people. Certainly we were better at it than any of the campaigning parties, but that wasn't hard! As good as we were, and it often took several tries, our successes were in this sense seductive, appropriationist, and misleading. We were not who we may have appeared to be. It was a catch-22, a necessary evil given that we were real historical beings operating in real time and not our "virtual" compositions.

Communication and Activism: Media as Social Means

Immediately following WAC's first meeting, several of us gathered to discuss writing a press release for the first action. What began as a small group, with most of us strangers to one another, later became WAC's notorious communications hub. In cooperation with action committees, we generated press releases for each and every event. These were then faxed to news organizations, and follow-up calls were made to confirm receipt, stimulate additional interest, and answer questions. Within a few short months, WAC was known nationally and internationally. Throughout 1992, we were continually flooded

with calls and requests from individuals, activist groups, and media. WAC was referred to as "the activist organization with a press kit."

Without an office or staff, for months on end phones were answered at all hours, with interviews given daily to hundreds of news organizations, journalists, and other interested parties around the world. We established relationships with newscasters and reporters both in and out of New York, and we were careful to nurture and cultivate these contacts. For example, as part of its action, the Committee to Abort Parental Consent in New York held a press conference in Albany, where it delivered several hundred three-by-five cards that had been completed by young people under age eighteen, stating their opinion on their right to self-determination in relation to teens' rights to safe abortion. Our efforts bore fruit. WAC appeared in newspapers and on magazine covers, in literally hundreds of articles, was featured on talk shows, on French, German, Canadian, and Japanese radio, in television election specials like MTV's "Rock the Vote," on a BBC special, on CNN's *Sonia Live*, and was included in Robert Downey, Jr.'s feature film about the 1992 campaign, *The Last Party*.

Eventually, we were sought out by editors, authors, producers, publishers, and talk shows to speak on issues not specifically related to WAC; we were also invited to comment and proffer our opinions as "feminists." Our early efforts and communications experience evolved organically into a comprehensive and strategic media-relations plan, complete with in-house training for women wanting to be media liaisons, or to improve their skills and gain confidence as spokespersons.

Because we understood the mass media as historically having been ineffective, if not hostile, in responding to the needs of people outside the status quo, throughout our work we stayed close to the issue at hand, preferring to use forceful but carefully chosen words to convey an easily communicated analysis as a means of securing initial visibility and then maintaining credibility in the media. While daytime talk shows regularly feature women discussing the tragedy of their individual circumstances of survival—from HIV infection to suffering from rising hate crimes and neo-fascism—little or no analysis is offered. By 5:00 p.m., when the "real" news comes on, these discussions end, replaced by sound bites often taken out of context and largely

determined by corporate media interests. As women, we knew we were especially vulnerable to this manipulation.

This insidious division between private and public spheres is ever present in most media practice, silencing what we know to be true: that the personal and the political, though not one and the same, are integrally related. Images of women appearing to be self-determined, independent, dissatisfied, angry, or in opposition are instead represented as the actions of hysterical, frantic, man-hating, aggressive bitches. The line on which women walk—as one constituency among many marginalized groups—is a fine one. Credibility played a critical role in the perception of WAC's charges and challenges. As women activists involved in direct action, we were well aware of the potential damage that could be done to our credibility by the combined forces of media inflation and gender bias.

WAC quickly became known for its ability to "work the media." But working it also meant working *with* it, and this was the subject of heated debate and disagreement within the group. The media committee was frequently charged with "conservatism" with respect to our messages in press releases, letters, and in our editing.

Finding balance on this issue was, and is, a constant struggle, philosophical in nature. Bold demands may run the risk of alienating more mainstream audiences, but is self-censorship a negotiation or a compromise? It was vital to those of us in media that we establish and maintain credibility, and we understood that once lost it's a power not easily restored. There was never a single right or wrong course of action with respect to these difficult choices. It was about multiple

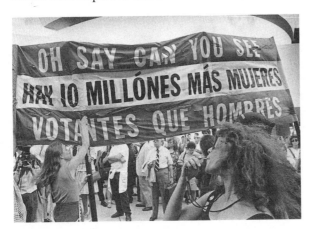

WAC, *Oh Say Can You See...*, cloth banner, approximately 240" x 50". Carried down Fifth Avenue during the 1992 Democratic Convention, the banner emphasized the significance of "10 million more women voters than men."
Photo Lisa Kahane

perspectives, likelihoods, and trade-offs, especially for women, especially as activists.

Social Change and Action Planning: Doing the Work

In order for our demands to be regarded seriously, we knew we had to have accurate information about our each and every action. Knowing our stuff was crucial to making good on our claims as a direct-action group. We fact-checked our materials, verified locations, reputations, and legal statutes. Eventually, *WAC Stats* was published. It was a compilation of statistics on issues relating to women that was distributed and sold by WAC.

Information gathering played an increasingly important role in the planning and execution of our actions and an enormous role in our overall success. We did not challenge Judge Figueroa's heinous remarks about the rape of a mentally disabled young woman until we were able to verify his reputation as a biased and unsympathetic judge within his own Latino community. We did not use an image of suffragettes for our T-shirt "Rescue Choice" until we knew for sure that the women depicted were not part of the eugenics movement in this country at the turn of the century. We made mistakes, but we also made the effort, improving our ideas collectively and being more than the sum of our parts.

Good intentions are insufficient political practice, and in WAC many learned this the hard way. The minimization of harm and damage could not be achieved by aspiring to do the right thing, but only by informing ourselves, each other, and our efforts. Both the Gay Pride posters and the Women Ignite images for the Republican Convention in Houston underwent numerous changes before being endorsed by the WAC floor. The process was intense and exhausting, but we consistently brought more to situations than we took away. Doing our "homework" was both about self-education and about demonstrating to others our wider commitment to principles beyond our own intentions and convenience.

We made manifest our willingness to do more than just "take to the streets," and our work went beyond "complaining." We not only sent letters protesting lesbo- and homophobic advertising, but we also sent "thank you" letters to companies such as Levi Strauss for its more

WAC, *Hero* and *Public Enemy* (not shown) posters, June 1992. Blueprint posters, 19" x 24". These posters featured an array of "heros" and "public enemies." On one side was a reproduced photographic portrait of a selected public figure, and on the other side appeared a quote by that person. These posters were created for New York City's annual Lesbian and Gay Pride Parade, and were carried behind the banner "WAC Is Here—Some Are Queer." The posters were also carried in other actions, including the United for AIDS Action in New York during the Democratic Convention.

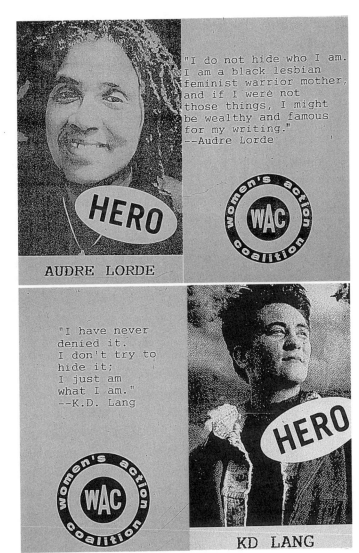

"I do not hide who I am. I am a black lesbian feminist warrior mother, and if I were not those things, I might be wealthy and famous for my writing."
--Audre Lorde

HERO

AUDRE LORDE

"I have never denied it. I don't try to hide it; I just am what I am."
--K.D. Lang

HERO

KD LANG

progressive labor and same-sex partner employee-insurance policies. For onlookers, or for those uncomfortable or disapproving of direct-action methods, this was important. You could see the effort that went into producing the illuminating posters of famous lesbians and gays for the Gay Pride March, and our slogans were intelligent and provocative. In fact, as informed as we were about our actions and as grounded in human and civil rights as we tried to be, it was hard to disagree with most of our demands.

WAC's chants, most often created by the drum corps, were catchy, hip, *and* informative. The drum corps drew observers in and seemed to keep the police away; that this was true was especially helpful in Houston when, after several attacks on ACT-UP, we opted to send the drum corps as a demonstration of solidarity and support, and as a means of intervening in the locally sanctioned police brutality.

Our creativity helped to generate credibility. Our work was by and large intriguing, sophisticated, and loaded with information. We were obviously going to great lengths to research our issues and deliver our messages in stimulating and challenging ways. Even sheriffs defending the antiabortion brigades in Houston chuckled at our extraordinary use of language in the "Operation Dessert Storm" mock menus. "Just Say No" ice cream featured specialties including the "Slush Fund Slush," "Snow Job Cone," "The Kennebunkport Float," "Ollie's Contra Cone," and the "Supreme Court Creme Sicle."

The "Dessert Storm" menus and our messages were carried by day throughout Houston in a real ice-cream truck with the official ice-cream truck jingle. WAC's legal committee had worked for months securing several thousand dollars' worth of city permits to ensure the legality of our various actions and the production itself. From our vehicle we distributed free ice cream to children, meanwhile passing out announcements inviting otherwise excluded Houston residents downtown to the only event free and open to the public during the entire convention, the WAC sound and light show, entitled Women Ignite.

On three consecutive evenings, on a six-story-high exterior wall across from a park, WAC projected sixty-by-forty-foot images with an accompanying text denouncing the state of national policy in the areas of health care, homelessness, education, lesbophobia, the lack of equal rights for gay men and all women, HIV infection, racism and discrimination, environmental abuse, rape, and military spending. The slides were set to a sound track consisting of music donated to the project and a mélange of voices edited to form a steady stream of women speaking for themselves on their lives and their issues. We also arranged for an open microphone. Each evening after the slide presentation and drum corps performance, women from the audience were invited to step up to the mike and speak freely about their lives and the issues that affected them. In the course of the three nights,

WAC, *Protect Yourself . . . Dam-It,* dental dam kits, June 28, 1992. Cardboard with attached dental dam, approximately 5" square. Distributed free of charge, these kits were intended to promote safe-sex awareness, discussion, and action.

protect yourself
from the lack
of information
DAM-IT

more than one hundred women took part in the speakout. Several hundred children, women, and men attended the soulful event, and many came back all three nights to share in what was truly a community-accessible and community-relevant multimedia spectacle.

WAC's ingenuity made people curious. Our humor and cleverness befriended outsiders, even hostile parties. Our enormous, sometimes extravagant efforts brought public attention, enthusiasm, and even approval for our issues and our activism. Our generative capacity was applauded as being exemplary even when it fell short of our own standards of inclusion, diversity, and representation. WAC's gestures complemented the untold efforts of the women organizing on behalf of women candidates, civil rights, health-care reform, housing, safety, and education from behind closed doors for more than thirty years. We were a moment of reawakening, of collective strength unleashed in the name of public social art that was a form of activism in itself.

Anxiety of Command: Leadership in the Nonhierarchy

Within WAC, accusations of elitism and unacknowledged leadership plagued us from early on. Practical truths challenged us: we were in fact "differently abled" and never actually equal. Individually within WAC, and relative to one another, our skills and abilities were unique and varied. Some of these differences were due to privilege; some of these "inequities" had to do with aptitude. Equality was an elusive

quality when it came to getting certain things done. For that, expertise loomed large. At our best, we were able to use it conscientiously; at our worst, it was abused, or its use instilled hostility and insecurity. Status was also unequally bestowed from within. Votes came and went. Some were more fully understood and thoughtfully executed than others. Democracy in practice won mixed reviews from virtually all of us, if only in private conversations.

Consciously and unconsciously, we battled essentialism(s) and essentialist thinking. In such phrases as "all women . . . ," "as women . . . ," "because we're women . . . ," "women of color," "you're a woman first . . . ," "men have the power," "it's patriarchy," "straight women are . . . ," "lesbian women should . . . ," "women" was used insistently in juxtaposition to "nonwomen," as if we had, or could have, a single unified vantage point, and as if alliances between women took precedence over race, sexual orientation, religious or ethnic identity, or class. It was often inferred that all women, merely by virtue of being women, were, or could be, or should be, "feminists," as if ovaries made a feminist. The proclamation that women with whom we had conflicts were under the influence of the "patriarchy" not only presumed a universality that does not exist, but in turn also imposed a cultural stereotype, inadvertently transmitting the concept that women are victims rather than independent agents.

If we couldn't *see* overt differences, sameness was supposed. Assumptions of this kind, in both language and attitude, produced cul-de-sacs of meaning rather than bridges of communication. This tendency ran deep but was not something we seemed to be able to do much about, although numerous attempts were made (most notably in WAC's two marathon philosophy meetings and by the continuing efforts of CODAI—the Committee on Diversity and Inclusion— and the Lesbian Caucus).

We were by no means unusual in our assumptions. In fact, that was the tragedy. So much has already been written, and the inappropriateness of these same suppositions already discussed in innumerable other groups, and yet for many—our majority—these issues remained largely unquestioned and unchallenged. The process of communicating in sound bites and seconds of video time disallowed certain complexities that were not only vital to a comprehensive understanding of

an issue but essential for coalition building and trust. And in the name of action and *immediacy*, it was arguably a "necessary evil" of the election year. WAC was in effect also campaigning on behalf of those who are often excluded from the political process.

In our "nonhierarchy," it was difficult to acknowledge insider knowledge, to credit and incorporate foresight, or to see wisdom as being distinct from opinion. Professionalism was sometimes confused with leadership. For example, fearing investigation by the IRS, a newly formed finance committee proposed increasingly elaborate criteria for reimbursement and disbursal of funds. Despite WAC's sovereign claim that any woman could attend any committee meeting, attendance was in fact disallowed on several occasions. In light of the fact that WAC's mission was in part about rejecting unexamined governmental authority, these procedures were a strange solution, and we accepted accounting systems that were in fact hostile to our most fundamental, if only just emerging, principles, with hardly a word.

Financial reports were instituted in place of real discussions about class and the interdependency between money and access. Those who could afford long-distance phone bills or mass photocopying could participate in ways that those whose incomes were limited could not. "Poorer" women had to go to the floor and ask for money and submit to all forms of inquiry regarding the justification of expenditures. Of course something like this had to happen to assure the group's economic integrity over time, but *how* it was done was far from progressive or inventive, especially given WAC's profound resources.

During WAC New York's first year, we were able to raise as much as two thousand dollars just by passing buckets at one evening's meeting. The Houston convention event alone cost between thirty-five and forty thousand dollars. In refusing as a group to discuss money as an enabler, and in refusing to have an office, we inadvertently maintained divisions in terms of who could afford to do what. Issues of class (and other forms of difference) were overlooked again and again. There was distrust of one another, namecalling, and eventually even a fight.

In other words, we were not immune to our own individual and collective fears, despite our strength in numbers. As women, we sought to represent ourselves both individually and collectively. Within WAC, this desire was often transformed into a struggle about

relinquishing authority among and between ourselves. Like many social-change groups before, and probably like those to come, we repeated patterns of oppression and exclusion. Our actions revealed our priorities and our priorities revealed our multiple selves. Even as structures were created with the hope that they would ensure the rotation of power and influence, hierarchies emerged in our midst, and only some were toppled.

But we were also "all just volunteers," and of necessity, efficiency made a casualty of some of our more profound problems. It simply was not possible to expect those who were volunteering their professional skills (graphics, silkscreening, video editing, law, media management, bookkeeping, accounting—the list is as long as we were many) to not only proffer services for the good of the group and its issues, but also to teach these skills to others within WAC as part of a commitment to nonhierarchy and a right-minded and well-meaning distributive sense of collective capability. Consequently, hierarchies related to expertise took hold, and the women outside them felt slighted. Many skills were indeed shared, but our professionalism continued to be both a blessing and a curse.

More often than not we worked hard to listen to each other, gain insight, grow, and most of all to keep the larger issues in the foreground no matter what our group dilemmas might be. The evidence of our success can be found in the many remarkable friendships and smaller networks that emerged and are continuing long after the larger WAC dissolved.

WACNET Works

Within a very few short months, WAC expanded its base to nearly thirty cities. Approximately ten of these branches succeeded in becoming action groups, making waves and making news, most notably in Chicago, Houston, Los Angeles, and San Francisco. Each city operated more or less independently, although WAC New York provided press kits and an orientation pamphlet explaining our methods and outlining our procedures, much of which we gratefully and respectfully took from ACT-UP's guidelines and modified for our purposes.

As they began, the other branches of WAC tended to fall into a "big-sister trap"—the feeling that they, women in other cities, had to

"live up" to WAC New York's precedents in terms of number of participants, monies available, number of actions, media attention, and "cool." Organizing in Los Angeles, for example, was a logistical nightmare simply in terms of transportation. In Toronto and Paris, attempts to initiate "WAC-like" entities began with outreach to social workers, health practitioners and counselors, and women whose jobs already had them working full-time, if not overtime, on progressive legislation, consciousness-raising, and issues of social welfare, advancing access, representation, and the civil rights of marginalized groups. The geopolitics of each city varied significantly. It's likely that the groups that fared the best over time were those who from the outset founded themselves and only took some cues from WAC New York, going on to establish their autonomy and to identify their own local conditions of organizing, including the specifics of location, access, and membership identity.

WAC Chicago, which is alive, well, and still very active, distributed wooden coffins all over the city of Chicago during the night to sites where women were raped, assaulted, or murdered, as an action to foster awareness of sexual violence and safety. WAC Los Angeles created an elaborate rally in response to the Tailhook incident, in which naval officers were charged with sexual harassment and assault of fellow women officers. In another action, Fairness and Accuracy in Reporting (FAIR!), in consortium with other women's and media groups, pressured network television to air public-service announcements during the Super Bowl, while WAC Los Angeles procured planes that flew over the Super Bowl carrying message banners denouncing sanctioned violence against women.

In Canada (and to a lesser extent in Berlin and Paris), government support for community organizing, antiracism training, women's shelters, and related issues created substantial conflict. In effect, the same positive state commitment to meeting the needs of a diverse population was also responsible for maintaining only a narrow margin of liberty. There, government money provided full-time work, with salaries enabling more women from diverse economic and social backgrounds to participate in social change in a way that volunteerism can not. But for these women, "not biting the hand that feeds you" then became a significant deterrent to actions that might jeopardize sources

of economic support for a clinic, shelter, or lobbying group. Who participates became a question of who can afford to do what and who can afford to lose what. WAC was distinct in its independent stance because that stance was based on the individual independence of our members, women who could, by and large, afford to contribute, and who did so to the best of their ability.

Walking the Talk

As veterans of an ongoing social war, women as a category have occupied more than one front. Although we are divided in our fears, opportunities, and safety, what we share as veterans is a war without a single date, without a name, and in which there are multiple enemies, some of whom may be other women.

With WAC's use of direct action, we were demanding accountability from judges, publicly funded museums, and grant-giving bodies like the National Endowment for the Arts, by elected political officials and potential candidates, and by magazine publications and corporate entities, at the same time that we were failing ourselves and each other in our own accountability process. Personality politics abounded. Some clashes were ugly, some simply unfortunate. Guilt and desire for absolution met with an intolerance born of cumulative experience and concomitant exhaustion. We had to learn what it meant to have accountability among ourselves—to differentiate personal injury from political process, and to distinguish institutional power from interpersonal conflict.

> **What we share as veterans is a war without a single date, without a name.**

We both scorned and courted legitimacy. Media "approval" was a means to an end, allowing us to access audiences we would otherwise never reach. Yet we were impatient with its limits and wary of compromises in our self-representation. We knew this to be a conflict and we were often in disagreement. The quest for legitimacy brought out our worst and our best, forcing us into tireless hours of searching and researching, writing and rewriting, designing and redesigning layouts, text, and images.

We expanded our vocabulary, demonstrated remarkable commitment and creativity, and produced informative materials and memo-

rable images. What we did not develop as a group was a structural analysis of inequality and discrimination at the level of such issues as sexual orientation, race, class, ability, leadership, or expertise. Nevertheless, the fact that we were able to execute so many marches and rallies, send literally thousands of letters and faxes in protest and in thanks, design slogans, chants, and musical rhythms, support other groups' initiatives, distribute educational information, direct national and international media attention, and actually change the course of certain legal cases and legislation, is testimony to our phenomenal will to learn, cooperate, and forge ahead.

What Caught Up with Us—A Conclusion of Sorts

While the nation's media insisted on naming 1992 "The Year of the Woman," by far the more significant occurrence, historically speaking, was the ongoing effort of unnamed women and the countless hours of work that produced 1992's women candidates, founded and funded their elaborate support networks, and created the environment in which they and other individuals representing historically marginalized groups could run for office and win in unprecedented numbers.

It was behind-the-scenes work like that of any artist preparing for an exhibition: slow, steady, and piecemeal, culminating in an event before repeating the cycle. From the infamous activism of the 1960s to the more private introspective identity politics of the 1970s and 1980s, there was a return to public protest and direct action, particularly in opposition to the appalling record of the Republicans. WAC participants stepped out and accomplished our stated mission to "launch a visible and remarkable resistance."

In this sense, the eventual dissolution of WAC—WAC New York in particular—was a forgone conclusion, a natural occurrence, cyclical and organic. We came forward, we made our contribution, and we moved on. But WAC's dispersal, like WAC itself, occurred in relation to many distinct and overlapping social phenomena. Without funding, most people can only volunteer for so long. And few of us could sustain that initial level of political negotiation (and the concomitant emotional exhaustion) without needing a break, a respite from the intensity and the urgency of responding to the unending need for creative social action in the face of the constant crises that character-

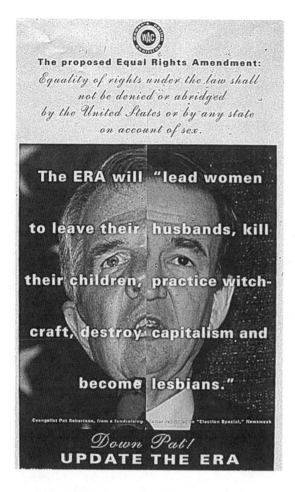

The proposed Equal Rights Amendment:
Equality of rights under the law shall not be denied or abridged by the United States or by any state on account of sex.

The ERA will "lead women to leave their husbands, kill their children, practice witch-craft, destroy capitalism and become lesbians."

Evangelist Pat Robertson, from a fundraising letter quoted in "Election Special," *Newsweek*

Down Pat!
UPDATE THE ERA

WAC, *Update the ERA* window installation, January 1993. Two panels, each 72" x 96". Installed in the window of Printed Matter, an art and artist's bookstore in lower Manhattan, the display was designed to provoke awareness of the absence of an equal-rights amendment for women in this country, the need for renewed initiative, and the absurd anti-women rhetoric of such spokespeople of the conservative Christian right as Pat Buchanan.

ize the lives of most women, children, and other socially disenfranchised people.

For example, in WAC New York at one point, "anticensorship" women resolved to defend a simple majority vote, which effectively silenced, i.e., censored, an "antipornography" minority, rather than endorse two separate WAC letters, or take the time to rewrite a single letter to the National Endowment for the Arts. A draft could have been written in such a way as to *both* express outrage at the NEA's violation of the First Amendment's assurance of the right to freedom of expression, *as well as* articulate the fact of violence against women as something deplorable, taking many forms, constituting a distinct area of concern, warranting its own discussion, challenging the rhe-

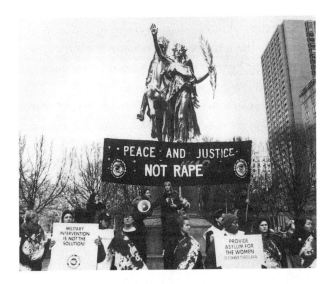

WAC, *Peace and Justice—Not Rape*, New York City, January 23, 1993. Making connections between the women of the former Yugoslavia and women victims and survivors of countless other wars and patterns of sexual violence throughout history, WAC marched across midtown to the United Nations building.
Photo Teri Slotkin

torical manipulation of censorship, and questioning so-called "community standards" and "family values" as appropriate means for dealing with sexual violence.

More personally, many women who had at one point or another emerged as "leaders" felt assaulted, and retreated or left. It's been said that in organizing on the basis of oppression the tendency is to bond at the level of victimization, at the weakest link, and then, within the group, to doubt or even alienate emergent leadership for appearing to be too much like the group's oppressors. Insecurities of this kind were played out within WAC, and many of those women who had viable professional and personal lives, or who had other ways or places to be politically active, moved on rather than experience or be subjected to the range of emotions and attitudes exhibited in such a young organization.

Furthermore, although there has clearly been no reduction of incidents appropriate for WAC actions following the Clinton victory—such as the struggle for equal treatment for lesbians and gays in the military, the debate on health care, and innumerable other instances of bias crime, sexual violence, and the overwhelming neglect of human rights in our international agenda—the postcampaign atmosphere called for a different kind of work, a different kind of involvement and energy, a different kind of action.

In crude terms, it has been said of WAC that in the Democratic victory we (feminists, and presumably the left as a whole) "lost our enemy." But I would invoke the words of feminist film critic B. Ruby Rich who, in her exposé of Camille Paglia in the *Village Voice* some years back, cautioned that "the enemies of your enemies are not necessarily your friends."[6] While Democratic leadership has brought back some semblance of social commitment, many of the issues addressed in the campaign have been lost or have simply eroded into less desirable forms. In this sense, it is unfortunate that WAC isn't here at this moment, thousands strong, to letter-zap the White House with demands for universal medical coverage and the establishment of an effective war-crimes tribunal able to respond to and prosecute the crimes of genocide, ethnic cleansing, and to the systematic mass rape of women in the former Yugoslavia.

But perhaps even more importantly, the "we" who lost our enemy was and continues to be a vast and irreducible ensemble of people whose points of alliance and reasons for aligning are necessarily in a state of flux, at times the source of great unity and shared vision, at times the source of contention and distrust.

In the words of the philosopher Hans-Georg Gadamer, "Horizons change for a person who is moving."[7] Moving on from WAC was for some a condition of exhaustion, for some a response to disappointment and failure—but for others it was timely and appropriate, about reflection and creative retreat.

We were women with cameras, fax machines, E-mail and computers, posters, flyers and billboards. Thoughtful and proactive, we brought our ideas into focus using the media coverage we sought in an attempt to reach audiences different from those that art usually generates, a mass audience typically much more conservative than ourselves. We used our "art" for direct communication, as a mechanism for social dialogue and enhanced political awareness. And then we too moved on.

Utopian, Not Utopia

Feminist philosopher and theoretician Drucilla Cornell has called for "a Feminism that lives the radicalism of its promise."[8] Yet even as WAC engaged itself in long discussions and hundreds of actions,

questions of process were overlooked. And while it may be true that actions speak louder than words, our collective and internal action(s) did not succeed in creating what could have been more lasting and self-conscious forms of feminist diplomacy and/or feminist civility. Neither the two marathon philosophy meetings, the first one in May 1992, the second in the spring of 1993, nor the short-lived theory committee were able to provide us with sufficient critical feedback on our own engagement. Too often we accepted uncritically what was known and familiar. And in so doing we neglected to seize the opportunity to invent feminist political practice.

As in the example of the anticensorship majority subjecting the so-called antipornography minority to the exclusive language of their anticensorship position, we in WAC New York failed to create a more coherent system for representing minority dissent. Had the minority been straight or white and the majority lesbian, black, or Latina, I believe we might have been more sensitive to the implications of the choice we ultimately settled for, which was effectively to silence the group smaller in number, and disallow them from representing their own interests in their own language.

In his introduction to *Common Sense,* Thomas Paine explains, "A long habit of not thinking a thing wrong, gives it the superficial appearance of being right, and raises at first a formidable outcry in defense of custom. . . . Time makes more converts than reason."[9] Simple majority will always limit the expression of anyone belonging to a minority group. And while it is true that democracy of any design will have inadequacies, as feminist practitioners engaging in social change it is precisely these challenges that summon our accountability among ourselves, between one another, and with anyone we hope to have listen. This is our responsibility and it is hard, aggravating work.

The Future Is Critical

Entering the next century as social activists, "we" (however we choose to define ourselves) must know what we want. When WAC first announced, "Let women define rape," and a sharp reporter asked how *did* we define rape, we weren't ready with an answer.

To these ends, it is essential that we "self-assess": What are we willing to risk, with whom do we share "our" goals, what are we will-

ing to commit as resources and to risk personally and politically, who are our allies across time (or for a time) and across distances? As Patricia Ireland, president of the National Organization for Women, has noted, women are not inherently obliged to "get along." The fact that conflicts between women have historically been dismissed as "cat fights" must not be allowed to obscure the fact that women have real philosophical differences with one another, and that these differences deserve serious recognition and require open debate.

"Walking the talk" requires that we know how we are segregated and stratified, and how conditions of privilege and exclusion are reflected in our lives, jobs, families, lovers, and circles of friends, our expectations, priorities, goals, our needs and perspectives, our words, our emotions, and our dreams. Diversity in representation cannot be an afterthought, in which those not like "ourselves" are asked to legitimize an already existing agenda that they have had no part in creating. If we are asking "others" (however circumstances name us) to listen, we must be able to demonstrate our own willingness to listen and negotiate divergent strategies.

The path to a less alien future demands that we be self-critical and self-educating, examining our motivations, understanding that comfort and discomfort often indicate sites of privilege, including safety, access, freedom, and social value. In making distinctions, it will in the end be the quality of our logic, not the quality of our intentions, that will ultimately make meaningful communication and revolutionary collaboration possible.

Notes and Bibliographies

Introduction

Notes

1. For earlier important discussions of activist art, see Lucy R. Lippard, *Get the Message? A Decade of Art for Social Change* (New York: E.P. Dutton, 1984); Douglas Kahn and Diane Neumaier, eds., *Cultures in Contention* (Seattle: Real Comet Press, 1985); and Arlene Raven, ed., *Art in the Public Interest* (Ann Arbor, Mich.: UMI Research Press, 1989).

2. Marshall McLuhan and Quentin Fiore, *The Medium Is the Massage* (New York and Toronto: Bantam Books, 1967), 123.

3. See Jeff Kelley's essay, "The Body Politics of Suzanne Lacy," in this book.

4. McLuhan and Fiore, 22.

5. Abbie Hoffman, in Derek Taylor, *It Was Twenty Years Ago Today* (London: Bantam Press, 1987), 239.

6. Vicki Goldberg, "Remembering the Faces in the Civil Rights Struggles," *New York Times,* July 17, 1994, H31.

7. For an excellent account of Greenpeace, with references to the Yippies as activist guerrilla theater, see Steven Durland, "Witness: The Guerrilla Theater of Greenpeace," reprinted from *High Performance* 40 (1987) in Raven, *Art in the Public Interest*, 31–42; for two articles by Abbie Hoffman about the importance of media to his brand of creative activism see "Media Freaking," *The Drama Review* 13, no. 4 (Summer 1969): 46–51, and "Museum of the Streets," in Kahn and Neumaier, eds., *Cultures in Contention*, 134–40.

8. Abbie Hoffman, "Media Freaking," *The Drama Review* 13, no. 4 (Summer 1969): 49.

9. Brian Wallis, ed. *Democracy: A Project by Group Material* (Seattle: Bay Press; New York: Dia Art Foundation, 1990), 8.

10. Lucy R. Lippard, "The Art Workers' Coalition: Not a History," *Studio International* 180, no. 927 (November, 1970): 171–74.

11. For a discussion of 1970s performance art, see RoseLee Goldberg, *Performance: Live Art 1909 to the Present* (New York: Abrams, 1979), 98–125.

12. Although the roots of the American Festival Project, a national network of multicultural, community-based performing arts groups, are not in the visual arts but rather in community-based theater, its process-oriented methodology and goals, as discussed by Jan Cohen-Cruz in her essay in this book, are similar to many of the practices examined here.

13. As quoted in Jeff Kelley's "The Body Politics of Suzanne Lacy" in this book.

14. Lucy R. Lippard, *Six Years: The Dematerialization of the Art Object* (New York: Praeger), 98.

15. From a statement by Joseph Kosuth in the exhibition catalog for *January 5–31, 1969,* held at 44 East 52nd Street, New York, N.Y., 1969.

16. The phrase "turd in the plaza" was coined by James Wines, an artist working in the field of architecture; confirmed by him in a telephone conversation with the author, August 5, 1994.

17. For an interesting discussion about the trashing of democracy and the rise and nature of activism on the left and right in the 1980s, see Wallis, *Democracy,* 5–10.

18. In the wake of its devastation to the art world, the AIDS crisis has also generated a large body of art, many exhibitions, numerous fundraising benefits, and a lively and effective activism among artists and art professionals. In addition to Gran Fury, examined in Richard Meyer's essay in this book, there is Visual AIDS and DIVA-TV (Damn Interfering Video Activist Television), a coalition of videomakers connected to ACT-UP. Visual AIDS began its work of increasing AIDS awareness both inside and outside the art world in 1989. Among its best-known projects are the annual national event, Day Without Art, and the the red ribbon project.

19. Group Material, "On Democracy," in Wallis, *Democracy,* ibid., 1.

20. Liz Lerman, quoted in Jan Cohen-Cruz's essay, "The American Festival Project: Performing Difference, Discovering Common Ground," in this book.

21. Jonathan Rabinowitz, "In L.A., Political Activism Beats Out Political Art," *New York Times,* March 20, 1994.

22. The Lannan Foundation also provided support for the relocation of the Robert Mapplethorpe retrospective exhibition after it was cancelled at the Corcoran Gallery of Art in 1989.

23. Susan Sturgis, "Dollars and Censorship," *Village Voice,* January 18, 1994, 4.

24. The exhibition was co-organized by Eleanor Heartney, whose essay, "Ecopolitics/ Ecopoetry: Helen and Newton Harrison's Environmental Talking Cure," appears in this book, and installed by Group Material, discussed by Jan Avgikos in her essay here, "Group Material Timeline: Activism as a Work of Art."

25. Douglas Crimp and Adam Rolston, *AIDS Demo Graphics* (Seattle: Bay Press, 1990), 19.

26. Ibid., 19.

1 The Invisible Town Square: Artists' Collaborations and Media Dramas in America's Biggest Border Town

Notes

1. Robert L. Pincus, "Bus Artists Driving Home a Point," *San Diego Union,* January 9, 1988, D1.

2. Ibid.

3. Richard A. Smith, letter, *San Diego Union,* January 13, 1988, B6; Florence Joiner, letter, *San Diego Union,* January 13, 1988, B6.

4. Michael Tuck, "Perspective," KGTV, January 11, 1988, unpaginated transcript.

5. Louis Hock and Elizabeth Sisco, interview with the author, March 1, 1994.

6. George Will, "The Interaction of Space and Tacos," *San Diego Union–Tribune,* August 22, 1993, B6; Mike Royko, "Artistic Talent Is a Handout Away," *San Diego Union–Tribune,* August 14, 1993, B12.

7. Robert L. Pincus, "'Number Crunchers' Ultimately End Up Deciding Art's Direction," *San Diego Union–Tribune,* September 13, 1993, E4.

8. Robert L. Pincus, "Controversial Artist Speaks Out About Art Scene Here," *San Diego Union,* September 4, 1988, E1.

9. David Avalos, Scott Kessler, and Deborah Small, interview with the author, March 31, 1994.

10. Hock and Sisco, interview, March 1, 1994.

11. Robert L. Pincus, "Bus Poster Artists Rap S.D. Again . . . This Time on Billboard," *San Diego Union,* April 13,1989, D1.

12. Ibid.

13. Uri Berliner, "Lowry Says Bench Ads 'Not Art,'" *San Diego Union,* November 1, 1990, B3.

14. Deborah Small, Elizabeth Sisco, Carla Kirkwood, Scott Kessler, and Louis Hock, *"NHI"* (San Diego: [self-published], 1992).

15. Robert L. Pincus, "Trio Elevates Migrant Tax Rebate Concept to an Art Form," *San Diego Union–Tribune,* August 2, 1993, E4.

16. Robert L. Pincus, "'Rebate' Gives Good Return for a Minor Investment," *San Diego Union–Tribune,* August 22, 1993, E1, E8.

17. Robert L. Pincus, "Noted Collaborator Goes It Alone Locally," *San Diego Union–Tribune,* January 31, 1994, E5.

18. John Dewey, quoted in William Carlos Williams, introduction to *Paterson* (New York: New Directions, 1963), unpaginated.

Bibliography

Avalos, David, James Luna, Deborah Small, and William E. Weeks. *California Mission Daze.* San Diego: [self-published], 1988.

Brookman, Philip, and Guillermo Gómez-Peña, eds. *Made in Aztlan.* San Diego: Centro Cultural de la Raza, Tolteca Publications, 1985.

Chavez, Patricio, and Madeleine Grynsztejn. *La Frontera/The Border: Art About the Mexico/United States Border Experience.* San Diego: Centro Cultural de la Raza and Museum of Contemporary Art, San Diego, 1993.

Gómez-Peña, Guillermo. "Death on the Border: A Eulogy to Border Art." *High Performance* 14 (Spring 1991): 8–9.

Jaffe, Maggie, and Deborah Small. *1492*. San Diego: [self-published], 1986.

Kelley, Jeff, ed. *The Border Art Workshop (BAW/TAF), 1984–1989: A Documentation of 5 Years of Interdisciplinary Art Projects Dealing with U.S.–Mexico Border Issues (A Binational Perspective).* (English text). New York: Artists Space; San Diego: Centro Cultural de la Raza and La Jolla Museum of Contemporary Art, 1989.

Pincus, Robert L. "The Spirit of Place: Border Art in San Diego." *Visions* 3 (Spring 1989): 4–7.

Small, Deborah, Elizabeth Sisco, Carla Kirkwood, Scott Kessler, and Louis Hock. *"NHI."* San Diego: [self-published], 1992.

Small, Deborah, ed. *There Are 206 Bones in the Human Body.* San Diego: [self-published], 1988.

2 This Is to Enrage You: Gran Fury and the Graphics of AIDS Activism

Notes

1. Gran Fury fact sheet and exhibition history (unpublished). Personal archives of Loring McAlpin, New York City. From its inception as an art collective in 1988 until its unofficial disbanding in 1992, Gran Fury remained deeply rooted within the lesbian and gay community and, more specifically, within the activist politics of the AIDS Coalition to Unleash Power (ACT-UP). All of the participants in Gran Fury had also been members of ACT-UP, and the art collective was initiated as a spin-off from the larger activist coalition. While ACT-UP organized direct political actions, Gran Fury created imagery and agitprop (much of which accompanied ACT-UP demonstrations) to rouse the public to action and anger over the AIDS pandemic. The relationship between ACT-UP and Gran Fury is discussed later in the essay.

2. The same-sex couples in *Kissing Doesn't Kill* are noticeably more passionate than the opposite-sex one: the two men kiss with open mouths; the women smile and sexily caress; the heterosexual pair kiss rather gingerly and stand relatively far apart from one another.

3. The most notorious episode concerning kissing and AIDS transmission occurred in August 1985 when Rock Hudson revealed that he had AIDS. Stills of Hudson kissing Linda Evans (taken from the television show *Dynasty*) were reproduced throughout the tabloid press, and the (supposed) possibility of transmission via that kissing was extensively discussed. See, for example, "Fear and AIDS in Hollywood," *People*, September 23, 1985, 13; "Has Linda Anything to Fear?" *The Globe*, August 13, 1985; "Linda Evans and *Dynasty* Cast Terrified—He Kissed Her on Show," *National Enquirer*, August 12, 1985.

4. Loring McAlpin, cited in Karrie Jacobs, "Night Discourse," in Karrie Jacobs and Steven Heller, eds., *Angry Graphics: Protest Posters of the Reagan/Bush Era* (Salt Lake City: Peregrine Smith Books, 1992), 12.

5. Gran Fury produced a rapidly edited video montage of forty kissing couples of various gender and racial constitutions. The footage was then edited down to four MTV-style "videos," and set to a popular music sound track. One of these videos was shown on PBS in conjunction with World AIDS Day, December 1, 1991. Others have been broadcast on British, German, and French versions of MTV.

6. Avram Finkelstein, cited in "Gran Fury," interview with David Deitcher, in *Discourses: Conversations in Postmodern Art and Culture,* ed. Russell Ferguson, William Olander, Marcia Tucker, and Karen Fiss (New York: New Museum of Contemporary Art, 1989), 198.

7. Jan Zita Grover, "AIDS: Public Issues, Public Art," *Public Art Issues* (1992): 6.

8. Marlene McCarty, interview with the author, May 19, 1994.

9. Cindy Patton, *Sex and Germs: The Politics of AIDS* (Boston: South End Press, 1985), 142.

10. In a 1989 interview, Tom Kalin argued that works such as *Kissing Doesn't Kill* were both politically adversarial and sexually affirmative: "Speaking personally, I think that along with being enraged and wanting to engage in direct action . . . we should also be giving ourselves something to look forward to. The media and information that we make doesn't have to be only adversarial. It can also be affirmative at a certain level and necessarily should be that way." Avram Finkelstein, another collective member, responded, "Of course, in the given context being affirmative about sex is being adversarial." See "Gran Fury," in *Discourses,* 201.

11. AMFAR has been described as "a massive fundraising enterprise which solicits contributions and makes grants in the name of biomedical and social scientific research about AIDS." See Kristen Engberg, "Marketing the (Ad)just(ed) Cause," *New Art Examiner* 18 (May 1991): 27.

12. Loring McAlpin, interview with the author, April 20, 1993.

13. Like every other graphic in the campaign, *Kissing Doesn't Kill* was accompanied by an *Art Against AIDS On the Road* logo.

14. Robert Shaw, cited in Gary Washburn, "AIDS 'Kiss' Posters Going Up on CTA," *Chicago Tribune,* August 15, 1990, 1, 8.

15. Robert Shaw, cited in David Olson, "CTA Postpones AIDS Awareness Display," *Windy City Times,* June 14, 1990, 1. Shaw's charge of "homosexual recruitment" was widely echoed by other local politicians and press columnists.

16. Robert Shaw, cited in Rick Pearson and Paul Wagner, "Senate Votes to Ban AIDS Posters from CTA," *Chicago Tribune,* June 23, 1990, 1.

17. Following the bill's defeat, Chicago's Mayor Richard Daley, rather than affirming Gran Fury's right to exhibit the poster, encouraged it to produce a "less offensive" image for the mass transit system, a proposal that the collective "unequivocally refused." See Engberg, "Marketing the (Ad)just(ed) Cause," 27.

18. These statistics are cited in Randy Shilts, *And the Band Played On: Politics, People, and the AIDS Epidemic* (New York: Penguin, 1988), 597.

19. The graphic was originally created by a collective of six gay men called the *SILENCE = DEATH* project. Several of the members of the *SILENCE = DEATH*

project subsequently became members of ACT-UP, and one, Avram Finkelstein, also became a member of Gran Fury.

20. ACT-UP originated in March 1987 when playwright Larry Kramer, in a lecture on AIDS at the Lesbian and Gay Community Center of New York, warned his audience: "At the rate we're going, you could be dead in five years. . . . If what you are hearing doesn't rouse you to anger, fury, rage, and action, [we] have no future here on Earth." According to one account, "Discussion following Kramer's speech ended in the resolve to meet again two days later, a meeting at which nearly 300 people would form the AIDS Coalition to Unleash Power. ACT-UP, 'a diverse, nonpartisan group united in anger and committed to direct action to end the AIDS crisis' set about immediately to plan its first demonstration." See Douglas Crimp and Adam Rolston, *AIDS Demo Graphics* (Seattle: Bay Press, 1990), 27–28. Kramer's 1987 speech is cited by David Friedman, "ACT-UP's Second Act," *New York Newsday*, August 24, 1993, Part 2, 42.

21. Crimp and Rolston, *AIDS Demo Graphics*, 14.

22. Adam Rolston, cited in Jacobs and Heller, eds., *Angry Graphics*, 12.

23. For an excellent account of ACT-UP's history as seen through their graphic work, see Crimp and Rolston, *AIDS Demo Graphics*.

24. Tom Kalin, cited in "Gran Fury," in *Discourses*, 196.

25. John Lindell, interview with the author, May 4, 1994. Although Gran Fury eventually allowed itself to be identified by the press, it always preferred to be known as an anonymous collective of AIDS activists rather than as a group of individual artists. For a detailed discussion of the relationship between anonymity and activism, see Elizabeth Hess's essay on the Guerrilla Girls in this volume.

26. Crimp and Rolston, *AIDS Demo Graphics*, 16.

27. In a recently published "roundtable discussion," ACT-UP/Gran Fury member John Lindell made this point even more strongly: "We knew that the 'real' demonstration was meaningless. The important question was, 'How does it look on camera?'" See "Survey on Terror and Terrorism," *Documents* 2, no. 4/5 (Spring 1994): 19.

As Cindy Patton pointed out in 1985, "The early identification of AIDS with the at-risk gay population set the tone for media coverage, delivery of medical care, and even for research. The media continued to link the illness with irresponsibility and sex, blaming gays for their illness. Hemophiliacs, transfusion cases, children, and wives of men with AIDS who came down with the syndrome were consistently called "innocent victims," who through no fault of their own were standing in the path of a dread disease.

28. Cindy Patton, *Sex and Germs: The Politics of AIDS* (Boston: South End Press, 1985), 23.

29. Crimp and Rolston, *AIDS Demo Graphics*, 53.

30. ACT-UP fact sheet on the New York "kiss-in," April 29, 1988, cited in ibid., 55.

31. I have argued elsewhere that *Sexism Rears Its Unprotected Head* sent a series of mixed messages to its viewing audience. Why, for example, should the image of an unsheathed penis necessarily signify unsafe sex and the murder of women: isn't that "unprotected" organ as much a threat to gay men as to (straight) women? And what

of the several sexual practices that the possessor of this penis might enjoy with either a male or female partner, practices such as (modified) oral sex, hand-jobs, frottage, or just plain visual pleasure and exhibitionism? The graphic also ignores women's choices in negotiating safer sex, choices that go beyond a man's agency to either "use condoms or beat it." The poster's ostensible mission of "protecting women" thus seems unconvincing (even ventriloquized). Quite problematically for AIDS activism, *Sexism Rears Its Unprotected Head* equates the erect cock with (dangerous) heterosexual intercourse while eliding gay male sex and ignoring the lesbian body—and its sexual practices and relation to AIDS—altogether. While Gran Fury selected the image of the monumental penis, at least in some measure, for its sexual appeal, that appeal is disavowed by the surrounding text. But the erotic power of the phallic image cannot be dismissed simply by labeling it "the ugly head of sexism." See Richard Meyer, "Representing Ourselves," *Outweek,* August 15, 1990, 59.

32. Steven Heller, "Hit and Run: A Legacy of Unofficial Graphic Protest," in Jacobs and Heller, eds., *Angry Graphics: Protest Posters of the Reagan/Bush Era* (Salt Lake City: Peregrine Smith Books, 1992), 4.

33. This quote, as Gran Fury's billboard makes clear, is taken not from the Pope himself but from remarks made by John Cardinal O'Connor, the Archbishop of New York, on the occasion of the First Vatican Conference on AIDS in 1989.

34. The final element in the work, a panel of print reminiscent of museum wall text, provided information about grassroots AIDS prevention efforts throughout the world, from street theater in Cameroon to clean-needle distribution in Germany to safe-sex strip shows in Bangkok.

35. McAlpin, interview, April 20, 1994.

36. Donald Moffett, interview with the author, May 19, 1994.

37. Gran Fury created two separate graphics for its Montreal project: one intended for street display, the other for exhibition on public transportation. Both graphics bore the *Je Me Souviens* slogan and the motif of the composite flag. While the street poster offered instruction on safer sex (the text of which is cited on p. 78), the subway poster declared, *"La politique aura toujours le dessus sur la santé des gens. Les personnes atteintes du SIDA qui se tiennent informées et participent activement à leur traitement vivent plus longtemps et en meilleure santé. Le sécurisexe, c'est la responsabilité de chacun. Sois sage au lit."* ("When politics and health come in conflict, politics will always win. People with AIDS who keep themselves informed and actively participate in their treatment live longer and in better health. Safer sex is the responsibility of each person. Be good in bed.") Montreal's mass transit agency refused to display Gran Fury's posters on the metro. The "subway" posters were therefore wheat-pasted on the streets of the city.

38. See, for example, Jocelyn Lepage, "Gran Fury pour l'ouverture du MAC: L'impudence grossière comme force de frappe," *La Presse* (Montreal), May 30, 1992, E3; "Publicité contre le SIDA interdite dans le métro," *Le Soleil* (Montreal), June 2, 1992, C3; Paul Gladu and Jean-Marc Blier, "La dialectique a remplacé la toile et la palette . . ." *La Presse* (Montreal), July 26, 1992, C2.

39. My account of the local response to *Je Me Souviens* is taken from the press coverage the poster received in Montreal (see note 38) as well as from the description of its public reception given by Emeren Garcia, Head of Traveling Exhibitions, Museum of Contemporary Art, Montreal. Emeren Garcia, interview with the author, April 21, 1994.

40. Douglas Buckley, cited in Ann Duncan, "Contemporary Art Museum a Knockout," *The Gazette* (Montreal), May 30, 1992, K3.

41. McAlpin, interview, April 20, 1994.

42. McAlpin, interview, April 20, 1994. Mark Simpson, interview with the author, May 2, 1994.

43. President Clinton's subsequent betrayal of his campaign promises concerning AIDS research and funding are discussed in (among other places) David Friedman, "ACT-UP'S Second Act," *New York Newsday*, August 24, 1993, 42–43, 63.

44. Ibid., 43.

45. Douglas Crimp, "Right on Girlfriend," in Michael Warner, ed., *Fear of a Queer Planet: Queer Politics and Social Theory* (Minneapolis: University of Minnesota Press, 1993), 304.

Bibliography

Crimp, Douglas. "AIDS: Cultural Analysis/Cultural Activism." *October* 43 (Winter 1987): 3–16. Reprinted in *AIDS: Cultural Analysis, Cultural Activism*, ed. Douglas Crimp. Cambridge, Mass.: MIT Press, 1988, 7–12.

———. "Mourning and Militancy." In *Out There: Marginalization and Contemporary Culture*, ed. Russell Ferguson, Martha Gever, Trinh T. Minh-ha, and Cornel West. Cambridge, Mass.: MIT Press, 1990.

———."Right on Girlfriend." In *Fear of a Queer Planet: Queer Politics and Social Theory*, ed. Michael Warner. Minneapolis: University of Minnesota Press, 1993.

———, and Adam Rolston. *AIDS Demo Graphics*. Seattle: Bay Press, 1990.

Deitcher, David. "Gran Fury." In *Discourses: Conversations in Postmodern Art and Culture*, ed. Russell Ferguson, William Olander, Marcia Tucker, and Karen Fiss. New York: New Museum of Contemporary Art, 1989.

Engberg, Kristin. "Marketing the (Ad)just(ed) Cause." *New Art Examiner* 18 (May 1991): 22–28.

XLIV Biennale di Venezia: Aperto '90. Venice, 1990.

Friedman, David. "ACT-UP'S Second Act." *New York Newsday*, August 24, 1993: 42–43, 63.

Garcia, Emeren, Head of Traveling Exhibitions, Museum of Contemporary Art, Montreal. Telephone interview with the author, April 21, 1994.

Gober, Robert. "Gran Fury" (interview). *Bomb* (Winter 1991): 8–13.

Godmer, Gilles, and Réal Lussier. *Pour la suite du monde*. Montreal: Museum of Contemporary Art, Montreal, 1992.

Gran Fury. "Control." *Artforum* 28, no. 2 (October 1989): 129–30, 167–68.

Grover, Jan Zita. "AIDS: Public Issues, Public Art." *Public Art Issues* (1992): 4–7.

Jacobs, Karrie, and Stephen Heller, eds. *Angry Graphics: Protest Posters of the Reagan/Bush Era.* Salt Lake City: Peregrine Smith Books, 1992.

Knafo, Robert. "Taking It to the Street: Public Art and AIDS." *Public Art Issues* (1992): 2–3.

Lindell, John, member, Gran Fury, interview with the author, May 4, 1994.

McAlpin, Loring, member, Gran Fury, interview with the author, New York City, April 20, 1994.

McCarty, Marlene, and Donald Moffett, members, Gran Fury, interview with the author, New York City, May 19, 1994.

McQuinston, Liz. *Graphic Agitation: Social and Political Graphics Since the Sixties.* London: Phaidon, 1993.

Meyer, James. "AIDS and Postmodernism." *Arts Magazine* 66, no. 8 (April 1992): 62–68.

Meyer, Richard. "Representing Ourselves." Review of *AIDS Demo Graphics* by Douglas Crimp and Adam Rolston. *Outweek,* August 15, 1990, 58–59, 64.

Olson, David. "State Senate Denounces 'Art Against AIDS.'" *Windy City Times,* June 28, 1990, 1, 8–9.

Simpson, Mark, member, Gran Fury, interview with the author, New York City, May 2, 1994.

3 Group Material Timeline: Activism as a Work of Art

Notes

The following is a list of Group Material exhibitions, installations, and public projects.

Public Interventions, installation design, Institute of Contemporary Art, Boston, April 1994.

Campaign, for *Public Domain,* Centre d'Art SantaMoniCA, Barcelona, Catalunya, March 1994.

Democracy Wall, for *In and Out of Place,* Museum of Fine Arts, Boston, October 1993.

Tomorrow, San Diego Museum of Contemporary Art, San Diego, October 1993.

Cash Prize, for *In Public Seattle,* advertisements in the *Seattle Post-Intelligencer,* November 1991.

AIDS Timeline, for the Biennial Exhibition, Whitney Museum of American Art, New York City, April 1991.

Collaboration, for *Social Studies: 4 + 4 Young Americans,* Allen Memorial Art Museum, Oberlin, Ohio, October 1990.

AIDS and Insurance, bus advertisements, sponsored by Real Art Ways, Hartford, Connecticut, September 1990.

AIDS Timeline, Wadsworth Atheneum, Hartford, Connecticut, September 1990.

Democracy Poll, newspaper insert, subway station billboards, and electronic billboard, sponsored by Neue Gesellschaft fur Bildende Kunst, Berlin, Germany, June 1990.

Your Message Here, billboard project, in collaboration with Randolph Street Gallery, Chicago, Illinois, March 1990.

AIDS Timeline, Matrix Gallery, University Art Museum, University of California, Berkeley, November 1989.

Shopping Bag, distributed in local shops and department stores for *D & S Austelling,* Kunstverein, Hamburg, Germany, October 1989.

Unisex, for *The Center Show,* Lesbian and Gay Community Center, New York City, June 1989.

AIDS and Democracy, for *Vollbild, AIDS,* Neue Gesellscaft fur Bildende Kunst, Berlin, Germany, January 1989.

Democracy, four installations and town meetings, Dia Art Foundation, New York City, September 1988 through January 1989.

Inserts, advertising supplement to the Sunday *New York Times,* May 1988.

Constitution, Temple University Gallery, Philadelphia, Pennsylvania, October 1987.

The Castle, for *Documenta 8,* Museum Fridericianum, Kassel, Germany, June 1987.

Resistance (Anti-Baudrillard), White Columns, New York City, February 1987.

Arts and Leisure, The Kitchen, New York City, May 1986.

Liberty and Justice, Alternative Museum, New York City, February 1986.

MASS, traveling exhibition: Hallwalls, Buffalo, New York; Spaces, Cleveland, Ohio; New Museum, New York City; Studio Museum of Harlem, New York City, 1985–86.

Alarm Clock, for *The Other America,* Festival Hall, London, England, November 1985.

Messages to Washington, Washington Project for the Arts, Washington, D.C., September 1985.

Democracy Wall, Chapter Arts Centre, Cardiff, Wales, May 1985.

Americana, for the 1985 Biennial Exhibition, Whitney Museum of American Art, New York City, March 1985.

A.D., Christian Influence in Contemporary Culture, Work Gallery, New York City, January 1985.

Timeline: A Chronicle of U.S. Intervention in Central and Latin America, for *Artists' Call,* P.S.1, New York City, January 1984.

Subculture, IRT subway trains, New York City, September 1983.

Revolutionary Fine Arts, Taller Latino Americano, New York City, April 1983.

Luchar, An Exhibition for the People of Central America, Taller Latino Americano, New York City, June 1982.

Primer (for Raymond Williams), Artists Space, New York City, May 1982.

DaZiBaos, democracy wall in Union Square, New York City, March 1982.

Works on Newspaper, Group Material headquarters, New York City, March 1982.

M-5, Fifth Avenue buses, New York City, December 1981.

Enthusiasm!, Group Material headquarters, New York City, October 1981.

Food and Culture (Eat This Show), Group Material Headquarters, New York City, June 1981.

Atlanta, An Emergency Exhibition, Group Material, East 13th Street, New York City, June 1981.

Facere/Fascis, Group Material, East 13th Street, New York City, April 1981.

Consumption: Metaphor, Pastime, Necessity, Group Material, East 13th Street, New York City, March 1981.

It's a Gender Show, Group Material, East 13th Street, New York City, February 1981.

The People's Choice (Arroz con Mango), Group Material, East 13th Street, New York City, January 1981.

Alienation, Group Material, East 13th Street, New York City, December 1980.

The Salon of Election '80, Group Material, East 13th Street, New York City, November 1980.

The Inaugural Exhibition, Group Material, East 13th Street, New York City, September 1980.

Bibliography

Alaton, Salem. "N.Y. Artists Get Vocal About Politics." *Toronto Globe,* October 20, 1988.

"Anti-Baudrillard," *File,* no. 28, part 1 (1987): 109–19.

Appley, John. "Collective Artwork Is Focus of '4 + 4' Exhibit." *(Cleveland) Plain Dealer,* October 26, 1990, 41n.

Arts and Leisure. New York: The Alternative Museum, February 1986.

Berkson, Bill. "Group Material, AIDS Timeline." *Artforum* (March 1990).

"Best Bet," *The Daily Californian,* November 10, 1989, 18.

Bonetti, David. "'AIDS Timeline' Gives Hard Facts with Visual Flair." *San Francisco Examiner,* November 24, 1989, C11.

Brenson, Michael. "Art People." *New York Times,* August 26, 1983.

Bulka, Michael F. "Your Message Here." *New Art Examiner* (Summer 1990): 39.

Cameron, Dan. "Whitney Wonderland." *Arts Magazine* (Summer 1985).

Cullinan, Helen. "Spaces Imports New York Works: A Foot Per Artist." *(Cleveland) Plain Dealer,* July 15, 1985.

———. "Oberlin Art Project Rally Passes 1st Round." *(Cleveland) Plain Dealer,* September 8, 1990, 5f.

D & S Ausstellung. Hamburg: Kunstverein/Kunstlerhaus Bethanien, 1989, 54–55.

Decter, Joshua. "Group Material." *Flash Art* (March/April 1989): 111.

Denson, G. Rodger. "Group Material, 'Education and Democracy.'" *Artscribe* (May 1989): 84–85.

Des emblèmes commes attitudes. Tourcoing: Ecole Regionale Supérieure D'Expressions Plastiques, 1988.

Documenta 8. June 1987.

Drobnick, Jim. "Dialectical Group Materialism," *Parachute* (October/November/December 1989): 29–31.

"Exposition conjunta." *El Diario.* August 1982, magazine section.

Fairbrother, Trevor, and Kathryn Potts, eds. *In and Out of Place: Contemporary Art and the American Social Landscape.* Boston: Museum of Fine Arts, 1993.

Fisher, Jean. "Group Material." *Artforum* (October 1986).

Glueck, Grace. "Art: Interventions on U.S. Latin Role." *New York Times,* February 3, 1984.

Goldstein, Richard. "Enter the Anti-Space." *Village Voice,* November 11, 1980.

"Group Material." *Artpapers* (January/February 1990): 38–39.

"Group Material." *Wolkenkratzer Art Journal* 6 (November/December 1989): 25.

Grove, Lloyd. "People's Voice." *Washington Post,* August 31, 1985.

Hall, Peter. "Group Material: An Interview." *RealLife* no. 11/12 (Winter 1983/84).

Hegewiisch, Katerina. "Mut zer kleinen Geste." *Frankfurter Allegemeine,* December 12, 1989.

Helfand, Glen. "Brave New Material." *San Francisco Weekly,* November 22, 1989, 1, 13.

———. "AIDS Reality Enters Art." *Artweek,* November 30, 1989, 1.

Hess, Elizabeth. "Safe Combat in the Erogenous Zone." *Village Voice,* January 10, 1989, 79.

"Interview, Group Material." *Artpapers* (September/October 1988): 23–29.

Isaak, Jo-Anna. "Documenta 8." *Parachute* (December/January/February 1987–88): 30.

Jones, Bill. "Graven Images." *Arts Magazine* (May 1989): 73–77.

Jones, Ronald. "Group Material." *Flash Art* (May 1987).

La Rosa, Paul. "Subway Art on the Way." *(New York) Daily News,* August 9, 1983.

Lawson, Thomas. "The People's Choice." *Artforum* (April 1981).

———. "Timeline." *Artforum* (May 1984).

———, and Susan Morgan. *Contemporary Perspectives.* Lewisburg, Pa.: Bucknell University Press, October 1984.

Levin, Kim. "The Whitney Laundry." *Village Voice,* April 9, 1985.

———. "It's Called Denial." *Village Voice,* January 17, 1989, 87.

Liberty and Justice. New York: The Alternative Museum, February 1986.

Liebmann, Lisa. "Almost Home." *Artforum* (Summer 1985).

Lippard, Lucy R. "A Child's Garden of Horrors." *Village Voice,* June 24, 1981.

———. "Revolting Issues." *Village Voice,* July 27, 1982.

———. *Get the Message? A Decade of Art for Social Change.* New York: E.P. Dutton, 1984, 206, 251–52, 254, 267, 330.

———. "One Foot Out the Door." *In These Times,* July 9–22, 1985.

———. "Apple Panache and Downtown Dowdy." *Z Magazine* (February 1989): 82–84.

Lonegan, Brian. "New Artists Settled." *The Other Paper* (September 1980).

Marmer, Nancy. "Documenta 8: The Social Dimension?" *Art in America* (September 1987).

Marzorati, Gerald. "Artful Dodger." *Soho Weekly News,* October 15, 1980.

MASS by Group Material. New York: The New Museum, April 1986.

Miller, John. "Baudrillard and His Discontents." *Artscribe* (May 1987).

Moore, Alan, and Marc Miller, eds. *ABC No Rio Dinero.* New York: ABC No Rio Collaborative Projects, 1984, 22–27.

Newton, Deborah. "Vox Pop Becomes Wall to Wall Art." *South Wales Echo,* April 19, 1985.

1985 Biennial Exhibition. New York: Whitney Museum of American Art, 1985: 46–47, 127.

O'Brien, Glen. "Subculture." *Artforum* (December 1983).

Olander, William. "Material World." *Art in America* (January 1989): 123–28, 167.

Osman, Sally. "Turning Over a New Leaf in the Exciting History of Chapter," *Western Mail* (Cardiff, Wales), April 30, 1985.

Plagens, Peter. "Nine Biennial Notes." *Art in America* (July 1985).

"Resistance—Anti-Baudrillard." Transcript of panel accompanying the exhibition. White Columns, New York City, February 1987.

Ribalta, Jorge, ed. *Domini Public.* Barcelona, Spain: Centre d'Art Santa MoniCA, Generalitat de Catalunya, 1994.

Rizzo, Frank. "An Education About AIDS." *Hartford Courant,* September 7, 1990, c1, 3.

Schmid, Karlheinz. "Ausflug ins Reich der Als-Ob-Art." *Hamburger Rundschau,* October 12, 1989, 15.

Schwendenwein, Jude. "AIDS Timeline Mixes, Matches Ideas." *Hartford Courant,* November 4, 1990, g6.

Sherlock, Maureen. "Documenta 8: Profits, Populism and Politics." *New Art Examiner* (October 1987): 22–25.

Siegfried, Sabine. "Gegen das Monumental." *Kunstforum* (November/December 1989): 419–20.

Silverthorne, Jeanna. "Primer (for Raymond Williams)." *Artforum,* November 1982.

Smith, Roberta. "Working the Gap Between Art and Politics." *New York Times,* September 25, 1988, 33.

Smith, Valerie. "Group Material, Consumption: Metaphor, Pastime, Necessity." *Flash Art* (Summer 1981).

"Social Studies 4 + 4 Young Americans." *Allen Memorial Art Museum Bulletin,* Oberlin College, 1990.

Spector, Nancy. "Democratic Vistas." *Artscribe* (November/December 1988): 10.

Staniszewski, Mary Anne. "Arte, SIDA y Activism." *Lapiz* (February 1989): 18, 19.

Talmer, Jerry. "Art Rides a Hole in the Ground." *New York Post,* September 17, 1983.

Tillman, Lynn. "Group Material." *Village Voice,* October 15, 1985.

Trend, David. "Back to School." *Afterimage* (December 1988), 18–19.

———. "Beyond Resistance." *Afterimage* (April 1989).

"Vollbild, AIDS." Berlin: NGBK. January 1989.

Wallis, Brian, ed. *Art After Modernism.* Boston: Godine, 1984: 352–54.

———. *Democracy: A Project by Group Material.* Seattle: Bay Press; New York: Dia Art Foundation, 1990.

Wilson, Beth. "Political (Mono)culture." *Fad* 12 (February 1989): 52.

Winter. New York: Institute for Art and Urban Resources, January 1984.

Wood, William. "A Circular Insanity." *Vanguard* (September/October 1987): 21–28.

Wye, Deborah. *Committed to Print.* New York: Museum of Modern Art, 1988: 8, 18, 26, 97–115.

4 The American Festival Project: Performing Difference, Discovering Common Ground

Notes

1. John O'Neal in Anne Johnson, *Open Windows,* videotape of the American Festival Project (Whitesburg, Ky.: Appalshop, 1991).

2. Caron Atlas, telephone conversation with the author, May 9, 1994.

3. ———, interview with the author, New York City, January 12, 1991.

4. Thomas C. Dent, Richard Schechner, Gilbert Moses, and John O'Neal, *The Free Southern Theater by the Free Southern Theater* (New York: Bobbs-Merrill, 1969), 3.

5. Ibid., 4–6.

6. Ibid., 7.

7. Ibid., 11–12.

8. There is an extensive literature on issues of universality, power, and race. See, for example, Wole Soyinka, *Art, Dialogue, and Outrage* (Ibadan, Nigeria: New Horn Press, 1987), Chinua Achebe, *Hopes and Impediments* (New York: Doubleday,

1989), and N'gugi wa' Thiong'o, *Decolonizing the Mind* (Portsmouth, N.H.: Heineman, 1986).

9. Thomas C. Dent and Jerry W. Ward, Jr., "After the Free Southern Theater: A Dialog," *The Drama Review* 31, no. 3 (Fall 1987): 120.

10. John O'Neal, telephone conversation with the author, April 30, 1993.

11. Junebug Productions, unattributed publicity materials, New Orleans, La., 1993.

12. Amil Cabral, cited in Lucy R. Lippard, "Trojan Horses," in *Art After Modernism*, ed. Brian Wallis (Boston: Godine, 1984), 342.

13. Atlas, interview, 1991.

14. Lippard, "Trojan Horses," in *Art After Modernism,* 355.

15. This thesis is more fully developed in my as yet unpublished dissertation, "Motion of the Ocean: U.S. Activist Performance in Transition, 1960s–1990s."

16. Saul Alinsky, cited in Harry Boyte, "Community Organizing in the 1970s: Seeds of Democratic Revolt," *Community Organization for Urban Social Change*, ed. Robert Fisher and Peter Romanofsky (Westport, Conn.: Greenwood Press, 1981), 224. For more information on Alinsky's theories on community organizing, see his classic works *Reveille for Radicals* (Chicago: University of Chicago Press, 1946) and *Rules for Radicals* (New York: Random House, 1971).

17. Steve Burghardt, *Organizing for Community Action* (Beverly Hills, Cal.: Sage Publications, 1982), 74.

18. Liz Lerman, telephone interview with the author, February 20, 1994.

19. Paulo Freire, *Pedagogy of the Oppressed*, trans. Myra Bergman Ramos (New York: Continuum, 1986), 58.

20. Urban Bush Women, unattributed publicity materials, New York City, 1993.

21. Paulo Freire, cited in Arlene Goldbard, "Postscript to the Past," *High Performance* 64 (Winter 1993): 23–27.

22. Two of Boal's books have been translated into English: *Theatre of the Oppressed* (New York: Theatre Communications Group, 1985) and *Games for Actors and Non-Actors* (London: Routledge, 1993). For a critical account of Boal's work and essays on how Theatre of the Oppressed has been translated to North American and European contexts, see *Playing Boal: Theatre, Therapy, Activism*, ed. Mady Schutzman and Jan Cohen-Cruz (London and New York: Routledge, 1994).

23. I am grateful to Linda Wilson of the Multicultural Center and Pam McMichaels from the Women's Center for conversations that provided me with background information on the Louisville project.

24. All direct quotes by Robbie McCauley are from a telephone interview with the author, February 4, 1994.

25. Linda Wilson, telephone conversation with the author, February 23, 1994.

26. Cecilia Ruppert, conversation with the author, Philadelphia, May 1991.

27. FrankfordStyle Community Arts, unattributed publicity materials, Philadelphia, 1991.

28. Martha Kearns, interview with the author, New York City, January 7, 1994.

29. John O'Neal, "The Thing About Criticism," in Mark O'Brien and Craig Little, *Reimaging America: The Arts of Social Change* (Philadelphia: New Society Publishers, 1990), 200.

30. This and other issues of Latinas in Latino liberation are addressed by Angie Chabram-Dernersesian in "I Throw Punches for My Race But I Don't Wanna Be a Man: Writing Us—Chica-nos (Girl, Us)/Chicanas—into the Movement Script," in *Cultural Studies*, ed. Lawrence Grossberg, Cary Nelson, and Paula Treichler (New York: Routledge, Chapman & Hall, 1992).

31. Gil Ott, interview with the author, Philadelphia, Pa., at the Painted Bride, July 30, 1991.

32. AFP choreographer Liz Lerman had worked at the Meredith School. Since the public showings were on a Saturday, the school was not part of that event.

33. Urban Cultures Festival, unattributed minutes from assessment meeting, Philadelphia, Pa., May 1991.

34. John O'Neal, telephone conversation with the author, May 15, 1994.

35. John Malpede, cited in William Alexander, "Lost and Presumed Dead, So What and Who Cares?" unpublished manuscript, 1993, 78.

36. Ibid., 86.

37. Urban Cultures Festival, unattributed minutes from assessment meeting.

38. Malpede, in Alexander, "Lost and Presumed Dead," 28.

39. Douglas Crimp, "Pictures," in Lucy Lippard, *Art After Modernism*, ed. Brian Wallis (Boston: Godine, 1984), 176.

40. Gil Ott, telephone conversation with the author, February 23, 1994.

41. O'Neal, "The Thing About Criticism," in *Reimaging America,* 199.

42. John O'Neal, cited in Kate Hammer, "John O'Neal, Actor and Activist: The Praxis of Storytelling," *The Drama Review* 36, no. 4 (Winter 1992): 20–21.

43. Ron Short, cited by Deborah Clover, student journal for the course Issues in Community-Based Arts, Ithaca, N.Y., Cornell University, 1993.

44. LAPD, unattributed course description brochure, 1994.

Bibliography

Boyte, Harry. "Community Organizing in the 1970s: Seeds of Democratic Revolt." In *Community Organization for Urban Social Change,* ed. Robert Fisher and Peter Romanofsky. Westport, Conn.: Greenwood Press, 1981.

Burghardt, Steve. *Organizing for Community Action.* Beverly Hills, Cal.: Sage Publications, 1982.

Crimp, Douglas. "Pictures." In *Art After Modernism,* ed. Brian Wallis. Boston: Godine, 1984.

Dent, Thomas C., Richard Schechner, Gilbert Moses, and John O'Neal. *The Free Southern Theater by the Free Southern Theater.* New York: Bobbs-Merrill, 1969.

———, and Jerry W. Ward, Jr. "After the Free Southern Theater: A Dialog." *The Drama Review* 31, no. 3 (Fall 1987): 120–25.

Freire, Paulo. *Pedagogy of the Oppressed.* Trans. Myra Bergman Ramos. New York: Continuum, 1986.

Goldbard, Arlene. "Postscript to the Past." *High Performance* 64 (Winter 1993): 23–27.

Hammer, Kate. "John O'Neal, Actor and Activist: The Praxis of Storytelling." *The Drama Review* 36, no. 4 (Winter 1992): 12–27.

Hardiman, Rita, and Bailey W. Jackson III. "Racial Identity Development: Understanding Racial Dynamics in College Classrooms and on Campus." In *Promoting Diversity in College Classrooms,* ed. Maurianne Adam. San Francisco: Jossey-Bass, 1992.

Johnson, Anne. *Open Windows.* Videotape of American Festival Project. Whitesburg, Ky.: Appalshop, 1991.

Lippard, Lucy R.. "Trojan Horses." In *Art After Modernism,* ed. Brian Wallis. Boston: Godine, 1984.

O'Neal, John. "The Thing About Criticism." In *Reimaging America: The Arts of Social Change,* ed. Mark O'Brien and Craig Little. Philadelphia: New Society Publishers, 1990.

5 Ecopolitics/Ecopoetry: Helen and Newton Harrison's Environmental Talking Cure

Notes

1. Jeffrey Deitch, "Artificial Nature," in *Artificial Nature* (Athens, Greece: Deste Foundation for Contemporary Art, 1991).

2. Craig Adcock, "Conversational Drift," *Art Journal* (Summer 1992): 41.

Bibliography

Adcock, Craig. "Conversational Drift." *Art Journal* (Summer 1992): 41.

Harrison, Helen Mayer, and Newton Harrison. *The Lagoon Cycle.* Ithaca, N.Y.: Herbert F. Johnson Museum of Art, Cornell University, 1981.

———. *Arroyo Seco Release/A Serpentine for Pasadena.* Pasadena, Cal.: Baxter Art Gallery,

California Institute of Technology, 1985.

———. *Devil's Gate Transformation/A Refuge for Pasadena.* Pasadena, Cal.: Pasadena Gallery of Contemporary Art; Community Action for the Parks; Art Center College of Design, 1987.

———. *Atempause für den Save Fluss* (Breathing Space for the Sava River). Berlin: Neuer Berliner Kunstverein, 1989.

———. *The Serpentine Lattice.* Portland, Ore.: Douglas F. Cooley Memorial Art Gallery, Reed College, 1993.

———. "Shifting Positions Toward the Earth." *Leonardo* 26, no. 5 (1993): 371–78.

Holt, Nancy, ed. *The Writings of Robert Smithson: Essays with Illustrations.* New York: New York University Press, 1979.

Matilsky, Barbara. *Fragile Ecologies.* Queens, N.Y.: Queens Museum of Art, 1992.

Raven, Arlene. *Crossing Over: Feminism and Art of Social Concern.* Ann Arbor, Mich.: UMI Research Press, 1988.

Sonfist, Alan, ed. *Art in the Land: A Critical Anthology of Environmental Art.* New York: E.P. Dutton, 1983.

6 Maintenance Activity: Creating a Climate for Change

Notes

1. Christopher D. Stone, *The Gnat Is Older Than Man: Global Environment and Human Agenda* (Princeton: Princeton University Press, 1993), 153.

2. Elizabeth Wilson, *The Sphinx in the City: Urban Life, the Control of Disorder, and Women* (Berkeley: University of California Press, 1991). General examination of women and cities.

3. Henri Lefebvre, *The Production of Space,* trans. Donald Nicholson-Smith (Oxford: Blackwell Publishers, 1991), 412.

4. Mierle Laderman Ukeles, interview with the author, March 14, 1994.

5. Mierle Laderman Ukeles, "Manifesto for Maintenance Art," 1969. Unpublished document provided by the artist.

6. Rosalind E. Krauss, *The Originality of the Avant-Garde and Other Modernist Myths* (Cambridge: MIT Press, 1986), 157–58.

7. David Harvey, "Afterword," in Henri Lefebvre, *The Production of Space,* trans. Donald Nicholson-Smith (Oxford: Blackwell Publishers, 1991), 429.

8. Mierle Laderman Ukeles, unpublished letter to 300 workers at 55 Mercer Street inviting their participation in *I Make Maintenance Art One Hour Every Day,* 1976.

9. Mierle Laderman Ukeles, unpublished letter to Department of Sanitation employees concerning the *Handshake Ritual,* 1979.

10. Ukeles, interview, March 14, 1994.

11. Ukeles, unpublished letter concerning the *Handshake Ritual,* 1979.

12. Wilson, *The Sphinx in the City,* 11.

Bibliography

Harvey, David. *The Condition of Postmodernity: An Enquiry into the Origins of Cultural Change.* Cambridge: Blackwell Publishers, 1989.

Lefebvre, Henri. *The Production of Space.* Trans. Donald Nicholson-Smith. Oxford: Blackwell Publishers, 1991.

Stone, Christopher D. *The Gnat Is Older Than Man: Global Environment and Human Agenda.* Princeton: Princeton University Press, 1993.

Wilson, Elizabeth. *The Livable City.* New York: Municipal Art Society, vol. 14, no. 2 (November 1990).

———. *The Sphinx in the City: Urban Life, the Control of Disorder, and Women.* Berkeley: University of California Press, 1991.

7 Is It Still Privileged Art?

Notes

1. Carole Condé and Karl Beveridge, *It's Still Privileged Art* (Toronto: Art Gallery of Ontario, 1976), unpaginated.

2. Walter Klepac, "Carole Condé and Karl Beveridge," *Artscanada* (April/May 1976).

3. Peter Benchley, "The Lumpen-Headache," *The Fox* 3 (1976): 1–39.

4. Carole Condé, conversation and informal interview with the author, May 1994.

5. Condé and Beveridge, *It's Still Privileged Art.*

6. Paul Litt, "The Care and Feeding of Canadian Culture," *The (Toronto) Globe and Mail,* May 31, 1991, A15.

7. For further analysis see Dot Tuer, "The Art of Nation Building: Constructing a Cultural Identity for Post-War Canada," *Parallélogramme* 17, no. 4 (Spring 1992): 24–36.

8. Bryan D. Palmer, *Working Class Experience: Rethinking the History of Canadian Labour, 1800–1991* (Toronto: McClelland & Stewart, 1992), 405.

9. Carole Condé and Karl Beveridge, *First Contract: Women and the Fight to Unionize* (Toronto: Between the Lines Press, 1986), 13.

10. This leeway extends to the dimensions of the images themselves. Although the size of an individual photo-narrative work is typically sixteen by twenty inches, the scale of the work may be larger or smaller according to the project for which it is produced.

11. Condé and Beveridge, *First Contract,* 15.

12. LAMWG's membership was constituted with equal representation from labor organizations (the Canadian Union of Public Employees, Canadian Labour Congress, ACTRA, CAMERA, the Labour Council of Metropolitan Toronto, Ontario Federation of Labour, and the United Steelworkers of America) and the artistic community (Karl Beveridge, Steven Bush, Tish Carnat, Carole Condé,

Rosemary Donegan, Catherine Macleod, Richard McKenna, Simon Malbogat, and Kim Tomczak). For more information see Susan Crean, "Labour Working with Art," *Fuse* 44 (April 1987): 24–35.

13. Condé and Beveridge, *First Contract*, 15.

14. Condé and Beveridge, *It's Still Privileged Art*.

15. Scott Lash and John Urry, *The End of Organized Capitalism* (Madison, Wisc.: University of Wisconsin Press, 1987), 2–7.

16. Carole Condé and Karl Beveridge, "In the Corporate Shadows: Community Arts Practice and Technology," *Leonardo* 26, no. 5 (1993): 451.

17. For an analysis of corporate/labor relations in the forest industry, see Oliver Kellhammer, "The State of the Forest: The Canadian Landscape as Propaganda," *Fuse* (Spring 1992): 22–30.

Bibliography

Bennekom, Josephine van. "Carole Condé and Karl Beveridge." *Perspektief* 35 (April 1989): 20–27.

Beveridge, Karl, and Ian Burn. "Don Judd." *The Fox* 2 (1975): 129–42.

Condé, Carole, and Karl Beveridge. *It's Still Privileged Art*. Toronto: Art Gallery of Ontario, 1976.

———. *First Contract: Women and the Fight to Unionize*. Toronto: Between the Lines Press, 1986.

———. *Class Work*. Toronto: Communications and Electrical Workers Union of Canada, 1990.

———. "In the Corporate Shadows: Community Arts Practice and Technology." *Leonardo* 26, no. 5 (1993): 451–57.

Crean, Susan. "Labour Working with Art," *Fuse* 44 (April 1987): 24–35.

Evans, David, and Sylvia Gohl. *Photomontage: A Political Weapon*. London: Gordon Frazer, 1986.

Fleming, Martha. "The Production of Meaning: An Interview with Carole Condé and Karl Beveridge." *Afterimage* 10, no. 4 (November 1982): 10–15.

Fleury, Jean Christian. "De la photographie engagée à l'image." *Photographies Magazine* (June 1993): 37–43.

Glass, Fred. "Class Pictures: Teaching About Photography to Labour Studies Students." *Exposure* 28 no. 1/2 (1991): 35–42.

Gupta, Sunil. *Disrupted Borders*. London: Rivers Oram Press, 1993.

Hansen, Henning. "Carole Condé og Karl Beveridge." *Katalog* 4 (June 1989): 36–49.

Hutcheon, Linda. *Splitting Images*. Toronto: Oxford University Press, 1989.

Kellhammer, Oliver. "The State of the Forest: The Canadian Landscape as Propaganda." *Fuse* (Spring 1992): 22–30.

Lash, Scott, and John Urry. *The End of Organized Capitalism.* Madison, Wisc.: University of Wisconsin Press, 1987.

Mitchell, Michael. "Things as They Are." *Photo Communique* 6, no. 4 (Winter 1984/85): 35–38.

Muir, Kathie. "Australian Labour-Based Art in an International Context." *Artlink* 10, no. 3 (Spring 1990): 23–26.

Palmer, Bryan D. *Working Class Experience: Rethinking the History of Canadian Labour, 1800–1991.* Toronto: McClelland & Stewart, 1992.

Trend, David. "Talking Union." *Afterimage* 14, no. 8 (March 1987): 19.

Tuer, Dot. "The Art of Nation Building: Constructing a Cultural Identity for Post-War Canada," *Parallélogramme* 17, no. 4 (Spring 1992): 24–36.

West, Cornel. "The New Cultural Politics of Difference." In *Out There: Marginalization and Contemporary Cultures,* ed. Russell Ferguson, Martha Gever, Trinh T. Minh-ha, and Cornel West. New York: The New Museum of Contemporary Art, 1991.

Withers, Josephine. "On the Inside Not Looking Out." *Feminist Studies* 11, no. 3 (Fall 1985): 558–64.

8 **The Body Politics of Suzanne Lacy**

Bibliography

Writings on Suzanne Lacy

Burnham, Linda. "Performance Art in the San Francisco International Theatre Festival." *High Performance* 5, no. 3 (1982).

Chadwick, Whitney. *Women, Art and Society.* London: Thames & Hudson, 1990.

Chicago, Judy. *Through the Flower: My Struggle as a Woman Artist.* Garden City, N.J.: Doubleday & Company, 1977.

Deak, Frantosek. "Inevitable Associations." *Openbaarkustbezit Kunstschrift* (January 1978).

———. "The Use of Character in Artistic Performance." *The Dumb Ox,* nos. 10–11 (Spring 1980).

Freuh, Joanna. "The Women's Room." *The Reader* (April 1980).

Gablik, Suzi. "Making Art as if the World Mattered: Some Methods of Creative Partnership." *Utne Reader* 34 (July/August 1989).

———. "Connective Aesthetics." *American Art* (Smithsonian Institution) 6, no. 2 (Spring 1992): 2–7.

Gaulke, Cheri. "Redefining the Whole Relationship Between Art and Society." *Art News* 79, no. 8 (October 1980): 58–63.

Iskin, Ruth E. "Female Experience in Art: The Impact of Women's Art in a Work Environ-ment." *Heresies* (January 1977): 71–77.

———. "The Contribution of the Women's Art Movement to the Development of Alterna-tive Art Spaces." *LAICA Journal* (April 1978).

———. "Point of View: Politics and Performance in New Orleans." *Artweek,* March 22, 1980, 2–3.

Kelley, Jeff. "Rape and Respect in Las Vegas." *Artweek,* May 20, 1978, 4.

———. "Performance at La Jolla's Cove." *Los Angeles Times,* May 22, 1984.

Kelly, Mary. "She Who Would Fly." *Repertoire* (Winter 1983).

Larson, Kay. "For the First Time Women Are Leading, Not Following." *Art News* 79, no. 8 (October 1980): 64–72.

Lippard, Lucy R. "Surprises: An Anthropological Introduction to Some Women Artists' Books." *Chrysalis* 5 (1978): 71–84.

———. "Dinner Party, A Four-Star Treat." *Seven Days,* April 27, 1979, 27–29.

———. "The Angry Month of March." *Village Voice,* March 18, 1981, 25–31, 91.

———. "Cross Country Music." *Village Voice,* March 8, 1983, 72.

———. *Get The Message? A Decade of Art for Social Change.* New York: E.P. Dutton, 1984.

———. "Give and Take Ideology in the Art of Suzanne Lacy and Jerry Kearns." In *Art and Ideology,* ed. Fred Lonider and Allan Sekula. New York: The New Museum of Contempo-rary Art, 1984, 29–38, 57.

———. "Time Will Tell." *Village Voice,* June 19, 1984, 100–01.

———. "Feminist Space: Reclaiming Territory." In *The Event Horizon,* ed. Fisher Falk. Toronto: Coach House Press, 1987.

———. "Lacy: Some of Her Own Medicine." *The Drama Review* (Spring 1988).

———. *Issue: Social Strategies by Women Artists.* London: Institute of Contemporary Arts, 1990.

———. *Mixed Blessings: New Art in a Multicultural America.* New York: Pantheon Books, 1990.

Loeffler, Carl E., ed. *Performance Anthology: Source Book for a Decade of Performance Art.* San Francisco: Contemporary Arts Press, 1980.

Muchnic, Suzanne. "The Artist as Activist for Feminist Events." *Los Angeles Times,* September 3, 1979.

———. "LAICA Looks at Social Works." *Los Angeles Times,* October 7, 1979.

Neumaier, Diane. "Recuperative Postmodernism: Some Notes for Practical Application." *San Francisco Camerawork* 16, no. 1 (Spring 1989).

Pollock, Griselda. "Issue: An Exhibition of Social Strategies by Women Artists." *Spare Rib* (Spring 1981).

Raven, Arlene. "Feminist Art." *Sister* (October 1975).

———. "The Circle: Ritual and the Occult in Women's Performance Art." *New Art Examiner* (November 1980): 8–9.

———. "Women Look at Women: Feminist Art for the '80s." In *Women Look at Women: Feminist Art for the '80s*. Allentown, Pa.: Center for the Arts, Muhlenberg College, 1981, 15–41.

———. *At Home*. Long Beach, Cal.: Long Beach Museum of Art, 1983, 35–38.

———. "Commemoration: Public Sculpture and Performance." *High Performance* 8, no. 2 (1985): 3, 36–40.

———. *Crossing Over: Feminism and Art of Social Concern*. Ann Arbor, Mich.: UMI Research Press, 1988.

———, ed. *Art in the Public Interest*. (Ann Arbor: UMI Research Press, 1989).

Rosler, Martha. "The Private and the Public: Feminist Art in California." *Artforum* (September 1977): 66–74.

Roth, Moira. "Toward a History of California Performance Art: Part Two." *Arts Magazine* (June 1978): 114–23.

———. "A Star Is Born: Performance Art in California." *Performing Arts* 4, no. 3 (1980): 86–96.

———. "Suzanne Lacy's Dinner Parties." *Art in America* 60 (April 1980): 126.

———. "Visions and Re-Visions." *Artforum* 19, no. 3 (November 1980): 36–45.

———. "Performance." *Studio International* (June 1982).

———. "A Family of Women?" *Village Voice,* September 28, 1982, 71–74.

———. "Suzanne Lacy: Social Reformer and Witch." *The Drama Review* (Spring 1988).

———, ed. *The Amazing Decade: Women and Performance Art in America, 1970–1980*. Los Angeles: Astro Artz, 1983: 112–15.

Rothenberg, Diane. "Social Art/Social Action." *The Drama Review* (Spring 1988).

Rothenberg, Jerome, ed. *Technicians of the Sacred*. Berkeley: University of California Press, 1985.

Selz, Peter. *Art in Our Times*. New York: Harcourt Brace Jovanovich, 1981.

Writings by Suzanne Lacy

"After Consciousness Raising." *Everywoman Magazine* (1971).

"Women's Design Program." *Networks Magazine* (June 1972).

"Evolution of a Feminist Art: Public Forms and Social Issues." *Heresies* 2, no. 2 (Summer 1978): 76, 78–85 (with Leslie Labowitz).

"*In Mourning and in Rage*." *Frontiers* 3, no. 1 (1978): 52–55 (with Leslie Labowitz-Starus).

"The Life and Times of Donaldina Cameron." *Chrysalis* 7 (1979): 29–35 (with Linda Palumbo).

"Mass Media, Popular Culture, and Fine Art: Images of Violence Against Women." In *Social Works*, ed. Nancy Buchanan. Los Angeles: Los Angeles Museum of Contemporary Art, 1979.

"Take Back the Night." *High Performance* 2, no. 4 (Winter 1979): 32–34 (with Leslie Labowitz).

"Two Approaches to Feminist Media Usage." *Proceedings of the Caucus for Art and Marxism* (January 1979): 2–5 (with Leslie Labowitz).

"Battle of New Orleans." *High Performance* 3, no. 2 (Summer 1980): 2–9.

"Broomsticks and Banners: The Winds of Change." *Artweek* 3 (May 1980): 3–4.

"Falling Apart." *Dreamworks* 1, no. 3 (Fall 1980): 234–41.

"Great Masterpieces Series No. 2: The Last Throes of Artistic Vision." *High Performance* 3, nos. 3–4 (Fall/Winter 1980): 68–69.

"Feminist Artists: Developing a Media Strategy for the Movement." In *Fight Back*, ed. Frederique Delacoste and Felice Newman. Minneapolis: Cleis Press, 1981, 266–72 (with Leslie Labowitz).

"Learning to Look: The Relationship Between Art and Popular Culture Images." *Exposures*, no. 19 (1981): 8–15.

"The Bag Lady." *Block Magazine*, no. 7 (1982): 32–35.

"The Forest and the Trees." *Heresies* 4, no. 3 (1982): 62–63.

"The Greening of California Performance: Art for Social Change—A Case Study." *Images and Issues* (Spring 1982): 64–67.

"*In Mourning and in Rage* (with Analysis Aforethought)." *IKON Magazine* 2, no. 1 (Fall/Winter 1982): 60–67.

"Made for TV: California Performance in Mass Media." *Performing Arts* 6, no. 2 (1982): 52–61.

"Organizing: The Art of Protest." *Ms.* (October 1982): 64–67.

"Speakeasy." *New Art Examiner* (October 1982): 7, 9.

"Political Performance Art: A Discussion by Suzanne Lacy and Lucy R. Lippard." *Heresies* 5, no. 1 (1984): 22–25.

"Feminist Media Strategies for Political Performance." In *Cultures in Contention,* ed. Douglas Kahn and Diane Neumaier. Seattle: Real Comet Press, 1985, 122–33 (with Leslie Labowitz).

"Fragments in a Rose Garden." *WARM* 6, no. 2 (1985): 4, 6.

"Fractured Space." In *Art in the Public Interest,* ed. Arlene Raven. Cambridge, Mass.: MIT Press, 1989.

"Finland: The Road of Poems and Borders." *Journal of Dramatic Theory and Criticism* (University of Kansas) (Fall 1990).

"Footnotes: A Conversation Continued," *Gallerie*, no. 9 (1990).

"In the Shadows: An Analysis of the Dark Madonna." *Whitewalls*, no. 25 (Spring 1990).

"Skeptical of the Spectacle." *The Act* 2, no. 1 (1990).

"Wrestling the Beast." *Public Art Review* (Fall/Winter 1990).

"Name of the Game." *Art Journal* (College Art Association) 50 (Summer 1991): 64–68.

"Practicing Pluralistic Discourse: Blurring the Boundaries." In *Sunbird: The Final Report*. Los Angeles: Getty Center for Education in the Arts, 1991.

"Saving the World: A Dialogue between Suzanne Lacy and Rachel Rosenthal." *Artweek* 22, September 12, 1991, 1.

"Teenagers and Popular Culture: What Is Taught and What Is Learned?" In *Publication for Expanding Sources Series*. San Francisco: San Francisco Art Institute, 1991.

"Debated Territory: Artists' Roles in a Culture of Visibility." *NACA Journal* 1 (1992).

"Mapping the Terrain: The New Public Art." *Public Art Review* 4, no. 2 (Spring/Summer 1993).

9 Making Art, Reclaiming Lives: The Artist and Homeless Collaborative

Notes

Quotes taken from interviews are cited here only when necessary to distinguish them from those drawn from printed material; all other uncited quotes are from in-person or telephone interviews.

1. Nancy Holt, ed. *The Writings of Robert Smithson: Essays with Illustrations* (New York: New York University Press, 1979), 221.

2. Enumerating the homeless has proven difficult at best. For an account of the various—and sometimes controversial—attempts to affix numbers to homelessness, see Christopher Jencks, "The Homeless," *New York Review of Books,* April 21, 1994, 20.

3. For a discussion of art exhibition that "offer[s] not only a diversity of objects but can contextualize a social field in and from which the objects are produced and derive their meaning," see Yvonne Rainer, "The Work of Art in the (Imagined) Age of the Unalienated Exhibition," *If You Lived Here: The City in Art, Theory, and Social Activism*, ed. Brian Wallis (Seattle: Bay Press, 1991), 13.

4. Martha Rosler, "Fragments of a Metropolitan Viewpoint," in *If You Lived Here: The City in Art, Theory, and Social Activism,* ed. Brian Wallis (Seattle: Bay Press, 1991), 17.

5. Allan Schwartzman, telephone interview with the author, April 3, 1994.

6. Allan Schwartzman, "After Four Years, the Message Is Murder," *New York Times,* May 8, 1994, 37.

7. Schwartzman, interview, April 3, 1994.

8. James Gardner, "Is This Art for People Who Are Not in on the Joke?" *New York Times,* January 9, 1994.

9. Mel Rosenthal, "On Photographing the Homeless," *Art and Artists* 17, no. 6 (December 1988/January 1989): 11.

10. Vivien Raynor, *New York Times*, February 7, 1986.

11. François Ganon, *Télerama,* February 2–8, 1985.

12. Pamela Kessler, unattributed review of the Hirshhorn show.

13. P. C. Smith, "Complex Vision," *Art in America* 81 (March 1993): 70.

14. "Hate that word 'homeless,'" says James Lewis, a self-described former street person in Robert Lipsyte, "Black and James and Hard-Sell Social Work," *New York Times*, May 15, 1994, sec. 14, 1. "It's like all my problems are over if you give me a home, forget why I'm out here in the first place, battered woman, alcoholic, drug addict, poor." After creating the A&HC, Sandrow learned that many shelter residents object to the word "homeless," which they may consider an inaccurate description of their situation. (In a video made at the Park Avenue shelter by Sandrow's husband, Ulf Skogsbergh, an off-screen voice can be heard saying, "I'm not homeless. You better watch your mouth.") For that reason, and because she considered the A&HC too limiting, Sandrow changed the organization's official name to Artists Response To, Inc. (ART, Inc.); technically, then, the A&HC is a project of ART, Inc.

15. There *are* those people whose sole need is housing; still, as Fred Siegel, professor of history at Cooper Union, points out, homeless advocates "were much too slow to admit that most chronically homeless people had other serious problems, so homelessness was considered a purely economic problem and the public health crisis was largely ignored." Melinda Hennenberger, "Where the Beggars Meet the Begged," *New York Times*, January 16, 1994. It bears mentioning, of course, that acknowledging the connections might have had little effect, since Reaganomics left many of the programs and services that could have addressed the needs of the poor severely underfunded. For an accounting of specific cutbacks affecting poor and homeless families—and for a devastating look inside New York City's family shelter system, including discussion of conditions at Catherine Street—see Jonathan Kozol, *Rachel and Her Children: Homeless Families in America* (New York: Crown Publishers, 1988).

16. Peter H. Rossi, *Down and Out in America: The Origins of Homelessness* (Chicago: University of Chicago Press, 1989), 8–9.

17. "The amount of homelessness is likely to be affected by the amount of inexpensive housing available: the less housing is available and the more expensive it is, the more people are homeless." Ibid., 143–44.

18. Linda Burnham, "Up the Revolution," *High Performance* 3, no. 8 (1987): 12.

19. For a sense of the bureaucratic tangle that must be negotiated in order to receive shelter, benefits, and permanent housing, see Kozol, *Rachel and Her Children*.

20. Allison Gamble, "Reframing a Movement: Sculpture Chicago's 'Culture in Action,'" *New Art Examiner* 21 (January 1993): 18–23.

21. E. G. Crichton, "Is the NAMES Quilt Art?" *Critical Issues in Public Art: Content, Context, and Controversy*, ed. Harriet F. Seine and Sally Webster (New York: HarperCollins, 1992), 291.

22. Ibid., 291.

23. Artist and Homeless Collaborative statement, undated.

24. Through the years, the Human Resources Administration has recognized the work of Sandrow and other A&HC participants with numerous community service

awards. Sandrow has also received a Manhattan Borough President's Citation for Excellence in the Arts (1991) and a Mayor Dinkins' Superstar Award (1992).

Bibliography

Cordray, David S., and Georgine M. Pion. "What's Behind the Numbers? Definitional Issues in Counting the Homeless." *Housing Policy Debate* 2, no. 3. Paper presented at the Fannie Mae Annual Housing Conference, Washington, D.C., May 14, 1991.

Hombs, Mary Ellen, and Mitch Snyder. *Homelessness in America: A Forced March to Nowhere.* Washington, D.C.: Community for Creative Non-Violence, 1982.

Jencks, Christopher. "The Homeless." *New York Review of Books,* April 21, 1994, 25.

———. "Housing the Homeless." *New York Review of Books,* May 12, 1994, 39.

Kozol, Jonathan. *Rachel and Her Children: Homeless Families in America.* New York: Crown Publishers, 1988.

Public Art Fund Inc. "Art and the Homeless." In *Public Art Issues.* (Winter/Spring 1989).

Rossi, Peter H. *Down and Out in America: The Origins of Homelessness.* Chicago: University of Chicago Press, 1989.

Senie, Harriet F., and Sally Webster, eds. *Critical Issues in Public Art: Content, Context, and Controversy.* New York: HarperCollins, 1992.

Wallis, Brian, ed. *If You Lived Here: The City in Art, Theory, and Social Activism.* Seattle: Bay Press, 1991.

10 Peggy Diggs: Private Acts and Public Art

Notes

1. Richard Sennett, *The Fall of Public Man* (New York: Alfred A. Knopf, 1977), 89–99.

2. Julie Blackman, *Intimate Violence: A Study of Injustice* (New York: Columbia University Press, 1989), 2.

3. Peggy Diggs, interview with the author, January 6, 1994. The artist reported that the woman has since been acquitted and released from prison.

4. Blackman, *Intimate Violence*, 72.

5. Diggs, interview, January 6, 1994.

6. Ibid.

Bibliography

Blackman, Julie. *Intimate Violence: A Study of Injustice.* New York: Columbia University Press, 1989.

Foster, Hal, ed. *Discussions in Contemporary Culture.* Seattle: Bay Press; New York: Dia Art Foundation, 1987.

Giroux, Henry A. *Theory and Resistance in Education: A Pedagogy for the Opposition.* South Hadley, Mass.: Bergin & Garvey Publishers, Inc., 1983.

Gutman, Amy. *Democratic Education.* Princeton: Princeton University Press, 1987.

Harvey, David. *The Condition of Postmodernity.* Cambridge: Blackwell Publishers, 1989.

Lippard, Lucy R. *Get the Message? A Decade of Art for Social Change.* New York: E.P. Dutton, 1984.

Sennett, Richard. *The Fall of Public Man.* New York: Alfred A. Knopf, 1977.

Stets, Jan E. *Domestic Violence and Control.* New York: Springer-Verlag New York, 1988.

Wallis, Brian, ed. *Democracy: A Project by Group Material.* Seattle, Bay Press; New York: Dia Art Foundation, 1990.

———. *Public 6: Violence.* Toronto: Public Access, 1992.

11 Guerrilla Girl Power: Why the Art World Needs a Conscience

Notes

1. The Guerrilla Girls were extremely generous with their time and their files for this essay. Finding members of a secret society has obvious problems. The Girls did not want me to interview them as a group, nor did they want me at any of their meetings. My phone number was, democratically, given out to the whole membership and I waited for those interested to get in touch. I offered each woman who called the choice of a face-to-face meeting or a phone interview. Not all members, past or present, take on the name of a deceased artist, so some Girls are simply identified as members. Eight Girls, two no longer members, were officially interviewed at some length for this article, and I had brief chats with a few other members on the phone. I thank them all for their patience and their willingness to contend with a pesky journalist in the midst of their busy, dual lives.

Bibliography

"Art Essay—The Guerrilla Girls." *Ms.* (September/October 1990): 60–63, poster and cover photo.

Carr, C. "Guerrilla Girls in the Art Zone." *Mirabella* (July 1992).

Centerfold Project, *Artforum* 29, no. 1 (September 1990): 128–29.

Flam, Jack. *Wall Street Journal,* April 29, 1987, Leisure and Arts section.

"Gallery Girls." Letters to the editor, *Vanity Fair* (December 1987).

"Guerrilla Girls Speak Back to the Whitney." *Village Voice,* April 29, 1987.

Guerrilla Girls. "Art World Shows Its Derriere." *Ms.* (January/February 1994).

———. "Dear Museum Director." *Ms.* (March/April 1994): inside front cover.

Heartney, Eleanor. "How Wide Is the Gender Gap?" *Art News* 86 (Summer 1987): 139–45.

Hess, Elizabeth. "Get Rid of 'Political Art'?" *Village Voice,* April 9, 1991, 87.

Loughery, J. "Mrs. Holladay and the Guerrilla Girls." *Arts Magazine* 62 (October 1987): 61–65.

Lubell, Ellen. "Collage: Who Are the Guerrilla Girls?" *Village Voice,* May 14, 1985, 99.

Prince, D. "Warfare in the Artworld." *(New York) Daily News,* October 18, 1985.

Salisbury, S. "Guerrilla Girls Fight Sexism with Fun." *Philadelphia Inquirer,* March 4, 1986.

Smith, Roberta. "Waging Guerrilla Warfare Against the Art World." *New York Times,* June 17, 1990.

Tallman, Susan. "Guerrilla Girls." *Arts Magazine* 65, no. 8 (April 1991): 21–22.

Trebay, Guy. "Guerrilla's Night Out." *Village Voice,* October 29, 1985, 71.

12 Louder Than Words: A WAC Chronicle

Notes

1. Sometime in the summer of 1992, the term lesbophobia replaced homophobia in our personal conversations and floor dialogue. Eventually in the fall it was incorporated into the WAC mission statement. I believe it was the product of the historically unique interactions of young lesbian women involved in various and often overlapping activist groups, including Lesbian Avengers, Fierce Pussy, Riot Girrls, WAC's Lesbian Caucus, the Third Wave, and others.

2. Degen Pener, "Blue Dots, a Drum Corps and Great Production." *New York Times,* May 3, 1992.

3. Toni Morrison, ed., *Race-ing Justice, En-gendering Power: Essays on Anita Hill, Clarence Thomas, and the Construction of Social Reality* (New York: Pantheon Books, 1992), and Patricia Williams, *The Alchemy of Race and Rights* (Cambridge, Mass.: Harvard University Press, 1991).

4. The pamphlet was a publication of the Calgary Lesbian and Gay Political Action Guild, Calgary, Alberta, 1992.

5. Tracy Ann Essoglou, sound bite developed specifically for the Houston Convention and later offered in an interview on the television talk show *Good Day New York,* Fox Network, March 12, 1993.

6. B. Ruby Rich, "Top Girl," *Village Voice,* October 8, 1991, 29.

7. Hans-Georg Gadamer, *Truth and Method* (New York: Continuum Books, 1990), 304.

8. Drucilla Cornell, from the conference, "Is Feminist Philosophy Philosophy?" held at the Graduate Faculty for the New School for Social Research, New York City, October 19, 1993.

9. Thomas Paine, *Common Sense* (London: Penguin Books, 1986), 63. Originally published in 1776, this pamphlet urged an immediate declaration of independence.

Bibliography

"Abortion: On the Streets." *The Economist,* August 22, 1992, 20.

Atkins, Robert. "Guggenheim or Guggen-Him?" *Village Voice,* March 24, 1992, 104.

"At the March: Support for Abortion Rights." *Glamour* (June 1992).

Baldwin, James. *Notes of a Native Son.* Boston: Beacon Press, 1955.

Bernikiow, Louise. "The New Activists: Fearless, Funny, Fighting Mad." *Cosmopolitan* (April 1993): 163–212.

Butler, Judith, and Joan Scott, eds. *Feminists Theorize the Political.* New York: Routledge, Chapman & Hall, 1992.

Carper, Alison. "Judge Gets Tough." *New York Newsday,* April 17, 1992, 6.

Carr, C. "A Boy's Life: The Last St. John's Defendant Pleads Guilty and Walks." *Village Voice,* February 25, 1992, 25–26.

———. "Battle Scars: Feminism and Nationalism Clash in the Balkans." *Village Voice,* July 13, 1993, 25–26.

Cembalist, Robin. "The We Decade." *Art News* (September 1992): 62.

Evans, Heidi. "For O'C, a Defining Moment." *(New York) Daily News,* June 14, 1992, 20.

Ferguson, Russell, Martha Gever, Trinh T. Minh-ha, and Cornel West, eds. *Out There: Marginalization and Contemporary Cultures.* Cambridge, Mass.: MIT Press, 1990.

Freire, Paulo. *Pedagogy of the Oppressed.* New York: Seabury Press, 1970.

Fried, Lisa I. "Women's Media Watchdogs Attack New York, Esquire." *Magazine Week,* September 7, 1992.

Fusco, Coco. "Army Rules." *Village Voice,* June 10, 1992, 20.

Gadamer, Hans-Georg. *Truth and Method.* New York: Continuum Books, 1990.

Gardner, John. *Excellence: Can We Be Equal and Excellent Too?* New York: Harper Colophon, 1961.

———. *Self-Renewal: The Individual and the Innovative Society.* New York: Harper Colophon, 1963.

Gimelson, Deborah. "Guerrilla Women's Art Group Targeting Documenta 9." *The Observatory,* June 1, 1992, 1.

"Guggenheim in a New Light: A Museum Reopens with Celebrations, and a Protest to Urge Further Diversity." *New York Times,* June 27, 1992, L13.

Heartney, Eleanor. "Wright Rewrit." *Art in America* (September 1992): 108.

Hendriks, Aart, Rob Tielman, and Evert van der Veen, eds. *The Third Pink Book: A Global View of Lesbian and Gay Liberation and Oppression.* New York: Prometheus Books, 1993.

Hirsch, Marianne, and Evelyn Fox Keller. *Conflicts in Feminism.* New York: Routledge, Chapman & Hall, 1990.

Hoban, Phoebe. "Big WAC Attack: Brash and Very Politically Correct, the Women's Action Coalition Is the Latest Rage in Post-Post Feminism." *New York Magazine*, August 3, 1992, 30–35.

hooks, bell. *Talking Back: Thinking Feminist, Thinking Black*. Boston: South End Press, 1989.

Houppert, Karen. "Feminism in Your Face: The Women's Action Coalition Confronts Sexism in the Media, the Courts, and on the Streets." *Village Voice*, June 9, 1992, 33.

———. "WAC Attacks Itself: Will the Direct Action Group Self-Destruct?" *Village Voice*, July 20, 1993, 28–32.

Ingall, Margie. "Acting Up for Choice." *Sassy* (September 1992): 70–71, 89–90.

Jacobs, Karrie. "Graphic Activism." *I.D. Magazine* (November/December 1992): 42–53.

Jaggar, Alison M., and Susan R. Bordo, eds. *Gender/Body/Knowledge: Feminist Reconstructions of Being and Knowing*. New Brunswick, N.J.: Rutgers University Press, 1990.

Joignot, Frederic. "Le XXI siecle sera feminin." *Actuel* (France) no. 23 (November 1992): 45–54.

Keeton, Laura E. "Activists Drumming Up Feminist Message." *Houston Chronicle*, August 24, 1992, 9.

Kriegl, Phyllis. "WAC Is Watching You!" *New Directions for Women* 21, no. 3 (May 1992): 13.

Landsberg, Michelle. "Canadian Feminists Ready to Zap Offenders." *Toronto Star*, May 9, 1992, G1.

———. "U.S. Feminists Are Finding Confrontation Gets Results," *Toronto Star*, May 9, 1992, J1.

Manegold, Catherine S. "Demonstrators Are Targeting the Democrats." *New York Times*, July 5, 1992, 22.

———. "No More Nice Girls." *New York Times*, July 12, 1992, 25.

Morrison, Toni, ed. *Race-ing Justice, En-gendering Power: Essays on Anita Hill, Clarence Thomas, and the Construction of Social Reality*. New York: Pantheon Books, 1992.

Morse, Holly. "WAC Takes Grand Central Station." *New Directions for Women* 21, no. 4 (July–August 1992), M1.

O'Grady, Lorraine. "Dada Meets Mama." *Artforum* 31 (October 1992): 11, 12.

Pagnozzi, Amy. "Half Million March on D.C. in Pro-Choice Rally." *New York Post*, April 6, 1992, 9.

Paine, Thomas. *Common Sense*. London: Penguin Books, 1986.

Pener, Degen. "Blue Dots, a Drum Corps and Great Production Values." *New York Times*, May 3, 1992.

Rich, Adrienne. "Compulsory Heterosexuality and Lesbian Existence." In *Blood, Bread and Poetry*. New York: W.W. Norton, 1986.

Rohan, Brian. "Abortion Case Sparks Day of Rage." *Irish Voice*, March 3, 1992, 8.

Sachar, Emily. "Question of Judgment." *New York Newsday*, April 15, 1992, 23.

Schwartz, Christine. "USA: Les feministes contre-attaquent." *Elle* (France), (September 1992): 20.

Siegel, Jessica. "In Your Face: A New Generation Takes Up the Feminist Struggle." *Chicago Tribune*, August 3, 1992, 1–2.

Sieloff, Kristine. "WAC Is Watching: Women's Action Coalition on the Streets of Chicago." *Off Our Backs* 24, no. 2 (February 1994): 7–17.

"SoHo Guggenheim Gets WACed." *Flash Art* (September 1992): 131.

Spellman, Elizabeth. *The Inessential Woman: Problems of Exclusion in Feminist Thought*. Boston: Beacon Press, 1988.

Stone, Judith. "Election '92: Women Raise Their Voices." *Glamour* (October 1992): 122–26.

Trinh T. Minh-ha. *Woman, Native, Other*. Bloomington, Ind.: Indiana University Press, 1989.

"WAC Supplement." *New Directions for Women* 2, no. 1 (January–February 1993): 19–22.

Wallach, Amei. "Branching Out in SoHo." *New York Newsday*, June 29, 1992, 43–54.

West, Cornel. *Race Matters*. Boston: Beacon Press, 1993.

Williams, Patricia. *The Alchemy of Race and Rights*. Cambridge, Mass.: Harvard University Press, 1991.

Wittig, Monique. *The Straight Mind*. Boston: Beacon Press, 1992.

"Women to Demonstrate at Guggenheim." *Art in America* (April 1992): 184.

Contributors

Jan Avgikos is an art critic and historian who lives and works in New York City. She is a contributing editor with *Artforum* and is a member of the editorial advisory board of *Acme Journal*. She is the author of numerous essays and articles on contemporary art and theory that appear in catalogs and magazines in the United States and Europe. She is the author of a monograph text on Jeff Wall (Phaidon Press Limited, 1995). Avgikos is on the faculty of the School for the Visual Arts and the A.I.C.A.D. program at Parsons School of Design, both in New York City.

Jan Cohen-Cruz is an assistant professor of drama at New York University. She has taught and directed performances at prisons, colleges, schools, psychiatric facilities, migrant camps, theaters, and parks, and has performed at the Edinburgh Festival Fringe, New York's Playwright's Horizons, the National Theater of Israel, and with the New York City Street Theater. Co-editor, with Mady Schutzman, of *Playing Boal: Theatre, Therapy, Activism* (Routledge, 1994), she coproduced Augusto Boal's workshops in New York City and Rio de Janeiro in 1989–91. Her articles have appeared in *The Drama Review, Women and Performance, American Theatre,* the *Mime Journal,* and *Urban Resources*. A Goddard Fellowship has recently permitted her to revise for publication her dissertation on U.S. activist performance art from the 1960s to the 1990s. Cohen-Cruz is currently directing the theater component of New York University's initiative in a large urban high school, a pilot project of AmeriCorps, President Clinton's new domestic Peace Corps.

Tracy Ann Essoglou, who holds a Master's Degree in Media Studies from the New School for Social Research, was a founding contributor to the media committee of the Women's Action Coalition, as well as the initiating coordinator of WACNET, the group's network of thirty-one sister groups. She has provided feminist commentary for television, radio, and print media, and has taught and lectured in Mexico City, Paris, Berlin, New York, Chicago, and Toronto. Essoglou has exhibited her work at the Sculpture Center, the Vrej Baghoomian Gallery, and the A/C Project room in New

York City; as an object-maker, she continues to work in the areas of sculpture, industrial design, space planning, and interior and architectural fabrication. Her recent activities include the development of a companion study guide on human rights for the television series *Rights and Wrongs,* produced by Globalvision, Inc. She is currently collecting material for a book of anti-American humor from around the world, and is developing Situation Design, a culture and communications consulting concept promoting progressive social forecasting and strategic use of media.

Nina Felshin is an independent curator, writer, and arts management consultant who lives in New York City. During the past twelve years she has curated more than fifteen exhibitions of contemporary art that have traveled to more than one hundred museums and galleries in the United States, Canada, and Europe. She is a founding member of Independent Curators, Inc., and has been a curator at the Corcoran Gallery of Art in Washington, D.C. and the Contemporary Arts Center in Cincinnati, Ohio; and program coordinator of the General Services Administration's Art-in-Architecture Program in Washington, D.C. Many of Felshin's exhibitions since the early 1980s have addressed social, political, and cultural issues. Recent exhibitions and catalogs include *Empty Dress: Clothing as Surrogate in Recent Art; No Laughing Matter; The Presence of Absence; New Installations;* and *Unknown Secrets: Art and the Rosenberg Era.* Other exhibitions include *Disorderly Conduct* (co-curator Wendy Olsoff); *Beyond Glory: Re-Presenting Terrorism* (co-curator David Brown); and *The Power of Words: An Aspect of Recent Documentary Photography* (co-curator Wendy Olsoff). Her essay "Women and Children First: Terrorism on the Home Front" appears in the book *Violent Persuasions: The Politics and Imagery of Terrorism* (Bay Press, 1993), and she is currently guest-editing a forthcoming issue of the *Art Journal* titled "Clothing as Subject" for Spring 1995.

Eleanor Heartney is a New York–based critic and curator, a contributing editor to *Art in America* and the *New Art Examiner,* and a regular contributor to *Sculpture, Artpress, Art and Auction,* and other publications. She has also contributed essays to numerous exhibition catalogs for such institutions as the Guggenheim Museum, the Toledo Museum of Art, the National Museum for Women in the Arts, and the Museo de Arte Contemporaneo, in Monterrey, Mexico. In 1992, she received the Frank Jewett Mather Award for Distinction in Art Criticism from the College Art Association, and in 1993 she was awarded a New York Foundation for the Arts fellowship. Heartney is a frequent public speaker both here and abroad and has

lectured and written extensively about political and public art. She has curated exhibitions at the Neuberger Museum of Art and at School 33 in Baltimore, and in 1994 was co-curator of the *Public Interventions* exhibition at the Institute of Contemporary Art in Boston, which examined new trends in public art.

Elizabeth Hess writes a column on art for the *Village Voice.* Over the years, she has written for the *Washington Post,* the *New York Observer, Art in America, Artforum, Art News, Ms.,* the *Women's Review of Books,* and other publications. Hess was a founding editor of *Heresies: A Feminist Journal on Art and Politics,* and of *Seven Days* magazine. She is the coauthor of *Remaking Love: The Feminization of Sex* (Anchor/Doubleday, 1986). She is currently writing a monograph on the artist Ida Applebroog (forthcoming from Rizzoli), and is working on a book about censorship.

Jeff Kelley, a practicing art critic since 1976, has written for such publications as *Artforum, Art in America, Artweek, Vanguard,* the *Headlands Journal,* and the *Los Angeles Times.* He also edited and introduced *Essays on the Blurring of Art and Life,* a collection of twenty-three of Allan Kaprow's writings, published by the University of California Press in 1993, and is currently working on *Childsplay,* a book about Kaprow's Environments, Happenings, and other works. Kelley received an M.F.A. from the University of California, San Diego, in 1985, and from 1986 through 1990 was the first director of the Center for Research in Contemporary Art at the University of Texas at Arlington, near Dallas. Now in Oakland, California, he works as a freelance critic and teaches courses in art theory and criticism at the University of California, Berkeley, as well as at the California College of Arts and Crafts and Mills College.

Richard Meyer is a Ph.D. candidate in the department of art history at the University of California, Berkeley. His recent publications include "Robert Mapplethorpe and the Discipline of Photography," in *The Lesbian and Gay Studies Reader,* edited by Henry Abelove et al. (Routledge, Chapman & Hall, 1993), and "Warhol's Clones," in the *Yale Journal of Criticism,* Spring 1994.

Patricia C. Phillips is an independent critic who writes on art, public art, architecture, design, and landscape. Her work has been published in international art and architecture publications including *Artforum, Art in America, Flash Art, Public Art Review,* and *Sculpture.* Her essays have been included in books published by the MIT Press, Princeton Architectural Press, and

Rizzoli International Publications. In addition to her writing, she has held academic and administrative positions at Parsons School of Design, the New School for Social Research, and S.U.N.Y.–The College at New Paltz, where she is currently an associate professor in the art department. Her current projects include a book on temporality and time in modern art. She is also curating exhibitions for the Katonah Museum of Art (*A Sense of Space,* Spring 1995), and the Queens Museum of Art (*City Speculations,* Fall 1995).

Robert L. Pincus, who holds an interdisciplinary Ph.D. in English and Art History from the University of Southern California, was art critic of the *San Diego Union* from 1985 to 1992 and has been art critic of the *San Diego Union–Tribune* since then. A corresponding editor for *Art in America,* he served as an art critic for the *Los Angeles Times* from 1981 to 1985, and won the 1994 Chemical Bank Award for distinguished newspaper art criticism. Pincus is also the author of the only full-length study of the art of Edward and Nancy Reddin Kienholz, *On a Scale That Competes With the World,* first published in 1990 and recently reissued in paperback by the University of California Press. His essays have appeared in exhibition catalogs for *L.A. Pop in the Sixties; Forty Years of Assemblage; Kienholz: The '80s;* and the 1988 Sydney Biennale. He has also published articles on Wallace Berman, Manuel Neri, Sophie Calle, Judy Fiskin, and the Border Art Workshop/Taller de Arte Fronterizo, among others, and has contributed numerous reviews to books and to magazines such as *Art in America, Flash Art, Art Issues, Artforum,* and *Sculpture.*

Dot Tuer is a writer and cultural critic who has written extensively on the visual and media arts for Canadian and international magazines and anthologies. She is the curator of a number of film and video programs, including a retrospective of independent Canadian cinema presented at the 1992 Toronto Film Festival. In addition to her critical writings and curatorial work, she has worked as a community radio journalist in Canada and Nicaragua. Tuer holds a Master of Arts in History degree from the University of Toronto, and teaches at the Ontario College of Art. A frequent lecturer on contemporary art at universities and art institutions in North America and Europe, she also serves on the boards of The Power Plant Contemporary Art Gallery, the Ontario Cinematheque, and *Fuse* magazine. Her recent essay on the intermedia art of Vera Frenkel, published in *Vera Frenkel: Raincoats, Suitcases, Palms* (Art Gallery of York University, 1993), won the 1994 Ontario Art Gallery Association's award for curatorial writing.

Andrea Wolper is a freelance writer who specializes in feminist and social issues and in the arts. She is coeditor of *Women's Rights, Human Rights: International Feminist Perspectives* (Routledge, 1994), and serves on the editorial panel of the *Metro Journal of Literary and Visual Arts*. Her fiction and nonfiction work has appeared in numerous publications, including *Back Stage, On the Issues, Manhattan Spirit, New Directions for Women, New York Newsday, New York Woman,* and *The Sun.* She was a contributor to each of two editions of *The Back Stage Handbook for Performing Artists,* and her own book, *The Actor's City Sourcebook,* was published by Watson-Guptill in 1992. She was associate producer of *The Beckett Project* documentary series in 1989 and served as a press liaison for the 1992 Conference on Women and Human Rights at Columbia University, and for the Women's Action Coalition.

Photo Credits

This credits page is a continuation of the copyright page. Works of art copyright by the artists. Photos courtesy of the artist unless otherwise noted.

262	George Hirose
263–64	Hope Sandrow
265	George Hirose
266–67	Hope Sandrow
269	Top, bottom: Ulf Skogsbergh
272–79	Hope Sandrow
280	Michael Boodro
284	From *Le Corbusier et Pierre Jeanneret: Oeuvre complète de 1929–1934*. 5th ed. Zurich: Les Éditions Girsberger,1952
288	Marty Heitner
290	Top: Marty Heitner; bottom: Peggy Diggs
292	Ralph Lieberman
294	Top, bottom: Ralph Lieberman
298	Top, bottom: John LeClaire
300	Marty Heitner
303–07	Top, bottom: John LeClaire
337–38	Bethany Johns
340	Lisa Kahane
343	Bethany Johns
346	Teri Slotkin
347	Bethany Johns
348	Lisa Kahane
349	Teri Slotkin
350	Lisa Kahane
351–52	Teri Slotkin
353	Bethany Johns
357	Lisa Kahane
359–68	Bethany Johns
369	Teri Slotkin

Other titles by Bay Press

AIDS Demo Graphics
Douglas Crimp with Adam Rolston

The Anti-Aesthetic: Essays on Postmodern Culture
Edited by Hal Foster

The Critical Image: Essays on Contemporary Photography
Edited by Carol Squiers

How Do I Look? Queer Film and Video
Edited by Bad Object-Choices

Line Break: Poetry as Social Practice
James Scully

Magic Eyes: Scenes from an Andean Childhood
Wendy Ewald, from stories by Alicia and Mária Vásquez

Mapping the Terrain: New Genre Public Art
Edited by Suzanne Lacy

Out of Site: A Social Criticism of Architecture
Edited by Diane Ghirardo

Recodings: Art, Spectacle, Cultural Politics
Hal Foster

Suite Vénitienne/Please Follow Me
Sophie Calle and Jean Baudrillard

Uncontrollable Bodies: Testimonies of Identity and Culture
Edited by Rodney Sappington and Tyler Stallings

Violent Persuasions: The Politics and Imagery of Terrorism
Edited by David J. Brown and Robert Merrill

Discussions in Contemporary Culture is an award-winning series of books copublished by Dia Center for the Arts, New York City, and Bay Press, Seattle. These volumes offer rich and interactive discourses on a broad range of cultural issues in formats that encourage scrutiny of diverse critical approaches and positions.

Discussions in Contemporary Culture
Edited by Hal Foster

Vision and Visuality
Edited by Hal Foster

The Work of Andy Warhol
Edited by Gary Garrels

Remaking History
Edited by Barbara Kruger and Philomena Mariani

Democracy
A project by Group Material
Edited by Brian Wallis

If You Lived Here: The City in Art, Theory, and Social Activism
A project by Martha Rosler
Edited by Brian Wallis

Critical Fictions: The Politics of Imaginative Writing
Edited by Philomena Mariani

Black Popular Culture
A project by Michele Wallace
Edited by Gina Dent

Culture on the Brink: Ideologies of Technology
Edited by Gretchen Bender and Timothy Druckrey

For information:
Bay Press

115 West Denny Way
Seattle, WA 98119-4205
tel 206.284.5913
fax 206.284.1218